Video Editing with Adobe Premiere 6.5

Dave D. Peck

THOMSON

DELMAR LEARNING

Australia Canada Mexico Singapore Spain United Kingdom United States

THOMSON
*
™
DELMAR LEARNING

Video Editing with Adobe Premiere 6.5

Dave D. Peck

Business Unit Director:
Alar Elken

Executive Editor:
Sandy Clark

Acquisitions Editor:
James Gish

Editorial Assistant:
Jaimie Wetzel

Executive Marketing Manager:
Maura Theriault

Marketing Coordinator:
Sarena Douglass

Channel Manager:
Fair Huntoon

Executive Production Manager:
Mary Ellen Black

Technology Project Manager:
David Porush

Production Editor:
Betsy Hough

Editorial:
Carol Leyba, Daril Bentley

Cover Design:
Cammi Noah

For more information, contact:
Delmar Learning
Executive Woods
5 Maxwell Drive
Clifton Park,
NY 12065-2919

Or find us on the World Wide Web at
http://www.delmarlearning.com

For permission to use material from
this text or product, contact us by
Tel : 1-800-730-2214
Fax: 1-800-730-2215
www.thomsonrights.com

ISBN: 0-7668-3368-2

NOTICE TO THE READER

About the Author

Dave Peck lives in Nashville, Tennessee, with his wife Trish and their children Chris, Chad, and Lauren. His firm, PeckDesign, provides graphic and interactive design for the development of CD/DVDs, video editing, presentation design, and touch-screen kiosk. PeckDesign also offers customized training for corporate and educational clients. Dave is the author of the Delmar Learning titles *Multimedia: A Hands-on Introduction* and *The Pocket Guide to Multimedia*. The author can be reached at *dave@peckdesign.com*.

Acknowledgments

Preparing over four hundred pages of printed material, developing tutorials, and organizing content for a CD-ROM is an awesome undertaking. Even though it is my name on the book, there were many behind the scenes that provided support and encouragement.

This is my third book for Delmar Learning. This time around, the support was exceptional. I would like to thank acquisitions editor Jim Gish. This project began with a phone call from Jim about another book project and took a one hundred and eighty degree turn when I suggested that we pursue a book on Premiere. The encouragement and research you provided fueled the process to get this one off the ground with a quick turnaround. Also thank you for supportive calls and e-mails at critical times during the development cycle.

To Daril Bentley, an exceptional developmental editor with an abundance of talent and patience. The project is a success because of your support and professionalism. To Carol Leyba, project manager and layout and design supervisor. Thank you for your expertise and design flair, and for allowing me to cause frequent bottlenecks to your e-mail. To Jaimie Wetzel, editorial assistant at Delmar. Thank you for your responsiveness, attention to detail, and professionalism as we jointly addressed the many details of bringing this project to life. Also thanks to Betsy Hough, who was responsible for producing the physical product you hold in your hands.

A special thanks to Alan Ford Hamill at Adobe Systems. Thanks Alan for the time and energy spent in reviewing the original manuscript and for your valuable input, ideas, and encouragement. Also to Bruce Bowman of Adobe Systems for providing the opportunity to be a part of the Premiere 6.5 beta team, for the software support, and the replies to many, many e-mails.

The following also deserve special praise. Ana Dias and Matrox, for providing support and products to help the project become a reality. Eric Howard, for providing breathtaking balloon visuals. Terry Bates and J. Terry Bates & Associates, Inc., Architects/Planners, Nashville. Thanks Terry for projects that inspire me. Jerry R. Atnip and Creative Services Agency, Nashville. Many thanks for your photographic expertise. Sonic Studio, for the background soundtracks that worked so well with the tutorials. Julie Hill and Artbeats, for the clip media support.

Paul Clatworthy at PowerProduction Software, thank you for providing the storyboard art. Glen Verner, thank you for the equipment support; and to Jane Verner for the hors d'oeuvres. Jonathan Hardison, for fantastic voiceover support on tutorials.

Lauren Peck, thanks for running endless loops until we "got it right." Chris Peck, thanks for showing the world how to give new meaning to life. Chad Peck, for ongoing technical dialog, support, and Mac bonding. Thanks also to Carl and Charlotte Shetter, for unending support. Frank and Carolyn Maddux, thank you for your generosity, hospitality, and steadfast example.

—D.D.P.

This book is dedicated to Trish Peck. Thank you for your bountiful love, support, dedication, and for your tireless pursuit of bringing out the best in others.

CONTENTS

INTRODUCTION

Perhaps the most engaging form of media is video. Because video incorporates moving images, still images, voice, and music, it can tell a story like no other medium. Now that personal computers have reached advanced power and performance levels, the ability for anyone to capture and edit video is possible. Not long ago, this capability was available only to industry professionals with specialized equipment. Today, with the advent of digital video equipment and high-speed connectivity between devices, anyone can be a part of the digital video revolution.

Living in this age of rapidly changing technology, we are no longer tethered to just presenting our video productions on a television. With the advent of the Web, we can now save our video in a format that can be viewed by anyone, anywhere, provided they have Internet access. And what about distributing a video project? No longer are we constrained to videotape as a solitary output solution. Video can be saved for use on a personal computer, CD-ROM, or DVD. This is changing the way in which stories are told, adding the dynamic of video to business and educational presentations.

I have been excited about this project from the first discussion with Jim Gish, acquisitions editor at Delmar. As I presented the idea, an enthusiastic yes was the response to pursue the project. Then came the challenge as to how to present the material in a book such as this. From my viewpoint, the overwhelming majority of content should be centered around using Premiere and not just reading about it. Becoming engaged in tutorials is where you learn how to use software programs such as Premiere 6.5. I remember being introduced to computing with the introduction of the Macintosh in 1984. My best learning experiences came by being shown how a tool or process works, rather than reading about it. The pages of this text are primarily designed to have the book be your teacher and guide as you learn by doing.

I have found that developing and editing video has so many uses, from family video albums to corporate presentation, and from interactive DVDs to classroom projects. An objective of this book is that upon completion you will have developed a working knowledge of Premiere so that you can begin video editing and realize just how easy it really is.

As one new to video editing, hopefully this text will be a catalyst to your journey into video editing. With Premiere's dominance in the video editing software arena, you can count on many years of editing "mileage" knowing that the software will become more sophisticated as your proficiency continues to increase.

Philosophy and Approach

This hands-on guide follows a "discovery learning" approach. The first two chapters are designed to provide a background of digital video editing and to set the stage for the book's series of tutorials. These tutorials begin at a basic level and progress to an increasing level of sophistication in subsequent project development.

Many rich content elements are provided on the companion CD-ROM. These files include video clips, audio clips, graphics, illustrations, and other types of media that hopefully will engage and entertain you during tutorial development. These clips are also examples of various content items that demonstrate the philosophy of how to capture and create items that can be used in future productions.

 NOTE: *See also the section "About the Companion CD-ROM" at the end of this introduction.*

Audience and Purpose of the Book

I have designed this book to teach you how to edit and assemble a video project in a simple, straightforward manner. Although video editing can be very demanding, requiring state-of-the-art equipment, the tutorials are designed to work on minimally configured systems. Knowledge and expertise are developed by using repetitive processes to build a variety of projects. Along the way, new techniques are applied that will deepen your understanding of the editing process and of Premiere 6.5.

Text and tutorials are designed for the beginner to intermediate user among practitioners, educators, and students. The approach of this text

is to use well-documented, specialized tutorials to teach the video editing process. By performing these easy-to-use tutorials, you will learn the following: (1) the editing process and (2) how to access menus, dialog boxes, and commands for customizing a video project.

By possessing basic Windows and MacOS skills, all tutorials can be developed by following the step-by-step tutorials. Upon completion of this book, you should have a firm understanding of video and audio editing. Another goal of this book is to stimulate creative thinking and planning geared toward the organization of materials and resources for future projects. You should also form a solid understanding of other products critical to the development of content for video and audio editing.

Content and Structure

The sections that follow review the main components of this book. These include text and tutorials, appendices, color insert, the companion CD-ROM, and the adjunct Instructor's Guide.

Text and Tutorials

The following describes the content and progression of chapters and tutorials. Chapters 1 and 2 provide an overview of Premiere, including the particulars of features that are new under Premiere 6.5. The tutorials that run throughout the rest of the book begin in Chapter 3. The tutorials deal with video editing, audio editing, and various output options. In general, the tutorials are grouped as follows.

Chapter 3: Demonstrates how to build a basic movie. You will build a movie containing video clips, art files, transitions, and soundtrack.

Chapters 4 and 5: Show how to create a movie with only still images. These still images become dynamic with the addition of motion effects. The visuals are accentuated with the addition of sound effects that support the dynamics of motion and the timing of the graphic display.

Chapters 6, 7, and 8: Plot the development of a project centered on a fictitious hot air balloon company. Techniques are demonstrated in these chapters that enforce learning of video manipulation, and special effects sharpen your overall knowledge of complex project development while teaching important tools for use during the development cycle.

Chapters 9, 10, 11, and 12: These chapters cover the development of a full-blown video production. Many external file types are covered here. Timing and effects are also a part of the development process in these chapters. The use of Adobe's Title Designer is incorporated in these chapters, illustrating this important aspect of the video editing process.

Chapter 13: This chapter focuses on editing audio clips in Premiere and uses the sophisticated audio mixer component. Tutorials are included for producing and editing sound clips.

Chapter 14: This chapter teaches you how to export Premiere projects to a variety of formats.

Chapter 15: This chapter exposes you to a number of directions your video projects can go upon completion. These options include print, web, Adobe Acrobat PDF, and more.

Appendix and Glossary

Appendix A contains illustrated windows and explains window and button functionality. These illustrations provide visual references to be used as you perform tutorials. You will also find a glossary of terms that relate to the video editing process. These terms include general video and audio editing terms, as well as terms specific to Premiere 6.5.

Color Insert

You will find a 16-page full-color insert designed as an informative tool, as well as a stimulus to thinking about options available for finished video productions. Illustrations cover the digital workflow, software options and workflow, output scenarios, Premiere primary on-screen windows, Macintosh and Windows OS interface differences, the storyboard process, video editing workstation examples, special effects ideas, and creative output options.

Companion Instructor's Guide and CD-ROM

An instructor's guide in support of this text is available from the publisher. The companion CD-ROM at the back of the book contains all video, audio, and graphic clips necessary to performing all tutorials in the text. Finished tutorial files are also found on the companion CD-ROM, should you wish to view the completed project against your tutorial work.

NOTE: *See also the sections "About the Instructor's Guide" and "About the Companion CD-ROM," which follow, for further detail.*

How To Use This Book

As previously stated, the content of this book is designed to begin with basic tutorials and advance progressively to increasingly more advanced hands-on material. A workflow for approaching this book is suggested in the section "Approaching the Material," which follows. First, however, some notes on prerequisites to using the book.

Prerequisites

This book is designed to be fully compatible with Windows and Macintosh operating systems. Familiarity with Windows 98, Windows 2000, or Windows ME, or with MacOS 9 or MacOS X, is required. The ability to navigate to folders and external drives is also necessary. No video editing experience is required.

Use of other Adobe products will be helpful. However, this is not necessary for using Premiere. This is true because of the common interface between Adobe's products. Prior experience with video editing or editing software may be beneficial, but again this is not required. Adequate hard disk space is a requirement due to the fact that files will be imported and saved to your hard drive.

Most of the processes reviewed or discussed in this text are specifically designed for Adobe Premiere 6.5. However, many tutorials are applicable to version 6.0 as well. Exceptions to this would include the new Title Designer and MPEG export functions, available only in version 6.5.

Approaching the Material

The following is a suggested approach to the material in this book. Begin by reading chapters 1 and 2. These chapters are a basic primer for digital video and Premiere 6.5. Then read and perform the tutorial in Chapter 3. This is a very basic tutorial that will demonstrate how to incorporate two video clips, a graphic image, an audio file, and transitions. Upon completion, you will be shown how to output the project to a completed movie file. Quickly and easily, you will have developed your first project and can proceed with confidence to the other tutorials in the book.

Develop the tutorial outlined in chapters 4 and 5. These two chapters guide you through development of a lengthier project but maintain simplicity of design. More exposure to audio file implementation is covered here. Then perform the tutorials contained in chapters 6, 7, and 8. Combined, these chapters teach numerous Premiere editing techniques to develop an interesting story-based project. Chapters are designed such that development can occur at various intervals.

Chapters 9, 10, 11, and 12 consist of a suite of tutorials that develop the most sophisticated project in the book. By focusing on four strategic elements of design, the final project is assembled, yielding a powerful video production. Individual chapters and tutorials can be assembled independently for final assembly in Chapter 12.

Chapter 13 is designed around audio-only tutorials and information. These tutorials can be developed at any time and are independent from other tutorials in the book. If you have a basic understanding of Premiere, this exercise can be developed at any time. Chapter 14, on the other hand, is specifically targeted to output options for tutorials developed in the book. It is recommended that this chapter be performed after tutorials have been completed in chapters 3 through 13.

Chapter 15 deals with output options as well. However, these output scenarios are centered on workflows to other software products. This chapter is informational rather than hands-on. Many references to how graphics were created and what you can do with projects that were developed are included. Completion of tutorials is important before reviewing this chapter.

Text Conventions

Italic font in regular text is used to distinguish certain command names, code elements, file names, directory and path names, user input, and similar items. Italic is also used to highlight terms and for emphasis.

Throughout the book you will notice tips, notes, and warnings that relate to subject matter under discussion. These items serve as highlights of important information, as signposts to keep you on track, and as alerts that avoid problems, as described in the following.

 NOTE: *Information on features and tasks that requires emphasis or that is not immediately obvious appears in notes.*

 TIP: *Tips on command usage, shortcuts, and other information aimed at saving you time and work appear like this.*

 WARNING: *The warnings appearing in this book are intended to help you avoid committing yourself to results you may not intend, and to avoid losing data or encountering other unfortunate consequences.*

About the Instructor's Guide

The *Video Editing with Adobe Premiere 6.5 Instructor's Guide* (ISBN: 0-7668-3369-0)is designed to provide an overview of the design of the book and guidance on how to approach the text, tutorials, and CD-ROM content in a manner that allows you to quickly grasp the tutorials and how to implement them in a classroom setting. Basic chapter overview pages include an explanation of the tutorials contained in each chapter.

In addition, an "application thinking" section is included that is designed to provide ideas for instructors as to how to creatively plan other exercises or projects based on the skills learned in specific chapters. A list of questions and answers is included (with references to specific chapters, pages, and sections), allowing the instructor to quickly reference related subject matter.

About the Companion CD-ROM

The companion CD-ROM located at the back of this book is essential to tutorial development. This hybrid disc is compatible with both Windows and Mac operating environments. The "Read Me" file located on the CD contains information on the book text, as well as on the content and use of the CD-ROM itself. You will want to read this file first. The *Tutorials* folder contains all support files for the creation of the tutorials included in the text. The subfolder structure of the *Tutorials* folder is as follows.

- *Beach:* Use these files to develop the tutorial in Chapter 3.

- *Fireworks:* Use these files to develop the tutorials in chapters 4 and 5.

- *Balloon:* Use these files to develop the tutorials in chapters 6, 7, and 8.

- *Energy Drink:* Use these files to develop the tutorials in chapters 9, 10, 11, and 12.

- *Audio:* Use these files to develop the tutorials in chapter 13.

The *Saved Files* folder contains folders that in turn contain files of each tutorial. The folders are named according to the tutorial they support. Use these files to reference how a finished project should appear or to check for technical accuracy.

The *Adobe PDFs* folder contains the following three informative PDF documents from Adobe Systems. They are a valuable resource containing up-to-date information about digital video technology.

- A DV Primer

- A Streaming Media Primer

- A DVD/MPEG Primer

AN INTRODUCTION TO ADOBE PREMIERE 6.5

Introduction

From a simple document to a beautiful four-color brochure; from a line drawing to a full-screen color photograph; from a slide show to a sophisticated multimedia presentation; from a small, grainy movie to a full-screen video: all of these processes reflect how the personal computer (PC) has evolved in its capability to bring richer content to your computer. In reality, the personal computer is still relatively a new tool. Born in the 1970s, the original PCs performed only basic functions, such as word processing, spreadsheet capabilities, and the running of simple programs.

PCs are devices designed to process information. Over the last twenty-plus years, more demands have been made of the PC to process information of a more diverse nature, and to do it faster. Letters have evolved into complex documents, clip art has evolved into high-resolution scans and photographs, and postage stamp size video clips have evolved into "real" video. However, these changes have not happened overnight. The growth of computing capabilities, especially in the realm of producing video on your PC, has taken quite some time.

Video takes huge amounts of computing power. It is probably the most demanding desktop application available. A 640 x 480 pixel (or approximately 6.5-inch x 9-inch) color photograph saved in JPEG format will consume approximately 290 K of disk space. At this size, almost five images would fit on a floppy disk. In contrast, one hour of digital video consumes 13 Gb of disk storage.

Objectives

In this chapter you will learn about the following.

- Premiere's history and technology

- What is new in Premiere 6.5

- Video editing system scenarios

- Content development

- Adobe software collections

- The project workflow

- Storyboarding

Hardware Technology and Premiere

PCs today will allow you to perform just about any task imaginable. Today's systems allow the video editing process to exist because of fast processors and large disk drives. In the early to mid 1980s, personal computers were just coming of age. Comparatively, at that time there was not much software; word processing, spreadsheet applications, and basic painting programs were some of the original offerings.

The computers of that day were just robust enough to handle such programs. However, as software companies began to add more features and functionality to their products, hardware companies would offer more powerful systems to support these new programs.

Since then, this process has continued to go back and forth, continually raising the performance and capability standard. With the initial offering of Premiere, the features and capabilities of the software were designed to run on the PCs of the time. As the processes previously mentioned might suggest, the need for higher-quality video and more options and flexibility in the software meant that computing power had to be enhanced in order to support these new features.

Contemporary computer systems offer extremely fast processors that provide computing power that will allow you to capture, edit, and output high-quality video to a number of output sources, all at about the same price of the typical computer of the early 1980s. Now that the hardware is available to support video editing, what about the software?

Adobe Premiere is the best-selling video editing software program available. With Premiere, you can still make the postage stamp size movies of years ago, as indicated in figure 1-1, or you can produce full-screen digital-quality output with pristine audio and video quality. Now that the technology has come of age, the capability is in place for anyone to use these products to capture, edit, and output video projects.

Fig. 1-1. An early Quick-Time movie shown at 160 x 120 pixels.

This book offers you hands-on experience with this state-of-the-art software program. While exposing you to numerous aspects of the software and output scenarios, you will continue to discover the power of Premiere. The tutorials presented are designed to give you a broad variety of experiences, from animating still images to creating output for the Web. The tutorials expose you to the many features and functions Premiere has to offer. The quality and creative nature of your work on future projects will be enhanced by the fundamentals you will learn in this text.

About Premiere

The sections that follow provide you with a broad view of Adobe Premiere in the marketplace, as well as a synopsis of the current state of digital video editing. A final section discusses features and functionality new with the release of Adobe Premiere 6.5.

The Dominant Video Editing Program

Premiere set the stage for desktop video in 1991. Apple's QuickTime, also introduced in 1991, introduced a technology that allowed a sequence of images to be played back at the proper frame rate, thus providing video capability to desktop computers. Premiere was the first system to address the need for a desktop video editing capability.

Premiere introduced the ability to take captured video files and still images (static graphics of various types) and place them in a format that would allow for display and playback on desktop computers. As shown in figure 1-1, the quality was mediocre, but it represented the beginning of better things to come. These movies were not confined to just the computer; they could be output to other mediums, such as CD-ROM. At the time, the Web was not quite ready for any type of video.

Why Premiere 6.5 Is Revolutionary

Premiere was a revolutionary product from the beginning. With the ebb and flow of technology, Premiere has continued to offer innovative features, functionality, and ease of use. Version 6.5 is no exception to this rule.

There are numerous features that have been incorporated in the 6.5 release. Many, but not all, of which are discussed in the section "New in Premiere 6.5." Introduced in Premiere 6.0, another significant advance was the full and direct support of IEEE 1394 (FireWire/i.Link). By using an IEEE 1394 cable, a DV camcorder, and a personal computer, you can capture, edit, and output video with greater precision than previously possible.

Digital Video Technology and Premiere

DV is an acronym for digital video, but it also refers to a mini-DV camera. Although other devices support mini-DV, such as recording decks, the camcorder is the device most commonly associated with "DV." The technology that drives the mini-DV product is based on the fact that the tape is small, about two-thirds the size of an 8-mm videotape (or about one-sixth the size of a standard VHS-format tape).

Figure 1-2 shows the relationship among mini-DV videotape, 8-mm videotape, and VHS videotape. The quality of mini-DV tape is superior to that of the other formats. The size of the tape is also an advantage, allowing camcorders and playback decks to be small and lightweight. Another aspect of digital tape is that it records information digitally. This digital format works with the circuitry built into the camcorder or other recording device to produce very high-quality audio and video imagery.

Fig. 1-2. Mini-DV tape compared with 8-mm and VHS.

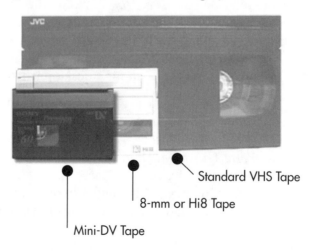

Standard VHS Tape

8-mm or Hi8 Tape

Mini-DV Tape

What makes this revolutionary is the fact that the captured video and audio files are just that...digital! The captured information is digitized within the camera. As shown in figure 1-3, when this digital information needs to be transferred to the computer, a simple FireWire connection between camera and computer is all it takes to transfer the content. However, the computer must contain a FireWire port.

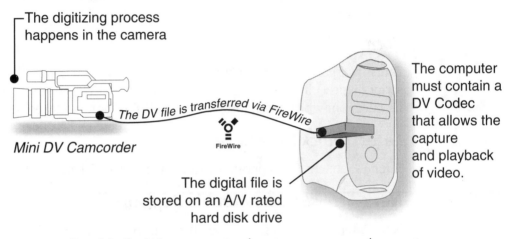

Fig. 1-3. FireWire connection between camera and computer.

Using Premiere as the interface, video can be previewed, played, captured, and saved to the computer's hard disk drive. Once saved on the computer as a digital file, it can be placed into Premiere to initiate the editing process. Once the file is edited, Premiere will allow these files to be output back to the camcorder. This means that content goes from the camera to the computer, is edited, and is then sent back to the camcorder, which turns into the recording device.

New in Adobe Premiere 6.5

The sections that follow describe features that are new in Adobe Premiere 6.5 under Windows, MacOS 9, and MacOS X. Other features operate under Windows only or under one of the Macintosh versions only.

New for Windows, MacOS 9, and MacOS X

The sections that follow describe features that are new in Adobe Premiere 6.5 under Windows, MacOS 9, and MacOS X.

Professional Titler

Completely new in Premiere 6.5, this state-of-the-art titler allows you to create professional, broadcast-quality title sequences. The titler includes over 300 predesigned templates, including still layouts, rolls, and crawls. Alternatively, you can create your own templates and styles, and save and share them. The titler also allows you to map textures onto text, apply multicolored gradients, emboss or bevel edges, create drop shadows, and apply transparency.

Fonts

Fonts incorporated in 6.5 include more than 90 high-quality Adobe Post-script (Type 1) and OpenType fonts chosen specifically for their legibility in video, but which work just as well applied to print and web design.

Latest QuickTime Support

Adobe Premiere 6.5 supports the most recent QuickTime application.

New After Effects Plug-in Support

New After Effects plug-ins available with 6.5 are Blend, Channel Blur, Directional Blur, Ramp, and Lightning, bringing the total to 34.

SmartSound Quicktracks

SmartSound Quicktracks is updated to support Windows XP and MacOS X, and includes 11 new Quicktracks. This powerful tool allows the generation of royalty-free soundtracks customized to the timing and cuts in your project.

Additional DV Device Support

Premiere 6.5 increases its scope of compatibility by incorporating support for a larger number of devices, including new camcorders and decks from Sony, Canon, Panasonic, and others.

Audio Enhancements

Audio mixing was introduced with Premiere 6.0, and now 6.5 includes an enhanced feature called the Audio Mixer panel. This professional feature is a real plus in 6.5. As shown in figure 1-4, the interface resembles that of a traditional audio mixing board and contains multichannel features, including gain and pan adjustments for up to 99 audio tracks. It

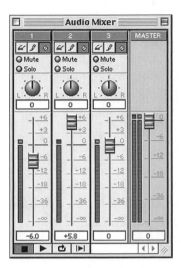

Fig. 1-4. The new Audio Mixer panel in Premiere 6.5.

also includes software volume unit (VU) meters, and automation features that allow you to save a live mix.

New for Windows Only

The sections that follow describe features new in Premiere 6.5 that operate in the Windows environment exclusively.

MPEG2 Encoding

Export MPEG1 and MPEG2 files directly from Premiere's timeline using the Adobe MPEG Encoder for output to DVD, Super Video CD, Video CD, and DVD. Presets are provided for common output configurations, and more advanced users can customize settings for even more options. MPEG encoding is powered by MainConcept, highly regarded for its award-winning DV and MPEG codecs.

New Professional Audio Plug-ins

Three industry-standard DirectX audio plug-ins from TC Works are included in 6.5: TC Reverb for powerful environmental effects, TC EQ for fine equalization, and TC Dynamics for compression and expansion of sound sources.

Advanced Windows Media Import and Export

Windows Media Export has been further optimized for better performance, and has been updated for Windows Media 8 and Windows Media 9 (Corona) support. You can use this capability to import directly from audio CDs or to import existing Windows Media footage.

DVD Authoring

Sonic DVDit! LE software, bundled with Premiere 6.5, allows the complete creation of DVDs, including the incorporation of interface elements and the actual burning of the DVD.

New for Windows and MacOS X

The following feature new in Premiere 6.5 operates in the Windows and MacOS X environments.

Software Real-time Preview

This new previewing capability renders the timeline "on the fly," displaying it on screen rapidly.

New for Windows and MacOS 9

The following sections describe features new in Premiere 6.5 that operate in the Windows and MacOS 9 environments.

Photoshop Filters Support

Premiere 6.5 offers Photoshop filter plug-in compatibility on Windows and MacOS 9 (currently incompatible with Premiere on MacOS X).

Advanced RealMedia Export

You can in 6.5 export to RealMedia directly from Premiere.

New for MacOS 9 and MacOS X

The following sections describe features new in Premiere 6.5 that operate in the MacOS 9 and MacOS X environments.

QuickTime Export Module Support

Premiere 6.5 allows use of special QuickTime export modules, such as the MPEG2 export module (installed with DVD Studio Pro) and the MPEG4 export modules (which will be part of QuickTime 6).

Two-track Audio Editor

Incorporation of a two-track audio editor allows real-time audio processing via TC Works SparkLE, bundled with Premiere 6.5, for use on WAV, AIFF, SDI, and QuickTime audio formats, as well as MP3.

RealProducer Basic

RealProducer Basic will provide RealMedia export in Classic mode for MacOS X users, in that the Advanced RealMedia Export plug-in is not supported under MacOS X.

DVD Studio Pro Integration

For Mac users, support for Apple's DVD Studio Pro allows DVD creation in Premiere 6.5. Markers created in Premiere can be used as chapter markers in DVD Studio Pro.

New for MacOS 9 Only

The following feature new in Premiere 6.5 operates in the MacOS 9 environment exclusively.

Cleaner EZ

The MacOS 9 version of Premiere 6.5 includes Media 100's Cleaner 5 EZ. This is a scaled-down version of this versatile compression utility for compressing audio and video for the Web.

Video Editing Systems and Applications

If you are planning to upgrade your system to handle the video editing process, or if you are planning to purchase new equipment, you need to be aware of the components that constitute a total solution. Based on your needs, or cash available, there are several configurations that will fulfill your requirements. The good thing about the components required for video editing is that they are all modular (or individual) components. This means that a basic system can be configured, with other components added as the need arises and/or funds become available.

When assembling a system, there are some components that cannot be compromised. The computer is the vehicle that makes the process happen. Make sure the computer contains the fastest processor, the largest hard disk drives, and the most RAM possible. Next is the capture device. Capturing the highest-quality images and sounds is a must in this process. Get the best camera, or other capture device, with the proper output connectivity to your computer. Corners can be cut in this area, but keep in mind that final output quality is directly related to original capture quality.

Figures 1-5 through 1-9 provide a look at a variety of editing solutions. The components suggested can be varied in many areas related to performance and manufacturer. However, the types of components depicted are common to the video capture, editing, and output scenario.

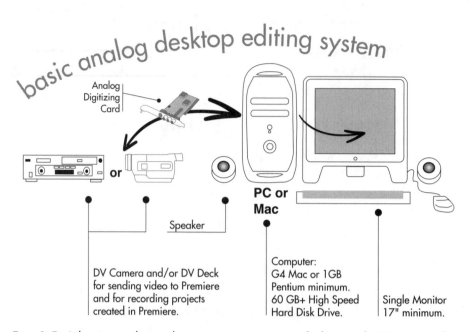

Fig. 1-5. A basic analog video capture system, including a digitizing card.

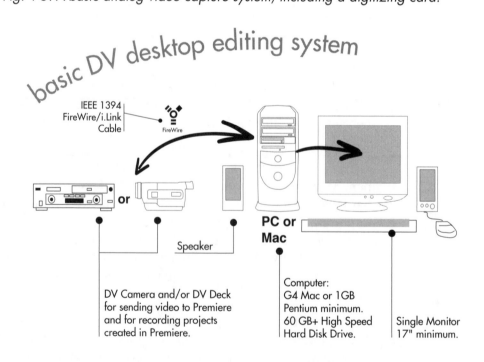

Fig. 1-6. A basic digital video configuration using FireWire.

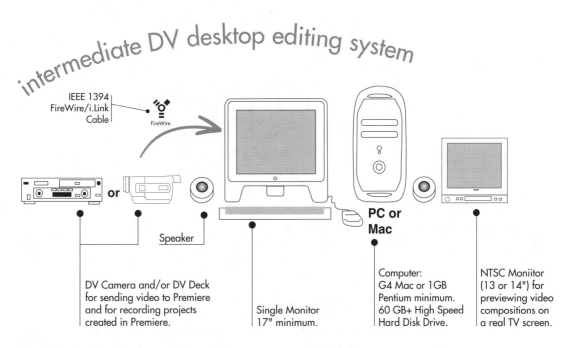

intermediate DV desktop editing system

IEEE 1394
FireWire/i.Link
Cable

FireWire

or

Speaker

PC or
Mac

DV Camera and/or DV Deck
for sending video to Premiere
and for recording projects
created in Premiere.

Single Monitor
17" minimum.

Computer:
G4 Mac or 1GB
Pentium minimum.
60 GB+ High Speed
Hard Disk Drive.

NTSC Moniitor
(13 or 14") for
previewing video
compositions on
a real TV screen.

Fig. 1-7. An intermediate DV configuration using FireWire.

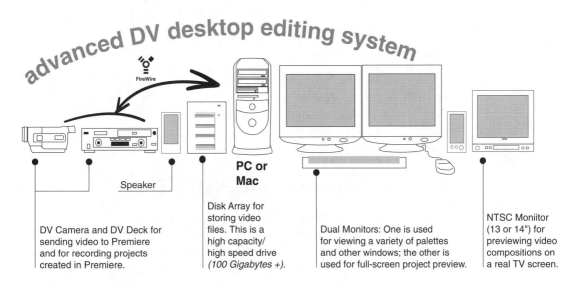

advanced DV desktop editing system

FireWire

Speaker

PC or
Mac

DV Camera and DV Deck for
sending video to Premiere
and for recording projects
created in Premiere.

Disk Array for
storing video
files. This is a
high capacity/
high speed drive
(100 Gigabytes +).

Dual Monitors: One is used
for viewing a variety of palettes
and other windows; the other is
used for full-screen project preview.

NTSC Moniitor
(13 or 14") for
previewing video
compositions on
a real TV screen.

Fig. 1-8. An advanced DV configuration.

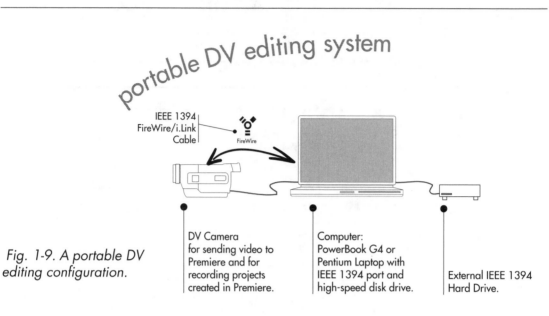

Fig. 1-9. A portable DV
editing configuration.

Levels of Usability

Premiere contains plenty of features that can intimidate the novice. However, it need not do so. As Chapter 3 relates, developing a movie is nothing to fear. In fact, by following the tutorials, you can develop a movie with excellent results in a very short period of time. So much of the quality of any production has to do with the quality of the original content. If you have imported high-quality digital video into Premiere, and if your hardware is properly configured and is adequate for the process, your output will be equal in quality.

If your objective in video editing is to capture content, add transitions, and then output to tape, your learning curve will be brief. However, Premiere is a very sophisticated nonlinear editing program, powerful enough to support industry professionals and projects of all types. The time it takes to master Premiere will depend on your particular level of use.

Content Development Versus Editing

Where will your content come from? Are you responsible for content development and acquisition, or will you place files into Premiere that have been provided to you? If your intent is to capture video, transfer video files from your DV camcorder to Premiere for editing purposes, and then transfer them back to videotape, you are involved in content development. But where does content development go from there?

Premiere can handle many types of content developed by external processes and devices. This content can be video, audio, illustration, photographic scans, 3D animations, and more. By placing these file types into Premiere, you can edit the files and create a dynamic video production for output to a variety of media.

If you are a graphics designer or multimedia developer, perhaps you have had experience with several types of software programs for developing and editing various file types. It is helpful, though not necessary, to know and understand what these files are and how they interact with Premiere. Even more beneficial is the mastery of some core programs that will allow you to edit the content of some file types as the need arises.

Adobe Software Collections

Some of the previously mentioned core programs can be found in a neatly bundled package, called a collection, from Adobe Systems. As shown in figure 1-10, the Adobe Digital Video Collection offers bundles of products designed to support the design, development, and editability of many of the file types used in the development of a movie file in Premiere. The Digital Video Collection bundle includes the following software products: Premiere, Photoshop, Illustrator, and AfterEffects.

Fig. 1-10. The Adobe Digital Video Collection bundle.

Adobe offers other bundles designed for specific applications. One such bundle is the Adobe Web Collection. This collection includes GoLive, LiveMotion, Photoshop, and Illustrator. With the addition of Premiere, the Web Collection offers a total web design and production solution. These programs are designed with extensive support for one another, allowing easy file exchange between applications. These applications also maintain a similar interface design to promote ease of use. Check out these and other solutions at Adobe Systems' web site at *www.adobe.com*.

Workflow

Workflow is a process you are already familiar with. When you write a letter, it is done in a format that flows logically from one topic to another. In Pre-

miere, there is a natural progression of events that dictates how the project will flow. Premiere is a receptacle program. That is, most files used to create a project are imported into Premiere. Premiere really excels in the manner in which it allows files to be imported, the orchestration it is capable of performing on such, and its ability to process effects in order to output high-quality audio and video productions.

As shown in figure 1-11, the workflow established in the Premiere interface involves inputting, adding effects, editing, previewing, and outputting. Each phase of this process has unique attributes that enhance the content as it passes through Premiere's workflow.

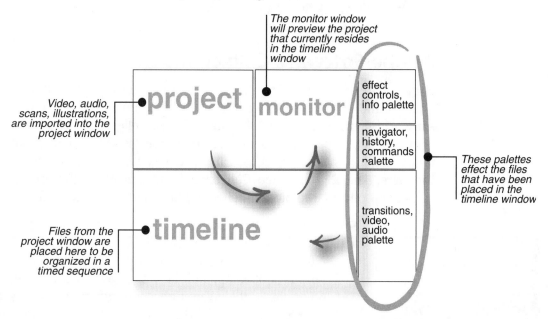

Fig. 1-11. General workflow in the Premiere interface.

To further elaborate on the workflow process, there is a punch list of processes that must happen to properly execute the design of any project. The video development process follows a certain regimen that dictates that specific steps are performed prior to moving on to the next. In figure 1-12, a suggested workflow is shown that illustrates the steps necessary from the beginning to the end of a project, and where the file can go upon completion.

the project development processes

Fig. 1-12. The project development process in Premiere 6.5.

1	Logging •	*Video clip selection from source tapes*
2	Capture •	*Capturing digital clips into the computer*
3	Insert •	*Placing clips into Premiere's timeline*
4	Initial Edit •	*Organizing files into a "rough draft"*
5	Preview •	*Viewing the "rough draft"*
6	Special Effects •	*Adding effects and titles to the clip*
7	Fine Tuning •	*Turn the "rough draft" into a "final draft"*
8	Audio Sweetening •	*Adjusting volumes and levels for impact*
9	Finished Project Output •	*Selecting the output path for the project*

output to... Tape
Computer
CD/DVD
Web

Storyboarding

Every project needs a plan. If you are simply shooting video and then capturing the footage in your computer for a home project, you may get by without a plan. However, if you are involved in a collaborative process, you will definitely benefit by developing a plan. In Hollywood, before any film is exposed or actor takes the stage, a detailed plan is put in place. This plan is executed through the development of a storyboard. A storyboard is a series of illustrations that outline the nature, content progression, and scope of a project.

Storyboards can be as simple as hand-drawn sketches on a notepad, a flow chart type of plan, or an extremely graphically detailed set of illustrations. Some storyboards go as far as to develop a movie with animated or computer illustrated figures to allow the director to get a feel for how the real actors will move and relate to one another, or to a particular physical environment. In many of today's science fiction epics, actors must perform interaction with characters that are computer generated. Therefore, they are interacting with characters that are not really there.

The main goal behind a storyboard is to develop an understanding of what has to be done and when it is to be done throughout the development process. Storyboards can also help identify segments of the project that may require additional equipment or other resources, which demand additional cost or development time. As shown in figure 1-13, there are software programs designed specifically for the storyboarding process.

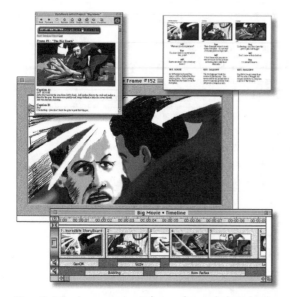

Fig. 1-13. A commercial storyboard development software program. (Images © Power Production Software, www.powerproduction.com.)

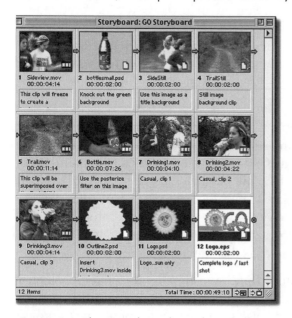

Fig. 1-14. The Storyboard window showing placed clips with notations.

Overall, the main benefit of the storyboard process is to develop a full understanding of your project before you begin. It helps identify equipment needs, support needs, lighting requirements, shot angles, specialized audio needs, and much more.

A great new feature in Premiere 6.5 is the Storyboard window. Shown in figure 1-14, the Storyboard window allows video and other clips to be imported and viewed, and most importantly, organized into a logical sequence. You can even play the files based on the sequence they are placed in the Storyboard window, to get a feel for how the content and story flows.

Summary

This chapter has introduced you to some of the features of, and ideas behind, Adobe Premiere 6.5. As you use this book as a learning tool, keep in mind that the process of video editing on a PC has become relatively easy.

This chapter has provided you with an overview of Premiere, including content development, project workflow, storyboarding, and hardware requirements. With each editing experience, the process of project development will become more intuitive.

If this is your first exposure to video editing, performing the tutorials in Chapter 3 will take the mystery out of the editing process. Subsequent tutorials will deepen your understanding of the editing process and your overall familiarity with Adobe Premiere.

CHAPTER 2
THE VIDEO CAPTURE PROCESS

Introduction

Just as the transition was made from vinyl record albums and tapes to CD-ROMs, video is transitioning from the analog world to the digital world. Consumer electronic retailers advertise all types of products as being digital. So, what's all the hype about digital? Basically, digital technology has ushered in a new era of visual quality, enhanced sound, and a reliable method of transmitting information. In the video/audio realm, devices that record or capture digital information are capturing specific electrical impulses that can be duplicated in the same format.

Digital video, for example, once captured to digital videotape, can be copied many times and still provide a pristine copy that rivals the original. Digital data is a very accurate media format that exhibits great consistency. On the other hand, analog media reproduces in a format that is subject to inconsistencies and noise. On an audiotape, this noise will appear as a hiss or a slight background sound. In video, noise is associated with a poor-quality picture, perhaps containing a grainy appearance. One thing is certain: the digital age is here and provides higher-quality audio and video for all to enjoy.

Premiere is a standard for the digital video process. Audio, video, scanned images, animations, illustrations, are types of media that flow into Premiere streaming. These files are transformed, blended, and output into a new format that is output to a variety of formats. These formats include analog formats such as video and audiotape. They also include digital formats such as for presentation on a computer, output to DVD or CD-ROM, or for distribution on the Web via a web server. The capture process is the first step in developing dynamic video.

This chapter will teach you about how video is captured in Premiere 6.5. Though this is not a hands-on tutorial, if you are new to Premiere and the video capture process, this guide will be beneficial. Just as video is captured, it will eventually be output. See Chapter 13 for information on how completed projects are output to a variety of formats.

Objectives

In this chapter you will learn the following.

- Hardware connectivity

- The digital video capture process

- Peripheral devices

Premiere on Macs and PCs

Premiere provides a powerful video editing solution for both Macintosh- and Windows-based personal computers. The interface of the software is almost identical. If you learn on one system, you can easily be fully proficient on the other. There are some issues, however, that are specific to each platform.

Macintosh Versus PC

The following items outline issues you should be aware of in regard to using Premiere with a Macintosh or a PC system.

- Macintosh

 - To capture file sizes larger than 2 Gb, you need a minimum of the following configuration: Macintosh OS 9.0.4, Apple QuickTime 4.1.2, and Macintosh OS Extended volume format (HFS+).

 - The Macintosh handles movies larger than 2 Gb as a series of movies. This means that after the first 2 Gb of space is consumed, Premiere will generate a new file to handle overflow. The movie will be named the same as the first, with the exception of adding a numbered extension to the original file name (e.g., *Mymovie, Mymovie01, Mymovie02*, and so on).

 - Many Macs, prior to the introduction of the FireWire interface, were shipped with audio/visual digitizing cards factory installed. These devices work well with Premiere as a capture source.

- Windows

 – Windows-based computers have a 1- to 2-Gb limits if the output format is AVI. This specification may vary based on the type of capture card used. It is important to know the capabilities and specifications of the video card before purchasing, as well as when it is used with new equipment and workflows.

 – To capture and export file sizes larger than 2 Gb, you need a minimum of the following configuration: Windows 98 Second Edition, Windows 2000, or Windows ME; QuickTime 4.0 or later; and FAT 32 or NTFS-formatted hard disk.

Software and Hardware Specifications

The software and hardware specifications outlined in table 2-1 are the recommended minimums to successfully develop projects in Premiere. However, the performance of the software will be enhanced with more RAM, disk space, disk speed, and faster processor. Figure 2-1 shows software and peripherals useful to content development under Premiere.

Table 2-1: Suggested Minimum Macintosh/Windows Configurations

Macintosh
PowerPC Processor
MacOS software 9.0.4
QuickTime software version 4.1.2
32 Mb of available RAM (128 Mb recommended)
50 Mb of available hard disk space required for installation
Windows
Pentium-class processor (300 MHz or faster)
Microsoft Windows 98, Windows 98 Second Edition, Windows 2000, Windows Millennium, or Windows NT 4.0 with Service Pack 6
32 Mb of RAM (128 Mb recommended)
85 Mb of available hard disk space required for installation (40 Mb for application)
256-color video display adapter
Large-capacity hard disk or disk array

Fig. 2-1. Premiere is the engine for video editing, but other software is essential for content development.

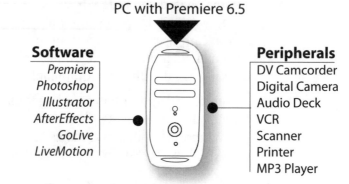

Total Production Software Suite
PC with Premiere 6.5

Software
Premiere
Photoshop
Illustrator
AfterEffects
GoLive
LiveMotion

Peripherals
DV Camcorder
Digital Camera
Audio Deck
VCR
Scanner
Printer
MP3 Player

Performance Enhancements

Computers are designed to perform many tasks, and to perform many of them at the same time! When capturing video, it is important to ensure that your computer is focused on one thing: capturing video. To optimize the performance of your computer, make sure the topics outlined in table 2-2 are reviewed to provide the best results.

Table 2-2: Strategies for Optimizing for Video Capture

Strategy	Purpose
Close other applications.	All open applications consume RAM. The video capture process performs better with all available RAM allocated to Premiere.
Disable file sharing or network activity.	File sharing and network activity require system resources, which will detract from allocation of resources to video capture. If turned on, the performance of the capture process may suffer.
Keep system functions at a minimum.	If utilities such as screen savers, virus programs, or other programs are running in the background, they will detract from the computer's allocation of resources to capturing video.
Try to incorporate a large, fast disk or array.	With video capture, faster is better! Large drives are needed to store the huge amount of storage video capture creates. There is a lot of data being moved in this procedure. Maximum disk space and processor speed should be the rule.
Defragment any drive to be used.	Disk defragmentation allows large files to be copied to a contiguous location on the hard drive. A fragmented disk will make the disk work harder and thus slow down the process of storing the captured data.

If you are planning on capturing video using analog equipment, see figure 2-2 for a recommended minimum system configuration.

Fig. 2-2. A suggested minimum computer system for working with Premiere.

Windows	Macintosh
Pentium 300 MHz or faster	PowerPC Processor
Microsoft Windows 98 SE, or later	Mac OS software 9.2.2, or later
256 MB available RAM minimum	QuickTime software version 5, or later
256-color video display adapter	256 MB available RAM minimum
Large-capacity hard disk or disk array	Large-capacity hard disk or disk array

Analog Video

The sections that follow explore issues associated with analog video. The first section discusses analog media. The subsequent section discusses capturing analog video in Premiere.

Analog Media Examples

The following are all examples of analog media. For these materials to work on your computer, and with Premiere, they must be converted to digital files. All of the tape formats can be digitized via a digitizing card that can be added to your computer.

- Videotape

- Hi-8 tape

- Audiotape

- Photographic slides

Slides can be digitized using a slide scanner, and photographs using a desktop scanner. The result of converting a file to digital format is a file that can be manipulated on a personal computer using applicable software (see figure 2-3). Using Premiere, almost any type of digital media can be imported for use in the moviemaking process.

Fig. 2-3. Examples of analog media that must be converted to digital media to work on a personal computer.

There is a wealth of content that currently exists in analog format, which is the way media has typically been stored for many years. If the conversion of analog media files is or will become an important part of your work or play in the video editing world, you will need to incorporate a digitizing card into your computer system.

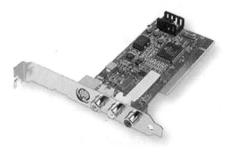

Fig. 2-4. A digitizing card converts analog media to digital.

Some computers come with built-in solutions for capturing audio and video. Typically, a third-party card must be purchased and installed to do this. In the past, these cards were expensive, and like most products, you get what you pay for. Today, these cards, an example of which is shown in figure 2-4, have incorporated many features and high-quality image capture for a very reasonable price.

Getting Analog Video into Your Computer

The following are the four key components that make the analog video process possible. Quality issues are associated with each of these components. For example, a fifteen-year-old VCR may be capable of playing back videotape, but the circuitry is old, the playback heads are probably worn and dirty, and the output jacks may not have S-VHS connectors. The result of this is a poor image from the original source. Remember the old computer adage "garbage in, garbage out." The device, the tape quality and speed, and compatibility are all issues that affect the final quality to be converted into a digital file format.

- Analog source (VCR, Hi8 video camera, audiotape deck)

- Cables

- Digitizing card

- Computer

Cables play a part in video signal quality as well. There are different levels of quality in cables. Obviously, gold-plated terminals and higher-quality cables will yield better results than standard connections. S-VHS compatibility in both the playback and recording component will allow for higher-quality video capture. The quality of the video digitizing card is also important.

The most demanding aspects of this process on the computer are speed of capture and storage. With large chunks of data being brought into the computer, fast throughput is a must, and a large hard drive for storing files is mandatory. Some VCRs and camcorders do not have S-video connections, which transfer a higher-quality image. These, however, have RCA plugs, which are the round connectors coded with red, white, and yellow. The red and white connectors are for stereo audio, and the yellow is for video connection.

You need to be aware of compatibility in regard to connections such as this and the digitizing card. Make sure the connectivity on the card offers the connections you need for your particular workflow and the resources you use. For example, figure 2-5 shows the connections involved in using a digitizing card with an Hi-8 camcorder and a PC.

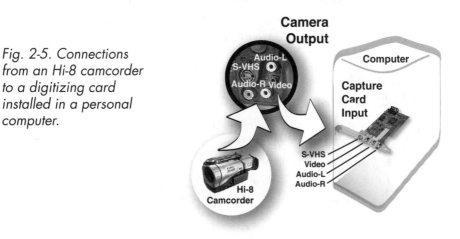

Fig. 2-5. Connections from an Hi-8 camcorder to a digitizing card installed in a personal computer.

Digital Video Basics

The sections that follow discuss the benefits of digital video and general information on the use of digital video. Topics include the storage and transfer of digital video.

Benefits of Digital Video

The benefits of digital video are significant, especially when compared to analog devices such as Hi-8 and 8-mm cameras, as well as VHS recording decks. The digital video format produces an image that contains 500 lines of vertical resolution. Compare this to a VHS tape, which has a resolution of about 250 lines, and it is easy to see that the quality is far superior.

This quality transcends to other areas; most notably, audio quality, which is at CD-ROM level (48 kHz). Another benefit of the digital video format is its superior color temperature and color accuracy. Color temperature refers to the balance and realistic appearance of the overall image. All in all, digital video quality is far superior to previous standards. It also represents the technology that promises the greatest advances in quality and performance in the future. The following summarize the benefits of digital video.

- *Image and sound quality:* Digital video produces a far superior image and sound file. The vertical resolution for digital video is 500 lines of vertical resolution. In comparison, VHS offers approximately 250 lines of vertical resolution. Digital video sound is excellent as well. The high quality is an excellent companion to the superb image quality. Color quality and accuracy is also enhanced with digital video.

- *No generation loss:* Because your information is in a digital format, there is no loss of quality when copying or transferring digital video. All copies will look and perform like the original.

- *No video capture card required:* All digitization happens in the video camera. Therefore, there is no need for a video capture card. The digital information is simply transferred from the camera to the computer via the IEEE 1394 connection. This represents cost savings in that a digitizing card is not required.

- *Tapes and playback devices are smaller:* In the case of digital videotape, the actual tape is smaller and lighter than traditional tapes. This means that the playback device is smaller as well.

General Information on Digital Video

The sections that follow explore storage and data transfer associated with digital video. Transfer is discussed in regard to FireWire, the latest standard for interconnectivity associated with digital video and the devices used to manipulate it.

Storage

One hour of digital video consumes 13 Gb of disk storage. A 1-hour project means that you should have gigabytes of free space for the development and editing of footage. Disk space is like RAM: the more, the better! It takes over 1.5 Gb to hold a minute of uncompressed video.

Transfer via FireWire

FireWire is one of the fastest peripheral standards ever developed. Transferring data at up to 400 Mbps (megabytes per second), FireWire can deliver more than 30 times the bandwidth of the USB peripheral standard. With this fast transfer rate and the ability to "plug-and-play," FireWire is the new standard for supporting the interconnectivity of today's high-tech digital video, audio, storage, and other high-speed capabilities.

Apple invented FireWire in the early 1990s. FireWare is also the IEEE 1394 standard, the norm in cross-platform high-speed connectivity. FireWire is a high-speed serial input/output technology for connecting digital devices such as digital camcorders and cameras to desktop and portable computers. The IEEE 1394 standard has widely been accepted by major suppliers of technology-based equipment. Industry giants such as Sony, Canon, Panasonic, JVC, and Kodak have adopted this standard for both consumer and professional equipment.

FireWire works with both Macs and PCs, which means that a lot of products will continue to be developed that will support this process. Many digital video cameras, hard disk drives, CD-RW and DVD-R devices already use FireWire. The advantage of the FireWire standard can be summed up in one word: speed. At 400 Mbps, FireWire has become the choice for high-speed storage and serious video capture. The following are other benefits of FireWire.

- As many as 63 peripheral (external) devices can be attached to a FireWire configuration. Cable lengths can be up to 14 feet each.

- FireWire is "hot-pluggable." That is, you do not have to turn off a camcorder, scanner, or CD-ROM drive to connect or disconnect FireWire.

- FireWire cables are easy to connect, and there is no need to modify device IDs, jumpers, DIP switches, or other settings to use FireWire.

Capturing Digital Video

This section of the book is designed to demonstrate the digital video capture process. Although the following is not a hands-on tutorial, it demonstrates the capture process. Therefore, if you have the equipment and wish to follow along with the scenarios described, feel free to do so.

As the tutorials in chapters 3 through 13 demonstrate, you do not need to capture video or audio to use Premiere. These tutorials, for example, rely on existing audio, video, and other digital files that reside on the companion CD-ROM. These files are ready to import into Premiere.

Fig. 2-6. A portable video editing solution including a laptop computer, digital camcorder IEEE 1394 cable, and Premiere.

You may also find that your entire involvement with Premiere will rely solely on the use of media captured by another content developer or from a clip media resource. In all likelihood, however, you will want to capture and use your own video clips. To do this, the digital files on your digital video camcorder must be transferred to the hard drive on your computer. This is where the capture process comes into play.

Premiere has made some important leaps in features and functionality since its introduction in the early 1990s. Without question, the most significant change to Premiere has been the addition of digital video capture and the ability to control external digital video devices. Having this capability puts a fully functioning video editing station on your desktop. The hardware and software configuration shown in figure 2-6 demonstrates how a video editing suite can even be totally portable.

Typical Hardware Configurations

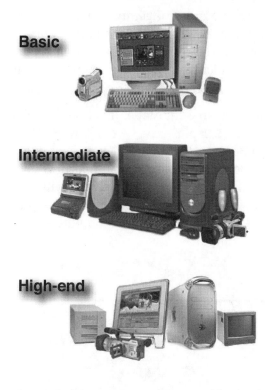

Basic

Intermediate

High-end

Fig. 2-7. Basic, intermediate, and high-end components assembled to meet any level of expertise or budget.

Computer hardware comes in many configurations for a wide variety of applications. When it comes to capturing and outputting digital video, there are certain requirements a system must meet to properly execute this process. The sections that follow outline three video configurations, ranging from basic to high end. Figure 2-7 shows an example of this range of components for various applications.

An important part of the hardware equation is the IEEE 1394 cable, shown in figure 2-8. This cable allows data to communicate between the playback device and the computer. IEEE 1394 sends and receives information at a rate of 3.6 Mbps.

Figure 2-8. The IEEE 1394 cable.

Typical Software Configuration

Adobe Premiere 6.5 is the software of choice for hundreds of thousands of consumers worldwide, representing a standard digital video editing solution. To capture video on your computer, not much is needed in the realm of other software products. Within Premiere, you can capture video, audio, and still images. There are also many controls, filters, and settings that allow files to take on a new look or sound within the Premiere application.

IEEE 1394: The Digital Difference

The IEEE 1394 connection makes the process of getting video into your computer easy. Computers only understand digital, or binary, information. IEEE 1394 connectivity allows this information to transfer from the source into the computer extremely quickly. To work with video on your computer, your video must be in a digital format.

Analog video, from a VHS or perhaps an 8-mm tape, must be digitized to be editable on your computer. Video capture can be done by connecting your video source to a digitizing card installed in your computer. Premiere allows analog video import as well as digital import, or capture. As the analog file is captured in Premiere, the saved file will be a digital video file. As indicated in figure 2-9, this file can then be processed for web, videotape, CD-ROM, DVD-ROM, and computer-based presentation, as well as for printed output.

Fig. 2-9. A digital video clip can be output to a variety of formats.

Digital cameras are now widely available and have become very reasonably priced. Digital cameras offer numerous benefits to analog cameras. Perhaps the greatest feature of a digital camcorder is that the audio and video it captures is converted to digital information within the camera. This means that the digitization process is complete before the data reaches the computer, and therefore no conversion process is required.

Digital video camcorders communicate with a computer via an IEEE 1394, or FireWire, interface. As previously mentioned, these standards transfer large amounts of information at a very fast rate. Sony has named this interface i.LINK. This technology allows digital files to be transferred at a rate of up to 400 million bits per second. With this standard firmly established, expect even faster transfer rates to be established in the future.

The IEEE 1394, or FireWire, cable allows for the transfer of a wide range of media, including video, audio, and time code information. (Time code is discussed in material to follow.) An astounding feature that has emerged from the FireWire standard is the ability to control devices from within Premiere. This process is called device control. For example, if you are using Premiere 6.5 with a digital video camcorder, connected via a FireWire cable, you can control the camcorder from a window within Premiere. Functions such as stop, forward, rewind, record, and timecode display are standard in Premiere.

All new Macintosh computers have at least one FireWire port built in. Most high-end PCs include this port as well. To add a FireWire card to a Mac or PC is an easy task, requiring a simple and inexpensive PCI card. The FireWire interface is not just for video. This connection also supports peripheral devices such as hard disk drives, networks, CD-RW, and DVD-R drives.

As indicated in figure 2-10, the FireWire interface is not to be confused with traditional video capture cards. A capture card converts an analog file to a digital format. FireWire is a transport function rather than a capture device. Digital video information is transferred from a camera to a computer using the FireWire connection to move the data from one place to another.

Fig. 2-10. An IEEE 1394 capture card and cable.

Scratch Disks

The term *scratch disk* refers to a disk designated as your disk of choice when capturing video or audio clips. The capture process is very intensive from a speed, capacity, and performance standpoint. Because this process is so demanding, the disk designated as the scratch disk must be the fastest and largest-capacity disk available. As video is captured, the success of the capture will rely on the performance of this disk drive. Assigning a scratch disk in Premiere is done by selecting Edit > Preferences > Scratch Disks and Device Control, as shown in figure 2-11.

Fig. 2-11. Preferences window showing scratch disk selection.

Pre-capture Checklist

As previously stated, digitizing video requires that your computer be configured to capture video only. Other applications should be terminated before the capture process. Capturing video is a demanding task due to the amount of data transferred in and out of your system. Before capturing video, it is important to perform a routine check of your computer and its peripheral devices to ensure that optimal performance is available. For best performance, make sure the following issues are addressed.

• Quit all other applications.

• Disable file sharing.

• Make sure the disk you have designated as your scratch disk is in optimal order. That is, make sure the disk has been optimized and/ or defragmented.

• Eject all disk media from any attached drives, especially CD-ROMs or DVD-ROMs that may be playing in the background.

• Premiere offers various compression settings for video capture. Make sure your computer is capable of handling this process at the desired setting.

• Disable any operating features that may take away from system performance. An example of this is a virus-scanning program that may operate in the background and be set to scan your drive on a regularly scheduled interval. This process may interfere with the rate and quality at which video clips are captured.

Pre-capture Settings

When you launch Premiere, you are asked to select a preset configuration from the Load Project Settings window, shown in figure 2-12. These settings are maintained as you develop your project.

Fig. 2-12. Load Project Settings window with the DV - NTSC > Standard 48kHz option selected.

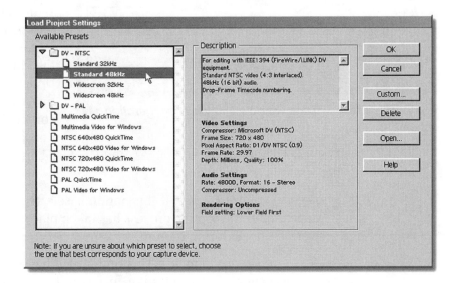

Usually, these settings will not need to be changed once established. However, they can be changed by selecting Project > Project Settings > Video, as shown in figure 2-13.

Fig. 2-13. Changing the video settings in the Project Settings > Video window.

The Project Settings dialog box also allows adjustments to be made to the following settings, as shown in figure 2-14: General, Video, Audio, Keyframe and Rendering, and Capture. This allows customization of every aspect of the capture process.

Fig. 2-14. Project Settings window showing configuration options.

Optional Settings

The Capture Format setting of the Project Settings dialog box offers settings that provide more information about the performance and scope of the video capture process. Under the Capture setting, the lower left-hand corner displays three options: Report Dropped Frames, Abort on Dropped Frames, and Capture Limit. These options are described in the following.

- *Report Dropped Frames:* If this option is selected, a report will appear after the capture process has taken place, indicating if frames were dropped during capture.

- *Abort on Dropped Frames:* This option will halt the capture process in the event any frame was not successfully digitized. This option allows control of the final capture.

- *Capture Limit:* This modifiable field will allow a limit, in seconds, for the capture process. This relates directly to a file limit that may be encountered.

Unique Hardware Settings

In the Project Settings window under the Capture dialog box, there are three Capture Format settings in the pop-up menu. As shown in figure 2-15, these are QuickTime Capture, DV/IEEE 1394 Capture, and Video for Windows.

Fig. 2-15. Project Settings window showing video capture formats.

The Digital Video Capture Process

Capturing digital video in Premiere is extremely easy. Because digital video is already in a digital format, video files under Premiere need only be transferred to the computer for processing. As previously mentioned, video consumes huge amounts of disk space.

Transferring video from the camera to the computer has been somewhat cumbersome in the past. With the advent of the IEEE 1394 standard, this process has changed. It has become as easy as copying video from one source to another. If you are new to the video editing process and plan to work in a digital environment, this technology makes it the perfect time to be involved in video editing.

Using the Movie Capture Window and Device Control

The following describes how video is captured using the Movie Capture window. The external device being used for this overview is a Digital8 camcorder, and you will see references to this device. If this is the first time you have used Premiere, you may encounter a dialog box titled Scratch Disk & Device Control Setup. If you do, select Cancel, and then select File > Capture > Movie Capture, as shown in figure 2-16. The Movie Capture window, shown in figure 2-17, appears.

Fig. 2-16. The File > Capture > Movie Capture selection.

Fig. 2-17. Movie Capture window.

To the right of the Movie Capture window are two tabbed palettes: Logging and Settings. The Logging tab allows input that is to be used with the batch capturing process. The Settings tab displays the currently selected settings. These settings can be changed by selecting the Edit button under the Capture Settings window. If all information is acceptable in these tabs, the Logging/Settings tab portion of this screen can be removed. If these tabbed palettes have been hidden previously by using the Collapse Window command, they will not appear until the Expand Window command is selected.

To hide the Logging/Settings tabs, click on the triangle in the upper right-hand corner of the Movie Capture window. This will reveal the Movie Capture window's pop-out menu, shown in figure 2-18. From this menu, select Collapse Window.

Fig. 2-18.
Collapse
Window option.

In this example, the Device Control option has not been configured. By clicking on the Enable Device Control button at the bottom of the screen, the Preferences dialog box (shown in figure 2-19) will open. At the bottom of this dialog box is the Device Control option, shown in figure 2-20. If the camcorder is connected via the IEEE 1394 cable, two options will appear as a result of clicking on the Enable Device Control button: None and DV Device Control 2.0.

Fig. 2-19. Enable Device Control button.

Fig. 2-20. Preferences dialog box showing the Device Control option.

Select DV Device Control 2.0 to access the DV Device Control Options dialog box, shown in figure 2-21, which contains several options for device control configuration.

From this dialog box, several options can be set to ensure even more compatibility with your equipment. The Video Standard option (shown in figure 2-22) defaults to NTSC, which is the video standard for television in the United States.

Fig. 2-21. DV Device Control Options dialog box.

Fig. 2-22. Device brand selected in the DV Device Control Options dialog box.

Fig. 2-23. *Premiere contains many camera brands and models to choose from.*

Fig. 2-24. *The Movie Capture window contains a variety of playback controls.*

In this example, the camera brand and model have been selected, as shown in figure 2-23.

The Timecode Format option in the DV Device Control Options dialog offers the options Drop-Frame and Non Drop-Frame. Non drop-frame is the easier of the two formats to understand because it is used by VCRs, camcorders, and so on and has the appearance of a real-time application. The drop-frame time code format is actually more accurate than the non drop-frame format, but the differences are minor.

If the camera or external playback device is properly connected, the Check Status option will show that you are on line. Clicking on OK confirms all settings.

Back in the Preferences window, the Scratch Disk settings should reflect previous settings. Confirming these settings here is important. The Movie Capture window is now ready to capture images from the camcorder.

By pressing the Play control, the camcorder plays the videotape. Figure 2-24 shows the playback controls at the bottom of the Movie Capture window. These controls look like the controls on a typical VCR.

To record a clip, the red Record button is selected. This begins the recording process at the point the camera is currently set. Information about the capture process is displayed at the top of the Movie Capture window. Among this information is a shortcut indicating that the Esc key will stop the capture process. When the movie stops, a Filename window appears. The name of the clip is entered here, along with any other information associated with the clip. To make the image full screen, click on the triangle at the top right of the window and select Fit Image in Window, shown in figure 2-25.

This will allow the video image to fill the entire screen, as shown in figure 2-26. Your video clip may appear to be stretched vertically. If this causes an undesirable effect, return the feature to its previous state.

Fig. 2-25. Fit Image in Window option.

Fig. 2-26. Movie Capture Window showing full-screen image.

If the Report Dropped Frames option is still selected in the Project Settings dialog box, a properties window will appear showing information about the dropped frames, as well as other details about the capture. This window is shown in figure 2-27.

Fig. 2-27. Properties window showing information about dropped frames and details of the capture.

```
┌──────────────────── Properties for balloon2 ──────────────────┐
│ File path : Macintosh HD :balloon2                             │
│ File size : 12.14MB bytes                                      │
│ Total duration : 0 ;00 ;03 ;10                                 │
│ Average data rate : 3.63MB per second                         │
│ Image size : 720 x 480                                        │
│ Pixel depth : 24 bits                                         │
│ Pixel aspect ratio : 0.900                                    │
│ Frame rate : 29.97 fps                                        │
│ Audio : 48000 Hz – 16 bit – Stereo                            │
│                                                                │
│ QuickTime details :                                            │
│ Movie contains 1 video track(s), 1 audio track(s) and 1 timecode │
│ track(s).                                                      │
│                                                                │
│ Video :                                                        │
│ There were 1 frames dropped when this movie was captured.      │
│ There are 100 frames with a duration of 1 /29.97th.            │
│                                                                │
│ Video track 1 :                                                │
│ Duration is 0 ;00 ;03 ;10                                      │
│ Average frame rate is 29.97 fps                                │
│                                                                │
│ Video track 1 contains 1 type(s) of video data :              │
│                                                                │
│ Video data block #1 :                                          │
│ Frame Size = 720 x 480                                         │
│ Compressor = DV – NTSC                                         │
│ Quality = Most (5.00)                                          │
│                                                                │
│ Audio :                                                        │
│ Audio track 1 contains 1 type(s) of audio data :              │
│                                                                │
│ Audio data block #1 :                                          │
│ Format = 16 bit – Stereo                                       │
│ Rate = 48000.0000 Hz                                          │
│ Compressor = 16–bit Big Endian (uncompressed)                 │
│                                                                │
│ Timecode :                                                     │
│ Timecode track 1 contains 1 type(s) of data :                │
│                                                                │
│ Timecode data block #1 :                                       │
│ Start Time = 00 ;04 ;39 ;25                                    │
│ Data Rate                                                      │
└────────────────────────────────────────────────────────────────┘
```

Using the Movie Capture Window Without Device Control

In Premiere, a movie clip can be captured without the use of the Device Control option. The following material outlines this process. In this scenario, Premiere is started without setting up the Device Control feature. The Movie Capture window is opened by selecting File > Capture > Movie Capture. At the bottom of the screen are two options: Enable Device Control and Record.

Use of the Record feature assumes that the videotape is in play mode prior to selecting the Record option. That is, for example, the camcorder is on and the Play button is pressed; therefore, video should be playing from the camcorder into the Movie Capture window. If the video is not visible, adjust the video input options in the Capture panel of the Project Settings dialog box until the video is properly displayed.

The video scene to be recorded is cued visually; that is, the tape is forwarded and rewound manually on the camcorder and not from the computer. The Record button is selected not where your desired start point is but several seconds prior to the beginning. This is done in order to give the software and equipment time to initiate the capture process. It is also a good idea to allow extra time beyond the cutoff point. Scenes recorded this way are then edited to the desired length in Premiere, and it is therefore beneficial to have additional footage incorporated.

Once the tape is playing, the Record button is pressed. The capture process begins. To stop video capture, press Record once again. The File Name dialog box will appear, prompting for a name to be assigned to this clip. The name is entered and OK is selected. If the Report Dropped Frames option is selected, the Properties window will appear, displaying details of the clip captured.

By closing the Movie Capture window, you can see that the movie clip was automatically added to the Project window and therefore ready to be placed into the Timeline window. Figure 2-28 shows an enlarged view of the bottom left-hand portion of the Movie Capture window.

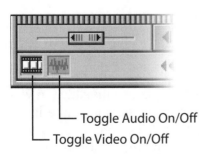

Toggle Audio On/Off
Toggle Video On/Off

Fig. 2-28. Video and audio capture can be toggled on and off by selecting the applicable icon.

There are two icons that represent video and audio input. When you select either of these icons, a red bar appears across the icon. This feature allows the audio or video to either be enabled or disabled during the capture process.

Batch Capture

As you have seen, Premiere possesses powerful features for capturing video. Premiere also supports the control of a wide range of tape equipment in order to perform a process called batch capture. Other software programs offer batch capture in one form or another. In Premiere, the batch capture process allows the automatic digitization of a number of clips by accessing the time code embedded in the tape. This works as follows.

1 The videotape must contain time code.

2 A batch capture list is compiled as shown in figure 2-29. This can be typed in manually or by logging clips visually using device control.

Fig. 2-29. Batch capture window showing clip to be captured automatically.

The Capture button is selected to begin the automated capture process.

3 The Capture button is selected to begin the automated capture process.

4 The capture process begins without further intervention.

Time code is a digitally encoded sequence that can be embedded in videotape. Time code contains hours, minutes, seconds, and frame information that extends the duration of the tape. This coding allows the user to go to specific frame locations on a tape in order to assign specific

in-points to out-points. These scenes are then used in Premiere to assemble a final project.

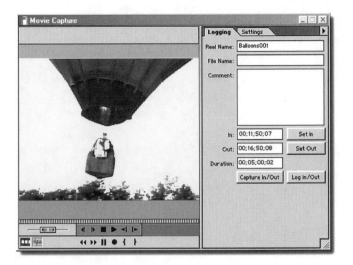

Fig. 2-30. Movie Capture window utilizing the Logging tab to batch capture selected video clips.

The batch capture process also works with device control. As shown in figure 2-30, in- and out-points can be set based on previewing desired scenes you wish to capture. After a sequence of these scenes is logged, the software and connected peripherals do the rest of the work.

Summary

This chapter has covered important aspects of how video is captured for use on a personal computer. Because options are available for video input into your computer, various capture scenarios were introduced. Hardware issues were also reviewed, to expose differences between Macintosh and Windows systems and their requirements regarding video import and running Premiere.

The Premiere interface has also been explored further, revealing the video capture process. Much emphasis has been placed on the IEEE 1394 (or FireWire) standard and how the video editing process has become revolutionary as a result. An integral part of FireWire is that it allows Premiere to control external camcorders, recording decks, and other devices, thus making the process of capturing and exporting video easy. This chapter has also introduced you to some of the video terminology and core concepts that will assist during the development of tutorials in Chapters 3 through 13.

CHAPTER 3

DEVELOPING YOUR FIRST MOVIE

Introduction

This chapter is a hands-on guide to developing a movie in Adobe Premiere. The tutorials herein are designed for those who are experienced computer users, but that are new to Premiere. Premiere has abundant features that can intimidate even an experienced user. In traditional video editing environments, there is certainly a lot to be known about how to assemble and edit video, but learning the basics and producing a movie can actually be done quite simply.

These tutorials not only demonstrate how to create a movie but expose you to a variety of menus and commands, as well as the Premiere interface. The goal of this approach is to have you experience the Premiere video-editing environment in a series of simple tutorials that allow you to develop a comfort level with the software. This will also remove the anxiety of learning Premiere's windows, menus, screens, and commands without relevant materials in place.

The theory of learning to use the power of Adobe Premiere 6.0 via a "learning by discovery" method is unique. Premiere can have a high learning curve. However, you need only learn a few solid principles to be able to import files and export them to high-quality movies. The purpose of these tutorials is to teach you how to make a movie in a few brief steps and to become grounded in the fundamentals of the video editing process.

When you compose a letter on your computer, chances are that the first draft it is not always perfect. If you delete a word or sentence and replace it with another word or sentence, you have "edited" your document. If you add a chart, a table, or a piece of clip art, you have once

again edited your document. Video editing with Premiere 6.5 is very much the same. By importing external files (such as graphics, photos, audio, and video), you can develop a movie to show off these elements in a totally new format. As you place these elements into Premiere, you are in fact editing video.

Because Premiere is a nonlinear video editor (NLE), external files can be added to change the scope of the video at any time. Premiere 6.5 includes many new features to add to the power of this highly customizable program. In the tutorials that follow, you will gain a sense of the ease with which a video can be assembled and output as a finished product.

Objectives

In this chapter you will explore and learn processes associated with the following.

- Project setup, the working environment, and the nature of editing in Premiere

- Creating and using bins

- Importing video, audio, and graphics files and previewing imported files

- Creating and using color mattes

- Working with the timeline

- Setting and using transitions

- Scrubbing

- Working with audio and video tracks and playing audiovisual clips

- Saving, previewing, and exporting movies

Installing Premiere 6.5

To work with the tutorials in this chapter, begin by installing Adobe Premiere 6.5. If you do not own a copy of Premiere 6.5, a demo version can be downloaded from the Adobe web site at *www.adobe.com*. This trial version will allow project development but not saving of files. If you own your copy of Premiere, you can save your work. The following are the requirements for installing Premiere 6.5 on your hard disk drive.

- Macintosh
 - PowerPC Processor
 - MacOS software 9.2
 - QuickTime software version 5.0
 - 32 Mb of available RAM (128 Mb recommended)
 - 50 Mb of available hard-disk space required for installation
- Windows
 - Pentium-class processor (300 MHz or faster)
 - Microsoft Windows 98, Windows 98 Second Edition, Windows 2000, Windows Millennium, or Windows NT 4.0 with Service Pack 6
 - 32 Mb of RAM (128 Mb recommended)
 - 85 Mb of available hard-disk space required for installation (40 Mb for application)
 - 256-color video display adapter
 - Large-capacity hard disk or disk array

If You Own Premiere 6.5

If Premiere is not installed on your computer, install it by following the directions provided in the *Adobe Premiere 6.5 User Guide.*

Using the Evaluation Version of Premiere 6.5

If you do not own a copy of Adobe Premiere 6.5, download the trial version from the Adobe web site (see the previous section, "Installing Premiere 6.5").

1 Locate the folder *Tryout Software* on the companion CD-ROM.

2 In this folder, locate the folder *Adobe Premiere 6.5.*

3 Open the folder and double click on the Install Adobe Premiere icon.

4 Follow the on-screen prompts to install the software on your hard drive.

 NOTE: *You will need approximately 85 Mb of hard disk space to effectively develop the tutorials in this book.*

Opening Premiere

With Premiere properly installed, double click on the Premiere icon to open the application. When Premiere opens, a splash screen appears with the Premiere version and other information. Next, another screen appears asking you to select an initial workspace. This option is set just once: the first time you install and run Premiere 6.5. For the purposes of this exercise, do as follows: Select the button Select A/B Editing from the Load Project Settings dialog box.

NOTE: *The Initial Workspace option is set the first time you install and run Premiere 6.5. After that, the window arrangement will be as you last left it (see figure 3-1).*

Fig. 3-1. Initial Workspace window allows on-screen windows to be configured for the beginner or experienced Premiere user.

Tutorial 3-1: Performing the Initial Phases of Making a Movie

In the sections that follow, you will establish initial project settings and otherwise create the basis of a movie.

Initial Project Settings

After the Initial Workspace window disappears, the Load Project Settings dialog box, shown in figure 3-2, appears. The Load Project Settings dialog box will allow you to create custom settings or to choose from a variety of built-in preset settings. The options in the Available Presets

screen are optimized to fit a variety of video editing scenarios. Selecting a preset setting typically means that you are familiar with what the outcome of the setting will be and that it will fit the format of the project you will be creating. Proper selection of these presets is critical to the development of your final movie.

Fig. 3-2. Load Project Settings dialog box in Premiere 6.5.

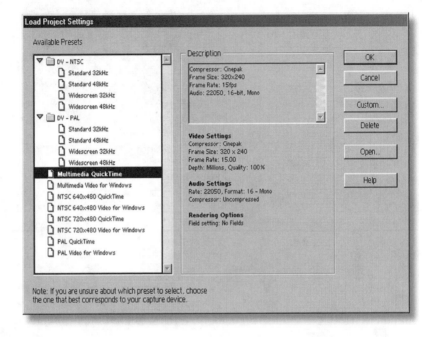

1 Select Multimedia from the Available Presets window.

When you select the Multimedia option, the Description window provides information on the details of this setting.

NOTE: *Do not be confused by the quantity or the detail of these settings; their purpose is revealed in the course of these and other tutorials in the book. In the Load Project Settings dialog box, there is a Description window. The area just below this window offers information on video settings, audio settings, and rendering options that have been selected. There are also other buttons and options in this dialog box that will be covered in other tutorials.*

2 Click on OK to confirm that you want these settings.

At this point, your screen will be filled with various windows that constitute the Premiere 6.5 interface, as shown in figure 3-3. The type of on-

screen windows, and their arrangement, are determined by the selections made in the Load Project Settings window.

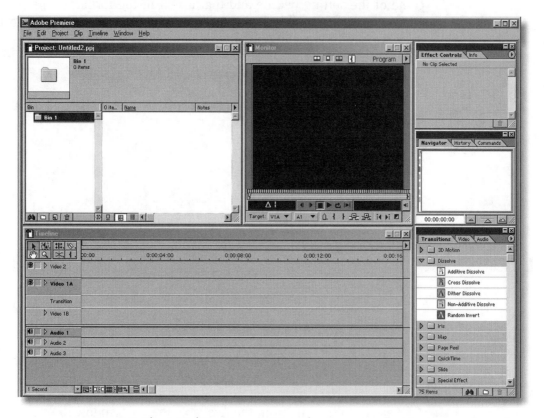

Fig. 3-3. The initial Premiere 6.5 interface arranged on a computer monitor.

Creating and Using Bins

You have created a new Premiere workspace that is ready to accept an array of media files that will be used to create your first movie. To import any type of digital media, you need a specific area to store these files. Premiere offers folders called bins to store files and to assist in the management of imported media. A bin is actually just a folder in which various media files are stored. The term *bin* comes from traditional film editing processes in which film clips were stored in actual bins.

In figure 3-3, note that the window in the upper left-hand side of the main interface screen is titled *Project: untitled*. This is the Project window. The name of this project has not yet been established, and therefore its default name is *untitled*. You will give the project a name later,

when you perform the first save operation. Note also that there is a folder in the Bin window titled *Bin 1*. Even though these files are in fact bins, you want to organize these folders using a logical naming convention to support the type of media they will contain. Remember that bins will contain audio, video, and other media types for your project. Change the name of this bin as follows.

1 Click on the file name *Bin1* to select the text.

2 With the text area selected, type *Video* as the new name for the file.

3 Deselect the file by clicking outside the file or file name.

To further organize the project for other media import, continue with the following steps.

4 With the Project window active, select File > New > Bin.

5 When the Create Bin window appears, you are ready to type a name for the new bin. Type *Audio* as the bin name.

6 Click on OK.

Your new audio bin has been created and placed above the video bin. It is placed above the video bin because the bins are by default listed in alphabetical order. Continue with the following steps.

7 Repeat this process to create yet a third bin.

8 Name this bin *Photos*.

Your Project window should now look like that shown in figure 3-4. You are now ready to place media into these bins. In the section that follows, you will import video files.

Fig. 3-4. The storage bins you have created will be arranged as shown.

Importing Video Files

Now that storage bins have been created, the next step is to systematically import the media files that will be used to develop the movie. Bins can contain video, audio, scans, line art, and other types of media files. Bins can also contain other Premiere projects. All media files must be imported into Premiere in order to use them in project development. The order in which files are imported does not matter.

The objective in importing video into a bin named *Video* will help to establish a logical workflow that will take the guesswork out of where a file resides. As files are retrieved for use in a project, the logical place for a file to reside is in a folder that reflects it genre. The first of the media clips to be imported will be the video clips.

1 Verify that the Project window is active and that the bin named *Video* is selected.

2 Select File > Import > File. Open the companion CD-ROM and navigate to the *Sample* folder.

3 Locate the *Video Files* folder. In this folder, find the file *Gulls.mov*. Select the file, and then click on Open. This will place a thumbnail of this video clip in the bin named *Video*, as shown in figure 3-5.

Fig. 3-5. Project window showing that the file Gulls.mov *is placed in the* Video *bin.*

By clicking once on any bin, a thumbnail view of each file will appear to the right of the bin. In addition, descriptive information about the clip will be displayed at the top of the window. When the folder is selected, the window at the top shows the selected folder and the number of items in the folder.

4 Select the *Video* bin.

5 Navigate to the companion CD-ROM.

6 Import the file *Ski.mov*.

You will now see two thumbnails in the *Video* bin, as shown in figure 3-6.

Fig. 3-6. Video bin showing two thumbnails representing two imported video clips.

These two clips are the only video clips that will be used in this movie.

 NOTE: *As files are imported for use in Premiere 6.5, placed files are from the original file. However, any modifications made in the new movie during the editing process will not affect the original file.*

These two clips are the only video clips that will be used in this movie.

Importing Audio and Art Files

In the following, you will import audio and art files.

1 Select the *Audio* folder in the Project window to make it active.

2 Select File > Import > File.

3 Navigate to the companion CD-ROM and locate the folder *Audio Files*.

4 Select the file *music1.aif,* and then click on Open.

5 As previously performed, create a new bin. Name this bin *Art*.

6 With the *Art* bin active, select File > Import > File.

7 Navigate to the companion CD-ROM and locate the folder *Art Files*.

8 Select the file *Logo.pct,* and then click on Open.

A thumbnail of *Music1.aif* file will now appear in the Project window in the *Audio* bin.

9 Verify that the file was placed in the *Audio* bin, shown in figure 3-7.

Fig. 3-7.
Music1.aif *file located in the* Audio *bin.*

A thumbnail of the *Logo.pct* file will now appear in the Project window in the *Art* bin. With this file imported, your Project window should look like that shown in figure 3-8.

*Fig. 3-8.
Logo.pct file
located in the
Art bin.*

Creating and Using Color Mattes

In this section, you will incorporate a color matte to add an important element to the movie. A color matte is merely a solid background image that appears in your production, along with your other media. Typically, these mattes are black; however, they can be any color in the computer's color palette.

Begin by creating a bin to hold the color matte. If the File > New > Bin option is not accessible, make sure the Project window is the active window; otherwise, this option will not be available.

1 Activate the Project window to make it the active window.

2 From the File menu, select File > New > Bin.

3 Create a new bin and name it *Miscellaneous*.

4 Select the bin, and then select File > New > Color Matte.

The Color Picker window will open, allowing you to select a color by clicking and dragging your cursor in the window. As you do this, you will notice the Red, Green, and Blue values on the right side of the screen change numerical values. This will show the RGB value you have selected. However, for this exercise, you are simply going to choose

black as the background matte color. This can be done in two ways, as depicted in figure 3-9.

Fig. 3-9. Color Picker window.

5 In the Color Picker window, move the pointer to the extreme lower left side of the screen. You will notice that the RGB values on the right change. When the RGB values change to 0 for Red, Green, and Blue, you will have selected Black as your choice. Alternatively, type in *0* for the Red, Green, and Blue values.

6 Click on OK.

7 You are now asked to give your color palette a name. Make a logical choice for future reference; name the file *Black Matte*.

8 Click on OK.

You can resize the Project window as shown in figure 3-10. The *Miscellaneous* bin could be useful during a project to store assorted files that are not primary source files for the presentation.

Fig. 3-10. Black matte stored in the miscellaneous bin.

Saving Your Project

The saving process can be done at any time following the import of the first file into the project. It is important to save often during project development. Saving a backup copy of the presentation is also encouraged, in the event you experience a system crash or if your hard disk drive becomes corrupted.

1 Select File > Save.

2 Select Desktop at the top of the Save File As window.

3 Name the project *Beachbash.ppj*.

4 Click on the New Folder button to the right of the Name field.

5 Name the folder *Tutorial1* and click on Create.

6 Click on Save in the Save File As window.

Your project is now saved in a folder on your desktop.

 TIP: *If you are using an evaluation version of Premiere, you will not be able to save changes. To have Premiere automatically save your project, select Edit > Preferences > Auto Save and Undo. (See figure 3-11.) Check the Automatically Save Projects checkbox. Enter a time period for which you want Premiere to save the project. Make selections in the Project Archive and History/Undo Levels areas based on your personal preference.*

Fig. 3-11. Auto Save window.

Placing Files in the Timeline

So far, you have worked exclusively in the Project window. Now that the media files for this project have been imported, you are ready to place them in the timeline, shown in figure 3-12. Premiere uses the timeline to establish a beginning and end point for your project. Your movie will consist of video, audio, art, and photographic files you have either created or imported from another source. The term *editing* comes into play when you take these individual components and put them together in a sequence that tells a story over a specified period.

Fig. 3-12. Timeline window.

Telling this story can be done entirely with the clips you have created or acquired through various sources. However, by adding a variety of effects that are built into Premiere, you can transform your assorted clips into a harmonic video production.

The timeline is where this harmonic convergence happens. In the timeline, you determine what file is placed where, how long it appears on the screen, and how it interacts with other on-screen elements. Transitions, effects, timing, and many other elements happen here, allowing you to produce your movie. All files that have been placed into bins must be placed into the timeline.

Importing a Color Matte

To import the color matte into the timeline from the Project window, perform the following steps.

1 From the Project window, select the *Miscellaneous* bin folder. A thumbnail image of the *Black Matte* file will appear to the right.

2 Click on the *Black Matte* thumbnail, hold the mouse button down, and drag the thumbnail to the Video 1A track in the timeline, as shown in figure 3-13.

Fig. 3-13. Black Matte file dragged from the Project window into the timeline.

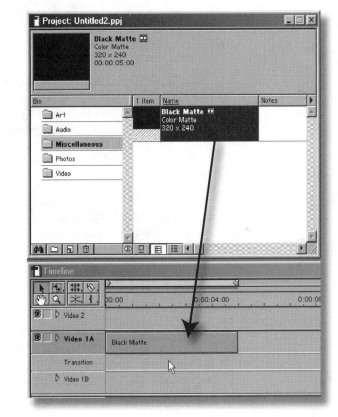

You will notice that the *Black Matte* file appears as a green-colored bar that illustrates the name of the file. You will also notice a yellow bar above the colored bar. This bar represents the current length, in seconds, of the *Black Matte* file just imported.

Importing Video Files

As with the color matte, video files must be placed in the timeline in order to use them. Import these files as follows.

1 Select the *Video* bin in the Project window to make it active. You will notice the video clips appears to the right of the bin.

2 Locate the file *Gulls.mov.*

3 With the pointer positioned over the *Gulls.mov* file, click-hold-drag the file into the Timeline window and release the mouse when the file is positioned in the Video 1B track, as shown in figure 3-14.

Fig. 3-14. The Gulls.mov movie and the Black Matte *file in place in the timeline.*

You can determine the exact length of this video clip by clicking once on the clip in the Project window. At the top of the window, a thumbnail of the clip will appear. Details about the clip will appear to the right of the thumbnail. For example, the *Gulls.mov* clip is 00:00:04:25 long, or 4.25 seconds. Import the next video clip into the timeline.

4 From the *Video* bin, select the file *Ski.mov.* Click-hold-drag the file into the Video 1A track, as shown in figure 3-14.

Do not worry about placement at this time. These files will be precisely arranged in the "Adjusting Video Files" section later in this chapter.

Importing Audio Files

To import the audio file associated with this tutorial, perform the following steps.

1 From the Project window, click once on the *Audio* bin.

2 Click-hold-drag the file *Music1.aif* into the Audio 1 track. Your screen should resemble that shown in figure 3-15.

3 Visually inspect the placement of the *Music1.aif* clip to ensure that it is aligned to the left of the screen; that is, beginning at the 00:00-second mark.

You will notice that the placed files appear as assorted colored bars containing the name of the particular file.

Fig. 3-15. Timeline displaying the matte, video, and audio clips in place.

Changing Icon Size and Track Format

The timeline offers flexible viewing options to help you relate visually to the imported files. The bars that represent your files can be modified to include graphic images of the actual clip, which will allow you to create a visual link to your source clips. To add these visual elements to the imported files, perform the following steps.

1 Select Windows > Window Options > Timeline Window Options.

2 In the Track Format section of the dialog box section of this menu, select the first option, as shown in figure 3-16.

3 The Timeline window should now show a visual representation of each imported clip, as shown in figure 3-17.

TIP: *If you place the pointer over a clip, it will display the file name of the clip.*

Fig. 3-16. Track
Format option for the
timeline.

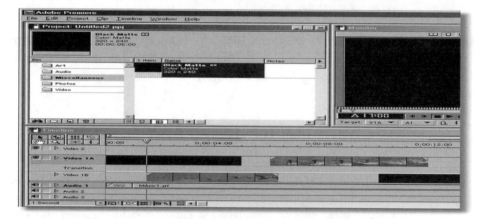

Fig. 3-17. Clips shown in icon view in the timeline.

Importing a Graphic File

The last media element to be imported into the timeline is a graphic
(art) file. Import the file as follows.

1 Select the *Art* bin, shown in figure 3-18.

2 As the file *Logo.pct* appears, click and drag the file into the Video 1A
track in the timeline, also shown in figure 3-18.

Fig. 3-18. Logo.pct *file dragged into the timeline.*

Exploring Imported Files

Take a moment to review the files you have imported into the timeline. You can preview any file placed in the Timeline simply by double clicking on the item. Try this on each imported element to learn how they differ. The sections that follow take you step by step through this process.

Exploring Video Clips

The video clips stored in bins in the Project window can be viewed and edited in the Clip window. To examine a clip in the *Video* bin, perform the following steps.

1 Double click on the *Ski.mov* clip. The Clip window will appear. From here, you can view the clip by clicking on the Play button in the controls at the bottom of the screen. See figure 3-19.

Fig. 3-19. The Clip window and the controls that allow a movie to be previewed.

2 Play with the Clip window controls shown in figure 3-20. These controls are like the operating controls typical of VCRs. You will notice that one control allows the movie to play in a continuous loop until deselected.

Fig. 3-20. Clip window operating controls, including Scrubbing track.

3 Another unique aspect of the Video Source window is a feature called the Scrubbing track, shown in figure 3-20. By clicking on and

dragging the handle in this slider bar, you can play the movie, frame by frame, backward or forward to locate a precise frame in the movie. As you drag the pointer, you will also hear the audio clip play. The clip is distorted because it is not being played at a consistent speed.

4 Close the Clip window.

Exploring an Audio Clip

The audio clip *Music1.aif*, stored in the *Audio* bin in the Project window, can be previewed in the Clip window. To examine this clip in the *Audio* bin, perform the following steps.

1 Double click on the *Music1.aif* file located in the Audio 1 track. The Clip window will appear. See figure 3-21.

2 Preview the clip by clicking on the Play button in the controls at the bottom of the screen.

Fig. 3-21. Sound waveform displayed in the Clip window.

Zoom In/Out

As the clip (audio track) plays, a vertical bar will move forward, indicating the location of the playhead in the clip. As depicted in figure 3-21, the distorted line that appears in the Clip window is a waveform representing the sound contained in the clip. The large vertical lines represent louder sounds, whereas shorter, vertical lines represent softer sounds.

Exploring a Graphics File

Like all other media types, graphics (art) files have preview and modification capabilities after they have been placed in Premiere. To preview and modify a graphics file placed in the timeline, perform the following steps.

1 In the timeline, double click on the *Logo.pct* file.

The file will open to normal size in the Clip window.

2 Click on the Duration button in the lower left-hand side of the window. Here you can see that the default duration time is set to 5 seconds. See figure 3-22. At this time, do not change the Duration setting in this window.

3 Click on OK or Cancel to close this window.

Fig. 3-22. Still images, such as the Logo.pct file, can have the duration of the image changed by modifying the time in the Clip Duration dialog box.

Tutorial 3-2: Arranging Clips in a Timeline

The elements you have placed in the timeline need to be adjusted before the final movie can be completed. The timeline is where the composition of these clips happens. The timeline accepts all types of media and allows these clips to be arranged in a timeline.

Adjusting the Black Matte

In the timeline, the movie being developed for this exercise will begin at 00:00. As the movie begins, the screen will be black for a period of time. This black screen is integrated into the movie in the form of the black

matte. This matte is an element of the movie placed in the timeline. Therefore, it must be assigned a duration. This duration may be either longer or shorter than the original duration assigned to the matte. To adjust the matte, perform the following steps.

1 In the timeline, select the Edit Line arrow. Click-hold-drag the arrow to the 2-second mark, as shown in figure 3-23.

Fig. 3-23. The Edit Line arrow set at the 2-second mark in the timeline.

2 In the Video 1A track, select the black matte by clicking on it once. (You know that the graphic is selected because it is outlined by the selection rectangle.)

Fig. 3-24. Timeline showing that the black matte has been adjusted to be a total of 2 seconds long.

3 Move the pointer to the right-hand side of the matte, directly over the right edge. (You will notice the pointer change into a resizing handle.)

4 With the resizing handle visible over the right-hand side of the black matte, hold the mouse down and drag to the left until you reach the 2-second mark; then release the mouse.

The edge will snap to the 2-second mark because the Edit Line arrow is also precisely located at the 2-second mark. (See figure 3-24.) The reason for the snap is because

the Snap To Edges option, from the Timeline menu, is set to On by default. This technique is beneficial in alignment operations discussed later in the book.

Adjusting Video Files

All media clips imported into the timeline will need some type of adjustment to make them function properly with other elements. The video clips are no exception. This clip will be positioned under the black matte so that a transition between the two can be added later. The first clip to be adjusted will be *Gulls.mov*.

Adjusting the First Video Clip

Adjust the *Gulls.mov* clip as follows.

1 Move the Edit Line arrow to the 1-second mark.

2 Click in the center of the video clip in track Video 1B. Click-hold-drag the clip to the left until it snaps to the edit line.

Fig. 3-25. The Gulls.mov *clip with the left edge aligned at the 1-second mark.*

3 Confirm the location of the movie by checking it against the position shown in figure 3-25.

This will position the start point for this clip precisely at the 1-second mark.

In the foregoing you have positioned the clips so that the color matte will play before the video clip *Gulls.mov*. You will continue to arrange these clips in an overlapping manner as you prepare the movie for transitions to be added later.

Adjusting the Second Video Clip

Just as the previous clip was positioned in a specific location, the *Ski.mov* clip must be in position to provide the proper result.

1 Move the Edit Line arrow to the 5-second mark and release the mouse.

2 The *Ski.mov* clip should be in the Video 1A track. Click-hold-drag the clip to the 5-second mark. The clip will snap to the edit line.

3 Confirm the location of the movie by checking it against the position shown in figure 3-26.

Fig. 3-26. The Ski.mov *clip with the left edge aligned at the 5-second mark.*

Examining figure 3-26, you will notice that the video clip in Video 1A and the clip in Video 1B overlap. The reason for this is that a transition has been added to make these clips dissolve from one to the other. Transitions will be added in the "Adding Transitions" section later in this chapter.

Adjusting an Art Clip

Just as the color matte and the video clips were repositioned, the art clip must be placed in a specific location to achieve desired results. Make the following adjustments to the art clip.

1 Move the Edit Line arrow to the 10-second mark and release the mouse.

2 Select the graphics file *Logo.pct* by clicking in the center of the clip of the same name.

3 Click-hold-drag the clip to the left until the left edge snaps to the 10-second mark; then release the mouse.

This will give a little less than a 1-second overlap of the video clip in the Video 1A track and the graphics (art) file in the Video 1B track. Confirm this alignment against the example shown in figure 3-27.

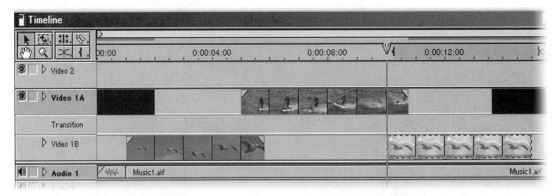

Fig. 3-27. Graphics file positioned under the clip in the Video 1A track.

Adjusting the Second Color Matte

Most movies usually start by transitioning from a black screen to video, and usually end just the opposite, by fading from video to a black screen. Like most movies, this movie will end with a black screen. The second color matte serves the same function as the one at the beginning of the movie, in reverse. This matte will allow the movie to end with a black screen. Adjust the second color matte as follows.

Fig. 3-28. The color matte file positioned over the graphics file in the Video 1B track.

1 Move the Edit Line arrow to the 14-second mark and release the mouse.

2 Click-hold-drag the color matte in the Video 1A track and drag it to the right or left, depending on its current location, until the left edge snaps to the edit line at the 14-second mark.

3 Release the mouse button.

This will give about a 1-second overlap between the two graphics files in the Video 1B track and the color matte file in the Video 1A track, as shown in figure 3-28.

Establishing the End of a Movie

To specify the end point of the movie, perform the following steps.

1 Move the Edit Line arrow to the 17-second mark.

2 Click once in the color matte (background) to select it.

3 Move the pointer over the right edge of the *Color Matte* clip.

4 The pointer will change to a resizing tool. Click-hold-drag the edge of the clip to the 17-second mark. The clip will snap to the edit line.

5 Release the mouse to set the new duration of the matte.

6 The Work Area bar determines the beginning and the end of the movie. Click-hold-drag the triangle at the end of the bar to the 17-second mark in the Timeline.

You have established the end of the movie, as shown in figure 3-29.

Fig. 3-29. The Work Area bar establishes the end of the movie.

Tutorial 3-3: Previewing, Adding Transitions, and Scrubbing

Thus far, all efforts have been given to the importation and placement of a variety of media files. Premiere allows you to preview your movie at any time during development. Even though the movie is not yet complete, the preview process provides a sense of the "pace and feel," as well as how the movie will look, when played back in a timed sequence. Preview the movie as follows.

1 In the File menu, select Save.

2 Examine the Timeline window to ensure that the Work Area bar starts at the beginning of the movie and runs to the end (at the 17-second mark).

3 In the Timeline menu, select Preview (or press the Enter key).

It will take a few seconds for the movie to be prepared for viewing. However, when processed, the movie will play from beginning to end in the Monitor window. You can press Enter again to preview the movie once more. This time, the movie will play instantly.

Adding Transitions

The movie is taking shape, but it is not complete without establishing some form of transition from scene to scene. Transitions allow color mattes, video clips, and graphics files to blend from scene to scene. Transitions are an essential part of the development of any movie. To begin creating transitions, perform the following steps.

Fig. 3-30. The floating palette folder contains the Transitions palette.

1 In the Timeline window, move the slider bar to the left side, revealing the very beginning of the movie.

2 On the lower right-hand side of the screen is a floating palette that contains three tabs at the top: Transitions, Video, and Audio. Make this palette active by clicking once on the Transitions tab. This reveals the Transitions palette, shown in figure 3-30, which offers a number of folders containing a variety of transition effects.

3 Click once on the triangle to the left of the Dissolve folder to reveal the Dissolve transitions.

4 Click-hold-drag the Additive Dissolve transition into the Transition channel in the timeline, as shown in figure 3-31.

As you place the transition into the Transition track, you will notice that the Additive Dissolve transition will snap into place, with the left side aligning with the movie in Video 1B, and the right side aligning with the color matte in Video 1A.

Fig. 3-31. Additive Dissolve transition placed into the Transition palette.

Fig. 3-32. The start image on the left will transition into the end image on the right.

5 In the Transition channel, double click on the Additive Dissolve transition. This reveals options for the transition.

6 When the Additive Dissolve Settings window opens, click on the Show Actual Sources button in the lower left of the screen. This shows the images at the top and bottom of the transition. Note that the start image on the left is black (the black matte) and the image (end image) on the right is a photo (the *Gulls.mov* clip). See figure 3-32.

7 The left start frame represents the image in Video 1A. *Start = 0%* means that the image is at 0% opacity. (If the slider at the bottom of the Start screen were moved to the right, it would reveal the End image.)

Previewing a Movie with Transitions in Place

Earlier, you previewed the movie prior to the addition of transitions. The movie will take on a more finished feel with the addition of transitions. Perform the following steps to preview the movie with transitions in place.

1 Select Timeline > Preview (or press the Enter key) to preview the movie.

You will notice that it takes quite a bit more time to preview a movie with transitions in place. This is true because Premiere must render each of the transitions that have been placed in the timeline. Rendering a transition means that it must blend one image (video, photo, illustration, and so on) into another.

Depending on the transition, many images are generated to create the smooth blending from one image to another. This is one reason the rendering process is so time consuming. However, the more powerful the computer, the faster the rendering process. Once the movie has completed this process, it will automatically play. An example of rendering is shown in figure 3-33.

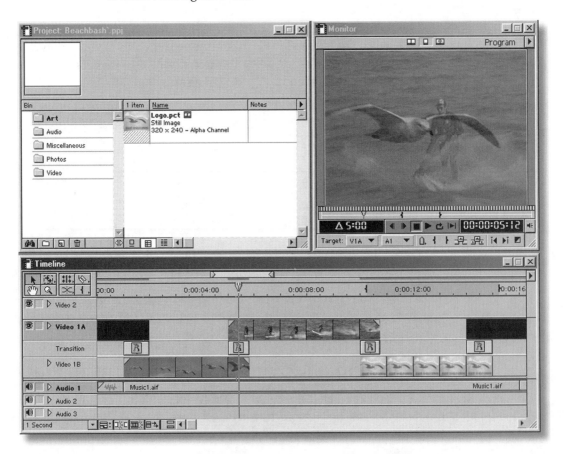

Fig. 3-33. Two video clips being blended in the rendering process.

2 To preview the movie again, select Timeline > Preview, or press the Enter key. The controls at the bottom of the Monitor window can also be used to manipulate the movie.

Scrubbing

Now that the movie has been rendered and previewed in its final state, a technique called scrubbing can be used to view a transition or any portion of the movie in detail. Scrubbing allows you to click and drag in a specific area on the screen to view frames at a speed based on how fast you drag the pointer to the right or left.

Scrubbing in the Timeline

To scrub in the timeline, perform the following steps.

Fig. 3-34. Pointer on the Preview bar.

1 Select the Timeline window.

2 Move the pointer to the Preview bar, as shown in figure 3-34. (The pointer will change to a downward arrow.)

3 While holding down the Alt/Option key, click and drag the pointer in the Preview bar to the right or the left.

You will notice that the edit line will move in conjunction with the pointer, showing you what part of the clip is being previewed.

4 Drag the pointer over the first two transitions and view the effect as the content changes that in Video 1A to that in Video 1B.

Scrubbing in the Monitor Window

As previously mentioned, scrubbing can also be done in the Monitor window my clicking and dragging the pointer in the area shown in figure 3-35.

*Fig. 3-35. Scrubbing
in the Monitor
window.*

Tutorial 3-4: Exporting a Movie

The movie that has just been created currently exists as a Premiere 6.0 file. An integral part of Premiere is its ability to output the movies you create to a variety of formats. For this exercise, the movie will be output as a QuickTime movie. QuickTime is a universal standard movie format that can be used for playback on a computer, CD-ROM, DVD-ROMs, and the Web. To create a QuickTime movie, perform the following steps.

1 Select File > Export Timeline > Movie.

2 When the Export Movie window appears, name the movie *Beachbash.mov.*

You will notice the settings for the movie on the lower left side of the Export Movie window, shown in figure 3-36.

3 Click on the Settings button to reveal the Export Movie Settings window. Note that File Type is set to QuickTime.

In the Export Movie Settings window, you can change many attributes of your movie. However, do not make any changes at this time.

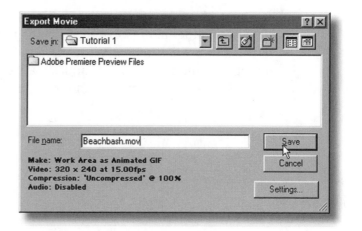

Fig. 3-36. Export Movie window, with settings for naming a new movie.

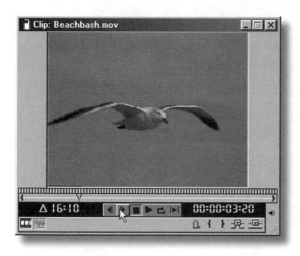

Fig. 3-37. Finished Beachbash.mov *QuickTime movie.*

4 Select Cancel to exit the Export Movie Settings window.

5 In the Export Movie dialog box, select Save.

Based on the power of your computer, the movie should export within two minutes. The completed movie should be approximately 6 Mb in size.

6 When the movie appears, press the Play button (shown in figure 3-37) on the Clip window to preview the final movie.

Congratulations, you now have a Quick-Time movie that can play back from your computer, a CD-ROM, a DVD-ROM, or another medium.

Summary

In this chapter you have used the Project window to establish several folders called bins. These bins have been renamed so that various media types can be contained in logically named folders. To create a new movie, specific media files were imported from the companion CD-ROM into these bins, where they are stored until needed.

You have also imported various media types into Premiere's Timeline window, in order to organize these media into a format that can be converted into a final movie. With the addition of Premiere's transitions and effects, the movie was output as a QuickTime movie that can be played back on any computer, or output to videotape.

CHAPTER 4
ANIMATING STILL IMAGES

Introduction

This chapter and Chapter 5 work in harmony toward the production of a unique video. This chapter guides you through the development of an entertaining movie made entirely out of still images and audio files. The goal of developing a movie of this type is to not only show the power of bright, colorful imagery but to place these images in motion to add a new dynamic. Not only will the images be put into motion but audio tracks will be added that will be timed with critical events among the images.

There is tremendous power that accompanies still imagery. There is even more power with the addition of motion and sound. The tutorials in this chapter are somewhat unconventional. However, the goal is to produce a compelling video production that will expose you to precision clip alignment, timing sound with visuals, animating still images, and much more. Hopefully, these tutorials will stimulate you to think of applications that can be produced with still images and audio files.

Objectives

The following are the objectives of this chapter.

- Using the Clip window
- Importing still images
- Adjusting aspect ratio
- Working with motion effects
- Using a clip more than once in a project

- Copying and pasting transitions

- Aligning transitions

Tutorial 4-1: Starting a New Project and Importing Art Files

In the following, you will practice starting a new project and importing art files.

Starting a New Project

To start a new Premiere project, perform the following steps.

1 Open Premiere.

2 When the Load Project Settings dialog box opens, select Standard 48kHz under the *DV-NTSC* folder in the Available Presets menu.

3 Click on OK.

Fig. 4-1. Load Project Settings dialog box.

The workspace will appear as shown in figure 4-2. This window layout is configured for A/B editing. A/B editing refers to editing video clips in the Video 1A and 1B tracks of the timeline.

Fig. 4-2. Premiere workspace.

Importing Art Files into Bins

The primary content for this section of the tutorial consists of graphic images. In the following, you will import these files for use in project development.

1 Select the Project window to make it the active window. As shown in figure 4-3, open the File menu and select File > Import > Folder. Navigate to the companion CD-ROM and locate the *Tutorials* folder. In this folder, open the *Fireworks* folder and click once on the *Art* folder to select it.

2 Select the OK/Choose button at the bottom of the screen (see figure 4-4). This will import the entire *Art* folder into the Project window.

3 Double click on the *Art* folder in the Project window. This will reveal the content of the folder, shown in figure 4-5.

The window displays a series of photograph files arranged alphabetically. Note that all of the files start with the word *Blast*. For this tutorial, it will be beneficial to arrange the Art Bin window to maximize the Icon view. Continue with step 4.

Fig. 4-3. Import/Folder menu option.

Fig. 4-4. Selecting a folder and then clicking on the OK/Choose button imports the entire folder.

Fig. 4-5. Files contained in the Art folder.

4 Figure 4-6 shows the files arranged in the Icon view. This view can be selected by clicking on the Icon View button at the bottom of the Project window. So that it does not visually interfere with the Timeline window, move the Art Bin window, or click and drag the lower right-hand corner of the window to the upper left, totally covering the Project window.

Fig. 4-6. Art Bin window covering only the Project window.

Icon View —— —— List View
 —— Thumbnail View

Tutorial 4-2: Importing Image Files into a Timeline

When beginning any project in Premiere, files are first imported into the Project window, where they are stored in bins. The next step is to place these imported files into the timeline, where they can be edited for use in a video production.

Adjusting Clip Duration

The nature of this project is to import and bring to life a series of still images. When planning a project such as this, the designer typically has a vision for how the end product will look. The initial vision for this tutorial was to display a series of photographs of fireworks that would, when edited, present the illusion of a staged fireworks display. In regard to planning the placement of these files in Premiere's timeline, a stan-

dard duration of 2 seconds per clip was chosen. In the processes that follow, this setting will be established prior to placing the files. Doing this will save time, because the setting will be performed once and will affect all placed files. Even though some file durations will be lengthened, most will remain at the 2-second setting.

1 Select Edit > Preferences > General & Still Image.

Fig. 4-7. Changing the Default option for duration in the Still Image area.

2 In the Still Image area, shown in figure 4-7, type in *60* (frames) in the Default Duration field and check the Lock Aspect box. By making the Default option for duration 60 frames, and establishing a video frame rate of 29.97 fps, the duration of the still image will be 2 seconds.

3 Click on OK.

4 To confirm that the image duration is 2 seconds long, double click on the clip *Blast.pct*. When the *Blast.pct* opens, note the Duration button at the bottom. Click on this button.

The Clip Duration field, shown in figure 4-8, will appear. This window shows the length of the clip; in this instance, 2 seconds. This setting will be the same for all imported still image clips.

5 Click on OK and close the Clip Duration field. Close the Clip window.

Fig. 4-8. The Clip Duration field specifies how long the clip will last.

Importing Clips into the Timeline

To import clips from the Art bin into the timeline, perform the following steps.

1 Click-hold-drag the video clip *Blast.pct* into the Video 1B track. Release the mouse when the clip is at about 0;00;04;00 (the 4-second mark).

2 Once the file is in position, release the mouse and click-hold the mouse button on the file in the timeline. While holding the mouse button down, drag the left edge of the clip to the 3-second mark in the timeline. When you click on a file and hold the mouse button down, vertical lines appear on both the right and left side of the clip, as shown in figure 4-9. When at the specified location, release the file.

Fig. 4-9. Aligning a clip precisely in the timeline.

You will notice at the top of the Timeline window a yellow and a red bar above the clip you just placed. The yellow bar represents the total time of the project. This starts at the beginning (00;00), and goes to the end of the last placed clip (in this case, 0;00;05;00). The red line indicates that the clip has not been rendered or previewed. You will preview this project later in the chapter.

3 At the lower left of the Timeline window, select the Toggle Snap To Edges option, shown in figure 4-10. Having this option activated will allow clips to automatically snap to second markers and to other files.

TIP: *There may be times during the process that having the Toggle Snap To Edges option activated will have a negative effect on clip placement. Turn the function on or off as needed. For the most part, having this option activated will be beneficial during this tutorial.*

Fig. 4-10. Toggle Snap To Edges option.

The Toggle Snap To Edges option

Following the placement process you performed previously, place the remaining 14 clips into the timeline.

NOTE: *Before placing the files in step 4, drag the edit line marker to the location each clip will start before placing the clip. This allows the clip to snap to the exact location. This requires that the Toggle Snap To Edges feature is activated.*

4 Place the remaining clips (Art Bin files) according to table 4-1.

Table 4-1: Art Bin File Placement

Clip Name	Track	Timeline Alignment
Blast1.pct	Video 1A	0:00:05.15
Blast2.pct	Video 1B	0:00:07.15
Blast3.pct	Video 1A	0:00:09.00
Blast4.pct	Video 1A	0:00:13.00
Blast5.pct	Video 1B	0:00:14.15
Blast6.pct	Video 1B	0:00:18.15
Blast7.pct	Video 1A	0:00:20.15
Blast8.pct	Video 1B	0:00:22.00
Blast9.pct	Video 1A	0:00:24.00
Blast10.pct	Video 1B	0:00:26.00
Blast11.pct	Video 1A	0:00:30.00
Blast12.pct	Video 1B	0:00:32.00
Blast13.pct	Video 1A	0:00:35.00
Blast14.pct	Video 1B	0:00:37.15

5 With these files in place, select File > Save. Create a new folder on your desktop and name it *Tutorial 2*. Name the file *Fireworks*, and save it in the *Tutorial 2* folder.

6 The logic for this file placement will unfold as the tutorial is developed. Refer to figure 4-11 to confirm proper clip placement. You will notice that the timeline has been split into three sections to show the entire length of the project.

Fig. 4-11. Placing the art files into the timeline.

Tutorial 4-3: Using the Clip Window

In this tutorial, you will adjust the imported clips in a variety of ways, including adjusting clip length and establishing beginning points and other placement criteria.

Changing Clip Duration

You will have noticed that the clips just placed are in somewhat of a random order. Some of the clips are by themselves and some overlap.

The next process is to adjust some of the clips in length to achieve the effect of a fireworks display.

1 Locate the *Blast3.pct* clip at the 0;00;09;00 position in the timeline.

2 Double click on the clip to open the Clip window.

3 Click on the Duration button at the bottom of the screen.

4 When the Clip Duration field appears, change the Duration setting to 0;00;03;00 (see the following Tip).

TIP: *In step 4, you can simply select the 2, delete it, and change it to a 3. This eliminates the need to type in the entire time sequence.*

5 Click on OK.

6 Close the Clip window.

You will notice that the length marker of the clip moves to the right, indicating the time addition of 1 second.

7 Using the scroll bar at the bottom of the Timeline window, scroll to the right and locate the clip *Blast10.pct*. This clip is at the 0;00;26;00 position in Video 1B.

8 Double click on the clip to open the Clip window.

9 Select the Duration button at the bottom of the screen.

10 When the Clip Duration window appears, change the Duration setting to 0;00;04;00.

11 Click on OK.

12 Close the Clip window.

TIP: *When navigating in the Timeline window, using the Navigator palette is extremely beneficial. By clicking on and dragging the rectangle enclosing the small timeline illustration, you can move quickly from one end of the timeline to the other.*

The next clip to be modified is *Blast12.pct*. Continue with the following steps.

13 Using the scroll bar at the bottom of the Timeline window, scroll to the right and locate the clip *Blast12.pct*. This clip is at the 0;00;32;00 position in Video 1B.

14 Double click on the clip to open the Clip window.

15 Select the Duration option at the bottom of the screen.

16 When the Clip Duration window appears, change the Duration setting to 0;00;03;00.

17 Click on OK.

18 Close the Clip window.

The next clip to be modified is *Blast13.pct*.

19 Using the scroll bar at the bottom of the Timeline window, scroll to the right and locate the clip *Blast13.pct*. This clip is at the 0;00;35;00 position in Video 1A.

20 Double click on the clip to open the Clip window.

21 Select the Duration option at the bottom of the screen.

22 When the Clip Duration window appears, change the Duration setting to 0;00;02;15.

NOTE: *Changing the duration to 0;00;02;15 means that the clip will become 2.5 seconds long. Remember that a second of video is 30 frames (or 29.97 frames); thus, a half-second of video is 15 frames.*

23 Click on OK.

24 Close the Clip window.

The final clip to be adjusted is *Blast14.pct*.

25 Using the scroll bar at the bottom of the Timeline window, scroll to the right and locate the clip *Blast14.pct*. This clip is at the 0;00;37;15 position in Video 1B.

26 Double click on the clip to open the Clip window.

27 Select the Duration option at the bottom of the screen.

28 When the Clip Duration window appears, change the Duration setting to 0;00;02;15.

29 Click on OK.

30 Close the Clip window.

Adjusting the Aspect Ratio

The clips that have just been placed are all still images. When importing files into Premiere, often the image size does not match the frame size specified in Premiere's Project Settings window. When images that do not match project settings are placed into the timeline, they appear distorted in either width or height, or both.

Previously, when you set the Still Image option default to 60 frames, you also selected the Lock Aspect box. This meant that images would be imported in their original format. For the sake of this tutorial, and to demonstrate an effect technique, in the following you will remove the aspect ratio from specific clips.

1 From the Timeline window, select the clip *Blast2.pct*, in Video 1B at 0;00;07;15.

2 With this clip selected, select Clip > Video Options > Maintain Aspect Ratio.

As shown in figure 4-12, if a check mark appears on the menu bar, the Maintain Aspect Ratio option is currently on. Selecting it again will turn it off.

Fig. 4-12. Setting or removing the Maintain Aspect Ratio option.

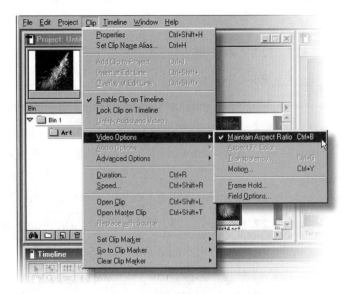

Figure 4-13 shows the clip in the two modes. The clip on the left shows the Maintain Aspect Ratio option activated, thus maintaining the original size and proportions. The clip on the right shows the clip with the

Maintain Aspect Ratio option deactivated, therefore distorting the image. In this tutorial, the goal of turning the Maintain Aspect Ratio option off is to have the image fill the entire screen.

Fig. 4-13. Maintain Aspect Ratio option activated (left) and deactivated

3 Following the procedure you performed previously, adjust placement of the images in the timeline as outlined in table 4-2.

Table 4-2: Timeline Art Clip Placement 2

File	Track	Timeline In-point Location
Blast7.pct	Video 1A	0:00:20.15
Blast11.pct	Video 1A	0:00:30.00
Blast12.pct	Video 1B	0:00:32.00
Blast13.pct	Video 1A	0:00:35.00
Blast14.pct	Video 1B	0:00:37.15

Previewing

Previewing, and previewing often, is essential when developing any project in Premiere. So far in this project, you have not worked with the preview function. To use the preview function, perform the following steps.

1 Select Timeline > Preview (Mac: Return > Windows > Enter).

2 Verify that the preview function has begun.

Based on your computer configuration, the preview function could take anywhere from a few seconds to a few minutes. The movie will play, demonstrating the sequence of placed images. There are many obvious missing ingredients in the movie. The movie will be continually embellished in this chapter and the next.

The preview function is also referred to as rendering. Previewing can be performed as often as you wish during the development stage of this project. Once the first preview is performed, the entire project is not rendered again. This means that as changes are made, only these changes need be rendered. The result is a faster rendering time if only minor changes are made in the timeline. Also note that as the project becomes more complex the preview (rendering) time increases accordingly.

 NOTE: *Project settings can be different from final output, depending on the movie output format selected. In this case, the project would need to be rendered.*

Tutorial 4-4: Working with Motion Effects

After previewing the project, it is plain to see that the clips placed so far are lifeless. After all, this is a video, right? You are using still images to create dynamic video. The dynamic part is what is missing. In this section, you will apply a variety of motion effects to the clips to bring the visuals to life. As the project continues in the development process, more dynamics will be added to further enhance the production.

This tutorial incorporates images of fireworks in the process of exploding. You can imagine several visual effects that need to be conveyed in this project. Perhaps the most important visual dynamic in observing fireworks as they explode is the flash of bright, colorful light. These bursts seem to rush toward you rapidly, then quickly fade away. For the most part, this is the effect that will be applied to the still images currently in the timeline.

Modifying Clips in the Timeline

In the following, you will modify (to add motion effects) the clips in the timeline in order, starting with the clip *Blast.pct*.

Fig. 4-14. Opening the Motion Settings dialog box.

1 Before starting this phase of the tutorial, review the explanation of the Motion Settings window in Appendix A.

2 In the timeline, click once on the clip *Blast.pct*.

3 Select Clip > Video Options > Motion. (See figure 4-14.)

When the Motion Settings dialog box appears, there are many options available. Figure 4-15 shows the full Motion Settings window. To better examine this window and its functionality, figures 4-15 through 4-21 show processes that occur in specific areas of the Motion Settings window.

Fig. 4-15. Motion Settings dialog box.

The window in the upper right of the Motion Settings dialog box contains a thumbnail of the *Blast.pct* graphic. The purpose of this window is to establish motion. To do this, a start point and an end point are established. In this example, the start frame, as shown in figure 4-16, is currently positioned off the main monitor screen.

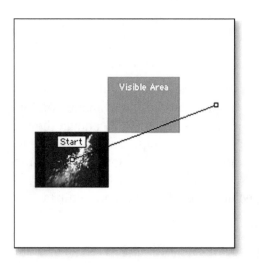

Fig. 4-16. Changing the direction of a clip, beginning with the start image.

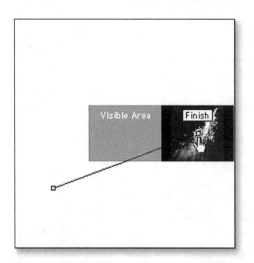

Fig. 4-17. Modifying the location of the finish image.

The monitor screen is represented by the gray box. By moving the start screen to this position, the first frame is not visible on the monitor. The diagonal line represents the path the image will follow. The start point and end point are called keyframes. A keyframe defines what is happening to a frame at a particular point in time. To reposition the start image, continue with the following steps.

4 Select the start image (*Blast.pct*) by clicking on the white box in the center of the image.

5 Click-hold-drag the start frame to the position shown in figure 4-16.

6 Release the mouse.

7 Once the start image is in place, click on the white square on the right side of the screen. A "finish" identifier will appear on the image, letting you know that this is the finish (i.e., end) position for this image. Move the image to the position shown in figure 4-17.

8 Select the finish image (*Blast.pct*) by clicking on the white box in the center of the image.

9 Click-hold-drag the finish image to the position shown in figure 4-17.

10 Release the mouse.

You now need to modify the finish keyframe. The effect being created here is to have the *Blast.pct* image enter the screen in full size and

then move across the screen while the image is being reduced. The desired effect is to make the image appear to vanish while streaking across the screen. Continue with the following steps.

11 Click on the finish image to make it active.

12 At the bottom of the Motion Settings dialog box is an area titled Click on a Point Above. In this area are Rotation, Zoom, and Delay options with shuttle controls. In the Zoom control, move the slider to the left until the value field changes to 25%. This can also be done by typing *25* in the field.

The finish image will appear as shown in figure 4-18.

Fig. 4-18. Finish image zoomed to 25% reduction.

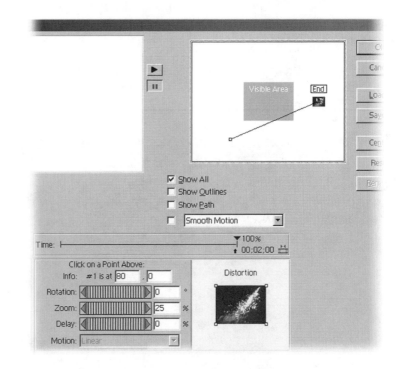

13 Select the finish image by clicking on the white handle in the center of the graphic and then while holding down the mouse button, dragging the image to the position shown in figure 4-19. The location of the graphic is shown in both the Preview window (left) and the Motion Path window (right).

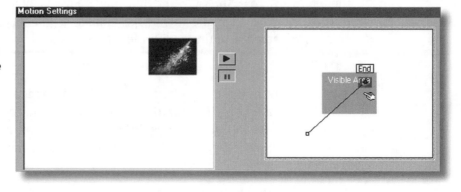

*Fig. 4-19.
Positioning the
reduced image
in the visible
area of the
screen.*

14 With the finish image placed visually, enter the specific settings for this keyframe, as shown in figure 4-20.

15 With the image selected, click on the Smooth Motion button. From the pull-down menu, select Averaging - High, shown in figure 4-20. This will give the maximum motion smoothness to the image as it moves across the screen.

*Fig. 4-20.
Adjusting Smooth
Motion and custom
keyframe settings.*

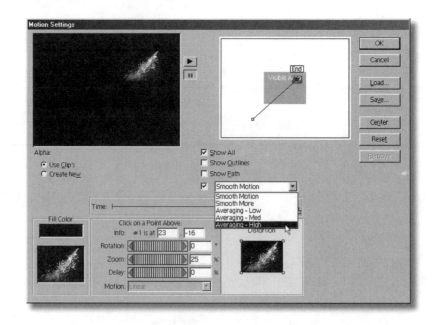

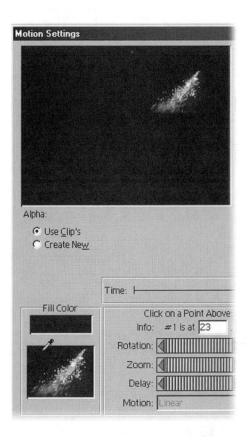

Because the graphic files will reduce in size, it is important for the screen to maintain a consistent background color. Continue with the following steps.

16 Move the pointer to the bottom left of the Motion Settings dialog box. Move the mouse over the thumbnail of the *Blast.pct* image. When the pointer changes to the eyedropper tool, move the point of the tool to the black background of the image.

Click the mouse to select the black background. As shown in figure 4-21, the Fill Color box above the image will change to reflect the selection. The Preview window will reflect the selected color.

Fig. 4-21. Choosing a fill color for the screen background.

Using a Clip More Than Once in a Program

The *Blast.pct* clip is the only image clip in this tutorial that will be used more than once. The reason it has not been positioned before this point is that when planning the workflow for any project it is a good idea to apply effects to clips prior to duplicating them. That is, of course, assuming that the same effect is desired at other locations.

Even if the effect is not to be exactly the same on repetitive uses, if some features are redundant, you may find that making minor tweaks are easier done this way than by starting from scratch. To place the *Blast.pct* clip in other locations, perform the following steps.

1 Click once on the *Blast.pct* clip to select it.

2 Select File > Copy.

3 Move the timeline edit line to the 00;00;11;15 position.

4 Position the pointer in the Video 1B track in the area near the edit line. Click once to select the track, and then select File > Paste.

5 Drag the pasted clip to the right or left, allowing the left side to snap to the timeline marker at the 00;00;11;15 position.

6 Move the edit line to the 00;00;16;15 position.

7 Position the pointer in the Video 1A track near the edit line position. Click once to select the track, and then select File > Paste.

8 Save and preview your project.

When finished, the duplicated clips should be positioned as shown in figure 4-22.

Fig. 4-22. Pasted clips precisely aligned in the timeline.

Setting Additional Effects

Now that you have seen the power of motion effects in regard to one clip, in the following you will add effects to the remaining clips.

1 From the Timeline window, click once on the clip *Blast1.pct*.

2 Select Clip > Video Options > Motion.

3 When the Motion Settings window appears, establish the settings according to the guidelines shown in figure 4-23.

4 The white handle on the left (A) represents the start keyframe. Click once on the handle to select the frame, and then click on the Center button on the right.

5 Click once on the motion path line to specify a new keyframe (B) just to the right of the start keyframe.

6 With this keyframe selected (item B in figure 4-23), notice the keyframe location in the Motion timeline (C).

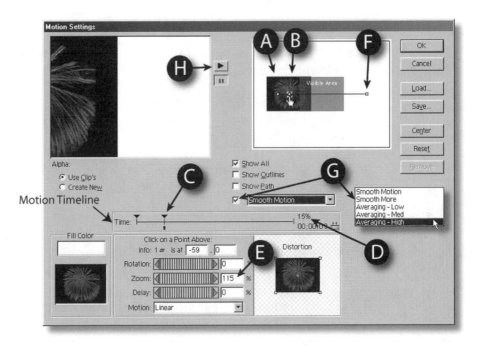

Fig. 4-23. Guidelines for specific settings for the Blast1.pct *clip.*

7　The keyframe should be at the 15% position (item D).

8　With item B still selected, adjust the Zoom (E) option to 115%. This can be done by using the right or left directional arrows or by typing in *115%*. Once completed, click on the Center button on the right.

9　Click on the finish keyframe (F). Click on the Center button on the right.

10　With the finish keyframe still selected, select the Smooth Motion option. When the pop-up menu appears, select Averaging - High (G). This will make the motion as smooth as possible.

11　Preview the effects in the Motion Preview window.

The reason a keyframe was set at the 15% location and the magnification set to 115% is to have the image quickly zoom in to simulate the nature of a burst of fireworks. From there, the image gradually recedes. This effect will be somewhat typical for the balance of the images.

12　Perform the changes indicated in figure 4-23 on clips *Blast2.pct* through *Blast14.pct*. Do not modify the *Blast10.pct* clip.

Modifying the Blast10.pct Clip

The *Blast10.pct* clip is missing from the clips that were just modified. In the following, you will incorporate an additional feature in this clip.

1 In the timeline, locate the *Blast10.pct* clip and click on it once to select it.

2 Select Clip > Video Options > Motion.

3 When the Motion Settings dialog box appears, follow the steps detailed in figure 4-24. The alphabetical listing will provide step-by-step directions for modifying the clip.

4 Select the start keyframe (A) and click on Center from the button options on the right.

5 Click on the motion path to add a new keyframe (B).

6 In the motion timeline at the bottom of the dialog box, set the marker (C) to the 20% location.

7 Select the finish keyframe and click on Center from the buttons on the right.

See figure 4-25, and continue with the following steps.

8 Select the finish keyframe (A).

Fig. 4-24. Settings for adjusting the Blast10.pct *clip.*

9 In the Distortion window at the bottom right of the screen, click-hold-drag the handle to the lower right (B), and then release the mouse button. Click-hold-drag the lower left handle to further distort the graphic image (B).

10 Move the pointer over the thumbnail image in the Fill Color area and select the black background color when the pointer changes to the Eyedropper tool (C).

11 Select Averaging - High from the Smooth Motion menu (D).

12 Click on the Play button (E) to preview the motion effects.

13 When completed, click on OK to exit.

The motion settings are now established and can be previewed in the Motion Settings window. Once back in the timeline, the changes must be rendered in order to preview. Once rendered, you can quickly move

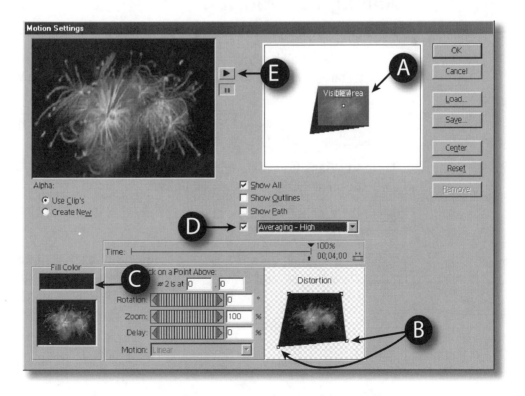

Fig. 4-25. Distorting the Blast10.pct *clip to achieve special effects.*

the edit line to the beginning of the clip and click on the Play button in the Monitor window to view the finished effects.

14 Save and preview your project.

The result of this tutorial is that you have made this graphic appear to burst instantly on screen, roll toward the viewer, and then fade from the screen.

Tutorial 4-5: Working with Transitions

In the preview you performed in the previous tutorial, you probably developed a better feel for the direction of this tutorial. Images are in place, and motion is in place, so what is left? Transitions are beneficial in making the project appear more realistic. In the following sections you will place transitions where needed to create this realism.

Adding the Transition

To add transitions, perform the following steps.

1 Using the scroll bar at the bottom of the window (or by dragging the Navigator window to the left), move the Timeline window to the 0;00;00;00 position.

2 Verify that the Premiere workspace is set to A/B Editing mode by selecting Window > Workspace > A/B Editing.

3 In the Transitions palette, click on the triangle next to the *Dissolve* folder. The Dissolve transition options will appear.

4 In the timeline, set the edit line as shown in figure 4-26 (at 9 seconds).

5 Click-hold-drag the Cross Dissolve transition into the Transition track in the timeline. When the transition snaps to the edit line, release the mouse. See figure 4-26 for the precise location.

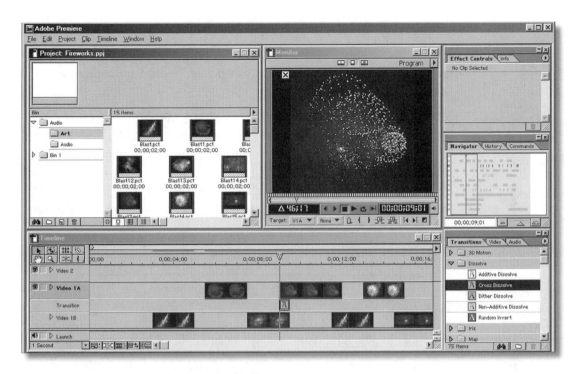

Fig. 4-26. Placing a Cross Dissolve transition into the timeline.

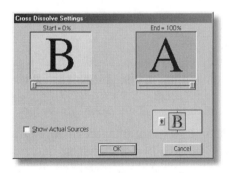

6 With this transition in place, double click on the transition to explore its settings. The Cross Dissolve Settings window will appear. The default setting should be as shown in figure 4-27. This figure indicates that the transition will dissolve the clip in Video 1B into the clip in Video 1A.

Fig. 4-27. Cross Dissolve Settings window.

NOTE: *When setting transitions, you want the first clip in the timeline to dissolve into the clip it overlaps. It does not matter what track the clips are in, because the timeline starts at 0 and runs forward.*

Copying and Pasting Transitions

With this transition in place, a quick method of adding additional transitions is to use the copy and paste function. In the following, you will work with this function.

NOTE: *When pasting the transitions into the timeline, you must select the area in the transition channel you want the transition to go. When you select this area, a border surrounds the area to indicate the selection. When you select the Paste command, the transition will be placed in the bordered area, but not exactly where you want the transition to go. Once pasted, click-hold-drag the transition to the specified location. See figure 4-28 for details.*

Fig. 4-28. Pasting and relocating the position of a clip.

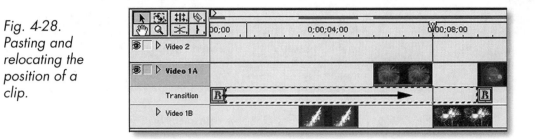

1 Click once on the Cross Dissolve transition in the Transition timeline. Select Edit > Copy.

2 Follow the diagram shown in figure 4-29 to paste the additional transitions. Use the timeline markers as a guide during placement of the transitions.

The transitions just copied and pasted into position are all identical. That is, they are all set to perform the functions delineated in figure 4-27. In reviewing this figure, you will notice that the Cross Dissolve setting indicates that the transition will start in Video 1B and then affect the clip in Video 1A. For this tutorial, not all transitions need to function in this manner.

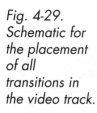

Fig. 4-29.
Schematic for
the placement
of all
transitions in
the video track.

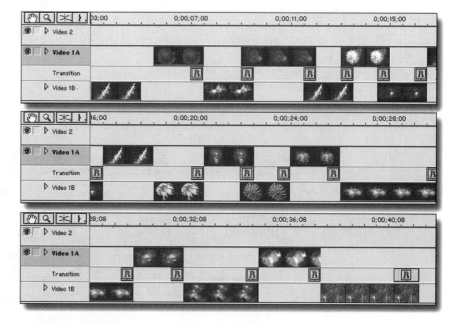

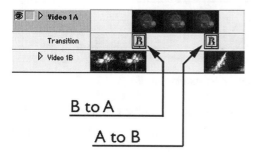

B to A

A to B

Fig. 4-30. A transition's effect is based
on a clip's track position.

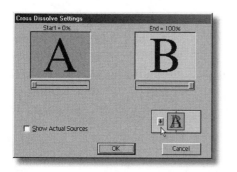

Figure 4-30 depicts the effect transitions have between video tracks. As Premiere plays a movie, the first clip (Video 1B) is displayed first. The transition, in this case a dissolve, will begin to fade out of the image in Video 1B while fading into the image in Video 1A. The transition creates a series of blended images. This is one reason the preview or rendering process takes so long to complete.

The Cross Dissolve setting can be changed to allow the video track direction priority to be changed. By clicking on the Track Selector button, you can choose which clip starts the transition. The Down arrow starts the transition from video track A to track B. The Up arrow starts the transition from track B to track A. (See figure 4-31.) You can view the process by opening the Show Actual Sources box.

Fig. 4-31. The transition effect can begin in the
A track or the B track.

3 To set the transitions so that the Cross Dissolve setting performs properly, follow the guidelines shown in figure 4-32.

Fig. 4-32. Schematic illustrating proper transition settings.

A/B indicates that the transition starts in Video 1A and changes to Video 1B. B/A indicates that the transition starts in Video 1B and changes to Video 1A.

4 Save your presentation and preview the file.

Remember, because so many transitions have been placed, the preview (or rendering) process will take much longer.

Verifying Transition at Clip Junctions

It is important that transitions are properly aligned with their related clips. A transition must start precisely at the beginning of the first clip and end at a specified location on the second clip. If the Toggle Snap To Edges option is activated, the clips should align automatically with the transition.

Clip and transition aligned

Fig. 4-33. Clip and transition alignment is critical to providing the proper effect.

If during the pasting of the transitions a visual misalignment is noticed, click on the transition and move it to the right or left until the transition aligns properly. If the Toggle Snap To Edges option hinders the precise alignment, temporarily turn off this feature. Figure 4-33 shows clips and transitions in proper alignment.

Why Some Clips Contain No Transitions

As you review the presentation, notice that the transitions should allow the images to smoothly blend into one another. You will also notice that there are clips that do not have transitions connecting them. No transition indicates that the clip will suddenly appear on the screen.

As these tutorials are further developed in Chapter 5, you will see the impact of this as sound effects are timed to give impact to these clips. Should you need to confirm the transition settings, refer to the *Fireworks* file in the *Fireworks* folder, located in the *Tutorials* folder on the companion CD-ROM.

Summary

This chapter has introduced you to the idea of using still images in a video production. Premiere contains the properties that make possible the addition of unique features and motion associated with still images that are not available in other software programs. The strength of this program allows precise control over content and the ability to output the project to video, computer, CD-ROM, DVD-ROM, and the Web. As these tutorials are completed in Chapter 5, you will see the power of sound and motion by utilizing the power of Adobe Premiere 6.5.

CHAPTER 5
ADDING SOUND
EFFECTS

Introduction

Chapter 4 demonstrated several functions of Premiere 6.0 in the course of showing you how to animate a number of still images. This chapter constitutes the second part of the tutorials you performed in Chapter 4. In this chapter, you will import and fine tune a series of audio files specifically designed to match the visuals created in Chapter 4. The goal of this chapter is to show the power that properly used audio effects play in a video production. This is especially true in a scenario such as the one used here, in which visuals are very dependent on audio files.

Objectives

The following are the objectives of this chapter.

- Adding audio tracks to the timeline
- Naming audio tracks
- Importing audio into the timeline
- Aligning audio clips with video clips
- Creating fading audio
- Expanding and collapsing tracks
- Creating fade-in and fade-out

Tutorial 5-1: Placing and Naming Audio Files

The placement of audio in the timeline works like any other media type. In the sections that follow, you will manipulate and name audio tracks.

Importing Audio Tracks into Bins

In all Premiere projects, content must be imported in order to create a new project. Prior to placement in the timeline, files are stored in bins. In the following, you will begin this series of tutorials by importing audio files into a bin.

1 Open the *Fireworks* file as prepared in Chapter 4.

2 Make the Project window active by clicking anywhere on the window.

3 Select File > Import > Folder.

4 When the Choose a Folder dialog box opens, navigate to the companion CD-ROM and select the folder sequence *Tutorials* > *Fireworks* > *Audio*. Click once on the *Audio* folder to select it. Click on the Choose/OK button. The audio bin will appear to the left, as shown in figure 5-1.

Fig. 5-1. Project window with a newly created audio bin.

5 Double click the audio bin to open it.

6 Reposition the Audio Bin window directly over the Project window. Make sure the Audio Bin window does not overlap other windows on the screen, As shown in figure 5-2.

Fig. 5-2. Audio Bin window in its default view.

Files in bins can be arranged in three views: Icon, Thumbnail, and List. For purposes of this tutorial, the List view will be used. To set the view to the List view, click on the List View icon at the bottom of the window (see figure 5-3).

Fig. 5-3. Audio bin shown in the List view.

Icon View —
Thumbnail View —
List View

By examining the content of this bin in the List view you will see the variety of files in the bin. You will also notice the information contained

at the top of the window as specific clips are selected. This bin contains a total of 13 audio files prepared for this tutorial. These files are arranged in alphabetical order. As you view these files by name, you will notice that they have been prepared and given logical names for organization and easy placement into the timeline.

Adding Multiple Audio Tracks

This series of tutorials is punctuated by the addition of sound effects, music, and background sounds that will create a feel of attending a live fireworks exhibition. To bring realism to the presentation, numerous audio effects need to be introduced and integrated into the movie. To make this work, many sounds need to be present at the same time. Premiere provides this functionality via multiple audio tracks.

Three audio tracks are present in the timeline's default window. Premiere will allow up to 99 audio tracks in a project at a time. Six additional tracks are required for this tutorial, making a total of nine tracks. To add these six tracks, perform the following steps.

1 Make the Timeline window active by clicking anywhere in the window.

2 At the bottom of the Timeline window are several icons. Click on the Track Options icon to open the Track Options dialog box (see figure 5-4).

└── Track Options Dialog

Fig. 5-4. Track Options dialog box as opened from the timeline.

3　When the Track Options dialog box appears, select Add.

 TIP: *Pressing the Tab key will move from one field to another.*

4　When the Add Tracks dialog box appears, type *0* in the Video field and *6* in the Audio Track(s) box.

5　Click on OK to close the Add Tracks dialog box, but leave the Track Options dialog box active.

Naming Audio Tracks

Before closing the Track Options dialog box, the tracks need to be named. This is an important part of the planning and layout process of designing this movie. To name the tracks, perform the following steps.

1　In the Track Options dialog box, click once on the *A1: Audio 1* track. The Name button on the right will be activated. Click on the Name button. The Name Track dialog box will open. Name the track *Launch*. Click on OK. See figure 5-5.

Fig. 5-5. Track Options dialog box with the Name button selected.

Track Options

Tracks:
V2: Video 2
V1: Video 1
A1: Audio 1
A2: Audio 2
A3: Audio 3
A4: Audio 4
A5: Audio 5
A6: Audio 6
A7: Audio 7

OK
Cancel
Add...
Delete
Name...

Name Track

Name A1 : Launch

OK　　Cancel

In the following, you will name the rest of the audio tracks. Continue with the following steps.

2　Double click on the file *A2: Audio 2*. Name the file *Whistles*.

3　Double click on the file *A3: Audio 3*. Name the file *Long Boom*.

4　Double click on the file *A4: Audio 4*. Name the file *Short Boom*.

◀) ▷ Launch	
◀) ▷ Whistles	
◀) ▷ Long Boom	
◀) ▷ Short Boom	
◀) ▷ Firecrackers 1	
◀) ▷ Firecrackers 2	
◀) ▷ Firecrackers 3	
◀) ▷ Applause	
◀) ▷ Soundtrack	
1 Second	↕

Fig. 5-6. The audio tracks in the timeline reflect the addition of new tracks and user-added titles.

5 Double click on the file *A5: Audio 5*. Name the file *Firecrackers 1*.

6 Double click on the file *A6: Audio 6*. Name the file *Firecrackers 2*.

7 Double click on the file *A7: Audio 7*. Name the file *Firecrackers 3*.

8 Double click on the file *A8: Audio 8*. Name the file *Applause*.

9 Double click on the file *A9: Audio 9*. Name the file *Soundtrack*.

10 Click on OK to close the Track Options dialog box.

The audio track names in the Timeline window will now display names for all nine audio tracks. See figure 5-6.

NOTE: *If you have less than nine audio tracks, repeat the process and add the necessary track(s). If you have more than nine tracks, select the extra track and click on the Delete button to remove it.*

Tutorial 5-2: Importing Audio into the Timeline

Because of the nature of the audio clips and their functionality in these tutorials, and to understand this process better, importing these clips one at a time is prudent. It is important when designing projects that proper planning is done on the front end. Assigning clips logical names, setting up the timeline with customized tracks, and employing other naming conventions are beneficial to the easy and successful development of any project.

1 To begin the audio clip placement process, make sure your audio bin is open and is currently displaying files in the List view. Adjust the Timeline window to make all audio tracks visible for placing the audio clips.

In the following you will use table 5-1 as a guide to dragging the audio clips to the appropriate audio track in the timeline. Continue with the following steps.

2 Make sure the Timeline window is set to begin at 0;00;00;00. Use figure 5-7 as a guide to placement. The files listed in table 5-1 will be placed in the appropriate track listed in table 5-1. Drag the clips into the timeline using the click-hold-drag technique. Place the clips in the order outlined in table 5-1.

Table 5-1: Clip Placement per Track

Track	Order
Launch	*Launch.aif, Applause.aif*
Whistles	*Whistles.aif*
Long Boom	*Boom.aif*
Short Boom	*BoomShort.aif*
Firecrackers 1	*Firecrackers1.aif, Firecrackers4.aif, Popping.aif*
Firecrackers 2	*Firecrackers2.aif*
Firecrackers 3	*Firecrackers3.aif*
Applause	*Applause.aif, Applause Burst.aif, Rhythm Clap.aif*
Soundtrack	*Soul.aif*

Fig. 5-7. The audio tracks in the timeline show sound clips placed from the audio bin.

3 Save your project.

At this point, it is too early to preview the project. You will do this once the clips have been put into position in tutorial 5-3. The placed sound clips are shown in figure 5-7.

Tutorial 5-3: Positioning Audio Clips

With the individual clips in place, the clips must now be duplicated and distributed throughout the timeline to relate to events happening in the video tracks. To do this, placement of audio clips will be performed on a track-per-track basis. This will help isolate the audio effect and its relationship with the clip in the video track. As this process builds, the end result is that the tracks will become layered and will blend to complement one another.

Figure 5-8 shows screen images of the timeline for the entire project. These images show all audio and video clips properly placed. These screens will overlap a bit so that they do not visually crop the placement of audio tracks. To ensure proper placement, use the timing markers at the top of the timeline as points of reference. Use the edit line to align video clips and audio clips. Remember to set the edit line first and then adjust the audio clip for proper alignment.

Placing the Launch Audio Track

Begin with the *Launch* audio track and follow the placement examples shown in figure 5-8 as placement guidelines.

1 Move the timeline to display the time 0;00;35;00 and click to insert the edit line at this precise location.

2 Scroll back to the start of the timeline. Click-hold-drag the *Applause.aif* clip to the right and release the clip at the edit line. As you drag to the right, the window will automatically scroll, allowing you to move to the right without releasing the clip.

3 At the bottom of the timeline, verify that the Toggle Snap To Edges option is turned on.

4 Move the *Applause.aif* clip until the left edge snaps to the edit line, and then release the file.

5 Select the *Launch.aif* clip and then select Edit > Copy.

Fig. 5-8. The timeline is segmented to show proper placement of all audio clips in relation to the video clips.

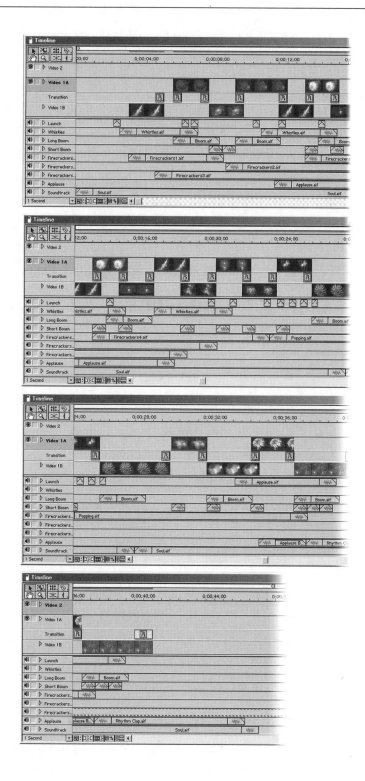

6 Click once in the *Launch* audio track just to the right of the first clip. Doing this selects an area the copied clip can be pasted into.

7 Select Edit > Paste.

8 Repeat this process until a total of 13 clips have been pasted into the *Launch* audio track.

9 Precisely place the files as indicated in figure 5-8.

 TIP: *Remember that you can use the edit line as a guide for clip alignment and that the Toggle Snap To Edges feature can be turned on (or off) as needed. Also, refer to the position details as shown in the Navigator palette.*

In the following sections, you will place the various tracks in the timeline.

Placing the Whistles Audio Track

To place the *Whistles* audio track in the timeline, perform the following steps.

1 Select the *Whistles.aif* clip, and then select Edit > Copy.

2 Click to the right of the existing track and select Edit > Paste.

3 Repeat this procedure until you have three copies of this file in this track.

4 Place the files as shown in figure 5-8.

Placing the Long Boom Audio Track

To place the *Long Boom* audio track in the timeline, perform the following steps.

1 Select the *Boom.aif* clip, and then select Edit > Copy.

2 Click to the right of the existing track and select Edit > Paste.

3 Repeat this procedure until you have six copies of this file in this track.

4 Place the files as shown in figure 5-8.

Placing the Short Boom Audio Track

To place the *Short Boom* audio track in the timeline, perform the following steps.

1 Select the *BoomShort.aif* clip, and then select Edit > Copy.

2 Click to the right of the existing track and select Edit > Paste.

3 Repeat this procedure until you have 14 copies of this file in this track.

4 Place the files as shown in figure 5-8.

Placing the Firecrackers 1 Audio Track

To place the *Firecrackers 1* audio track in the timeline, perform the following steps.

1 Verify that the following clips are in this track in the following order, left to right: *firecrackers1.aif*, *firecrackers4.aif*, and *popping.aif*.

2 Place these clips as shown in figure 5-8.

Placing the Firecrackers 2 Audio Track

To place the *Firecrackers 2* audio track in the timeline, perform the following steps.

1 Place one copy of the *Firecrackers2.aif* audio track in the *Firecrackers 2* audio track.

2 Arrange this clip as shown in figure 5-8.

Placing the Firecrackers 3 Audio Track

To place the *Firecrackers 3* audio track in the timeline, perform the following steps.

1 Place one copy of the *Firecrackers3.aif* audio track in the *Firecrackers 3* audio track.

2 Arrange this clip as shown in figure 5-8.

Placing the Applause Audio Track

To place the *Applause* audio track in the timeline, perform the following steps.

1 Verify that this track contains the following clips: *Applause.aif*, *ApplauseBurst.aif*, and *Rhythm Clap.aif*.

2 Arrange this clip as shown in figure 5-8.

Placing the Soundtrack Audio Track

To place the *Soundtrack* audio track in the timeline, perform the following steps.

1 Verify that this track contains the clip *Soul.aif*.

2 Move the clip to the 00;00 position at the beginning of the timeline.

3 Select the file, and then select Edit > Copy.

4 Select the track to the right of this clip, and then select Edit > Paste.

5 Align the clip as shown in figure 5-8.

Tutorial 5-4: Incorporating the Fading Audio Effect

The fading audio effect is an extremely easy to use technique for fading in and out of sound clips. In this tutorial, this is used to ease in the audio at the beginning of the project, as well as to slowly fade out at the end. This process is also referred to as the rubberband technique, or rubberbanding. This name comes from the stretching appearance that happens as points are moved in each clip.

Fig. 5-9. Expanding an audio track.

1 To access the rubberband feature in an audio track, select the triangle to the left of the track name.

Step 1 reveals the entire track and increases the vertical size of the track. Keep this in mind, as it affects the visible area of the timeline and may require scrolling to view the rest of the tracks. See figure 5-9.

The way the rubberband effect works is actually very much like a rubberband.

2 By clicking on the rubberband line, a point is established that can be selected and moved anywhere in the clip. (See figure 5-10.)

Fig. 5-10. Adjusting sound levels using the rubberband tool.

Once the point is established, it can be moved using the click-hold-drag method. As the point is moved, the line (rubberband) will appear to stretch. The line between points represents the playback level of the clip. Dragging the point at the bottom of the screen indicates the sound level at a minimum setting. Dragging the point to the top of the track indicates the sound level at a maximum. Obviously, dragging the point to the center of the track is at 100%.

Fig. 5-11. Changes made in a sound clip are reflected in the Info palette.

Figure 5-11 demonstrates that by pressing and holding the Shift key while adjusting the rubberband, precise information is provided about the percentage of level adjustment, as well as the decibel levels. The information is also reflected in the Info palette.

Of the 13 sound clips that have been imported into the audio tracks, only a few require modification. The illustrations that follow show the position of the rubberband settings for these clips. Continue with the following steps.

3 In the *Launch* track, modify the rubberband settings as shown in figure 5-12.

Fig. 5-12. Adjustments made to Applause.aif.

4 In the *Applause* track, modify the rubberband settings for the three clips as shown in figure 5-13.

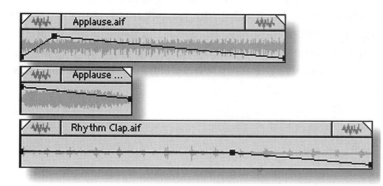

Fig. 5-13. Adjustments made to three sound clips.

Beginning

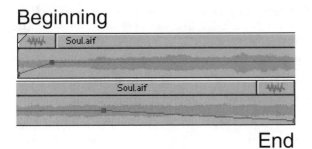

End

Fig. 5-14. Adjustments made to the start and finish of the soundtrack.

5 In the *Soundtrack* track, modify the rubberband settings as shown in figure 5-14. Note that the top clip refers to the beginning of the first file placed: *Soul.aif*. The bottom image refers to the second file, and is located at the end of the second *Soul.aif* clip.

6 With rubberband adjustments in place, save your project and then preview the project by pressing Return (Mac) or Enter (PC).

Remember that the preview process takes some time. However, changes made in the audio track render much faster than changes made in the video track.

Summary

Chapter 4 and this chapter were designed to create a single production that would engage the learning process through repetitive involvement in activities such as importing, placement, alignment, and adding transitions. The objective of these tutorials was to become immersed in the development of a project while learning menus, dialog boxes, features, and other attributes of Premiere 6.5. This prepares you for performing other tutorials in the book, as well as for other projects you might develop on your own.

The skills learned here are a great foundation for the technical aspects of Premiere and the necessary creative thinking during the development processes of any project. Hopefully you have gained some level of insight into how to bring photos (still images) and other types of static images to life using motion, timing, and sound effects. This concludes this set of tutorials. Output formats for these tutorials are discussed in Chapter 13.

CHAPTER 6

TIMELINE ASSEMBLY TECHNIQUES

Introduction

This chapter begins a three-chapter sequence of tutorials that will increase your familiarity with the many features and tools contained in Premiere. You will learn many features of Premiere in general, but special emphasis is given to editing in the timeline, as well as in the Monitor window. As you have previously seen, Premiere is easy to use, even for the first-time user. However, Premiere is an extremely powerful and sophisticated program that provides advanced features to meet the needs of professionals.

As new skills and techniques are introduced, a strong emphasis is placed on working with clips in the timeline. Learning how to modify clips will benefit the movie-making experience. This chapter is the initial phase in this series of tutorials. You will develop an informative video about a hot air balloon company. You will learn many new skills in these tutorials and, as with all tutorials, hopefully ideas will be given that will stimulate the creative thinking process.

Objectives

The following are the objectives of this chapter.

- Disabling a clip
- Using edge viewing
- Moving clips and transitions at once
- Locking a clip
- Adjusting clip length

- Pasting to fit

- Trimming in the Monitor window

- Creating a rolling edit

- Creating a ripple edit

- Creating a storyboard

Tutorial 6-1: Importing Video Clips

Each Premiere project begins with the importation of files to be used for development. For the tutorials in this chapter, files will be imported, and logic and planning will be applied to make the process easy. During the importation process, you will be exposed to project settings and techniques that will enhance your knowledge of the Premiere development process. You will also be exposed to workflow scenarios that include using Premiere's storyboard.

Before Beginning

Make sure the following settings are in place before beginning this tutorial.

- Select Edit > Preferences > General & Still Image. In the Preferences dialog box, select Still Image > Default Duration 50 frames.

Saving Files

Throughout chapters 6, 7, and 8, the project you create must be saved as follows.

- Create a folder on your desktop and name it *Balloon Files*.

You will be prompted to save files to this folder repeatedly throughout the development of these tutorials.

NOTE: *In chapters 6, 7, and 8, several projects will be developed that will be assembled into one large project at the end of Chapter 8. As you are asked to create new movies in these chapters, one standard setting will be used for all movies. You will be prompted to select these settings with the creation of each new movie. The required settings begin with this tutorial.*

The following settings will be the standard new project settings for developing movies in chapters 6, 7, and 8. The only exception is the final movie, which concludes at the end of Chapter 8. Create a new project as follows.

1 Select File > New Project > Custom.

2 Make the following entries in the New Project Settings dialog box.

- General:
 - Editing Mode: QuickTime
 - Timebase: 30
 - Time Display: 30 fps Non Drop-Frame Timecode
- Video:
 - Compressor: Sorenson Video
 - Frame Size: 320 x 240
 - Frame Rate: 30
 - Quality: 100/High
- Audio:
 - Rate: 44100 Hz
 - Format: 16-Bit Stereo
 - Compressor: Uncompressed
 - Interleave: 1 Second

3 Click on OK to accept these settings.

4 In the timeline, turn the Snap To Edges feature on.

Importing the Setup Video Clips

In the following, you will import the first of three groups of video clips. The first group consists of the setup files, which are clips that demonstrate how a hot air balloon is unloaded and set up prior to inflation. The second group of clips is imported in tutorial 6-2. Import the setup files as follows.

1 Select the Project window to activate it.

2 Select File > New > Storyboard. An empty Storyboard window will appear.

3 Select File > Import > Folder.

4 Import the following folder: *CD-ROM/Tutorials/Balloon/Video/Setup*.

Fig. 6-1. Files arranged in Storyboard window.

Fig. 6-2. Automate to Timeline dialog box settings.

5 A total of six files have been imported. To rearrange thumbnails in the Storyboard window, click-hold-drag a thumbnail to the desired position. Arrange the files in the Storyboard window as shown in figure 6-1. Save the storyboard and name it *Setup Storyboard.psq*. Save the file in the *Balloon Files* folder on your desktop.

6 Click on the Automate to Timeline icon in the lower right corner of the Project window. When the Automate to Timeline dialog box appears, select the settings shown in figure 6-2.

Figure 6-2 indicates that the Use Default Transition box is to be checked. Checking this box will automatically place a transition between each clip upon placement in the timeline. By default, Premiere uses the cross-dissolve transition. For future use, the default transition can be changed by selecting Window > Show Transitions (this opens the Transitions palette if needed). You can then select a desired transition from the pop-out menu on the Transitions palette and specify Set Selected as Default.

The clips were copied into the timeline with transitions in place.

7 Close the storyboard window.

Adding a Color Matte

In the following, you will add a color matte at the beginning and end of the movie. To create a new color matte, perform the following steps.

1 Click on the Create Item icon at the bottom of the Project window.

2 From the Create dialog box, select Object Type > Color Matte. Click on OK.

3 The color picker will open, with the default settings set to 0 for the Red, Green, and Blue settings. Accept the defaults or, if needed, change the settings to reflect 0 in each field. Click on OK.

4 When the Color Matte dialog box appears, name the matte *Black Matte*. Click on OK.

The new matte will appear in the Project window. In the sections that follow, you will place the matte.

Moving Clips and Transitions at Once

To make room for the black matte in the timeline, the existing clips must be moved to the right. You will add a 2-second space at the beginning of the timeline to make room for the black matte to be inserted. The toolbox contains a tool specifically designed to make this process easy.

Fig. 6-3. Multi-track selection tool.

1 To move the existing video clips at one time, make sure the timeline is positioned at the beginning. In the Timeline toolbox, click and hold on the Selection toolbox. When the pop-out panel appears, select the Multi-track selection tool, shown in figure 6-3.

2 With the Multi-track selection tool selected, move the mouse over the first clip in the Video 1A track. You will notice the pointer change to a double-arrow pointer, indicating that the Multi-track selection tool is the current tool. Click on the first clip in the Video 1A track. You will notice that all of the clips in the Video 1A track and the Video 1B track, as well as the transitions, are selected.

3 Insert the edit line at the 0;00;02;00 position.

4 In Video 1A, click-hold-drag the first clip to the right until the left edge of the clip aligns with the edit line at the 0;00;02;00 position. Release the mouse.

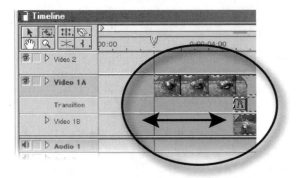

Fig. 6-4. All clips and transitions moved at once with the Multi-track selection tool.

The new starting point for all video clips should be as shown in figure 6-4.

Now that the clips have been repositioned, and the 2-second space has been created, place the black matte by continuing with the following steps.

5 In the Timeline toolbar, select the Pointer tool.

6 Click anywhere in the Project window to make it active.

7 Click-hold-drag the black matte into the timeline, releasing it at the 0;00;00;00 position in the Video 1B track.

8 Insert the edit line at the 0;00;02;15 position. Click-hold-drag the right edge of the black matte clip to the right until it snaps to the edit line at this location.

Fig. 6-5. Black Matte file in position at the beginning of the movie.

This clip should be in the position shown in figure 6-5. Continue with the following steps.

9 Scroll, or use the Navigator palette, to go to the end of the movie.

10 Position the edit line at the 0;00;34;15 position.

11 Click-hold-drag the *Black Matte* file from the Project window into the timeline until the left edge of the matte snaps to the edit line in the Video 1A track.

The black matte has a default length of 0;00;01;20 seconds. The work area bar will extend to the end of the black matte. To complement the black matte clips, add the following transitions.

12 While still at the end of the movie, click-hold-drag the cross-dissolve transition from the *Dissolve* folder in the Transitions palette so that the left edge of the transition snaps to left edge of the black matte (the 0;00;34;15 position). The right edge of the transition will automatically snap to the end of the clip in Video 1B.

13 Move the timeline to the start of the movie and drag the cross-dissolve transition into the transition channel between the black matte and the first clip until the transition automatically aligns with the end of the black matte and the beginning of the clip in Video 1A.

14 Save the project to the *Balloon Files* folder on the desktop and name it *Setup2.ppj*. Select Preview.

The core movie has been created. The following section will demonstrate additional timeline functionality.

Timeline for the Setup Movie

Using the material previously assembled, the sections that follow take you through three techniques involving three features in the timeline.

Locking a Clip

Clips in the timeline can be both locked and unlocked. The purpose of this feature is to avoid accidental changes to the clip and its current location in the timeline. The functionality of the clip does not change because it is locked. To lock a clip, perform the following steps.

Locked Video Clip

Fig. 6-6. Locked clip in the timeline.

1 In the timeline, select the *Burner5.mov* clip.

2 Select Clip > Lock Clip on Timeline.

Once a clip is locked, there is an obvious visual difference. The clip displays a series of cross-hatch lines, as shown in figure 6-6. These markings distinguish the locked clip from other clips. The clip will play back and function as usual, but cannot be moved in the timeline.

3 To unlock the clip, select Clip > Lock Clip on Timeline.

The cross-hatch lines will disappear.

Disabling a Clip

The more you edit in Premiere, the more diverse your projects will become. As in the storyboard process discussed in Chapter 1 and earlier in this chapter, there is a constant need to revise the layout of content in the timeline. Premiere offers many options for planning, editing, and viewing content.

In managing content, you need to be able to enable or disable a clip in the timeline. Disabling clips allows content to remain in tact while temporarily removing it from a preview or any movies that may be exported. This feature is very beneficial as projects are tested and previewed, and obviates the need to remove clips from the timeline. To disable a clip, perform the following steps.

1 In Video 1A, scroll to the left to reveal the first clip (*Unload1.mov*).

2 Click on the clip once to select it.

3 Select Clip > Enable Clip on Timeline. (You will notice that this option is checked. This is the default setting, which allows all clips to be enabled until deselected.) Select Clip > Enable on Timeline to disable the clip in the timeline.

Disabled Video Clip

The clip displays a horizontal pattern, indicating that it has been disabled.

4 Move the work area bar over the clip, as shown in figure 6-7. Preview the movie to view the effect.

5 When you have completed this tutorial, return the clip to its previous state by selecting the *Unload1.mov* clip in the timeline, and then Clip > Enable on Timeline.

Fig. 6-7. A disabled clip in the timeline.

Using Edge Viewing

Using the Toggle Edge Viewing tool, shown in figure 6-8, you can have the content of the clip display in the Monitor window as you make adjustments to the length of the clip. To preview this effect, perform the following steps.

1 Select Window > Workspace > A/B Editing.

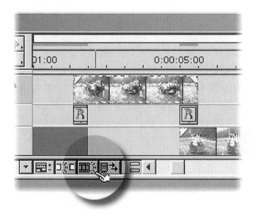

Fig. 6-8. With Edge Viewing turned on, clip positioning is displayed in the Monitor window.

2 Select the *Burner2.mov* clip in Video 1A.

3 At the bottom of the timeline, select the Edge Viewing feature by clicking on the icon. This feature is on when the lines are displayed to the right of the icon.

4 Select the pointer and move it to the extreme right edge of the *Burner2.mov* clip.

5 When the pointer changes to the Trim tool, click-hold-drag slowly to the left.

The video clip will display the current position of the clip in the Monitor window, based on the position of the Trim tool in the timeline. When you have tested this process, return the right-hand edge to its original position, or select Edit > Undo Out Point.

 TIP: *If you release the clip in an undesired location, select Undo Out Point from the Edit menu.*

6 Release the Trim tool and click on the Toggle Edge Viewing icon once more to turn this feature off. The lines on the right-hand side of the icon will disappear.

7 Move the pointer back to the right edge of the *Burner2.mov* clip and move the clip to the left once more. Notice that the Monitor window does not change or show clip movement.

Having this feature activated will be helpful as you position or trim specific clips. Keep in mind that functionality such as this consumes computing power. If your system is minimally configured, turning this feature off may be useful.

8 Reactivate the edge-viewing feature.

Project Output Option

This section is optional, but it shows you how to output a small portion of the movie. In performing these steps, keep in mind that there are two types of settings used in Premiere: those configured prior to starting the project, and those established for the output of a project to a movie or other file type.

The movies prepared in this chapter will be used in tutorials in chapters 7 and 8. If you wish, you can output the project previously assembled using the instructions that follow. If you want to use a saved version of the file found on the companion CD-ROM, you will be instructed as to how to access these files at the appropriate time. If you choose to use the existing file on the companion CD-ROM, you can skip the following output scenario. To export the setup project as a movie, perform the following steps.

1 Set the work area bar from the beginning of the timeline to the end of the project, which should be from the following positions.

 - Beginning: 0;00;01;00

 - End: 0;00;36;04

2 Select File > Export Timeline > Movie.

3 When the Export Movie dialog box opens, click on the Settings button. When the Export Movie Settings dialog box opens, establish the following settings.

 • General:

 - File Type: QuickTime

 - Range: Work Area

 - Export Video

 - Deselect: Export Audio

 • Video:

 - Sorenson

 - Frame: 320 x 240

 - Frame Rate: 30

 - Quality: High

 - Square Pixels (1.0)

4 Click on OK. Name the file *Setup2.mov* and save the file to the *Balloon Files* folder on your desktop.

5 When the movie opens, preview from the finished movie file.

6 Save the *Setup2.ppj* project.

Tutorial 6-2: Importing Inflation Clips

In this tutorial, you will import the second group of video clips, which demonstrate how a hot air balloon is configured for inflation. The third group of clips is imported in tutorial 6-3. Begin this process as follows.

Before Beginning

Create a new project as follows.

1 Select File > New Project > Custom.

2 Make the following entries in the New Project Settings dialog box.

- General:
 - Editing Mode: QuickTime
 - Timebase: 30
 - Time Display: 30 fps Non Drop-Frame Timecode
- Video:
 - Compressor: Sorenson Video
 - Frame Size: 320 x 240
 - Frame Rate: 30
 - Quality: 100/High
- Audio:
 - Rate: 44100 Hz
 - Format: 16-Bit Stereo
 - Compressor: Uncompressed
 - Interleave: 1 Second

3 Click on OK to accept these settings.

4 In the timeline, turn the Snap To Edges feature on.

5 Select Window > Workspace > A/B Editing.

Importing the Inflation Video Clips

To import the inflation clips, perform the following steps.

1 Select the Project window to activate it.

2 Select File > New > Storyboard. An empty Storyboard window will appear.

3 Select File > Import > Folder.

4 Import the following folder: *CD-ROM/Tutorials/Balloon/Video/Inflation*.

5 A total of six items will be imported. Arrange the files in the Storyboard window as shown in figure 6-9.

6 Select File > Save and name the storyboard *Inflation Storyboard.psq*.

7 Click on the Automate to Timeline icon in the lower right corner of the Project window. When the Automate to Timeline dialog appears, select the settings shown in figure 6-10.

Fig. 6-9. Inflation folder arranged in the storyboard.

Fig. 6-10. Automate to Timeline settings for the Inflation storyboard.

The clips were copied into the timeline with transitions in place.

8 Close the Storyboard window.

Adding a Color Matte

In the following, you will add a black matte at the front and end of the movie. To create a new color matte, perform the following steps.

1 Click on the Create Item icon at the bottom of the Project window.

2 From the Create dialog box, select Object Type > Color Matte. Click on OK.

3 The color picker will now appear. The default settings should be set to 0 for the Red, Green, and Blue settings. Accept the defaults or, if needed, change the settings to reflect 0 in each field. This will create a black matte.

4 When the Color Matte dialog box appears, name the matte *Black Matte*. Click on OK.

The new matte will appear in the Project window.

Moving Clips and Transitions at Once

To make room for the black matte in the timeline, the existing clips must be moved to the right. To move the existing video clips at one time, make sure the timeline is positioned at the beginning, or the 0;00;00;00 position. The following steps take you through this process.

1 In the Timeline toolbox, click and hold on the Selection toolbox. When the pop-out panel appears, select the Multi-track selection tool, shown in figure 6-3.

2 With the Multi-track selection tool active, move the mouse over the first clip in the Video 1A track. You will notice the pointer change to a double-arrow pointer, indicating that the Multi-track selection tool is the current tool. Click on the first clip in the Video 1A track. You will notice that all of the clips in the Video 1A track and the Video 1B track, as well as the transitions, are selected.

3 Insert the edit line at the 0;00;02;00 position.

4 In Video 1A, click-hold-drag the first clip to the right until the left edge of the clip aligns with the edit line at the 0;00;02;00 position. Release the mouse.

Now that the clips have been repositioned, and the 2-second space has been created, place the black matte as follows.

5 In the Timeline toolbar, select the Pointer tool.

6 Click anywhere in the Project window to make it active.

7 Click-hold-drag the black matte into the timeline, releasing it at the 0;00;00;00 position in the Video 1B track.

8 Insert the edit line at the 0;00;02;15 position. Click-hold-drag the right edge of the *Black Matte* clip to the right until it snaps to the edit line at this location.

This clip should be in the position as shown in figure 6-11.

Fig. 6-11. Black *Matte file in position at the beginning of the movie.*

Black matte at the Start or 0;00;00;00 position

Black matte at the End or 0;00;02;15 position

9 Scroll, or use the Navigator palette, to go to the end of the movie.

10 Position the edit line at the 0;00;53;15 position.

11 Click-hold-drag the *Black Matte* file from the Project window into the Video IA track until the left edge of the matte snaps to the edit line.

The right edge of the black matte will constitute the end of the movie. To complement the black matte clips, add the following transitions.

12 While still at the end of the movie, click-hold-drag the cross-dissolve transition from the *Dissolve* folder in the Transitions palette so that the left edge of the transition snaps to left edge of the black matte (the 0;00;53;15 position). The right edge of the transition will automatically snap to the end of the clip in Video 1B.

13 Move the timeline to the start of the movie and drag the cross-dissolve transition into the transition channel between the black matte and the first clip until the transition automatically aligns with the end of the black matte and the beginning of the clip in Video 1A.

14 Save the project to the *Balloon Files* folder on the desktop and name it *Inflation2.ppj*. Select Preview.

Timeline Functionality for the Inflation Movie

Using the material previously assembled, in the following you will work through three techniques that will demonstrate three features in the timeline for the Inflation movie.

Adjusting Clip Length

To make a video clip longer or shorter, the clip's speed must be adjusted. Even though the speed of a clip is changed, the clip will maintain its start and end point. What will change is the duration of the clip. To adjust the speed of a clip, perform the following steps.

1 Move the timeline so that it begins at 0;00;06;00.

2 In the toolbox, select the Multi-track selection tool. In the timeline, position the tool over the *Fan.mov* clip in Video 1A and click once. Doing this will select all tracks from the *Fan.mov* clip to the end of the timeline.

3 Click-hold-drag the clips to the right, releasing them when the left edge of the first clip reaches the 0;00;16;00 position. Doing this will provide space for modifying the *Basket.mov* clip.

4 Select the Pointer tool from the toolbox.

5 Select the *Basket.mov* clip by clicking on it once.

6 Select Clip > Speed. The Clip Speed dialog box will appear.

The Clip Speed dialog box presents two options: New Rate and New Duration. The New Rate option allows a new speed to be assigned for the clip. If a value of less than 100% is chosen, the speed of the clip will increase. If a value greater than 100% is chosen, the speed of the clip will decrease. The New Duration option works the same way. A shorter duration will increase the speed, and a longer duration will decrease the speed.

7 With the Clip Speed dialog box selected, select New Duration and type in *0;00;06;24*. Click on OK.

As shown in figure 6-12, the clip has now expanded a total of 2 seconds in length and now extends beyond the previously placed transition. This change has added a slow motion effect to the clip. However, this is not a dramatic change to the original clip.

Fig. 6-12. Resetting the clips after the New Duration option was chosen.

8 With the *Basket.mov* clip still selected, select Clip > Video > Options > Field Options. When the Field Options dialog opens, verify that the *Deinterlace When Speed is Below 100%* option is checked. Click on OK. Doing this will smooth the appearance of the clip.

9 Click-hold-drag the transition above the *Basket.mov* clip to the right until it snaps to the end of the clip.

10 Select the Multi-track selection tool and click once on the *Fan.mov* clip. This selects all clips to the right. Click-hold-drag the clips to the left, aligning the beginning of the *Fan.mov* clip with the beginning of the transition at the 0;00;14;27 position. See figure 6-12 for details.

11 Save the movie.

Pasting to Fit

Perhaps the most useful feature in any software program is the ability to cut and paste. Premiere offers cutting and pasting of all media types. However, Premiere offers a very unique twist to the pasting process. Premiere has the ability to paste a clip into an area that is too small for the clip being pasted. To better understand this process, perform the following steps.

1 Move the timeline so that it begins at the 0;00;46;00 position near the end of the movie.

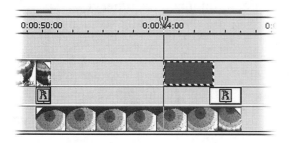

Fig. 6-13. Positioning the black matte.

2 In Video 1A, use the pointer to click-hold-drag the black matte so that the left edge begins at the 0;00;54;00 position. See figure 6-13 for proper positioning.

3 In Video 1B, select the *Inside2.mov* clip by clicking on it once, and then select Edit > Cut.

4 Insert the pointer into the blank area after the *Inflating.mov* clip in Video 1A and the black matte and click once to select the area. The blank area between the *Inflating.mov* clip and the black matte will be selected.

5 Select Edit > Paste to Fit. A Fit Clip dialog box will appear, with an option for changing the speed of the clip or to trim the source file. Select Change Speed.

The original speed of the clip has been changed to fit the space available. This has made the clip more compressed in time and will make the clip play at a faster setting.

6 In the transition track, select the cross-dissolve transition under these clips and delete it.

7 Drag the black matte into Video 1B so that its left edge begins at 0;00;53;15. Delete the transition and drag a new cross-dissolve transition into the transition track, between the *Flyaway.mov* clip and the black matte.

Project Output Option

The movies prepared in this chapter will be used in tutorials in chapters 7 and 8. If you wish, you can output the project previously assembled using the instructions that follow. If you want to use a saved version of the file found on the companion CD-ROM, you will be instructed as to how to access these files at the appropriate time. Therefore, you can skip this output option. To create a movie of the Inflation project, perform the following steps.

1 Set the work area bar from the beginning of the timeline to the end of the project, which should be from the following positions.

 - Beginning: 0;00;00;00

 - End: 0;00;55;00 (If necessary, move the work area bar to the left to the 0;00;55;00 position. It is important for future use that the clip be exactly at this position.)

2 Select File > Export Timeline > Movie.

3 Name the file *Inflation2.mov* and save the file in the *Balloon Files* folder on your desktop.

4 Ensure that the settings are as shown in figure 6-14.

Fig. 6-14. Movie output settings.

Tutorial 6-3: Importing Journey Clips

In this tutorial, you will import the third group of video clips, which demonstrate the launch and flight of a hot air balloon. This tutorial requires the development of a new project, as follows.

1 Select File > New Project > Custom.

2 Make the following entries in the New Project Settings dialog box.

 - General:
 - Editing Mode: QuickTime
 - Timebase: 30
 - Time Display: 30 fps Non Drop-Frame Timecode

 - Video:
 - Compressor: Sorenson Video
 - Frame Size: 320 x 240
 - Frame Rate: 30
 - Quality: 100/High

- Audio:
 - Rate: 44100 Hz
 - Format: 16-Bit Stereo
 - Compressor: Uncompressed
 - Interleave: 1 Second

3 Click on OK to accept these settings.

4 In the timeline, turn the Snap To Edges feature on.

Importing the Clips

To import the Journey clips, perform the following steps.

1 Select the Project window to activate it.

2 Select File > New > Storyboard. An empty Storyboard window will appear.

3 Select File > Import > Folder.

4 Import the following folder: *CD-ROM/Tutorials/Balloon/Video/Journey*.

5 A total of four items will be imported. Arrange the files in the Storyboard window as shown in figure 6-15.

Fig. 6-15. Proper clip placement for the Journey storyboard.

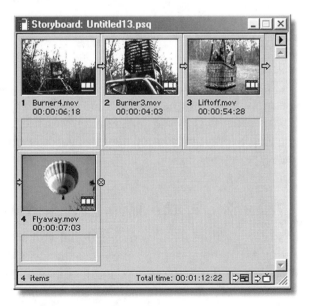

Fig. 6-16. Automate to Timeline settings for the Journey storyboard.

6. Name the file *Journey Story-board.psq* and save it to the *Balloon Files* folder on your desktop. Click on the Automate to Timeline icon in the lower right corner of the Project window. When the Automate to Timeline dialog box appears, select the settings shown in figure 6-16. Click on OK.

7. The clips were copied into the timeline with transitions in place. Close the Storyboard window.

8. Select File and save the project in the *Balloon Files* folder as *Journey2.ppj*.

Trimming Options

In the sections that follow, you will work with various trimming options, including trimming in the timeline and trimming in the Monitor window.

Trimming in the Timeline

At this point in the book, you are already experienced with trimming clips in the timeline. This is a very straightforward process that involves simply dragging the right or left edge of a clip to the desired position. This process is based on the length of the clip, and edits can be made based on the content of the clip. As you position the pointer over the beginning or end of a clip, the pointer automatically changes to the Trimming tool.

Trimming in the Monitor Window

So far, all tutorials have required that you set the Premiere workspace to the A/B Editing setting, meaning that the Monitor window is a single screen. In the following, you will edit two clips in the same track in the Monitor window.

1 Open the *Journey2.ppj* project. If the project is already open, make sure it is saved before starting this portion of the tutorial.

2 Click once on the *Burner3.mov* clip to select it. Select Edit > Cut.

3 Insert the pointer in the blank area after the *Burner4.mov* clip and select Edit > Paste to Fit. Select Trim Source from the Fit Clip dialog box.

The clip will be placed in the blank area. This creates a total of three consecutive clips in the Video 1A track.

4 Based on previous settings, the workspace should be in the A/B Editing mode. To change the monitor to the trim mode, click on the pop-out menu at the upper right of the Monitor window and select Trim Mode. If necessary, place the edit line at the 0;00;06;17 position (or between the *Burner4.mov* and *Burner3.mov* clips).

The Monitor window will now appear as shown in figure 6-17, which shows the out point of the *Burner4.mov* clip on the left and the in point of the *Burner3.mov* clip on the right.

Fig. 6-17. Monitor window in trim mode.

When editing in trim mode, a consideration must be given to what is being edited. In this tutorial, the imported clips are video-only clips. Therefore, no audio file is associated with the clip. When editing clips that contain both audio and video source material, the following must be considered.

At the bottom of the timeline is the Synch Mode icon. This feature can be turned on or off here by clicking on the icon. With synch mode on, edits in trim mode will affect the video as well as the audio files. By

turning synch mode off, edits can be made to individual clip sources. See figure 6-18.

Fig. 6-18. Turning synch mode on and off.

Creating a Rolling Edit

Before beginning this part of the tutorial, save the project. The following sections demonstrate how to create a rolling edit. At the end of these sections, you will make a change in the edit mode based on these three options.

Experimenting with the Set Focus Left Button

1 At the top of the Monitor window are three icons that represent monitor configuration options. The option on the right is the Trim Mode option. Select this option. With Trim Mode active, set the edit line at the 0;00;06;17 position. The image on the left displays the clip settings. Click on the Set Focus Left button to activate the left clip (*Burner4.mov*). See figure 6-19 for guidance.

2 Click on the –1 button to trim one frame to the left. You will notice that the clips move in the trim mode windows as well as in the timeline.

3 Click on the –5 button to trim the frame 5 frames at a time to the left. Once again, the clips will shift accordingly. This function trims the out point, or end, of the clip.

4 Insert the pointer in the shuttle slider. Click-hold-drag to dynamically edit the clip. Adjust this slider to 0;00;04;20 and release the mouse. See figure 6-19.

Experimenting with the Set Focus Right Button

1 With trim mode active, click on the Set Focus Right button to activate the Clip In monitor, or the screen on the right (*Burner3.mov*). See figure 6-19 for guidance.

2 Click on the +1 button to trim one frame to the right. You will notice that the clips move in the trim mode windows as well as in the timeline.

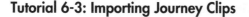

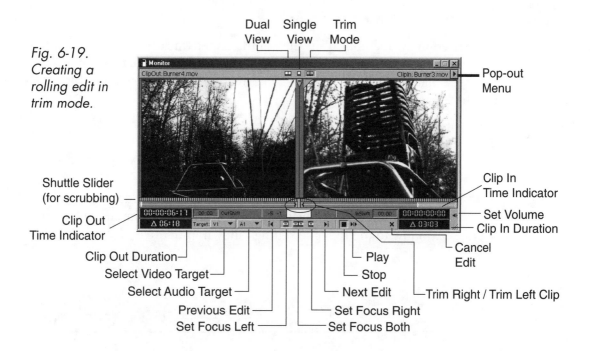

Fig. 6-19.
Creating a
rolling edit in
trim mode.

3 Click on the +5 button to trim the frame 5 frames at a time to the right. Once again, the clips will shift accordingly.

4 The Trim Right Clip option allows you to dynamically edit the clip. Drag the Trim Right Clip slider to the 0;00;00;18 position and release the mouse. Leave the clip at this position.

You should now have a better understanding of the functionality of the Trim Mode window.

Using the Set Focus Both Button

1 In the Monitor window, click on the Set Focus Both button.

2 Click between the two clips in the windows. The pointer changes to the Rolling Edit tool.

3 Click-hold-drag to the right or to the left to trim the clips.

4 You will notice that the values in the OutShift and InShift fields change to indicate the number of trimmed frames.

Using the Jog Track Option

The Frame Jog control in the shuttle slider track, located below either the left or right window, will move the Trim Clip slider dynamically as you click-hold-drag the track. This allows easy visualization of trim settings.

Establishing Settings

In the following, you will establish settings for the trim mode Monitor window.

1　Having experimented with the controls in trim mode using one of the techniques previously described, adjust the trim mode Monitor window to the timeline settings shown in figure 6-20.

Fig. 6-20. Rolling edit settings for the Journey.mov *clip.*

Creating a Ripple Edit

To create a ripple edit, perform the following steps.

1　In the timeline, delete the two transitions located at the 0;00;07;00 and the 0;00;08;00 positions.

2　Move the timeline so that it begins at the 0;00;11;00 position.

3　Insert the edit line at the 0;00;15;00 position and select Timeline > Razor at Edit Line.

4　Insert the edit line at the 0;00;27;00 position and select Timeline > Razor at Edit Line.

5　Select the clip between the two razor edits and press Delete.

6　Select the Multi-track selection tool from the toolbox and click-hold-drag the clips from the 0;00;27;00 position to the left to adjoin the clips ending at the 0;00;15;00 position.

Trim the out point of the *Liftoff.mov* clip by continuing with the following steps.

7 Select the *Liftoff.mov* clip. Select the Set Focus Left button.

8 Set the monitor to trim mode.

9 At the bottom of the Trim Mode window, click on the Next Edit or Previous Edit button repeatedly until you reach the junction of the *Liftoff.mov* and *Flyaway.mov* clips. The edit line will move to this position, centered in the transition between the two clips.

10 Select the *Liftoff.mov* clip by clicking on it once.

11 In the trim mode Monitor window, click on the Set Focus Left button. Type *-30* in the Numeric Trim entry field. Press Enter to activate.

The *Liftoff.mov* clip will be trimmed back 30 frames. The transition and *Flyaway.mov* clip will shift accordingly.

Previewing Trim Mode Edits

To preview the changes previously made in trim mode, perform one of the following.

- Press the space bar.

- Type the letter *L*.

- Select the Play Edit button in the Trim Mode window.

Adding a Black Matte

To add a black matte, perform the following steps.

1 Using the procedures performed in the Setup movie earlier in this chapter, import a black matte for use in this movie. The positions for the first and last mattes are shown in figure 6-21. Make your settings match these settings. Use the Multi-track selection tool to reposition the clips to make room for the black matte at the beginning of the movie.

Fig. 6-21. Timeline locations for the black matte for the Journey movie.

2 Add a cross-dissolve transition from the *Dissolve* folder.

3 Save the movie.

4 If you wish, preview the movie. At this juncture, this is an option. The movie is 58 seconds long and will take a few minutes to preview.

5 Reset the monitor to single-view mode.

Timeline for the Journey Movie

In the following, you will perform operations related to the timeline for the Journey movie.

Locking a Track

You have seen that individual clips can be locked. Entire tracks can also be locked. Locking tracks will protect the placement of files as other development is taking place. Remember that locked tracks cannot be modified until they are unlocked. This includes removing or adding any component to the track. To lock a track, perform the following steps.

1 In the *Journey2* project, position the timeline to begin at 0;00;42;00.

2 In the Video 1A track header, to the left of the track name, there is an empty box. This is the Lock/Unlock Track option.

3 Click once in this box to lock the clip. An icon of a lock will appear, indicating that the selected clip is locked.

4 Move the pointer over the clip in the locked track. The pointer will now display a small lock image to the right, as shown in figure 6-22. The track cannot be moved until this process is reversed.

Fig. 6-22. A locked track in the timeline.

Project Output Option

This project will be used in Chapter 8 to build a final movie. If you wish, you can output the project previously assembled using the following instructions. If you want to use the saved version of the file found on the companion CD-ROM, you will be instructed as to how to access these files at the appropriate time. Therefore, you can skip this output

option. To create a movie of the Journey project, perform the following steps.

1 Set the work area bar from the beginning of the timeline to the end of the project, which should be from the following positions.

- Beginning: 0;00;00;00

- End: 0;00;58;00

2 Select File > Export Timeline > Movie.

3 Name the file *Journey2.mov* and save the file in the *Balloon Files* folder on your desktop.

 TIP: *If for some reason the movies cannot be saved for future use, the movie can be found on the companion CD-ROM in* Saved Files/ Journey2.ppj.

4 Open and preview the finished movie.

Summary

This chapter is the first part of a series of tutorials in this and the next two chapters. In this chapter, you have learned how to use tools that are essential to the development of just about any project you will design in Premiere. The names of many of these tools are derived from terminology used in traditional video editing processes.

For veteran video editors, these terms are logical and easily transition to nonlinear editing. If you are new to video editing, these terms and processes will begin to make sense in a short period of time. No matter what your background, by completing this chapter you are well on your way to understanding how to harness the power of Premiere.

In chapters 7 and 8, the clips you have imported and edited in this chapter will constitute the foundation of further tutorials. As development continues, you may find that referring to this chapter for technical guidelines will be beneficial.

CHAPTER 7

CONTENT

DEVELOPMENT

Introduction

Chapter 6 set the stage for placing and arranging clips using special tools and features of Premiere. This chapter introduces you to additional tools that will make the movie-making process easier. This chapter, along with Chapter 6, will set the stage for the further development of these tutorials. Along with exposure of a number of practical features, this chapter also shows you how to develop a movie that will be extracted for use in Chapter 8. The tools and features learned in this chapter will elevate your status as a Premiere user and assist in the technical aspect of assembling any type of project.

Objectives

The following are the objectives of this chapter.

- Working with video in a window
- Saving the timeline as a movie
- Adding a title

Tutorial 7-1: Video in a Window, Part I

The "video in a window" technique is a process with which you are no doubt familiar. In a TV newscast, the announcer is routinely shifted to the right or left to make room for a graphic or a video clip to play in a portion of the video screen. This tool has been around for a long time, and still proves to be a very effective method of storytelling.

In this chapter you will create three "video in a window" screens that will utilize the video clips prepared in Chapter 6. The scenes will be similar but will contain different backgrounds and video clips.

Before Beginning

In Chapter 6, you created and saved to your desktop a folder named *Balloon Files*. Throughout this chapter, you will be prompted to save files to this folder. To begin, create a new project as follows.

1 Select File > New Project.

2 Select Custom from the Load Project Settings dialog box.

3 Set the video settings to reflect the following options.

- Compressor: Sorenson Video
- Frame Size: 320 x 240
- Frame Rate: 30
- Depth: Millions
- Quality: 100%

Disregard any audio settings. No audio will be used in this tutorial.

4 In the timeline, turn the Snap To Edges feature on.

Developing the Setup Video in a Window Clip

To develop the Setup video in a window screen, perform the following steps.

1 Select the Project window to make it active.

2 Select File > Import > File. Select *CD-ROM/Tutorials/Balloon/ Graphics/Backgrounds/Setup.psd*. This will import the *Setup.psd* graphic into bin 1.

3 Set the Project window to the Thumbnail view by clicking on the Thumbnail View icon at the bottom of the screen.

4 Click on the Create Item icon at the bottom of the Project window. When the Create dialog box appears, select Black Video, and then click on OK. The *Black Video* clip will be added to the Project window.

5 Click-hold-drag the *Black Video* clip into the Video 2 track so that it begins at the 0;00;00;00 position. Click-hold-drag the right edge of the clip to the left until the right edge is aligned at the 0;00;01;00 position. The *Black Video* clip will be 1 second long.

6 Click once on the Project window to make it active. Select File > Import > File. Select *CD-ROM/Tutorials/Tutorial 3/Video/ Setup1.mov*. Select Open. The movie will be placed in the Project window.

7 Click-hold-drag the *Setup1.mov* clip into the timeline in the Video 2 track. Set the left edge of the clip to begin at the 0;00;01;00 position. The left edge should snap to the right edge of the *Black Video* clip.

8 Select the *Black Video* clip. Select Edit > Copy. In the area to the right of the *Setup1.mov* clip, insert the pointer and click to select the area, and select Edit > Paste. A copy of the *Black Video* clip will be pasted immediately after the *Setup1.mov* clip. See figure 7-1 for proper positioning and alignment.

9 In the Project window, click-hold-drag the *Setup.psd* image into the Video 1B track, aligning the left edge at the 0;00;00;00 position. Click-hold-drag the right edge of the clip to the right so that it aligns with the end of the *Black Matte* clip. This will be at the 0;00;07;00 position. See figure 7-1.

Fig. 7-1. Setup.psd image alignment.

Adding Transitions

So far in this book, transitions have been typically created via the Transitions palette or by adjusting the rubberbands. Creation of the following transitions uses the rubberbands in a unique manner.

1 Expand the Video 2 track to reveal the edit lines at the bottom of the clip.

2 In the first *Black Video* clip, click-hold-drag the right handle to the bottom. This will make the black clip fade from 100% black to transparent, revealing the *Setup.psd* graphic in Video 1B. This creates a fade-in effect.

3 In the last *Black Video* clip, do just the opposite: click-hold-drag the first handle to the bottom of the track. This will allow the black clip to fade from transparent to 100% black. See figure 7-2 for positioning.

Fig. 7-2. Transitions created from black video clips in the superimpose track.

4 Select File > Save and name the project *Setup.ppj*. Make sure to save the file to the *Balloon Files* folder.

NOTE: *Do not attempt to preview the project at this time. The effects are not yet in place.*

Resizing Video Clips

As you might imagine, to have a video clip in a window, one of the video clips must be resized and then superimposed over an existing clip or graphic. In this tutorial, the *Setup1.mov* clip will be reduced in size and placed in a strategic location in order to fit precisely in a predesigned graphic background.

NOTE: *If the project is previewed before the clip has been resized, the* Setup1.mov *clip will fill the screen, covering the entire background.*

To resize the video, perform the following steps.

1 Select the *Setup1.mov* clip in the Video 2 track.

2 Because this movie is in a superimpose track, there are two options in the Effect Controls palette: Motion and Transparency. Select Motion > Setup.

No motion will be applied here. The Motion Settings dialog will allow the start and finish image to be resized and repositioned with no in-between changes. Therefore, the clip will play in place.

3 In the Motion Settings dialog box, the Start image should be selected automatically. With the Start image selected, make the following settings in the keyframe property controls. See figure 7-3 for specific details.

- Info: #0 at –15, -10

- Rotation: 0

- Zoom: 50%

- Delay: 0

Fig. 7-3. Motion settings for the Setup1.mov start and finish image.

4 Select the End image and apply the identical settings. Click on OK.

5 Position the work area bar over the project and preview the timeline to see the resized clips in place.

6 Save the project.

Adding the Setup2.mov File

In Chapter 6, you created a movie and saved it in the *Balloon Files* folder on your hard disk drive. This file was named *Setup2.mov*. This file will now be imported for use in developing this movie.

 NOTE: *If the file is not available from your hard disk, it can be found as follows:* CD-ROM/Tutorials/Balloon/Video/Setup2.mov.

1 Select the Project window to activate it. Select File > Import > File. Either from the desktop *Balloon Files* folder or from the CD-ROM, import the file *Setup2.mov*.

2 From the Project window, click-hold-drag the *Setup2.mov* clip into the Video 2 track in the timeline, placing it immediately after the *Black Video* clip. This will allow the project to flow from the "video in a window" section immediately into the *Setup2.mov* clip.

3 With the *Setup2.mov* clip in place, select File > Save.

Outputting the Movie

To output the movie, perform the following steps.

1 Position the work area bar over the entire project, beginning at the 0;00;00;00 position to the end of the *Setup2.mov* clip.

2 Select File > Export Timeline > Movie. When the Export Movie dialog box opens, name the movie *Setup Master.mov* and save it in the *Balloon Files* folder on the desktop.

3 Click on the Settings button and verify the following settings.

 • Compressor: Sorenson Video

 • Depth: Millions

 • Frame Size: 320 x 240

 • Frame Rate: 30

 • Quality: 100% High

4 Click on OK.

The Setup movie is completed and output as an independent movie file. This movie will be used in Chapter 8 as a section of a combined movie.

5 Preview movie from the *Setup Master* movie clip, not from the timeline.

Tutorial 7-2: Video in a Window, Part II

This is the second of three "video in a window" tutorials. Here and in the next section, you will repeat the process performed in the previous section. The only difference is that the background art and the movie clip have different names.

Before Beginning

Throughout this tutorial, you will be prompted to save files to the *Balloon Files* folder. A new project must be opened to begin this tutorial. Create a new project as follows.

1 Select File > New Project.

2 Select Custom from the Load Project Settings dialog box.

3 Set the video settings to reflect the following options.

- Compressor: Sorenson Video
- Frame Size: 320 x 240
- Frame Rate: 30
- Depth: Millions
- Quality: 100%

Disregard any audio settings. No audio will be used in this tutorial.

4 In the timeline, turn the Snap To Edges feature on.

Developing the Inflation Video in a Window Clip

To develop the Inflation video in a window screen, perform the following steps.

1 Select the Project window to make it active.

2 Select File > Import > File. Select *CD-ROM/Tutorials/Balloon/ Graphics/Backgrounds/Inflation.psd*. This will import the *Inflation.psd* graphic into bin 1.

3 Set the Project window to the Thumbnail view by clicking on the Thumbnail View icon at the bottom of the screen.

4 Click on the Create Item icon at the bottom of the Project window. When the Create dialog box appears, select Black Video, and then Click on OK. The *Black Video* clip will be added to the Project window.

5 Click-hold-drag the *Black Video* clip into the Video 2 track so that it begins at the 0;00;00;00 position. Click-hold-drag the right edge of the clip to the left until the right edge is aligned at the 0;00;01;00 position. The *Black Video* clip will have a 1-second duration.

6 Click once on the Project window to make it active. Select File > Import > File. Select *CD-ROM/Tutorials/Balloon/Video/Inflation1. mov.* Select Open. The movie will be placed in the Project window.

7 Click-hold-drag the *Inflation1.mov* clip into the timeline in the Video 2 track. Set the left edge of the clip to begin at the 0;00;01;00 position after the *Black Video* clip.

8 Select the *Black Video* clip in the timeline. Select Edit > Copy. Click on the area to the right of the *Inflation1* video and select Edit > Paste. A copy of the *Black Video* clip will be pasted immediately after the *Inflation1.mov* clip. See figure 7-4 for proper positioning and alignment.

Fig. 7-4. Positioning and alignment for the Inflation1.mov clip.

9 In the Project window, click-hold-drag the *Inflation.psd* image into the Video 1B track, aligning the left edge at the 0;00;00;00 position. Click-hold-drag the right edge of the clip to the right so that it aligns with the end of the *Black Matte* clip. This will be at the 0;00;07;00 position.

Adding Transitions

So far in this book, transitions have been typically created from the Transitions palette or by adjusting the rubberbands. The transitions you will work with in the following are a bit unique and demonstrate another method.

1 Expand the Video 2 track to reveal the fade edit lines, or rubber-bands, at the bottom of the clip.

2 In the first *Black Video* clip, click-hold-drag the right handle to the bottom. This will make the black clip fade from 100% black to transparent, revealing the *Inflation.psd* graphic in Video 1B. This creates a fade-in effect.

3 In the last *Black Video* clip, do just the opposite: click-hold-drag the first handle to the bottom of the track. This will allow the black clip to fade from transparent to 100% black. See figure 7-5 for positioning.

Fig. 7-5. Transitions created from black video clips in the superimpose track.

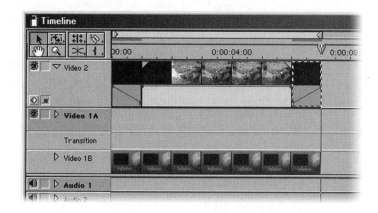

4 Select File > Save and save the project as *Inflation.ppj*.

 NOTE: *Do not attempt to preview the project at this time. The effects are not yet in place.*

Resizing Video Clips

As previously stated, to have a video clip in a window, one of the video clips must be resized and then superimposed over an existing clip or graphic. In the following, again the clip will be reduced in size, and placed in a strategic location in order to fit precisely in a predesigned graphic background.

 NOTE: *If the project is previewed before the clip has been resized, the* Inflation1.mov *clip will fill the screen, covering the entire background.*

To resize the video, perform the following steps.

1 Select the *Inflation1.mov* clip in the Video 2 track.

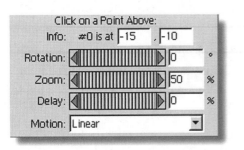

Fig. 7-6. Motion settings for the
Inflation1.mov *start and finish image.*

2 Because this movie is in a superimpose
track, there are two options in the Effect
Controls palette: Motion and Transparency. Each of these options has a setup
option available. Click on the Setup
option located to the right of the Motion
text.

There will be no motion applied here. The
Motion Settings dialog will allow the start
and finish image to be resized and repositioned with no in-between changes. Therefore, the clip will play in place.

3 In the Motion Settings dialog box, the Start image should be selected
automatically. With the Start image selected, make the following
settings in the applicable fields. See figure 7-6 for specific details.

TIP: *Press the Tab key to jump from one field to another.*

- Info: #0 at –15, -10

- Rotation: 0

- Zoom: 50%

- Delay: 0

4 Select the Finish image and apply the identical settings.

5 Preview the timeline to see the resized clips in place.

6 Save the project.

Adding the Inflation2.mov File

In Chapter 6, you created a movie and saved it in the *Balloon Files* folder
on your hard disk drive. This file was named *Inflation2.mov*. This file
will now be imported for use in developing this movie.

NOTE: *If the file is not available from your hard disk, it can be found as
follows:* CD-ROM/Tutorials/Balloon/Inflation2.mov.

1 Click on the Project window to activate it. Select File > Import >
File. Either from your desktop or from the companion CD-ROM,
import the file *Inflation2.mov*.

2 From the Project window, click-hold-drag the *Inflation2.mov* clip into the Video 2 track in the timeline, placing it immediately after the *Black Video* clip.

3 With the *Inflation2.mov* clip in place, select File > Save.

This will allow the project to flow from the "video in a window" section immediately into the *Inflation2.mov* clip.

Outputting the Movie

To output the movie, perform the following steps.

1 Position the work area bar over the entire project, beginning at the 0;00;00;00 position to the end of the *Inflation2.mov* clip.

2 Select File > Export Timeline > Movie. When the Export Movie dialog box opens, name the movie *Inflation Master.mov* and save it in the *Balloon Files* folder on the desktop.

3 Click on the Settings button and verify the following settings.

- Compressor: Sorenson Video
- Depth: Millions
- Frame Size: 320 x 240
- Frame Rate: 30
- Quality: 100% High

4 Click on OK.

The Inflation movie is completed and output as a movie file. This movie will be used in Chapter 8 as a section of a combined movie.

5 Preview movie from the *Inflation2.mov* movie clip, not from the timeline.

Tutorial 7-3: Video in a Window, Part III

This is the last of three "video in a window" tutorials. You will again repeat the process you performed in the previous two tutorials. Again, the only difference is that the background art and the movie clip have different names.

Before Beginning

Throughout this chapter, you will be prompted to save files to the *Balloon Files* folder. A new project must be opened to begin this tutorial. Create a new project as follows.

1 Select File > New Project.

2 Select Custom from the Load Project Settings dialog box.

3 Set the video settings to reflect the following options.

- Compressor: Sorenson Video
- Frame Size: 320 x 240
- Frame Rate: 30
- Depth: Millions
- Quality: 100%

Disregard any audio settings. No audio will be used in this tutorial.

4 In the timeline, turn the Snap To Edges feature on.

Developing the Journey Video in a Window Clip

To develop the Journey video in a window screen, perform the following steps.

1 Click on the Project window to make it active.

2 Select File > Import > File. Select *CD-ROM/Tutorials/Balloon/ Graphics/Backgrounds/Journey.psd*. This will import the *Journey.psd* graphic into bin 1.

3 Set the Project window to the Thumbnail view by clicking on the Thumbnail View icon at the bottom of the screen.

4 Click on the Create Item icon at the bottom of the Project window. When the Create dialog box appears, select Black Video, and then click on OK. The *Black Video* clip will be added to the Project window.

5 Click-hold-drag the *Black Video* clip into the Video 2 track so that it begins at the 0;00;00;00 position. Click-hold-drag the right edge of the clip to the left until the right edge is aligned at the 0;00;01;00 position. The *Black Video* clip will be 1 second long.

6 Click once on the Project window to make it active. Select File > Import > File. Select *CD-ROM/Tutorials/Balloon/Video/Journey1.mov*. Select Open. The movie will be placed in the Project window.

7 Click-hold-drag the *Journey1.mov* clip into the timeline in the Video 2 track. Set the left edge of the clip to begin at the 0;00;01;00 position.

8 Select the Black Video clip in the timeline. Select Edit > Copy. Click on the area to the right of the *Journey1.mov* clip, insert the pointer to select the area, and select Edit > Paste. A copy of the *Black Video* clip will be pasted immediately after the *Journey1.mov* clip. See figure 7-7 for proper positioning and alignment.

Fig. 7-7. Positioning and alignment for the Journey1.mov *clip.*

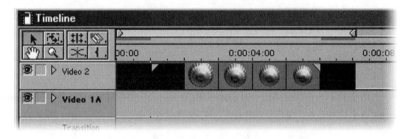

9 In the Project window, click-hold-drag the *Journey.psd* image into the Video 1B track, aligning the left edge at the 0;00;00;00 position. Click-hold-drag the right edge of the clip to the right so that it aligns with the end of the *Black Matte* clip at the end of the project. This will be at the 0;00;07;00 position.

Adding Transitions

To add transitions, perform the following steps.

1 Expand the Video 2 track to reveal the edit lines at the bottom of the clip.

2 In the first *Black Video* clip, click-hold-drag the right handle to the bottom. This will make the black clip fade from 100% black to transparent, revealing the *Journey.psd* graphic in Video 1B. This creates a fade-in effect.

3 In the last *Black Video* clip, do just the opposite: click-hold-drag the first handle to the bottom of the track. This will allow the black clip to fade from transparent to 100% black. See figure 7-8 for positioning.

Fig. 7-8. Transitions created from black video clips in the superimpose track.

4 Select File > Save and name the project *Journey.ppj*. Save this file to the *Balloon Files* folder on your desktop.

NOTE: *Do not attempt to preview the project at this time. The effects are not yet in place.*

Resizing Video Clips

Again, to have a video clip in a window, one of the video clips must be resized and then superimposed over an existing clip or graphic. Here, too, the clip will be reduced in size, and placed in a strategic location to fit precisely in a predesigned graphic background.

NOTE: *If the project is previewed before the clip has been resized, the* Journey.mov *clip will fill the screen, covering the entire background.*

To resize the video, perform the following steps.

1 Select the *Journey1.mov* clip in the Video 2 track.

2 Because this movie is in a superimpose track, there are two options in the Effect Controls palette: Motion and Transparency. Each of these options has a setup option available. Click on the Setup option located to the right of the Motion text.

There will be no motion applied here. The Motion Settings dialog will allow the start and finish image to be resized and repositioned with no in-between changes. Therefore, the clip will play in place.

3 In the Motion Settings dialog box, the Start image should be selected automatically. With the Start image selected, make the following settings in the keyframe property controls. See figure 7-9 for specific details.

Fig. 7-9. Motion settings for the Journey.mov start and finish image.

| Click on a Point Above: |
| Info: ≠0 is at -15 , -10 |
| Rotation: ◄▐▌▐▌▐▌▐▌▐▌► 0 ° |
| Zoom: ◄▐▌▐▌▐▌▐▌▐▌► 50 % |
| Delay: ◄▐▌▐▌▐▌▐▌▐▌► 0 % |
| Motion: Linear ▼ |

- Info: #0 at –15, -10
- Rotation: 0
- Zoom: 50%
- Delay: 0

4 Select the End image and apply the identical settings.

5 Preview the timeline to see the resized clips in place.

6 Save the project.

Adding the Journey2.mov File

In Chapter 6, you created a movie and saved it in the *Balloon Files* folder on your hard disk drive. This file was named *Journey2.mov*. This file will now be imported for use in developing this movie.

NOTE: *If the file is not available from your hard disk, it can be found as follows:* CD-ROM/Tutorials/Balloon/Journey2.mov.

1 Click on the Project window to activate it. Select File > Import > File. Either from your desktop or from the companion CD-ROM, import the file *Journey2.mov*.

2 From the Project window, click-hold-drag the *Journey2.mov* clip into the Video 2 track in the timeline, placing it immediately after the *Black Video* clip. This will allow the project to flow from the "video in a window" section immediately into the *Journey2.mov* clip.

3 With the *Journey2.mov* clip in place, select File > Save.

Outputting the Movie

To output the movie, perform the following steps.

1 Position the work area bar over the entire project, beginning at the 0;00;00;00 position to the end of the *Journey2.mov* clip.

2 Select File > Export Timeline > Movie. When the Export Movie dialog box opens, name the movie *Journey Master.mov* and save it in the *Balloon Files* folder on the desktop.

3 Click on the Settings button and establish the following settings.

- Compressor: Sorenson Video
- Depth: Millions
- Frame Size: 320 x 240
- Frame Rate: 30
- Quality: 100% High

4 Click on OK.

The Journey movie is completed and output as an independent movie file. This movie will be used in Chapter 8 as a section of a combined movie.

5 Preview movie from the *Journey Master* movie clip, not from the timeline.

Tutorial 7-4: Creating the Intro Movie

A clip will be developed here that will serve as the intro clip for the movie to be assembled in Chapter 8. This will be a short segment to establish recognition of the fictitious company. The clip will involve a video clip, photographs, and graphic images.

Adding External Files

Begin the project as follows.

1 Open a new project and verify the following settings.

- Compressor: Sorenson Video
- Depth: Millions
- Frame Size: 320 x 240
- Frame Rate: 30
- Quality: 100% High

2 Click on the Project window to make it active. Import the following files from the *Tutorials/Balloon* folder.

- *Graphics/BalloonStill.psd*
- *Graphics/Moon.psd*

3 Click-hold-drag the *Moon.psd* image into Video 1A, aligning it at the beginning of the timeline. Double click on the clip. When the Clip window appears, set the duration to 8 seconds.

4 Click-hold-drag the *BalloonStill.psd* clip into the Video 2 track in the timeline. Set the duration of this clip to 8 seconds. In the track header, expand the track to reveal the fade controls. Using the edit line for precise positioning, create a fade-in handle at the 0;00;00;15 position and a fade-out handle at the 0;00;07;15 position. Adjust the rubberbands by dragging them to the bottom of the track, which will create the fades. See figure 7-10 for details.

Fig. 7-10. Balloon.Still.psd clip in the Video 2 superimpose track.

5 Select the *BalloonStill.psd* clip in the timeline.

6 From the Effect Controls palette, select Transparency > Setup. When the Transparency Settings dialog box opens, select Key Type > Green Screen. Then select Smoothing > Low. The bright green background will disappear. Click on OK.

7 With the *BalloonStill.pct* clip still selected, select the Motion option in the Effect Controls palette. When the Motion Settings dialog box opens, the Start image should be selected by default. Change the position of the Start image as shown in figure 7-11. The Start image can be dragged into position or values can be typed in the keyframe property controls. Make sure the fill color (i.e., the green of the background) is selected to remove the color.

8 To set the End image, select the handle on the End image or the handle in the keyframe property controls. Establish the settings in the appropriate fields per figure 7-12.

9 In the fill color box, click on the green background of the image, removing the background. Click on OK to accept these settings.

Fig. 7-11.
Motion settings
for the Start
image.

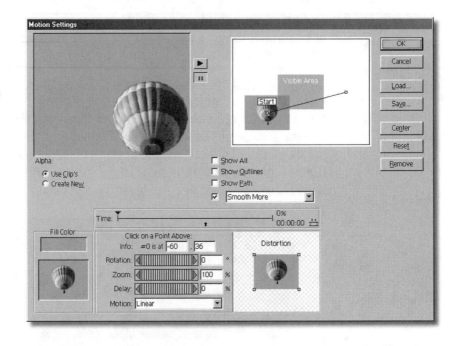

Fig. 7-12.
Motion settings
for the End
image.

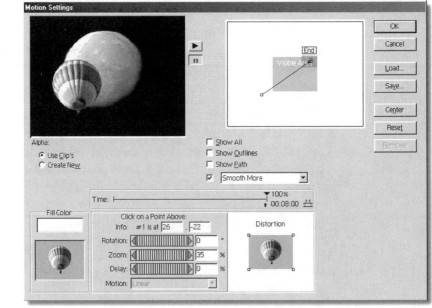

Adding a Title

In the following you will add a title to complete this tutorial. Titles are covered in more detail in Chapter 12.

1 In the Project window, click on the Create Item icon. When the Create dialog opens, Title should be the default object type option. Click on OK.

2 The Adobe Title Designer window will open. From the tool palette on the left of the screen, select the Text tool, and then click inside the dotted line to establish a new text field. On the left side of the title screen, type *Sojourn Balloon Flights*.

3 Select the text you just typed, and then select Title > Font > Arial/Bold.

4 Select Title > Size > 36.

5 With the text still selected, select Title > Align Text > Center.

6 Using the handles in each corner of the text field, click-hold-drag the handles to the positions shown in figure 7-13.

To the right of the Title window is the Object Style menu. Continue with the following steps to establish settings in this menu to add a shadow to the existing text.

7 Select the title text.

Fig. 7-13. Premiere's Title window.

8 Select the tab next to the Shadow option, and then click in the check box to reveal shadow options.

9 Set the Angle option to 0.0. This will allow numeric entry into this field. With the text selected, type 320.0 and press Enter to accept the new value.

10 In the Distance field, enter 4.0, and press Enter.

11 In the Size field, enter 12.0, and press Enter.

12 In the Spread field, enter 20.0, and press Enter.

13 Close the Title Designer window. You will be asked if you want to save this title. Select Save, name the file *Sojourn Title*, and save the file to the *Balloon Files* folder on your desktop.

This concludes the title preparation for this tutorial.

NOTE: *When new title files are saved, a copy is placed in the Project window in addition to being saved to a specified location on your computer.*

Adding the Title to the Project

In the timeline, add a new superimpose track as follows.

1 Select Timeline > Add Video Track. A new video track, named Video 3, will appear immediately above the Video 2 track. In the Video 3 track header, click on the triangle to expand the track.

2 In the Project window, click-hold-drag the *Sojourn Title.ptl* clip into the *Balloon Files* folder in the Video 3 track. Using the edit line as an alignment aid, position the left edge of the title at the 0;00;02;00 position. Click-hold-drag the right edge of the clip to the 0;00;06;00 position. The new duration of the title clip is 4 seconds.

3 Adjust the fade-in and fade-out handles so that a 15-frame fade-in and 15-frame fade-out are created on the *Sojourn Title* file. This requires that a handle be inserted at the 0;00;02;15 and 0;00;05;15 positions. Drag the beginning and end handles to the bottom of the track.

The Intro movie is now complete. See figure 7-14, which shows the completed timeline.

Fig. 7-14. Completed Intro movie timeline.

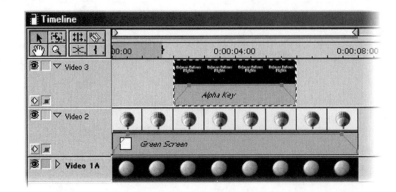

4 Save the file as *IntroLogo.ppj* in the *Balloon Files* folder. With the work area bar positioned over the active project area, select Timeline > Preview to review the project.

This completes the development of the *Intro Logo.ppj* project. Save the file and close the Project window.

Tutorial 7-5: Creating the Final Movie

This section covers the development of the clip that will be the last to play when these tutorials come together in Chapter 8. Somewhat like the Intro movie, this will be a brief clip designed to close the movie with a unique combination of graphics, photos, and video. The audio track will be added in Chapter 8.

Adding External Files

Begin the project as follows.

1 Open a new project and establish the following settings.

- Compressor: Sorenson Video

- Depth: Millions

- Frame Size: 320 x 240

- Frame Rate: 30

- Quality: 100% High

2 In the Preferences menu, select Edit > Preferences > General & Still Image > Still Image > Duration > 150 frames.

3 Click on the Project window to make it active. Import the following three files from the *Tutorial 3* folder.

- *Graphics/BalloonStill.psd*

- *Graphics/BalloonLogo.psd*

- *Video/Clouds.mov*

4 In the Project window, click-hold-drag the *Clouds.mov* clip into the Video 1A track in the timeline. Align the left edge of the clip at the beginning of the timeline.

5 Click-hold-drag the *BalloonStill.psd* graphic into the Video 2 track in the timeline, positioning the left edge at the beginning of the time-

line. Move the pointer over the right edge of the clip. When the pointer changes to the Trim tool, click-hold-drag the clip until its right edge aligns at the 0;00;09;15 position. Use the Monitor window to view precise positioning in the program location area.

6 In the timeline, add a new superimpose clip by selecting Timeline > Add Video Track. The new track will be automatically inserted and will be named Video 3.

7 In the Project window, click-hold-drag the *BalloonLogo.psd* file into the Video 3 track. Position the left edge to begin at the 0;00;03;15 position. The right edge should align at the 0;00;08;15 position.

At this point, all clips are in place. The next process is to add fades, motion, and transparency to the clips in the superimpose tracks to bring the clips to life.

Adding Fades

In the following sections, you will use the edit line repeatedly to precisely position locations for fade handle placement.

Adding Fades to the BalloonStill.psd Clip

Before beginning, expand the Video 2 and Video 3 tracks to reveal the fade lines. To add fades to the *BalloonStill.psd* clip, perform the following steps.

1 In the Video 2 track, position the edit line at the 0;00;03;00 position. Where the edit line and the fade line intersect, click once to create a fade handle. Click the handle at the beginning of the clip and drag to the bottom of the fade track to create a fade-in effect.

2 Position the edit line at the 0;00;04;15 position and create a handle where the edit line and the fade line intersect. Make no additional changes to this location.

3 Move the edit line to the 0;00;07;00 position and insert a handle at this location. Once inserted, click-hold-drag the handle to the bottom of the screen.

4 Click-hold-drag the handle at the end of the clip to the bottom of the screen. See figure 7-15 for details.

Adding Fades to the BalloonLogo.psd Clip

To add fades to the *BalloonLogo.psd* clip, perform the following steps.

1 In the Video 3 track in the timeline, move the edit line to the 0;00;04;15 position. In the Video 3 track, click on the fade line where the line intersects the edit line, creating a handle. Click-hold-drag the handle at the start of the movie to the bottom of the clip, creating the fade-in effect.

2 Position the edit line at the 0;00;07;00 position and insert a handle in the fade line at this position.

3 Click on the handle at the end of the *BalloonLogo.psd* clip and drag the handle to the bottom of the clip, creating the fade-out effect. See figure 7-15 for details.

Fig. 7-15.
Fade handle settings for the BalloonStill.psd and BalloonLogo.psd graphics files.

Adding Transparency

In the sections that follow, you will add transparency to the various clips.

Adding Transparency to the BalloonStill.psd Clip

To add transparency to the *BalloonStill.psd* clip, perform the following steps.

1 Select the *BalloonStill.psd* clip in the Video 2 track. Select the Setup option next to the Transparency option in the Effect Controls palette.

2 When the Transparency Settings dialog box opens, select Green Screen from the Key Type pull-down menu. The green background will disappear.

3 Click on OK to accept these changes and close the dialog box.

Adding Transparency to the BalloonLogo.psd Clip

To add transparency to the *BalloonLogo.psd* clip, perform the following steps.

1 Select the clip in the Video 3 track. Select the Setup option next to the Transparency option in the Effect Controls palette.

2 When the Transparency Settings dialog box opens, select Blue Screen from the Key Type pull-down menu. The blue background will disappear.

3 In the Smoothing pull-down menu, select Low.

4 Click on OK to accept the changes and close the dialog box.

Adding Motion

In the sections that follow you will add motion to the various clips.

Adding Motion to the BalloonStill.psd Clip

To add motion effects to the *BalloonStill.psd* clip, perform the following steps.

1 Select the *BalloonStill.psd* clip in the Video 2 track. Select Motion > Setup from the Effect Controls palette.

When the Motion Effects dialog box opens, establish settings for the start and end locations as follows.

2 With the Start image selected, click on the Center button on the right of the screen. Adjust the zoom feature to 50, and set the Smooth Motion option to Averaging - High.

3 Select the End image and click on the Center button on the right of the screen.

4 In the fill color box, click on the green background with the Eyedropper tool to remove the green background. Click on OK to accept the changes and exit the dialog box.

Adding Motion to the BalloonLogo.psd Clip

To add motion effects to the *BalloonLogo.psd* clip, perform the following steps.

1 In the timeline, select the *BalloonLogo.psd* clip. Select Motion > Setup from the Effect Controls palette.

When the Motion Effects dialog box opens, establish settings for the Start and End locations as follows.

2 With the Start image selected, click on the Center button on the right of the screen. Adjust the zoom feature to 85% and set the Smooth Motion option to Averaging – High.

3 Select the End image and click on the Center option button on the right of the screen. Set the Zoom option to 120%.

4 In the fill color box, click on the blue background with the Eyedropper tool to remove the blue background. Click on OK to accept changes and to close the dialog box.

Previewing and Saving

To preview and save the project, perform the following steps.

1 Select File > Save, name the file *Finale Logo.ppj*, and save the file to the *Balloon Files* folder on your desktop.

2 Set the work area bar from the beginning to the end of the *Clouds.mov* clip, which is at the 0;00;09;27 position. Select Timeline > Preview.

Summary

In this chapter you have created a variety of independent projects that will become part of a finished movie in Chapter 8. Most productions are created in segments and then assembled once all segments are in place. As you are developing these tutorials, you are gaining an understanding of how projects are organized, developed, and finally output to a logical stream of information and effective storytelling. Through the rigors and repetitiveness of developing these tutorials, you are gaining insight as to how to approach future projects thoughtfully and efficiently.

CHAPTER 8

PROJECT DEVELOPMENT AND FINAL PROJECT ASSEMBLY

Introduction

This chapter brings together the tutorials you performed in previous chapters. The tools and processes learned in chapters 6 and 7 have prepared the way for the culminating tutorials here. However, this chapter has plenty of surprises in store.

This chapter takes you step by step through the creation of new effects and processes that will create a unique visual presentation. Through the power of Premiere, you will composite various images and scenes to create dynamic effects. At the end of the chapter you will assemble all projects developed in this and chapters 6 and 7 into a finished movie.

Objectives

The following are the objectives of this chapter.

- Creating a countdown leader
- Creating an animated chart
- Working with multiple motion keyframes
- Working with motion graphics on a path
- Importing projects and movies into other projects

Tutorial 8-1: Creating a Countdown Leader

As one who may be new to video editing, using a countdown leader may have never crossed your mind. A countdown leader is something with which we are all familiar but may not have known its name. Simply stated, a countdown leader is a series of numbers displayed on screen just prior to the actual start of a finished movie.

The primary use of a countdown leader is for a projectionist to understand just how much time is left before the video or film begins. This feature is included in these tutorials to further explore the variety of features contained in Premiere 6.5. To create a countdown leader, perform the following steps.

1 Create a new project using the following settings.

 • Compressor: Sorenson Video

 • Frame Size: 320 x 240

 • Frame Rate: 30

 • Depth: Millions

 • Quality: 100%

 • Audio Rate: 5000 Hz

 • Format: 8-bit Mono

 • Compressor: Uncompressed

 • Interleave: 1 second

2 Select the Project window to make it active. Select File > New > *Universal counting leader*.

3 When the Universal Counting Leader Setup dialog box opens, you will notice that in the Video section there are color fields. These fields are editable by clicking on the applicable rectangle.

4 Double click on the color chip next to the Numeral Color field. From the Color Picker, type the following values in the respective fields and then click on OK.

 • Red: 8

 • Green: 29

 • Blue: 255

5 Activate (check) the *Cue Blip on out* option.

The selection is reflected in the color chip and in the Preview window.

6 In the Audio section, select the *Cue Blip at all Second Starts* option. This will provide an audible tone during the countdown process. Click on OK.

The leader will appear in bin 1 of the Project window.

7 Click-hold-drag the clip into the Video 1A track. The associated audio file will be placed in the Audio 1 track.

8 Save the project as *Countdown.ppj*.

9 Preview the file.

Figure 8-1 shows a screen image of the newly created countdown leader.

*Fig. 8-1.
Countdown
leader in the
timeline.*

Tutorial 8-2: Creating an Animated Chart

Typically, when you think of developing a chart you think of presentation programs that facilitate the creation of charts and graphs. Premiere's capabilities are limited only to one's imagination. Charts can be developed and can truly come to life with video and motion. In this tutorial, you will develop another module to be included in the master balloon movie that will be assembled later in this chapter.

Before Beginning

In Chapter 6, on your desktop, you created a folder named *Balloon Files*. Throughout this chapter, you will be prompted to save files to this folder. A new project must be opened to begin this tutorial. Create a new project as follows.

1 Select File > New Project.

2 Select Custom from the Load Project Settings dialog box.

3 Set the video settings to reflect the following options.

 • Compressor: Sorenson Video

 • Frame Size: 320 x 240

 • Frame Rate: 30

 • Depth: Millions

 • Quality: 100%

Disregard any audio settings. No audio will be used in this tutorial.

4 In the timeline, turn the Snap To Edges feature on.

Importing Graphics

Begin this tutorial development by importing graphics, as follows.

1 Select the Project window to make it active. Select File > Import >
 File. Navigate to the CD-ROM and select *Tutorials/Balloon/Graphics/*
 BalloonStill.psd.

2 Select File > Import > Folder. From the *Graphics* folder, select the
 Charts folder. Click on OK (Windows) or Choose (Mac). This will
 import the *Charts* folder into the Project window. See figure 8-2 for
 details.

Fig. 8-2. Imported graphics in the Project window shown in the thumbnail view.

Placing Graphics

You will place graphics in the timeline in a manner that allows the information to build as the movie progresses from beginning to end. Import the graphic images as follows.

1 From the Edit menu, select Preferences > General & Still Image. In the Still Image portion of this dialog box, type *150* for the Default Duration field. This will make each chart image consume 5 seconds in the timeline. Click on OK. If this value is already set, click on Cancel.

2 In the Project window, double click the Charts bin to reveal the individual chart files. From the pop-out menu on the right-hand side of the Project window, select Automate to Timeline. When the Automate to Timeline dialog box opens, establish the following settings, shown in figure 8-3.

- Contents: Whole Bin
- Placement: Sequentially
- Insert At: Beginning
- Clip Overlap: 30 frames
- Use Default Transition
- Ignore Audio

3 Click on OK to initiate this process. The clips will be placed in Video 1A and Video 1B, along with transitions. The clips will extend from the beginning of the timeline to the 0;00;25;00 position.

Fig. 8-3. Settings for importing the chart clips into the timeline.

4 Insert the edit line at the beginning of the timeline and press the space bar to preview the images and transitions. This will provide a sense of how the graphics will build from beginning to end.

5 Position the timeline at the beginning. Select the Multi-track Select tool (or type *M*) and click once on the first clip (*Chart A*). Click-hold-drag the selected clips to the right until the first clip (*Chart A*) begins at the 0;00;01;00 position. Select the Pointer tool from the

toolbox (or type *V*) and position it over the left edge of the Chart A graphic. When the Pointer tool changes to the Trim tool, click-hold-drag the left edge of the *Chart A* clip to the left to the 0;00;00;00 position. Release the mouse. This process is being performed so that a fade effect can be applied later.

Adding Transitions

As the clips were imported using the "automate to timeline" process, default transitions were also added. The default is fine for certain transitions, but other transitions will be added to achieve the desired effect at specific locations.

As charts are introduced with bars added, the desired effect is to have the bars revealed from left to right. To do this, you will use the Wipe transition. Add the Wipe transitions as follows.

1 Remove the transitions at the 0;00;09;00 and 0;00;17;00 positions.

2 In the Transitions palette, open the *Wipe* folder and click-hold-drag the Wipe transition into the transition track in the 0;00;09;00 and 0;00;17;00 positions.

The transition should snap into place at the beginning of the clip in Video 1A and to the end of the clips in Video 1B. Figure 8-4 provides placement details.

Fig. 8-4. Proper placement of the Wipe transitions.

Inserting Graphics and Applying Transparency and Fades Before Duplicating

In the following, you will add balloon graphics to enhance the charts with animation effects. Import the *BalloonStill.psd* graphic as follows.

1 Activate the Project window and double click on bin 1 to reveal the *BalloonStill.psd* image.

2 Select the *BalloonStill.psd* image and click-hold-drag it into the Video 2 track at the beginning of the timeline.

3 Expand the track to reveal the fade lines.

This clip will be used a total of three times in this project. The clip will have transparency, fades, and motion effects applied with each use. The motion effects will vary for each use. However, the transparency and fade settings will be the same each time. First, position the first instance of the clip by continuing with the following.

4 With the *BalloonStill.psd* clip selected, move the clip so that its right edge aligns at the 0;00;06;00 position. This is also where the *Chart A* clip and the transition end.

Set the transparency for this clip by continuing with the following.

5 Select the *BalloonStill.psd* clip. Select Transparency > Setup from the Effect Controls palette. When the Transparency Setting dialog box opens, select Green Screen from the Key Type pull-down menu. Click on OK.

Set the fade-in and fade-out for this clip by continuing with the following steps.

6 Insert the edit line at the 0;00;01;15 position. Click to add a handle where the edit line and the fade line intersect. To create a fade-in effect, drag the fade handle at the very beginning of the clip to the bottom of the track.

7 Move the edit line to the 0;00;05;15 position. Click to add a handle where the edit line and the fade line intersect. To create a fade-out effect, drag the fade handle at the very end of the clip to the bottom of the track.

8 With the *BalloonStill.psd* clip selected, select Edit > Copy.

 TIP: *When using a clip repetitively, apply repetitive effects prior to duplicating the clip. This will save time and additional steps.*

9 Insert the pointer in the Video 2 track after the first placement of the *BalloonStill.psd* clip and select Edit > Paste. Click-hold-drag the *BalloonStill.psd* clip to the right so that it is directly over the *Chart C* graphic.

The *Chart C* and *BalloonStill.psd* clips should have a duration of 5 seconds.

10 Position the pointer in the Video 2 track after the second placement of the *BalloonStill.psd* image and select Edit > Paste. Click-hold-drag the *BalloonStill.psd* clip to the right so that it is directly over the *Chart E.psd* graphic.

The *Chart C* and *BalloonStill.psd* images should have a duration of 5 seconds. When all three *BalloonStill.psd* clips have been placed, they should be in the positions shown in figure 8-5.

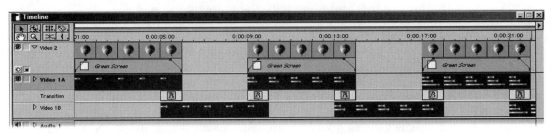

Fig. 8-5. Proper placement of the BalloonStill.psd *clips.*

11 Save the file as *Chart.ppj*.

Applying Motion Effects

As mentioned previously, the *BalloonStill.psd* clip was used a total of three times and contained effects that could be applied to one clip and then duplicated for use at other locations. The motion effects you will apply to each of the clips in the following will be unique in nature, with distinctive settings for each clip. Therefore, copying and pasting is not a logical option.

Figures 8-6 through 8-8 show the proper motion settings for each of the three clips. It is recommended that as you establish motion settings for each clip (via the steps that follow) that you perform the preview function on each clip by positioning the work area bar over the clip and selecting Timeline > Preview.

NOTE: *If you wish to preview how these effects should appear, open the finished movie as follows:* CD-ROM/Saved Files/Chart.ppj.

1 Establish the settings shown in figure 8-6 for the first *Balloon-Still.psd* clip (beginning at 0;00;01;00). After settings are made, select the fill color for each graphic (to remove the background image).

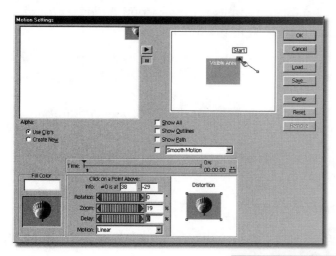

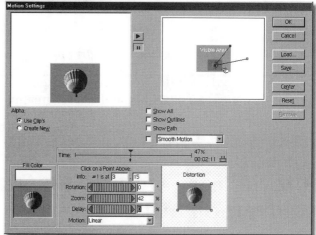

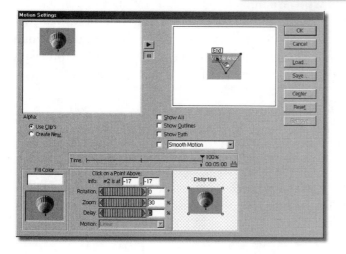

Fig. 8-6. Motion settings for the first BalloonStill.psd graphic.

2 Using figure 8-7, establish settings for the second *BalloonStill.psd* clip (beginning at 0;00;09;00 in the timeline).

3 After settings are made, select the fill color for each graphic to remove the background image.

4 Using figure 8-8, establish settings for the third *BalloonStill.psd* clip (beginning at 0;00;17;00).

5 After settings are made, select the fill color for each graphic to remove the background image.

Saving and Previewing

To save and preview the project at this point, perform the following steps.

1 Save the project.

2 Name the file *Chart.ppj*.

3 Set the work area bar over the entire project (0;00;00;00 to 0;00;26;00) and select Timeline > Preview.

This project will not be output at this time. It will, however, be used later in this chapter in producing the final movie.

Tutorial 8-3: Moving an Object on a Keyframe Path

In the following you will assemble an additional movie to complete the content development for these tutorials. In this simple tutorial, you will establish a visible motion path in a graphic. Using the motion settings, you will establish multiple keyframes to make an object follow precisely along the visual path. Open a new Premiere project as follows.

1 Select File > New Project.

2 Select Custom from the Load Project Settings dialog box.

3 Set the video settings to reflect the following options.

 — Compressor: Sorenson Video

 — Frame Size: 320 x 240

 — Frame Rate: 30

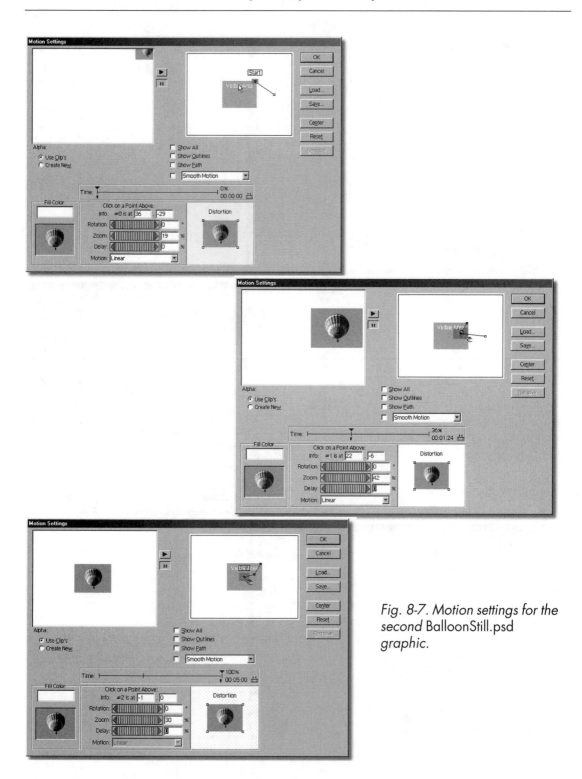

Fig. 8-7. Motion settings for the second BalloonStill.psd graphic.

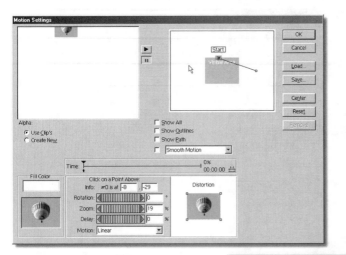

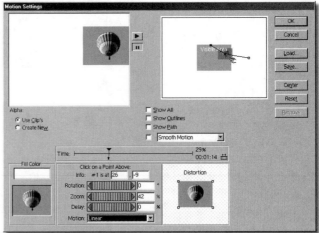

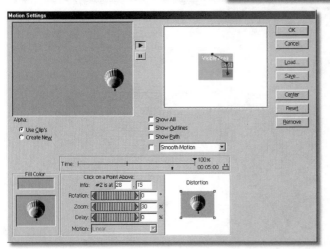

Fig. 8-8. Motion settings for the third BalloonStill.psd *graphic.*

- Depth: Millions
- Quality: 100%

Disregard any audio settings. No audio will be used in this tutorial.

4 In the timeline, turn the Snap To Edges feature on.

Importing Media

1 Add the following to bin 1 in the Project window. Go to *CD-ROM/ Tutorials/Balloons* and import the following files.

- *BalloonStill.psd*
- *Line.psd*
- *Valley.psd*

2 Select the Create Item icon at the bottom of the Project window and select Black Video from the Object Type pull-down menu. The *Black Video* clip will appear in the Project window.

3 Add one additional video track in the timeline by selecting Timeline > Add Video Track. This should be the Video 3 track. Expand the Video 2 and Video 3 tracks.

Placing Files in the Timeline

With the timeline located at the beginning, place the following files in the locations specified in table 8-1. Use the edit line as a placement aid. See also figure 8-9 for details.

Table 8-1: Track Locations and Beginning Positions for File Placement

File	Track	Beginning Position
BalloonStill.psd	Video 3	0;00;04;00
Line.psd	Video 2	0;00;02;15
Valley.psd	Video 1A	0;00;00;15
Black Video	Video 1B	0;00;00;00

Fig. 8-9. Guidelines for file placement in the timeline.

Expanding Clips

Adjust the clips previously placed to reflect the timeline ending positions specified in table 8-2. To expand the clips, click-hold-drag the right edge to the specified location. Use the edit line to set the position first. This will allow the clips to snap to the precise location.

Table 8-2: Track Locations and End Positions for File Placement

File	Track	End Position
BalloonStill.psd	Video 3	0;00;12;15
Line.psd	Video 2	0;00;12;15
Valley.psd	Video 1A	0;00;13;00
Black Video	Video 1B	0;00;12;15

At this point, your timeline should appear as shown in figure 8-10.

Fig. 8-10. Current timeline settings.

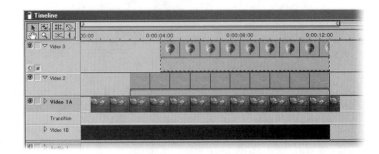

Other Elements

To complete the placement of objects in the timeline, perform the following steps.

1 Click-hold-drag the right side of the *Black Video* clip to the 0;00;13;15 position.

This will place the black video from the beginning to the end of the project. The back video is at the lowest level of the video tracks. Therefore, no video overlays this portion of the clip and only the beginning and end will be visible.

2 From the Transitions palette, expand the *Dissolve* folder and then click-hold-drag the Cross Dissolve transition over the *Black Video* clip at the beginning and end. Double click on the transition at the beginning of the timeline and make sure it is set to begin in the B track.

The placement of these transitions should appear as shown in figure 8-11.

Fig. 8-11. Transition and black video placement.

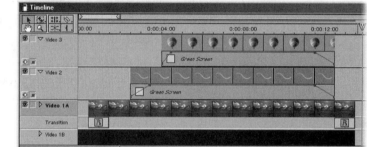

3 Save the project as *Motion Path.ppj*.

Adding Transparency

In the following, you will remove the green background from the clips in the superimpose tracks, Video 2 and Video 3. This will remove the green background image, leaving only the line (in Video 2) and the balloon (in Video 3). Perform this change as follows.

1 Select the *BalloonStill.psd* clip in the Video 3 track. In the Effect Controls palette, select Transparency > Setup. When the Transparency Settings dialog box opens, select the pull-down menu next to Key Type and select Green Screen. Set the Threshold slider to 75. Click on OK.

2 Select the *Line.psd* clip in the Video 2 track. In the Effect Controls palette, select the Setup option next to Transparency. When the Transparency Settings dialog box opens, select the pull-down menu next to Key Type and select Green Screen. In the Smoothing pull-down menu, select High. Set the Threshold slider to 75. Click on OK.

Adding Fades

In the following, you will set the clips in the Video 2 and Video 3 super-impose tracks to fade in and fade out. Set the fade controls for these two clips by performing the following steps.

1 Select the *BalloonStill.psd* clip in the Video 3 track. Move the edit line to the 0;00;04;15 position. Click on the fade line to insert a handle where the edit line intersects the fade line. Click-hold-drag the handle at the start of the movie to the bottom of the track.

2 At the end of the *BalloonStill.psd* clip, insert the edit line at the 0;00;11;15 position, and insert a handle in the fade line where it intersects the edit line. Click-hold-drag the fade line handle at the end of the clip to the bottom of the track.

3 In the Video 2 track, select the *Line.psd* clip. Insert the edit line at the beginning of the clip, at the 0;00;03;15 position. Click to add a new handle. Click-hold-drag the handle at the start of the movie to the bottom of the track.

4 At the end of the *Line.psd* clip, insert the edit line at the 0;00;11;15 position, and insert a handle in the fade line where it intersects the edit line. Click-hold-drag the fade line handle at the end of the movie to the bottom of the track.

5 If you wish, position the work area bar over the first 6 seconds of the timeline and preview the file. There is no motion at this point, but you can see the effects of the placed files.

Adding Motion Effects

In the following, you will add motion effects to the *BalloonStill.psd* image. You will also establish keyframes along the *Line.psd* image, which will allow the balloon to follow the path of the line. To begin this process, perform the following steps.

1 Select the *BalloonStill.psd* clip in Video 3. Select Motion > Setup in the Effect Controls palette. When the Motion Settings dialog box opens, you will see the Start image to the left of the visible area screen in the upper right of the screen. Click on the Play button located between the Motion Preview window on the left and the Motion Path window on the right. This will display the current motion settings in the Motion Preview area.

2 In the Fill Color area, move the mouse into the green area around the balloon image. The pointer will change to the Eyedropper tool. Click once in the green area to select the fill color. This will remove the frame outline.

To establish seven keyframes, including the Start and Finish keyframes, along the *Line.psd* image, perform the following. This will create a smooth motion path for the balloon graphic to follow.

3 Before adjusting the position of the balloon images, click on the Pause button beneath the Play button. This will allow the keyframe placement to be viewed without animating between the Start and Finish images.

TIP: *When adding keyframes in the Motion Path area, if a keyframe is inserted in an undesirable location, click-hold-drag the keyframe outside the window to remove it.*

4 Figure 8-12 shows the placement of the points over the *Line.psd* clip. Use this illustration as a point of reference for the illustrations that follow. Figures 8-13 through 8-19 serve as guides to precise placement of all keyframes.

Fig. 8-12.
Keyframe positions
along the Line.psd
path.

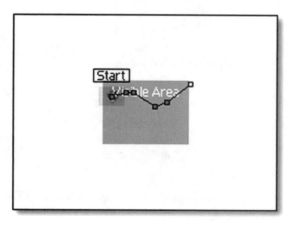

NOTE: *When adjusting keyframe 1 (the Start image) and keyframe 7 (the Finish image), keep in mind that fades have been applied to these images. This means that the balloon image will be invisible at the 0% and 100% locations.*

Fig. 8-13. Keyframe 1 position instructions.

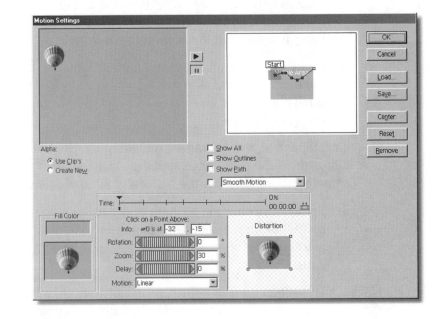

Fig. 8-14. Keyframe 2 position instructions.

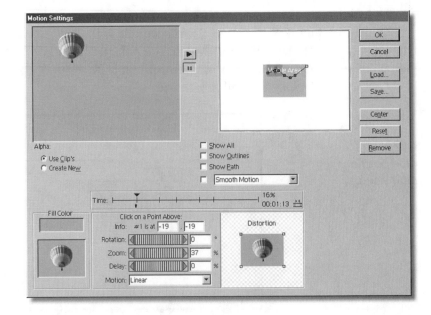

Fig. 8-15.
Keyframe 3
position
instructions.

Fig. 8-16.
Keyframe 4
position
instructions.

5 In the Motion timeline, drag the small arrow to make the balloon
image gradually fade in. This will help when positioning and view-
ing the Start and Finish images.

TIP: *Use the Tab key to move from field to field.*

Fig. 8-17.
Keyframe 5
position
instructions.

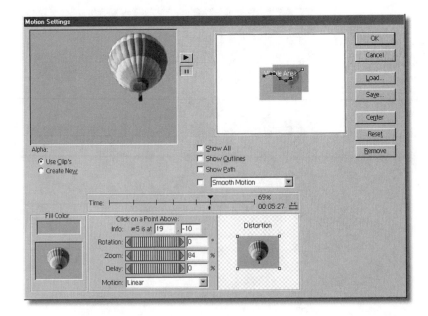

Fig. 8-18.
Keyframe 6
position
instructions.

6 When all keyframes have been set, select the first keyframe. Select
 Averaging - High from the Smooth Motion pop-up menu to provide
 maximum smoothing to the motion of the graphics. Select Deceler-
 ate from the Motion pop-up menu at the bottom of the screen.

*Fig. 8-19.
Keyframe 7
position
instructions.*

To complete the project and view the file as a movie, continue with the following steps.

7 While still in the Motion Settings dialog box, click on the Play button just above the Pause button to preview the motion setting. Click on OK.

8 In the timeline, position the work area bar over the entire project and select Timeline > Preview.

9 When you have previewed the file, save the project.

10 Select File > Export Timeline > Movie. Select the following export settings.

- Make: Work Area as QuickTime
- Video: 320 x 240 at 30 fps
- Compression: 'Sorenson Video' @ 100%
- Audio: Disabled

11 Name the file *MotionPath.mov* and save it to the *Balloon Files* folder on your desktop.

12 The completed movie will open. Preview the movie from the new movie file.

This completes the motion path tutorial.

Tutorial 8-4: Assembling the Balloon Movie

Chapters 6 and 7 and this chapter have had as a goal the assembly of various small projects that will be used to create a single larger project. In the following, you will assemble the individual project segments.

The Assembly Process

In the following, you will import the independent segments prepared in chapters 6 and 7 and this chapter into a master project for final movie output. This process can be performed in a variety of ways. As you may recall, some of the projects were output as movies, whereas others were saved as Premiere projects. In creating the final Balloon movie, you will employ various techniques for importing the movies.

You will import the movies in playback order, not the order in which they were created. The playback order follows. Note that the *.ppj* extension denotes a file saved as a Premiere project. The *.mov* extension denotes a project output as a QuickTime movie.

- *Countdown.ppj*
- *Popularity.mov*
- *Intro Logo.ppj*
- *Chart.ppj*
- *Setup.ppj*
- *Inflation.ppj*
- *Journey.ppj*
- *MotionPath.mov*
- *Finale Logo.ppj*

Assembling the Final Product

In this section, you will create a new Premiere project that will serve as the completed movie. In chapters 6, 7, and 8, several small projects were created as stand-alone video projects. However, none of these projects tells a complete story. In this section, you will assemble these individual projects into one Premiere project to create a comprehensive video.

1 Select File > New Project. Select Custom and establish the following settings.

- General:
 - Editing Mode: QuickTime
 - Timebase: 30
 - Time Display: 30 fps non-drop frame timecode
- Video:
 - Compressor: Sorenson Video
 - Frame Size: 320 x 240
 - Frame Rate: 30
 - Depth: Millions
 - Quality: 100%
- Audio:
 - Rate: 44100Hz
 - Format: 16 Bit - Stereo
 - Compressor: Uncompressed
 - Interleave: 1 Second

2 Click on OK.

Importing Projects and Movies

For the remainder of this chapter, you will use the Commands palette repeatedly to import files and folders. By default, the Commands palette contains an Import File option. However, it does not include an Import Folder option. To add this feature to the Commands palette, perform the following steps.

1 Make sure the Commands palette is visible by clicking on its tab or by selecting Window > Show Commands.

2 Select Button Mode from the pop-out menu. This will deselect it (no check mark).

3 Select Add Command from the pop-out menu.

4 When the Command Options dialog box opens, select the following to create a new button on the Premiere Commands palette: File > Import > Project.

The text *Import > Project* is now listed to the right of the Command item in the Command Options dialog box, indicating that this option has been selected.

5 Type the following in the Name field: *Import Project*. Click on OK.

6 Select Button Mode from the Commands palette pop-out menu to make the Import Project button functional. Figure 8-20 shows this workflow.

Fig. 8-20. Workflow for establishing a new command in the Commands palette.

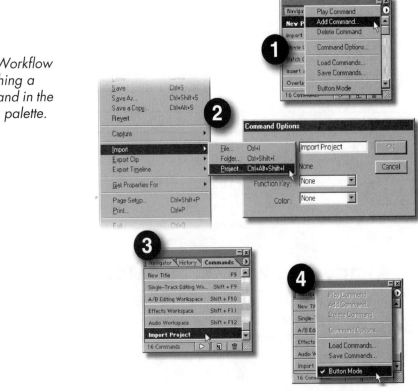

Step-by-step instructions follow for importing the Premiere projects and movies into a new project.

Importing the Countdown Project

To import the Countdown project, perform the following steps.

1 In the Commands palette, click on the Import Project button. Open the following file from your desktop or from the companion CD-ROM as follows.

- Desktop: *Balloon Files/Countdown.ppj*

- Companion CD-ROM: *CD-ROM/Saved Files/Countdown.ppj*

2 When the Import Project dialog appears, select Beginning and then click on OK. The project is automatically inserted in the timeline, in the Video 1A track, and a folder is created in the Project window that contains the imported file.

3 Select File > Save and name the file *Tutorial 8-4*. Save the file to the *Balloon* folder on your desktop.

Importing the Popularity Movie

To import the Popularity movie, perform the following steps.

1 In the Commands palette, select Import > File. Open the following file from your desktop or from the companion CD-ROM as follows.

- Desktop: *Balloon Files/Popularity.mov*

- Companion CD-ROM: *CD-ROM/Saved Files/Popularity.mov*

2 Click on OK.

3 The *Popularity.mov* clip will be placed in the Project window only, not in the timeline.

4 Click-hold-drag the Popularity movie into the timeline, placing it in the Video 1A track immediately after the *Countdown* clip (at the 0;00;11;00 position).

NOTE: *Based on the size of your monitor, you may need to scroll to the right for proper viewing.*

Importing the Intro Logo Project

To import the Intro Logo project, perform the following steps.

1 In the Commands palette, select Import Project. Open the following file from your desktop or from the companion CD-ROM as follows.

- Desktop: *Balloon Files/Intro Logo*

- Companion CD-ROM: *CD-ROM/Saved Files/Intro Logo.ppj*

2 When the Import Project dialog appears, select Import Project At > End and then click on OK.

The project is automatically inserted in the timeline, and a folder is created in the Project window that contains the imported file. You will notice that the *Intro Logo* file contains clips in the Video 3 track. When the file is imported, the Video 3 track is automatically inserted to accommodate this clip.

Importing the Chart Project

To import the Chart project, perform the following steps.

1 In the Commands palette, select Import Project. Open the following file from your desktop or from the companion CD-ROM as follows.

- Desktop: *Balloon Files* > *Chart.ppj*

- Companion CD-ROM: *CD-ROM/Saved Files/Chart.ppj*

2 When the Import Project dialog appears, select Import Project At > End and then click on OK.

The project is automatically inserted in the timeline, and a folder is created in the Project window that contains the *Chart* file. The project is now over 1 minute long.

3 Save the project.

Importing the Setup Project

To import the Setup project, perform the following steps.

1 In the Commands palette, select File > Import Project. Open the following file from your desktop or from the companion CD-ROM as follows.

- Desktop: *Balloon Files/Setup.ppj*

- Companion CD-ROM: *CD-ROM/Saved Files/Setup.ppj*

2 When the Import Project dialog appears, select Import Project At >
End and then click on OK.

The project is automatically inserted in the timeline, and a folder is cre-
ated in the Project window that contains the *Setup.ppj* file.

Importing the Inflation Project

To import the Inflation project, perform the following steps.

1 In the Commands palette, select Import Project. Open the following
file from your desktop or from the companion CD-ROM as follows.

- Desktop: *Balloon Files/Inflation.ppj*

- Companion CD-ROM: *CD-ROM/Saved Files/Inflation.ppj*

2 When the Import Project dialog appears, select Import Project At >
End and then click on OK.

The Inflation project is automatically inserted in the timeline, and a
folder is created in the Project window that contains the *Inflation.ppj*
file.

Importing the Journey Project

To import the Journey project, perform the following steps.

1 In the Commands palette, select Import Project. Open the following
file from your desktop or from the companion CD-ROM as follows.

- Desktop: *Balloon Files/Journey.ppj*

- Companion CD-ROM: *CD-ROM/Saved Files/Journey.ppj*

2 When the Import Project dialog appears, select Import Project At >
End and then click on OK.

The Journey project is automatically inserted in the timeline, and a
folder is created in the Project window that contains the *Journey.ppj* file.

Importing the MotionPath.mov Movie

To import the *MotionPath.mov* movie, perform the following steps.

1 In the Commands palette, select Import File. Open the following movie from your desktop or from the companion CD-ROM as follows.

- Desktop: *Balloon Files/Motion Path.mov*
- Companion CD-ROM: *CD-ROM/Saved Files/MotionPath.mov*

The *MotionPath.mov* clip will be placed in the Project window only, not in the timeline.

2 Click-hold-drag the *MotionPath.mov* clip into the timeline, placing it in the Video 1B track at the 0;04;00;00 position.

NOTE: *Remember to use the edit line to set positions before moving clips in the timeline.*

Importing the Finale Logo Project

To import the Finale Logo project, perform the following steps.

1 In the Commands palette, select Import Project. Open the following file from your desktop or from the companion CD-ROM as follows.

- Desktop: *Balloon Files/FinaleLogo.ppj*
- Companion CD-ROM: *CD-ROM/Saved Files/FinaleLogo.ppj*

2 When the Import Project dialog appears, select Import Project At > End and then click on OK.

The Finale Logo project will be automatically inserted in the timeline, and a folder created in the Project window that contains the *Finale Logo* file. The movie is now over 4 minutes long.

3 Save the file and return to the beginning of the timeline.

This completes the project and movie importation process for these tutorials.

Adjusting Imported Project and Movie Files

You may have noticed during the development cycle, or during file placement, that the movie and project files may have incompatible transitions between projects or clips. In this section, you will adjust the projects/clips to make room for transitions or to create proper timing between scenes. The two projects/clips being adjusted will be named in

the header. Screen images of the proper placement in the timeline accompany each adjustment. This will ensure that clips are at the proper location.

 TIP: *Save often during this portion of the tutorials.*

Settings Between the Countdown and Popularity Projects

To make these position adjustments, perform the following steps.

1 Position the timeline to begin at 0;00;00;00. At the 0;00;11;00 position, the Countdown project and the *Popularity.mov* clip intersect. These files should not overlap, being aligned as shown in figure 8-22.

 NOTE: *The Countdown project ends with a fade and the* Popularity.mov *clip begins with a fade. Therefore, the transitions are already in place.*

2 To ensure proper alignment, position the work area bar over the clips as shown in figure 8-21 and preview the way in which the two files transition. Use this technique to preview transitions between all clips.

Fig. 8-21. Timeline at the junction between the Countdown and Popularity projects.

Settings Between the Popularity and Intro Logo Projects

To make these position adjustments, perform the following steps.

1 Set the timeline to begin at the 0;00;33;00 position.

The *Popularity.mov* clip ends at the 0;00;36;25 position, and the Intro Logo files currently begin at the 0;00;36;25 position. The *Popularity.mov* clip has a fade-out at the end of the clip. The Intro Logo has no fade controls at the beginning. To add a transition to the beginning of the Intro Logo project, continue with the following steps.

Fig. 8-22. Timeline at the junction between the Popularity movie and the Intro Logo project.

2 Insert the edit line at the 0;00;37;10 position. In the Transitions palette, click-hold-drag the cross-dissolve transition so that the left edge of the transition aligns with the clips at the 0;00;36;25 position and the right edge aligns with the edit line at the 0;00;37;10 position.

3 Double click on the transition and set the Start image as B and the End image as A. Click on OK.

4 Preview the file by positioning the work area bar as shown in figure 8-22.

Settings Between the Intro Logo and Chart Projects

To make these position adjustments, perform the following steps.

1 In the transition track, copy the transition that was created at the 0;00;36;25 position.

Fig. 8-23. Timeline at the junction between the Intro Logo project and the Chart project.

2 Click to the right of the existing transition in the transition track. Select Paste.

3 Click-hold-drag the pasted transition to the right, releasing it when its left edge aligns with the chart background graphic at the 0;00;44;26 position. See figure 8-23 for placement details.

Settings Between the Chart and Setup Projects

The Chart project ends abruptly. However, the Setup project begins as a black screen and fades in. No additional transition will be used here. However, see figure 8-24 for placement details.

Fig. 8-24. Timeline at the junction between the Chart project and the Setup project.

Adjustments to the Setup and Inflation Projects

Fig. 8-25. Using the Razor at Edit Line function to trim the black matte.

Fig. 8-26. Repositioning the Setup2.mov clip.

Adjust the Setup project as follows.

1 The *Setup2.mov* clip begins at the 0;01;18;00 position. The black video at the beginning of this movie is too long. To trim the black video, set the edit line at the 0;01;19;15 position and select Timeline > Razor at Edit Line. See figure 8-25 for details.

2 Using the pointer, select the left section of the black matte and then select Edit > Clear. This will remove the left portion of the matte.

3 In the toolbox, select the Multi-track selection tool, or type *M*. Click-hold-drag the files to the right of the edit line until the black matte aligns with the *Setup* clip at the 0;01;18;00 position. When in position, release the mouse. This will shorten the duration between the two projects. See figure 8-26 for selection details.

Settings Between the Setup and Inflation Projects

To make these position adjustments, perform the following steps.

1 Position the timeline to begin at 0;01;50;00.

Trim the beginning of the *Inflation2.mov* clip by continuing with the following steps.

2 Insert the edit line at 0;02;01;00 and select Timeline > Razor at Edit Line.

3 Select the matte to the left of the edit line and then select Edit > Clear, to remove the matte.

4 Select the Multi-track selection tool in the toolbox, or type *M*, and then click-hold-drag the clips located to the right of the edit line to the left until the left edge snaps to the clips at the 0;01;59;15 position.

When properly placed, the files should be in position as shown in figure 8-27.

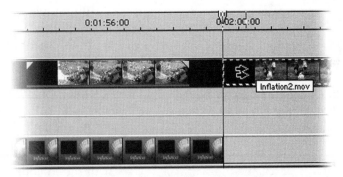

Fig. 8-27. Moving all clips to the left using the Multi-track selection tool.

Settings Between the Inflation and Journey Projects

No changes are required between these two projects. The *Journey.ppj* clip should begin at the 0;02;53;00 position. See figure 8-28 for positioning in the timeline.

Settings Between the Journey Project and the Motion Path Movie

The Journey2.mov clip ends with a "fade to black," and the *Motion-Path.mov* clip begins with a "fade in from black." This will create the desired fade effect between the two clips. To make these position adjustments, perform the following steps.

Fig. 8-28. Timeline location between the Inflation2.mov and the Journey project.

1 Position the timeline so that it begins at 0;03;55;00.

2 Make sure the clips are aligned as shown in figure 8-29. The clips join at the 0;03;58;01 position.

Fig. 8-29. Timeline location between the Journey 2.mov and the Motion Path movie.

Settings Between the Motion Path Movie and the Finale Logo Project

The *MotionPath.mov* clip ends with a "fade to black." Add a transition to the Finale Logo project as follows.

1 Verify that the Finale Logo project starts at the 0;04;10;16 position.

2 In the Transitions palette, open the *Iris* folder. Click-hold-drag the Iris Round transition into the transitions track, releasing it at the 0;04;10;16 position.

3 Double click on the transition and set the start to B and the end to A. Click on OK. This will make the transition zoom in from black.

4 Position the work area bar over the transition as shown in figure 8-30 and preview the file.

Fig. 8-30. Timeline location between the MotionPath.mov clip and the Finale Logo project.

End of the Project Movie

To establish the end of the entire movie project, perform the following steps.

1 Set the timeline to begin at 0;04;18;00.

2 Click on the Create Item icon at the bottom of the Project window. Create a new black video clip. Place this clip in Video 1B, starting at 0;04;19;15 and ending at 0;04;23;00.

3 Position the edit line at 0;04;19;15 and then click-hold-drag the cross-dissolve transition into the transition track so that its left edge aligns with the edit line. By default, the transition will dissolve from Video 1A to Video 1B. See figure 8-31.

4 Save the project.

Fig. 8-31. Proper positioning for the end of the project.

Placing Audio Files

The following four audio files have been prepared for use in this tutorial.

- *Narration.wav*
- *Wind.wav*
- *Blast.wav*
- *Flying.wav*

Import these files into bin 1 in the Project window as follows. In the Project window, select bin 1. Select File > Import > Folder and then select the file sequence *CD-ROM/Tutorials/Balloon/Audio*.

The *Audio* folder will appear in the Project window.

Placing the Narration.wav Clip

The *Narration.wav* clip is a continuous clip that will run the duration of the movie, excluding the countdown portion. Place the file as follows.

1 Insert the edit line at the 0;00;11;00 position.

2 In the Project window, open the audio bin and click-hold-drag the *Narration.wav* clip into the timeline in the Audio 1 track. Align the clip's left edge with the edit line at the 0;00;11;00 position.

This clip has been designed to run the duration of the movie and is timed according to project and movie placement.

Placing the Wind.wav Clip

To place the first occurrence of the *Wind.wav* clip, perform the following steps.

1 Move the Timeline window so that it begins at the 0;00;36;00 position. Insert the edit line at the 0;00;40;00 position.

2 In the Project window, open the audio bin and import the *Wind.wav* clip into the timeline in the Audio 2 track. Align the clip's left edge with the edit line at the 0;00;40;00 position.

To place the second occurrence of the *Wind.wav* clip, continue with the following steps.

3 Move the Timeline window so that it begins at the 0;04;10;00 position. Insert the edit line at the 0;04;13;00 position.

4 In the Project window, open the audio bin and import the *Wind.wav* clip into the timeline in the Audio 2 track. Align the clip's left edge with the edit line at the 0;04;13;00 position.

Placing the Blast.wav Clip

To place the first occurrence of the *Blast.wav* clip, perform the following steps.

1 Move the Timeline window so that it begins at the 0;01;47;00 position. Insert the edit line at the 0;01;49;00 position.

2 In the Project window, open the audio bin and import the *Blast.wav* clip into the timeline in the Audio 2 track. Align the clip's left edge with the edit line at the 0;01;49;00 position.

To place the second occurrence of the *Blast.wav* clip, continue with the following steps.

3 Move the Timeline window so that it begins at the 0;02;21;00 position. Insert the edit line at the 0;02;23;00 position.

4 In the Project window, open the audio bin and import the *Blast.wav* clip into the timeline in the Audio 2 track. Align the clip's left edge with the edit line at the 0;02;23;00 position.

To place the third occurrence of the *Blast.wav* clip, continue with the following steps.

5 Move the Timeline window so that it begins at the 0;04;12;00 position. Insert the edit line at the 0;04;14;00 position.

6 In the Project window, open the audio bin and import the *Blast.wav* clip into the timeline in the Audio 2 track. Align the clip's left edge with the edit line at the 0;04;14;00 position.

Placing the Flying.wav Clip

To place the *Flying.wav* clip, perform the following steps.

1 Move the Timeline window so that it begins at the 0;03;57;00 position. Insert the edit line at the 0;04;03;00 position.

2 In the Project window, open the audio bin and import the *Flying.wav* clip into the timeline in the Audio 2 track. Align the clip's left edge with the edit line at the 0;04;03;00 position.

Final Movie Preview

The finished movie is 4 minutes and 23 seconds long. With all projects and movies assembled, preview the project. To preview, position the work area bar over the movie beginning at 0;00;00;00 and ending at 0;04;23;00. Select Timeline > Preview to view the movie.

The preview will take several minutes to execute. The Premiere preview files that will be generated will become very large. Make sure you have plenty of disk space available to support the preview process. In Chapter 14, you will output this movie as a standalone movie.

Summary

You have developed various content and have assembled it into a final production. As you know, the storyboard process encourages the development of the story, or workflow, from beginning to end. However, content development does not necessarily take the same path.

These tutorials have enlightened you as to how content can be developed in a random order, based on the availability of resources. As the files were placed in a logical, flowing sequence in the preceding section, the planning process became a working reality.

CHAPTER 9
A FRAMEWORK FOR SPECIAL EFFECTS

Introduction

This chapter sets the stage for the development of an intensive, multidimensional movie filled with special effects, motion, and techniques designed to expose you to a wealth of ideas. Video editing covers a wide range of ideology about what is good and proper in regard to content editing. This and chapters 10 through 12 will expose you to many inspiring techniques and processes. As you perform these tutorials, what you learn will enhance the creative aspect of your future editing endeavors.

Objectives

The following are the objectives of this chapter.

- Creating a movie's framework
- Storyboarding
- Importing and placing video and graphics files
- Beginning a project
- Planning using a storyboard
- Automating to a timeline
- Adding bars and tone
- Adding black video
- Arranging video clips
- Previewing a movie

Planning a Movie

So far you have performed tutorials in a step-by-step manner without much attention to the planning process. In this and chapters 10 through 12 you will perform a series of tutorials that build upon one another. In this chapter, you will build the "skeleton" (or framework) of the project. The video clips you place in the tutorial in this chapter will set the stage for further development in chapters 10, 11, and 12.

The planning and setup scenario for this project involves a marketing video for a fictitious energy beverage. The initial stages of this project call for a variety of media elements, such as video, soundtracks, narration, and graphics. The overall project calls for substantial planning, especially in the areas of video, staging, storyboarding, and on-location shooting. Each of these phases requires time and organization.

As simple as this movie may seem, the time required to pull it together would be significant. Figure 9-1 depicts the thought process involved in developing this project.

Fig. 9-1. The thought process for developing this movie.

▶ Develop a product video

 ▶ Videotape someone exercising

 ▶ Have participants use the product

 ▶ Make the video fast action

 ▶ Insert a high-energy soundtrack

 ▶ Use a narration to describe the product

 ▶ Create special effects for emphasis

As the planning process evolves, so does each of the processes listed in the "Objectives" section. The storyboarding process is crucial to a project such as this. Storyboarding helps turn ideas into a planned sequence of events. Here, storyboarding might begin with ideas recorded on a notepad, as indicated in figure 9-2. For the tutorial in this chapter, ideas were sketched as to what the story would be, how it would be arranged, and what components would be used to bring it to life.

From the original sketches, a list of scenes to be videotaped was compiled for use in this project. The list is as follows.

Fig. 9-2. Storyboarding this tutorial began with a pen and a notepad.

- Group running toward camera (distant)
- Group running toward camera (close)
- Group running toward camera (offset lower right)
- Side shots (running)
- Front shot center (single)
- Still shots (various)
- Trail with runners (rear shot)
- Trail without runners
- Bottles on table
- Casual group shot
- Casual single shots (various)
- Drinking beverage shot (single)
- Drinking beverage shot (group)
- Close-up of bottle in hand
- Zoom in on drinking (side view)
- Group laughing
- Individuals laughing

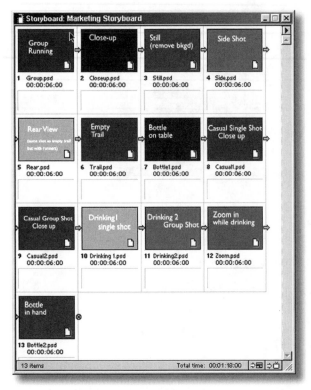

Fig. 9-3. Dummy clips organized in Premiere's Storyboard window.

Prior to actually videotaping the scenes listed previously, additional planning was required. The next phase was to develop multi-colored graphics with the names of the video scenes on them. These graphics were saved and treated as dummy video clips, and then placed in a folder named *Video*. Next, Premiere was opened, the Video folder imported, and the files assembled in Premiere's Storyboard window and arranged in a logical manner, as shown in figure 9-3.

Once the clips were placed in a desired sequence, the Automate to Timeline feature was used to import the dummy clips, as shown in figure 9-4.

Fig. 9-4. Dummy video clips were created and placed in the timeline.

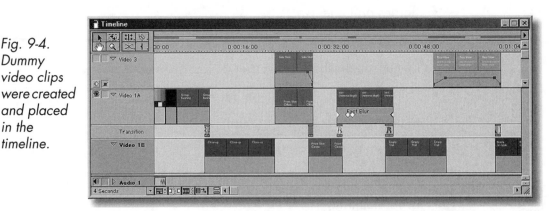

With the clips placed in a timeline, a project can be better visualized. Clips can be lengthened or shortened, and transitions and effects can be studied and placed to get a feel for the final production. Placing clips in a timeline also helps you determine the overall length of a project. This

is beneficial if your project has a predetermined length. Developing this type of plan will provide the necessary structure for planning the narration audio and soundtrack placement.

At this stage, planning for special effects is also done. Effects planning can require a significant amount of time as well. However, it is usually not as intensive as acquiring video. Graphics files, like video files, can also be placed in a dummy format (or actual graphics can be used if available).

Effects used on the graphics files can be tested here as well. Any standard Premiere effect, transition, motion, or transparency can be applied to develop a feel for the final production. In the actual production of any movie, Premiere provides specialized effects that can enhance badly shot material. For example, one such effect adjusts the brightness or contrast of a clip. In the following tutorial, you will create the framework for a move that incorporates special effects.

Tutorial 9-1: Creating the Framework of a Special Effects Movie

Proper planning is critical. The extent of planning will vary from project to project, and will also be determined by the extent of your involvement in the video editing/moviemaking process. You may be part of a team with some individuals assigned to the planning process and others to the production process only. If you are developing and producing the entire project, you will be involved in the planning process, and this is where it all begins.

Beginning Development of the Project

With the initial planning process completed, you can begin development of the project. For this tutorial, begin the development process by performing the following steps.

1 Select File > New Project.

2 When the Load Project Settings dialog box opens, select Custom.

3 The New Project Settings dialog box will appear. In this dialog box, select the settings shown in figure 9-5.

Fig. 9-5. Settings for the New Project Settings dialog box.

4 From the General pop-up menu, select the Video tab and establish the following settings.

- Video Options:
 - Compressor: Sorenson Video
 - Depth: Millions
 - Frame Size: 320 x 240
 - Frame Rate: 29.97
 - Quality: 100% High
 - 4:3 Aspect
 - Pixel Aspect Ratio: Square Pixels (1.0)
 - Data Rate: Leave unselected
- Audio Options:
 - Rate: 22050 Hz
 - Format: 16 Bit - Stereo

- Compressor: Uncompressed

- Interleave: 1 Second

• Keyframe and Rendering

- Preview: From Disk

5 Click on OK. As the new project appears, the workspace will reflect the layout for the most recent project. To refresh the screen, select Window > Workspace > A/B Editing.

In the following you will import files into storyboard windows for organization prior to placement in the timeline. Begin this process as follows.

1 Select File > New > Storyboard. The blank Storyboard window appears.

2 Select File > Import > Folder. Navigate to the companion CD-ROM and select *Tutorials/Energy Drink/Video*. Select the *Video* folder by clicking on it once (double clicking opens the folder), and then click on the OK/Choose button. The content of the folder will flow into the Storyboard window.

3 With the storyboard still selected, select File > Import > Folder. On the companion CD-ROM, select *Tutorials/Energy Drink/Graphics*.

The Storyboard window, shown in figure 9-6, will appear.

4 With the Storyboard window opened, select File > Save. Name the Storyboard file *Go Storyboard*.

As you review the Go Storyboard window, you will notice that the clips have been placed in alphabetical order according to the order of the imported folders. In the following, you will rearrange the video and graphics clips to fit the flow and design of the story.

 TIP: You can save as many storyboards as you want. They can be printed as PDFs or archived.

5 Click-hold-drag the clips and arrange them in the order shown in figure 9-7.

 TIP: *Clips can be previewed in the Storyboard window by double clicking on them. Clips can also be played back as a movie (in their order in the Storyboard window) by clicking on the Print to Video icon in the lower right-hand side of the Storyboard window.*

*Fig. 9-6.
Storyboard
window with
Video and
Graphics folders
imported.*

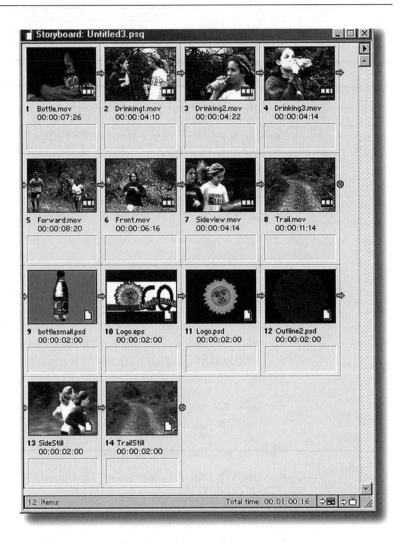

With the clips arranged in the Storyboard window, the next step is to import the clips directly from the Storyboard window into the timeline. Continue with the following steps.

6 With the Storyboard window active, select the Automate to Timeline icon at the bottom of the Storyboard window. See figure 9-8.

7 When the Automate to Timeline dialog box opens, select the settings shown in figure 9-9 and click on OK.

Fig. 9-7. Clips properly arranged in the Storyboard window prior to placement in the timeline.

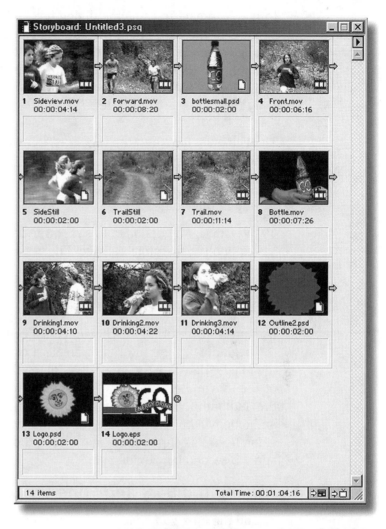

Fig. 9-8. Automate to Timeline icon in the Storyboard window.

Fig. 9-9. Automate to Timeline dialog box with settings selected.

In the Automate to Timeline dialog box, the Whole Bin setting imports all clips in the Storyboard into the timeline. The Sequential Placement setting will place the clips in order, end to end. The clips will start at the beginning of the timeline, with no overlap. No transitions will be used and no audio will be imported for this tutorial.

8 Click on OK.

The clips will flow into the timeline. You will notice that the Storyboard window remains open.

9 Close the Storyboard window by clicking on the Close button at the top of the window.

10 It is always a good idea to save your project often and to save it early on in the project. Select File > Save and name the project *Go Energy Drink*.

Adding Bars and Tone

In a previous tutorial, a UCL (universal counting leader) was placed at the beginning of the tutorial to create a countdown to the beginning of the movie. Here, a bar and audible tone will be inserted at the beginning of the movie. Bars and tone screens are used to preview and calibrate the audio and video level of a video or movie. In this tutorial, the bar and tone will be inserted as a file at the beginning of the movie. To transition from this clip to the beginning of the first video clip, you will also add a 2-second black video clip.

Adding the Bars and Tone

To add the *Bars and Tone* file, perform the following steps.

1 Click on the Project window to make it active.

2 At the bottom of the window, click once on the Create Item icon, shown in figure 9-10.

3 When the Create dialog box opens, select the Object Type pull-down menu and select the Bars and Tone option. Click on OK.

Fig. 9-10. Create Item icon.

The *Bars and Tone* file should now be present in the Storyboard bin. The default length of the clip should be 2 seconds. In the following section, you will add the black video.

Capturing Digital Video

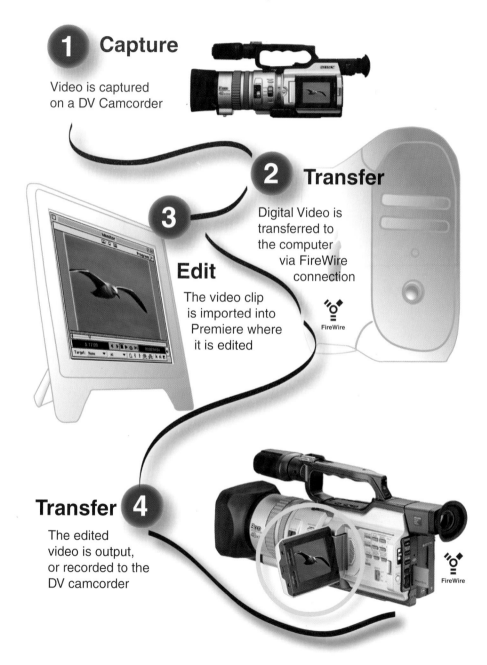

1 Capture

Video is captured on a DV Camcorder

2 Transfer

Digital Video is transferred to the computer via FireWire connection

FireWire

3 Edit

The video clip is imported into Premiere where it is edited

Monitor
Program

Target: None AI

Transfer 4

The edited video is output, or recorded to the DV camcorder

FireWire

Project Development Software

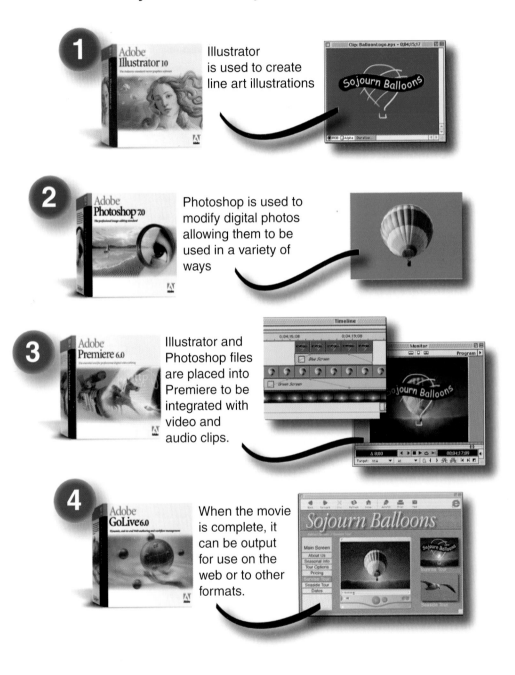

1. Illustrator is used to create line art illustrations

2. Photoshop is used to modify digital photos allowing them to be used in a variety of ways

3. Illustrator and Photoshop files are placed into Premiere to be integrated with video and audio clips.

4. When the movie is complete, it can be output for use on the web or to other formats.

Premiere Workflow

Once content elements have been acquired, they are imported into Premiere for assembly. Once edited, several output options are available.

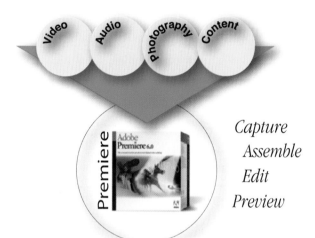

Capture
Assemble
Edit
Preview

Final Output Options

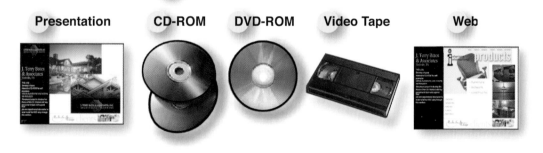

Presentation **CD-ROM** **DVD-ROM** **Video Tape** **Web**

Premiere Primary Windows

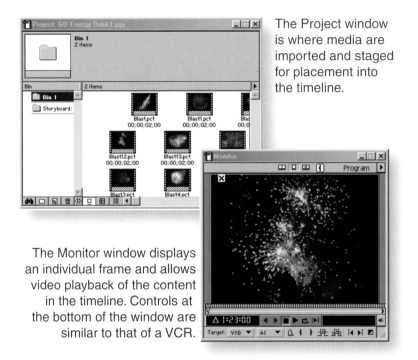

The Project window is where media are imported and staged for placement into the timeline.

The Monitor window displays an individual frame and allows video playback of the content in the timeline. Controls at the bottom of the window are similar to that of a VCR.

The timeline is where clips are placed and modified with transitions and effects to create a finished movie.

Premiere Primary Windows

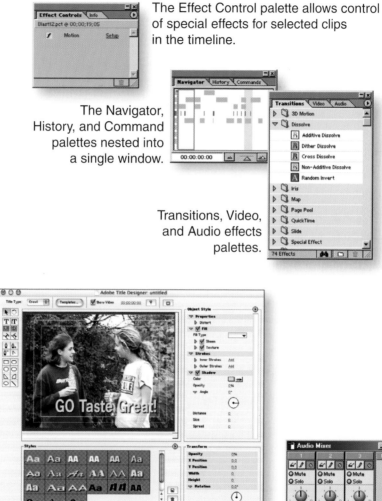

The Effect Control palette allows control of special effects for selected clips in the timeline.

The Navigator, History, and Command palettes nested into a single window.

Transitions, Video, and Audio effects palettes.

The Title window allows the assembly of text and graphics to create titles that overlay video clips.

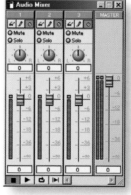

The Audio Mixer resembles professional mixing components and can precisely balance audio clips in the Premiere timeline.

Macintosh and Windows Screen Differences

The Monitor windows shown above illustrate the similarity between the Macintosh and Windows interface. The functionality of both windows is also identical.

In contrast, the Locate File dialog box demonstrates differences in button locations. The Macintosh dialog box provides options that are not available in Windows. Typically, these are operating system differences. The Premiere workflow is not affected by these differences.

The Storyboard Process

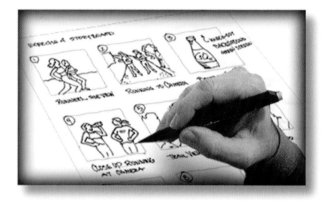

The storyboarding process is best done by sketching ideas on a notepad. Once content is captured and imported into Premiere, clips can be arranged in Premiere's storyboard window prior to being placed in the timeline.

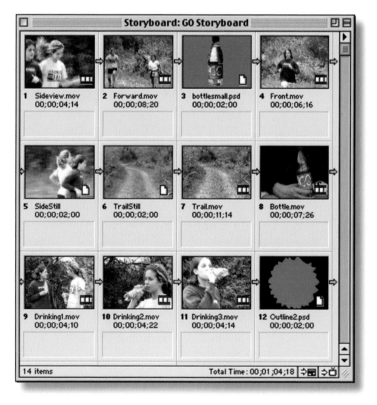

Editing Workstation Peripherals

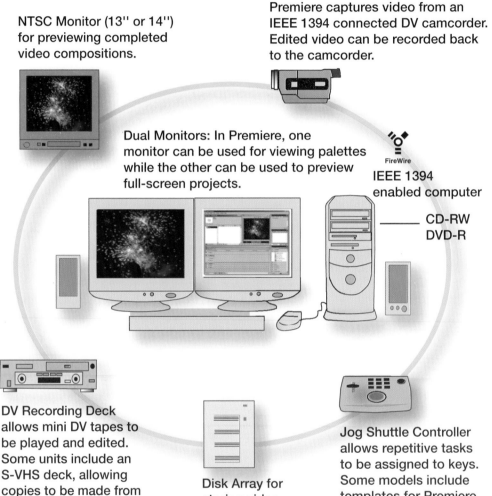

NTSC Monitor (13'' or 14'') for previewing completed video compositions.

Premiere captures video from an IEEE 1394 connected DV camcorder. Edited video can be recorded back to the camcorder.

Dual Monitors: In Premiere, one monitor can be used for viewing palettes while the other can be used to preview full-screen projects.

FireWire

IEEE 1394 enabled computer

CD-RW
DVD-R

DV Recording Deck allows mini DV tapes to be played and edited. Some units include an S-VHS deck, allowing copies to be made from the mini DV tape, and vice versa.

Disk Array for storing video files. This is a high-capacity/ high-speed drive (100 + Gigabytes).

Jog Shuttle Controller allows repetitive tasks to be assigned to keys. Some models include templates for Premiere, reducing production time.

Using the Audio Mixer

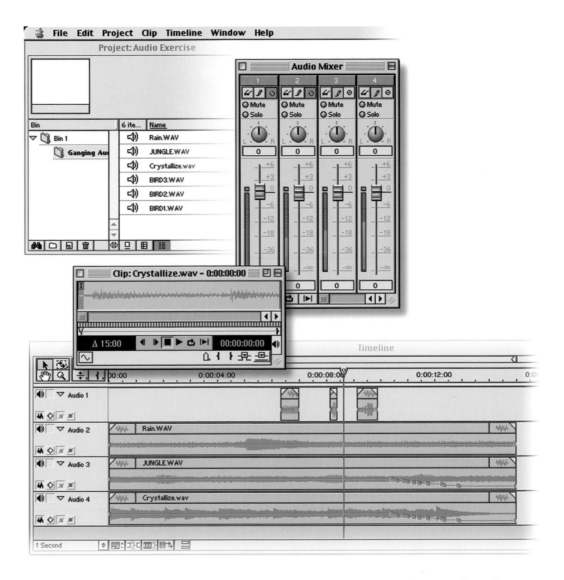

Producing video and audio projects requires precise control over imported media elements. Premiere's audio mixing capabilities allows subtle adjustments to perfect the audio track of any production.

Video Capture Solutions for Macintosh and Windows Computers

The Matrox RT2500 bundle includes a capture card, a breakout box, and a suite of software, including Premiere. The breakout box contains connections to camcorders and other input/output devices.

The RTMac solution is a similar solution designed specifically for the Macintosh.

Corporate and Professional Editing Workstations

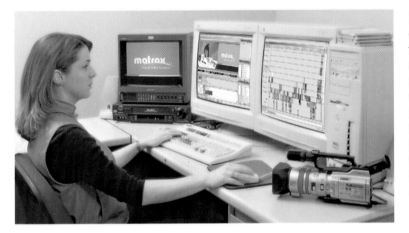

Professional video editing has come to the desktop. In this example, a corporate user assembles a video production using Adobe Premiere. Hardware is available for capture, editing, previewing, and output to video tape or DVD.

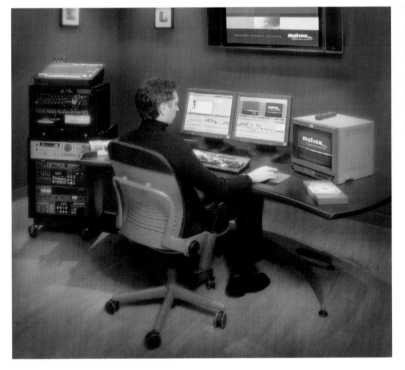

Video editing workstations come in many configurations. This example demonstrates a high-end workstation with rack mounted equipment.

Transparency and Motion in Premiere

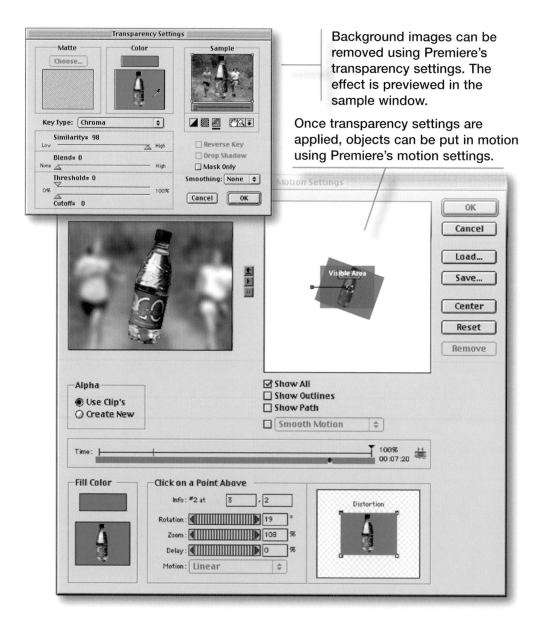

Background images can be removed using Premiere's transparency settings. The effect is previewed in the sample window.

Once transparency settings are applied, objects can be put in motion using Premiere's motion settings.

Video Content for Kiosk and Presentations

Touch Screen Kiosk

Both touch screen kiosk and presentations are richly enhanced by adding video and audio clips. Premiere adds the dynamic of video to both of these environments. By saving movies in the proper format, clips can be used in conjunction with other software products to produce stunning interactive presentations.

Presentation

Video Content for CD-ROM

Software such as Adobe Photoshop and Adobe Illustrator are essential to develop background elements that support the video clip.

Movies created in Premiere work well with products such as Macromedia Director to produce compelling content that can be distributed via cd-rom.

Video Content for DVD-ROM

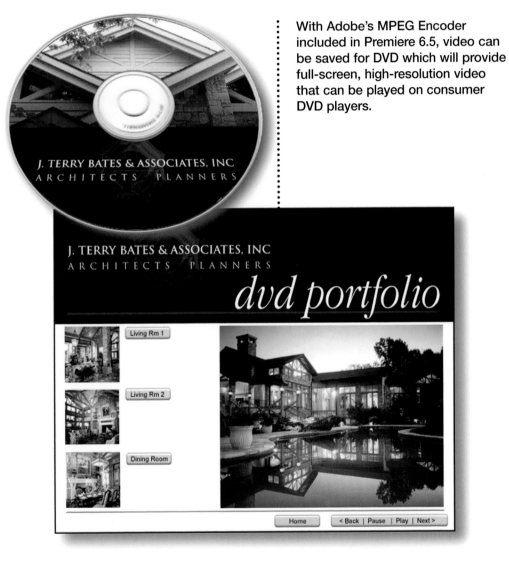

With Adobe's MPEG Encoder included in Premiere 6.5, video can be saved for DVD which will provide full-screen, high-resolution video that can be played on consumer DVD players.

J. TERRY BATES & ASSOCIATES, INC
ARCHITECTS PLANNERS

J. TERRY BATES & ASSOCIATES, INC
ARCHITECTS PLANNERS
dvd portfolio

Living Rm 1

Living Rm 2

Dining Room

Home | < Back | Pause | Play | Next >

Video Content for the Web

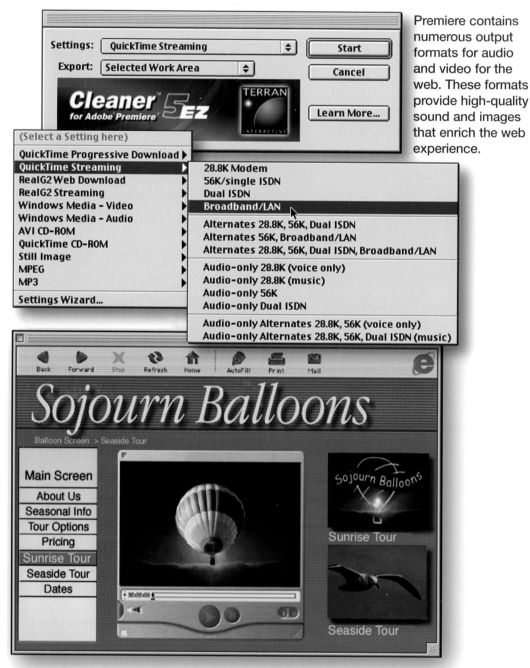

Premiere contains numerous output formats for audio and video for the web. These formats provide high-quality sound and images that enrich the web experience.

Adding the Black Video

To add the black video, perform the following steps.

1 In the Project window, click on the Create Item icon.

2 When the Create dialog box opens, select the Object Type pull-down menu and select the Black Video option. Click on OK. The *Black Video* file (clip) will be placed in the Storyboard bin. The default length of the clip is 2 seconds. See figure 9-11.

Fig. 9-11. Bars and Tone *and* Black Video *clips in the Storyboard window.*

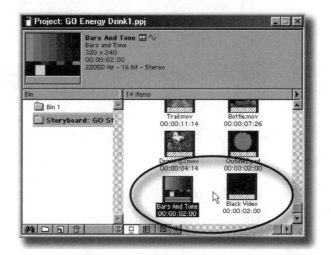

With the *Bars and Tone* and the *Black Video* clips created, they can then be imported into the timeline and placed at the beginning. The timeline currently contains the imported video and graphics clips, which begin at the 0;00;00;00 position. To move these clips to make room for the *Bars and Tone* and *Black Video* clips, continue with the following steps.

3 Select the Multitrack Select tool from the toolbox. See figure 9-12.

4 Click on the first clip in the timeline. All clips will be selected.

5 Click-hold-drag the clips to the right, releasing the mouse button when the left edge of the first clip is at the 0:00:04:00 position.

Fig. 9-12. Multitrack Select tool.

6 Click-hold-drag the *Bars and Tone* clip into the timeline's Video 1A track, beginning at the 0;00;00;00 position, and then release the mouse.

7 Click-hold-drag the *Black Video* clip into the timeline's Video 1A track, beginning at the 0;00;02;00 position, or immediately after the *Bars and Tone* clip. Your timeline should appear as shown in figure 9-13.

Fig. 9-13. Bars and Tone and Black Video clips placed at the start of the movie.

The *Bars and Tone* clip includes an audio clip that is automatically placed in the Audio 1 track. As the name implies, this is the tone.

 TIP: *If the Premiere workspace becomes disorganized, select Window > Workspace > A/B Editing. This will tidy up the workspace.*

With the addition of the *Black Video* clip, now that all video clips have been incorporated, you need to arrange the clips in the timeline.

Arranging the Video Clips

Fig. 9-14. The Navigator palette allows instant viewing of any portion of the timeline.

In the timeline, view the placement of clips by reviewing the Navigator palette, shown in figure 9-14. By moving the Navigator window to the extreme right, you can view the end of the project to determine the current length of the placed clips. You will notice that the clips currently consume a little over one minute in the timeline.

Having used the Automate to Timeline option, the clips have been placed in a manner that will allow embellishment. This series of tutorials requires much customization of individual clips, as well as the addition

of other audio and video tracks. The placement of these clips will set the stage for the ongoing development of this tutorial in chapters 10, 11, and 12.

Because there are many video and graphics clips to configure, you will modify them individually according to their order in the timeline. Step-by-step instructions for doing so follow, and the final layout is shown in figure 9-18.

Before beginning individual clip modification, remember that the name of each clip will appear by moving the pointer over the clip. If this does not happen, turn this feature on by selecting Edit > Preferences > General & Still Image > Show Tool Tips.

When aligning clips to a specific time, first drag the edit line to the location, set the Snap To Edges option to the On position, and then move the clip so as to align its left edge with the edit line. For precision alignment, refer to the counter located in the lower right-hand side of the Monitor window. In the sections that follow, you will align the clips.

Sideview.mov/Track Video 1A. To align the *Sideview.mov* clip, perform the following steps.

1 Align the left edge to begin at position 0;00;04;00.

2 Align the right edge to end at position 0;00;08;13 (no modification required).

Forward.mov/Track Video 1B. To align the *Forward.mov* clip, perform the following steps.

1 Align the left edge to begin at position 0;00;07;15.

2 Align the right edge to end at position 0;00;16;04 (no modification required).

BottleSmall.psd/Track Video 2. To align the *BottleSmall.psd* clip, perform the following steps.

1 Align the left edge to begin at position 0;00;08;13.

2 Align the right edge to end at position 0;00;16;04.

Forward.mov (Copy 2)/Track Video 2. To align the *Forward.mov* (copy 2) clip, perform the following steps.

1 Select the *Forward.mov* clip and then select Edit > Copy.

2 Click to the right of the *BottleSmall.psd* clip to select the empty area and then select Edit > Paste. A copy of the clip will be pasted here.

3 Align the left edge to begin at position 0;00;16;04.

4 Leave the right edge alignment as is for the moment. You will trim this right edge along with the following clip.

Front.mov/Track Video 1A. To align the *Front.mov* clip, perform the following steps.

1 Align the left edge to begin at position 0;00;16;04.

2 To align the right edge, move the edit line to the 0;00;22;15 position and select Timeline > Razor at Edit Line. The clips will be trimmed. Select both clips to the right of the edit line and delete them.

NOTE: *Remember to save your project often during development.*

3 Scroll to the right, or use the Navigator palette to move to the right. Set the Timeline window so that the left edge begins at the 0;00;21;00 position.

Sideview.mov (Copy 2)/Track Video 1B. To align the *Sideview.mov* (copy 2) clip, perform the following steps.

1 From the Project window, double click on the *Go Storyboard* file.

2 Once the *Go Storyboard* file is open, click-hold-drag the *Sideview.mov* clip into video track 1B. Close the Storyboard window. Modify this clip as follows.

3 Align the left edge to begin at position 0;00;22;00.

4 Align the right edge to end at position 0;00;26;13 (no modification required).

TIP: *This is a copy of the* Sideview.mov *clip at the beginning of the movie. Copies can be made from other copies in the timeline, or can be imported over and over again, such as this clip.*

Sidestill/Track Video 1A. To align the *Sidestill* clip, perform the following steps.

1 This is a still image. Before adjusting its alignment, select the Multi-track Select tool and move the tracks forward as shown in figure 9-15. Move the clips approximately 10 seconds forward.

Adjustments to the *Sidestill* image cannot be made until these tracks have been moved forward.

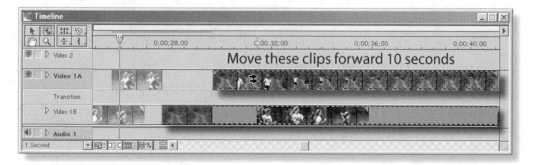

Fig. 9-15. *Tracks shifted forward to make room for changes in the* Sidestill *image.*

2 Align the left edge to begin at position 0;00;26;00.

3 Double click on the *Sidestill* clip. The Clip window will appear. Select the Duration option at the bottom of the screen and type in a new duration of *0;00;10;00.*

The clip will expand to the right, reflecting the 10-second duration.

 NOTE: *For the clip to expand to the right, a 10-second space must be available in the timeline.*

BottleSmall.psd (Copy 2). In the following, you will place a second copy of the *BottleSmall.psd* file.

1 Open the storyboard, locate the *Bottlesmall.psd* clip, and click-hold-drag the clip into the timeline in Video 2.

2 Align the left edge to begin at position 0;00;26;00.

3 Double click on the clip and set the Duration option to 0;00;10;00.

4 In the Timeline window, expand the timeline to reveal all video tracks.

Figure 9-16 shows how your Timeline window should now appear, and the location your screen should currently display.

Fig. 9-16. The Timeline window should be at this location at this point in the tutorial.

TrailStill/Video 1B. To align the *TrailStill* clip, perform the following steps.

1 In video 1B, move the timeline to begin at the 0;00;33;00 position.

2 In video 1B, double click on the *TrailStill* clip. Set the Duration option to 0;00;12;00. Position the clip as follows.

3 Align the left edge to begin at position 0;00;34;15.

4 Align the right edge to end at position 0;00;46;15 (no modification required).

Trail.mov/Video 1A. To align the *Trail.mov* clip, perform the following steps.

1 The clip *Trail.mov* is currently in video 1A. Click-hold-drag the clip into the video 2 track.

2 Align the left edge to begin at position 0;00;37;09.

3 Align the right edge to end at position 00;0048;22 (no modification required).

Bottle.mov/Video 1B. To align the *Bottle.mov* clip, perform the following steps.

1 Align the left edge to begin at position 0;00;47;15.

2 Align the right edge to end at position 0;00;55;10 (no modification required).

Drinking1.mov/Video 1A. To align the *Drinking1.mov* clip, perform the following steps.

1 Align the left edge to begin at position 0;00;54;15.

2 Align the right edge to end at position 0;00;58;24 (no modification required).

Drinking2.mov/Video 1B. To align the *Drinking2.mov* clip, perform the following steps.

1 Align the left edge to begin at position 0;00;58;00.

2 Align the right edge to end at position 0;01;02;21 (no modification required).

Drinking3.mov/Video 1A. To align the *Drinking3.mov* clip, perform the following steps.

1 Align the left edge to begin at position 0;01;02;00.

2 Align the right edge to end at position 0;01;06;13 (no modification required).

Outline2.psd/Video 2. To align the *Outline2.psd* clip, perform the following steps.

1 This clip currently resides in video 1B. Click-hold-drag the clip into video 2 and release to align the left edge to begin at position 0;01;02;00 (aligned with the *Drinking3.mov* clip).

2 To align the right edge, move the edit line to the 0;01;07;00 position.

3 Click-hold-drag the right edge of the *Outline2.psd* clip until it snaps to the edit line at this position.

Logo.psd/Video 1B. To align the *Logo.psd* clip, perform the following steps.

1 Move the edit line to the 00;01;05;23 position and release the mouse. Click-hold-drag the *Logo.psd* clip into the video 1B track and release at the edit line location.

2 Align the left edge to begin at position 00;01;05;23.

3 Double click on the *Logo.psd* clip and set a new duration of 6 seconds (0;00;06;00).

4 Align the right edge to end at position 00;01;11;22 (no modification required).

Logo.eps/Video 2. The *Logo.eps* file is the last clip to be placed in the timeline. To align the *Logo.eps* clip, perform the following steps.

1 Move the edit line to the 00;01;11;00 position and release the mouse.

2 Click-hold-drag the *Logo.eps* clip into the Video 2 track at the 0;01;11;00 position.

3 Double click on the clip and change the Duration setting to 10 seconds (0;00;10;00).

The clip will expand to the right to reflect the new duration.

4 With the *Logo.eps* clip selected in the timeline, select Clip > Video Options > Maintain Aspect Ratio.

Black Video . Most video projects end by fading to black. This movie is no exception. To align the *Black Video* clip, perform the following steps.

1 In the Project bin, double click on the Storyboard bin. The content will display in the View window. Scroll to the bottom of the window and locate the *Black Video* clip. Click-hold-drag this clip into video 1B in the Timeline window and release the mouse.

2 Drag the edit line to the 0;01;09;00 position. Move the *Black Video* clip so that its left edge snaps to this position.

3 Drag the edit line to the 00;01;23;00 position and release the mouse. Click on the right edge of the *Black Video* clip and drag it to the right until it snaps into this position.

Figure 9-17 shows how this clip marks the end of the movie.

4 Save the movie.

Figure 9-18 shows the precise placement of each clip in this movie, as well as the relationship between clips in various tracks.

Fig. 9-17. The end of the movie is established with the Black Video *clip.*

NOTE: *Some details in the timing locations cannot be illustrated here. See the previous tutorial material for individual clip details regarding appropriate beginning and ending times.*

Fig. 9-18. Placement for all clips in the tutorial movie.

Previewing the Movie

You have created the "skeleton" (framework) for the tutorial movie. The clips you placed into the timeline are at this point only roughly formatted. You have not yet developed these clips to a degree they could be considered a "rough cut" of the project. A rough cut is an unrefined version of a movie that can be previewed. This provides a sense of the movie's structure.

You will be taken through the "rough cut" process in subsequent chapters. Chapters 10, 11, and 12 take the project through the rough cut process and to completion. As you develop your own projects, the structure of this series of tutorials will help you with initial project planning, as well as with the implementation of effects, titles, and other elements that will contribute substance to any production.

Summary

With a movie framework established in this chapter, the project will continue to develop in chapters 10, 11, and 12. Fundamentals such as creating storyboards, automating to the timeline, and arranging clips in the timeline have been introduced in this chapter. The processes learned here will be beneficial in the balance of this tutorial, as well as for independent projects developed on other subject matter.

CHAPTER 10
SUPERIMPOSING CLIPS AND KEYING TRANSITIONS

Introduction

In Chapter 9, the foundation was developed for chapters 10, 11, and 12. Beginning in this chapter, enhancements will be made to the clips you placed during the tutorial in Chapter 9. This chapter focuses on the addition of special effects. These effects will modify both video clips and still images to provide a new dynamic to the video.

The tutorials in this chapter incorporate many effects to demonstrate the power of these tools. However, just because Premiere offers many video and other types of effects, it does not mean that they should all be used in a single production. Good taste is always the rule.

Objectives

The following are the objectives of this chapter.

- Manipulating images using matte tools
- Manipulating images using keying
- Manipulating images using other specialized tools
- Layering images and scenes

Tutorial 10-1: Working with Special Effects

To begin, the *Go Energy Drink* file should be opened. A quick way to open this file is to select File > Open Recent Project, and then from the pop-out menu select the *Go Energy Drink* document. See figure 10-1.

Fig. 10-1. How to quickly access recent projects.

If for some reason you do not have access to the completed tutorial from Chapter 9, a copy can be opened as follows: CD-ROM > *Tutorials* > *Energy Drink* > *Go Energy Drink1.ppj.*

The Track Format

As the *Go Energy Drink* file was completed in Chapter 9, the Timeline view was changed to better view the clip names. To view clips here, change the Track Format section as follows.

1 Select Window > Window Options > Timeline Window Options.

2 In the Track Format section of the Timeline Window Options dialog box, select the top option to change to the Icon view.

This will aid in the design and implementation of the project as a whole as development progresses.

The Video Effects Palette

The Video Effects palette is a series of folders that contain an assortment of effects that can be applied to clips in the timeline. Once a video

effect is applied to a clip, the effect can be customized. Video effects are applied to a clip by selecting the effect and dragging it onto a clip in the timeline. Once the effect has been placed on the clip, the effect can be modified by making changes in the Effect Controls palette. Video effects and the Effect Controls palette will be used in the remainder of this tutorial.

Applying the Gaussian Blur Video Effect

With a fundamental understanding of the Video Effects palette, in the following you will apply the Gaussian blur effect to a clip in the timeline.

 NOTE: *The video effect here and in the material to follow will be applied to clips located in the Video 1A and Video 1B tracks.*

Orient the timeline to reveal the *Forward.mov* clip, as shown in figure 10-2. Expand the Video 1B track by clicking on the triangle to the track header.

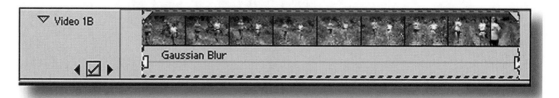

Fig. 10-2. The Gaussian blur filter placed on a video clip.

1 In the Effects palette, click on the Video tab to reveal Premiere's video effects.

2 Click on the triangle next to the *Blur* folder to reveal the blur filters.

3 Click-hold-drag the Gaussian blur filter into the timeline, releasing it over the *Forward.mov* clip. See figure 10-2.

Three visual changes happened when you placed the filter on the clip.

- The name of the filter is indicated at the bottom of the clip, along with the keyframes at the beginning and end of the clip.

- A check box with directional arrows to the left and the right is added to the track header.

- The Effect Controls palette in the top right of the screen is activated and displays information about the effect settings.

These are typical of the result of all added effects. However, each effect has unique adjustments and some filters will open unique dialog boxes.

NOTE: *You may have noticed the difference in the icons in the Blur Effects selection. The Gaussian blur effect just placed is a filter that has been imported from Adobe AfterEffects. See figure 10-3.*

Fig. 10-3. Standard Premiere effects icons and Adobe AfterEffects filter icons.

Why this effect? The purpose of using this filter is to prepare the clip to support the *Bottlesmall.psd* clip. The bottle image will be transparent. Therefore, you will use *Forward.mov* as a background image. In addition, to emphasize the bottle, the runners will gradually blur.

Modifying Effect Settings

Before modifying settings for the Gaussian blur filter, you need to review the Effect Controls palette and how it affects the clip in the timeline. Review figure 10-4. With the Gaussian blur effect in place, you can now make modifications to the default settings.

1 In the Effect Controls palette, turn on the Stopwatch feature. This will activate the keyframe feature and allow effects to occur and to be recorded between specific keyframes.

2 Position the edit line at 0;00;10;00.

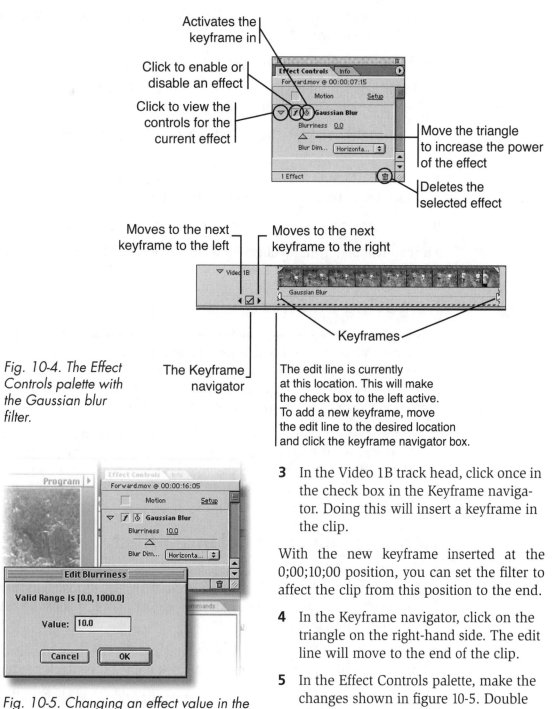

Activates the keyframe in

Click to enable or disable an effect

Click to view the controls for the current effect

Move the triangle to increase the power of the effect

Deletes the selected effect

Moves to the next keyframe to the left

Moves to the next keyframe to the right

Keyframes

Fig. 10-4. The Effect Controls palette with the Gaussian blur filter.

The Keyframe navigator

The edit line is currently at this location. This will make the check box to the left active. To add a new keyframe, move the edit line to the desired location and click the keyframe navigator box.

Fig. 10-5. Changing an effect value in the Effect Controls palette.

3 In the Video 1B track head, click once in the check box in the Keyframe navigator. Doing this will insert a keyframe in the clip.

With the new keyframe inserted at the 0;00;10;00 position, you can set the filter to affect the clip from this position to the end.

4 In the Keyframe navigator, click on the triangle on the right-hand side. The edit line will move to the end of the clip.

5 In the Effect Controls palette, make the changes shown in figure 10-5. Double click on the number after the Blurriness control. The Edit Blurriness dialog box

will open. Type in *10.0* here, or if you wish, use the slider control to make the changes.

Preview the effect by continuing with the following steps.

6 Double click on the work area bar at the top of the timeline. Left-side and right-side handles will appear.

7 Position the handles to begin and end directly over the *Forward.mov* clip.

8 Temporarily hide the content in Video 2 by clicking on the Toggle Track Output/Shy State icon in the track header.

9 Press Enter to preview the clip with the Gaussian blur effect.

The clip will play with no effect for a couple of seconds before it begins applying the Gaussian blur effect.

Removing an Effect

Any clip in the timeline that contains an effect has a blue line at the top of the clip. When the clip is selected, the effect properties appear in the Effect Controls palette. Any effect can be removed as follows. First, verify that the effect is selected in the Effect Controls palette. Click on the Trash Can icon located at the bottom of the palette.

When the trash can is selected, a dialog box opens, asking you to confirm that you want to delete the effect. If you select Yes, the effect will be deleted. However, if you immediately select Edit > Undo Remove Filter, the filter will reappear. If you want to recover a removed effect, use the History palette to go back a step.

Applying the Color Balance Effect

In the following, you will apply a color balance effect to the *SideStill* clip. The *SideStill* clip is located in the Video 1A track and is a graphic. To prepare, move the timeline so that its left edge begins at the 0;00;25;00 position.

1 Select the clip by clicking on it once, and expand the track by selecting the triangle next to the Video 1A track name in the track header.

2 In the Video Effects palette, locate the *Adjust* folder and click on the triangle to reveal the effects.

3　Click-hold-drag the color balance effect onto the *SideStill* graphic. You will notice in the Effect Controls palette that this effect contains its own set of controls.

4　In the Effect Controls palette, set the controls to reflect the settings shown in figure 10-6. Additional controls are available by scrolling or by enlarging the Effect Controls window.

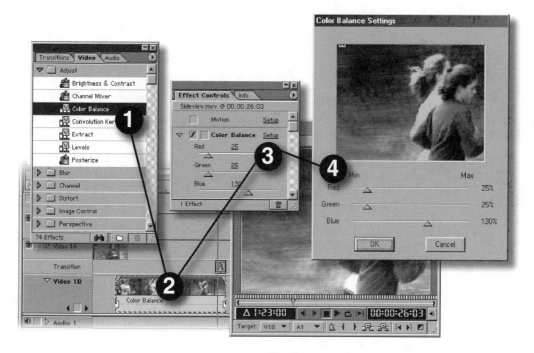

Fig. 10-6. Changing the effect value in the color balance effect.

The changes made to this clip will not appear until the clip has been rendered. It is not necessary to preview this clip because it is a still image and the effects were visible as the color balance was adjusted.

Why this effect? The color balance filter is used on this clip to prepare it for use in Chapter 12. This clip will become a background for a tutorial involving scrolling text.

Temporarily Disabling Effects

Effects can be set and temporarily disabled as needed. The Effect Controls palette contains an Enable Effects toggle. As shown in figure 10-7,

the effect is on when the Enable Effect icon is visible. By clicking this icon, the effect will be temporarily disabled. The effect also remains in the Effect Controls palette.

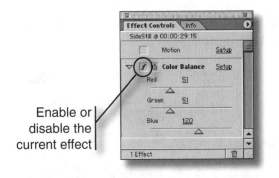

Enable or disable the current effect

Fig. 10-7. Toggle button for enabling or disabling an effect.

Applying the Posterize Effect

In the following, you will add an effect to the *Bottle.mov* clip in the Video 1B track.

1 Using the Navigator palette, move the timeline so that it begins at the 0;00;47;00 position.

2 Select *Bottle.mov* by clicking anywhere on this clip.

3 Select the Video tab in the Effects palette.

4 Click on the triangle next to the *Adjust* folder. When the filters are revealed, click-hold-drag the Posterize filter onto the *Bottle.mov* clip and release the mouse. You will notice that this is an Adobe AfterEffects filter.

5 With the edit line at the beginning of the clip, select the stopwatch, and then set the level to 9. Move the edit line to the end of the clip and set the level to 12. Figure 10-8 shows the setting for the beginning of the clip.

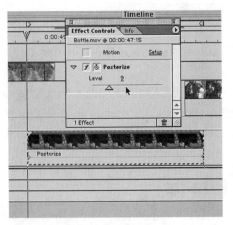

Fig. 10-8. Settings for the Posterize filter.

These settings will allow the effect to gradually build from the start of the clip to the end, with three visual modifications in between. The edit line must be at the beginning of the clip (the first keyframe) to initiate the first setting. The edit line must be at the end of the clip (the last keyframe) when modifying the last setting.

6 With the filter on the clip, make the changes as shown in figure 10-8.

The settings for this effect will allow the effect to start at the beginning of the clip and gradually build to the end of the clip with no changes

between. The edit line must be at the beginning of the clip (the first keyframe) to initiate the first setting. The edit line must be at the end of the clip (the last keyframe) when modifying the settings.

7 Preview the *Bottle.mov* clip by double clicking on the work area bar at the top of the timeline. Adjust the handles to begin and end at the same duration as the *Bottle.mov* clip. Press Enter to begin the preview.

Adding a Black-and-White Effect

In the following, you will modify the *Drinking2.mov* clip in the Video 1B track.

1 Using the Navigator, position the timeline so that it begins at the 0;00;56;00 position.

2 Select the *Drinking2.mov* clip by clicking anywhere on this clip.

3 Select the Video tab in the Effects palette.

4 Click on the triangle next to the *Image Control* folder. When the filters are revealed, click-hold-drag the Black & White filter onto the *Drinking2.mov* clip and release the mouse.

5 Move the work area bar over the clip and press Enter to preview the effect.

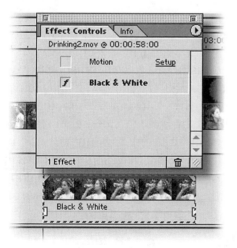

In the Effect Controls palette you will notice that there are no options for the Black and White effect beyond having the effect turned on or turned off. See figure 10-9.

Why this effect? The Black & White filter is a somewhat trendy effect that can really have impact as applied in the context of a colorful, fast-action series of video clips. Although typically used to evoke a nostalgic feel, in this tutorial the effect is used primarily for interest and impact. You will also notice that the Black & White filter has no controls; that is, it is either on or off.

Fig. 10-9. Settings for the Black & White filter.

 TIP: *Remember to save your work often!*

Applying the Lens Flare Effect

The last of the effects to be applied from the Video Effects palette is the lens flare effect. In the following, you will apply this to the *Logo.psd* clip in the Video 1B track.

1 Reposition the timeline so that it begins at 0;01;05;00.

2 Select the *Logo.psd* clip to activate it.

3 In the Video Effects palette, locate the *Render* folder and click on the triangle to reveal its content.

4 Click-hold-drag the lens flare effect onto the *Logo.psd* clip and release the mouse. You will notice that after placing this effect on this clip that a unique dialog box opens, called the Lens Flare Settings dialog box. This is unlike previously applied effects.

5 In the Lens Flare Settings dialog box, make the following adjustments.

- Set the brightness to 225.

- Flare Center: No Change.

- Lens Type: 50 - 300mm Zoom.

6 Click on OK.

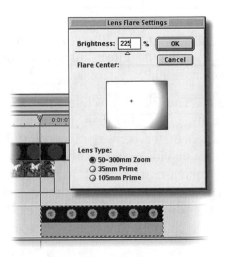

Fig. 10-10. Lens Flare Settings dialog box for the beginning of the clip.

These settings can be retrieved and modified by selecting the Setup option in the Effect Controls palette. As you made this initial adjustment, you may have noticed the flare center. This is a cross (+) located near the center of the graphic. The location of the flare center can be moved by click-hold-dragging the center to any position in the window. This will change the point of origin of the center of the lens flare effect. By making this initial setting, this clip will open into virtually a 100% white screen. See figure 10-10.

 NOTE: *Before adding a different Lens Flare setting to the end of the clip, it is important to click on the Stopwatch icon, which will initiate the keyframing process.*

Setting the Lens Flare option for the end of the *Logo.psd* clip works the same as for the previous effect. The keyframe at the end of the clip must be selected before applying the effect. To set the effect, continue with the following steps.

7 In the Keyframe navigator, click on the right-hand arrow to move the edit line to the end of the clip.

8 Click on the Enable Keyframing button.

9 In the Effect Controls palette, double click on the Setup option. The Lens Flare Settings dialog box will open.

10 Make the following changes in the Lens Flare Settings dialog box.

- Set the brightness to 125.
- Flare Center: See figure 10-11 (approximate this location).
- Lens Type: 50 - 300mm Zoom.

11 Click on OK.

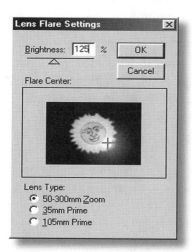

Fig. 10-11. The Lens Flare Settings dialog box for the end of the clip.

12 With the lens flare effect set at the beginning and the end, move the work area bar over the clip and preview the effect.

Why this effect? The Lens Flare is a graceful, dynamic filter that was created to represent the effect that occurs when a camera lens is exposed directly to the sun during an outdoor event. It brings a sense of warmth and subtle movement to any type of graphic object. In this scenario, the flare is placed on an image of the sun to bring the image a unique atmosphere.

13 Preview the file to review the effects placed so far.

Although the project is not complete, previewing will give you a sense of where the tutorial is going.

Tutorial 10-2: Superimposing Clips and Keying Effects

In the previous section, you made modifications to individual clips in the Video 1A and Video 1B tracks. These modifications affected the content of those clips only. In this section, you will modify clips in the Video 2 and Video 3 tracks in a manner that will allow them to affect or to be intertwined with the images directly under them in the timeline.

 NOTE: *In the following, video effects will be added to clips located in the Video 2 track.*

Track Hierarchy

As you have probably noticed, the order of the tracks in the timeline affects what clips are visible on screen. The clips in the higher tracks have viewing priority over clips in lower tracks. You may have experienced similar effects in a drawing program in which objects can be brought to the front, or sent to the back. If you are a Photoshop user, you are familiar with the layer process and how the opacity of a layer can be adjusted to reveal the image below.

As additional tracks are added, beginning with the Video 2 track, clips can be superimposed over lower tracks. This is why tracks from Video 2 and up are referred to as *superimpose tracks*. The superimpose tracks will allow you to add visual elements to the images below by reducing transparency, by adjusting the size of a clip, by using keying effects, and by using an abundance of other special effects. This section of the chapter deals with certain techniques that will show you how to effectively utilize the superimposing process, as well as other features, to further enhance this movie.

Superimposing Clips

To begin this phase of the tutorials, expand the Timeline window to the bottom of the monitor, turn track viewing on, and expand the track to reveal the entire track by clicking on the triangle next to the title in the video track header.

Using the Chroma Key

In the following, you will use the Chroma Key feature to remove the background from the *Bottlesmall.psd* clip and allow the bottle image to appear over the clip in Video 1B.

1 Move the timeline to the left so that the timeline begins at the 0;00;05;00 location.

2 Enable the Toggle Track Output/Shy State icon in Video 2, and then select the *Bottlesmall.psd* clip by clicking on it once.

3 In the Effect Controls palette, select the Setup option next to the Transparency option. The Transparency Settings dialog box opens.

4 Under the Key Type menu, select the Chroma option.

5 In the Color window, move the pointer over the green background. You will notice that the pointer changes to the Eyedropper tool, allowing you to select a color to be removed. Click anywhere in the green background.

Most of the color will immediately be removed. The Sample window will display the amount of color removed, thus revealing the clip directly under the bottle image.

6 In the lower part of the Transparency Setting screen, there are three adjustment sliders. Click-hold-drag the Similarity slider to the right to the 98-percent level.

Fig. 10-12. Transparency Settings dialog box.

As you view the changes happening in the Sample window, you will notice that doing this will remove all of the green background from the Sample image screen. By clicking on the Magnifying Glass tool, you can zoom in to more closely examine the edges of the bottle to ensure that the green has been removed. Using the Hand tool allows you to move the image. The Sample window also contains a slider control that will allow you to scrub through this clip to see how it relates to the clip beneath it.

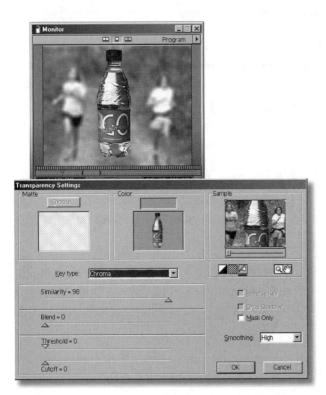

Fig. 10-13. The Bottlesmall.psd *clip with the background removed, revealing the clip in Video 1B.*

7 Leave the Blend, Threshold, and Cutoff settings as they are and click on OK.

As shown in figure 10-12, the Sample window provides a sample of how the green background will be removed. This figure also shows the features of the Transparency Settings dialog box.

8 Figure 10-13 shows a sample of the previewed image taken from the Monitor window. To ensure that the green screen has been totally removed, preview the clip and scrub through the rendered clip in the Monitor window.

In the timeline, you will notice in the *Bottlesmall.psd* clip that the name of the effect has been added to the clip. This will be helpful as more effects are added, providing a quick reference to clips and their applicable effects.

Modifying the Second Bottlesmall.psd Clip

In the following, you will use the Chroma Key feature to remove the background from the *Bottlesmall.psd* clip that begins at the 0;00;26;00 location in the Video 2 track. This will allow the *Bottlesmall.psd* image to overlay the *SideStill* clip in Video 1A.

1 Select the *Bottlesmall.psd* clip by clicking on it once.

2 In the Effect Controls palette, select the Setup option next to the Transparency option. The Transparency Settings dialog box opens.

3 Under the Key Type menu, select the Chroma option.

4 In the Color area in the center of the window, move the pointer over the green background. You will notice that the pointer changes to

the Eyedropper tool, allowing you to select a color to be removed. Click anywhere in the green background. Most of the color will be immediately removed. The Sample window will display the amount of color removed, thus revealing the clip directly under the bottle image.

5 In the lower part of the Transparency Settings screen, there are four adjustment sliders. Click-hold-drag the Similarity slider to the right to 55, and position the Blend setting to 50.

6 Click on OK to exit the Transparency Settings dialog box.

Using Garbage Mattes

Interesting term...garbage mattes! A garbage matte is used when the video clip contains an element unusable or undesirable for the scene you wish to create. The garbage matte process allows clips to be overlapped and dynamically cropped, creating an interesting effect. In this tutorial, the garbage matte effect will be used to integrate two scenes and to create a split-screen effect that will merge two scenes.

1 To begin creating a garbage matte, move the timeline so that the left edge begins at the 0;00;12;00 position.

2 Select the *Forward.mov* clip by clicking on it once.

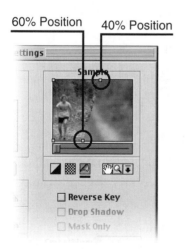

Fig. 10-14. Adjusting the Forward.mov *clip.*

3 In the Effect Controls palette, select the Setup option next to the Transparency option. The Transparency Settings dialog box opens. (You can also select Clip > Video Options > Transparency.)

4 In the Sample section of this dialog box, you will notice that the sample image has a handle in each corner. You will modify the two handles on the right side.

5 Click-hold-drag the handle in the upper right of the screen to the left and release it at approximately the 40% location, keeping the handle at the top of the screen. You will notice as you drag the handle that the clip below will be revealed.

6 Click-hold-drag the handle in the lower right of the screen to the left, keeping the handle at the bottom of the screen, and release it at approximately the 60% location. See figure 10-14 for placement details.

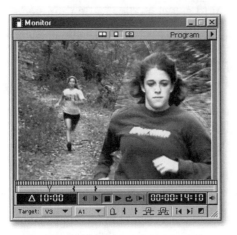

Fig. 10-15. Merged clips using the garbage matte technique.

7 Using the slider under the image in the Sample window, scrub through the clip to preview the effects.

8 In the timeline, double click in the work area bar to make the bar active in current timeline area. Adjust the left and right handles to place the bar over the garbage matte clips and press Enter to preview. Figure 10-15 shows how the clip will appear in the Monitor window.

This clip will undergo additional enhancements later in the chapter.

RGB Difference

The RGB Difference key works in a manner similar to the Chroma key. In the following, you will employ additional keying effects to perform further superimposing.

1 Position the timeline so that the left edge begins at the 00;01;00;00 position. You will modify the *Outline2.psd* clip.

2 Select the *Outline2.psd* clip by clicking on it once.

3 Select Clip > Video Options > Transparency.

4 When the Transparency Settings dialog box opens, select Key Type > RGB Difference. In the Color window, click on the green portion of the graphic.

5 Move the Similarity slider to the right, to the 55 position.

6 In the Sample screen, use the Magnifying Glass tool to zoom in to inspect the edges of the graphic to ensure that no green pixels are present.

7 In the Smoothing pull-down menu, select Low.

8 Use the slider under the sample image to preview how using the RGB Difference key will affect the merged video clips, and then click on OK.

9 Review figure 10-16 for setup details.

10 Move the work area bar over the clip and preview the clip.

Fig. 10-16. Merged clips using the RGB Difference key.

Alpha Keys

Like the previous key effects, the alpha key will make a part of the image transparent to achieve a desired effect. In the following, you will apply an alpha key to the *Logo.eps* file in the Video 2 track.

1 Position the timeline so that the left edge begins at the 0;01;10;00 position. You will modify the *Outline2.psd* clip.

2 Select the *Logo.eps* clip by clicking on it once.

3 Select Clip > Video Options > Transparency (or Setup from the Transparency option in the Effect Controls palette).

4 From the Key Type menu, select Alpha Channel from the pull-down menu. You will notice the background disappear by viewing the Sample screen in the upper right of the dialog box.

5 Click on OK to close the Transparency Settings dialog box.

In the monitor, you will notice that the background image in the *Logo.eps* file will have been removed. In addition, the Alpha Key text is inserted into the clip in the timeline to reflect the placed transition.

Previewing the *Logo.eps* clip at this point would not be very beneficial due to the fact that there is no underlying clip to affect the visual impact. In Chapter 11, you will add motion to this clip to bring it to life.

6 Save your project.

Tutorial 10-3: Placing Transitions

Chapter 9 placed the video clips. So far in Chapter 10, these clips have been enhanced with numerous special effects. To continue the building process, in material to follow you will place transitions associated with the existing clips.

About Transition Placement

Each transition will contain a figure that relates to the proper position for placement and use. There are a total of nine transitions to be placed. They will be referred to by number, beginning at number 1, which will be the first transition in the timeline. Higher numbers will progress as the timeline progresses in length. Before placing transitions, perform the following.

1 Verify that the Transitions palette is open and that the Transitions tab is selected.

2 Using the Navigator palette, move the timeline to the beginning.

Placing Transitions

This portion of the tutorial assumes that you will navigate to the specific portion of the timeline as shown in the illustrations that accompany each transition.

Transition 1

Using figure 10-17 as a guide, place the first transition by performing the following steps.

1 From the Transitions palette, open the *Dissolve* folder and click-hold-drag the Cross Dissolve transition into the Transition track.

2 In the timeline, drag the edit line to the 0;00;04;15 position.

3 Click-hold-drag the right side of the transition to the left until it snaps to the edit line.

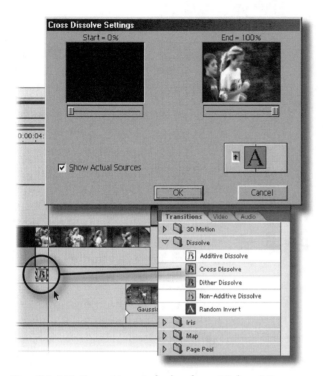

Fig. 10-17. Transition 1 fades from Video 1B to Video 1A.

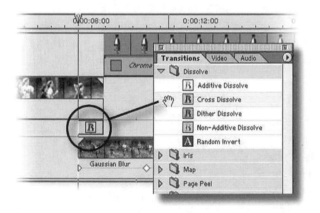

Fig. 10-18. Transition 2 fades from Video 1A to Video 1B.

4 Double click on the transition and make the changes shown in figure 10-17.

5 Preview the clip to ensure that the fade begins with the video clip in Video 1B and fades into Video 1A. The transition will be black and dissolve into the *Sideview.mov* clip.

Transition 2

Using figure 10-18 as a guide, place the second transition by performing the following steps.

1 From the Transitions palette, open the *Dissolve* folder and click-hold-drag the Cross Dissolve transition into the Transition track into the specified position. If the Snap To Edges option is turned on, the clip will automatically align to the left (with the clip in Video 1B), and automatically align to the right (with the clip in Video 1A).

2 No change is necessary in the default settings to this clip. The default will allow the transition to dissolve from A to B. This is the desired effect.

3 Set the work area bar to preview the transition 2 seconds before and 2 seconds after the transition, and press Enter to preview the transition and its effects on the clips.

Transition 3

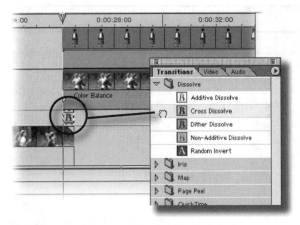

Fig. 10-19. Transition 3 dissolves the clip in Video 1B into Video 1A.

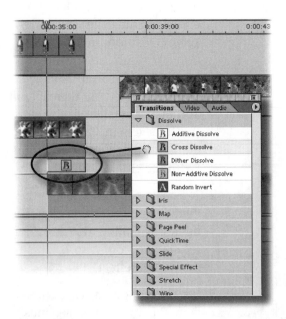

Fig. 10-20. Transition 4 joins Video 1A to Video 1B.

Using figure 10-19 as a guide, place the third transition by performing the following steps.

1 From the Transitions palette, open the *Dissolve* folder and click-hold-drag the Cross Dissolve transition into the Transition track into the specified position. If the Snap To Edges option is turned on, the clip will automatically align to the right (with the clip in Video 1B), and automatically align to the left (with the clip in Video 1A).

2 Double click on the transition to ensure that the Cross Dissolve setting starts at B and ends with A. Click on OK to close the dialog box.

3 Set the work area bar to preview the transition 2 seconds before and 2 seconds after the transition, and press Enter to preview the transition and its effects on the clips. Important: A clip resides in the Video 3 track that may interfere with the preview process. Disable the Video 3 track from appearing in the preview by clicking on the Eye icon. The Eye icon will disappear.

Transition 4

Using figure 10-20 as a guide, place the fourth transition by performing the following steps.

1 From the Transitions palette, open the *Dissolve* folder and click-hold-drag the Cross Dissolve transition into the Transition track into the specified position. If the Snap To Edges option is turned on, the clip will automatically align to the left (with the clip in Video 1B), and automatically align to the right (with the clip in Video 1A). You will notice that this transition is longer in duration than previous transitions. This is due to the fact that the overlap of the clips is longer.

2 Double click on the transition to ensure that the Cross Dissolve setting starts at A and ends with B. Click on OK to close the dialog box.

3 Set the work area bar to preview the transition 2 seconds before and 2 seconds after the transition, and press Enter to preview the transition and its effects on the clips.

Transition 5

Using figure 10-21 as a guide, place the fifth transition by performing the following steps.

*Fig. 10-21.
Transition 5
provides a funnel
effect between
two clips.*

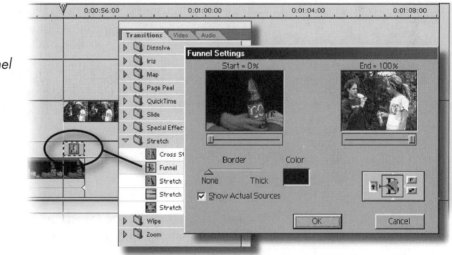

1 From the Transitions palette, open the *Stretch* folder and click-hold-drag the Funnel transition into the Transition track into the specified position. If the Snap To Edges option is turned on, the clip will automatically align to the right (with the clip in Video 1B), and automatically align to the left (with the clip in Video 1A).

2 Double click on the transition to ensure that the Funnel setting starts at B and ends with A. The Show Actual Sources feature will allow you to view the nature of the transition. Click on OK to close the dialog box.

3 Set the work area bar to preview the transition 2 seconds before and 2 seconds after the transition, and press Enter to preview the transition and its effects on the clips.

Transition 6

Using figure 10-22 as a guide, place the sixth transition by performing the following steps.

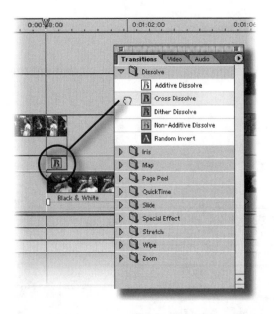

1 From the Transitions palette, open the *Dissolve* folder and click-hold-drag the Cross Dissolve transition into the Transition track into the specified position. If the Snap To Edges option is turned on, the clip will automatically align to the left (with the clip in Video 1B), and automatically align to the right (with the clip in Video 1A).

2 Double click on the transition to ensure that the Cross Dissolve setting starts at A and ends with B. Click on OK to close the dialog box.

Fig. 10-22. Transition 6 dissolves from Video 1A to Video 1B.

3 Set the work area bar to preview the transition 2 seconds before and 2 seconds after the transition, and press Enter to preview the transition and its effects on the clips.

Transition 7

Using figure 10-23 as a guide, place the seventh transition by performing the following steps.

1 From the Transitions palette, open the *Dissolve* folder and click-hold-drag the Cross Dissolve transition into the Transition track into the specified position. If the Snap To Edges option is turned on, the clip

will automatically align to the right (with the clip in Video 1B), and automatically align to the left (with the clip in Video 1A).

Fig. 10-23. Transition 7 dissolves from Video 1B to Video 1A.

2 Double click on the transition to ensure that the Cross Dissolve setting starts at B and ends with A. Click on OK to close the dialog box.

3 Set the work area bar to preview the transition 2 seconds before and 2 seconds after the transition, and press Enter to preview the transition and its effects on the clips.

Transition 8

Using figure 10-24 as a guide, place the eighth transition by performing the following steps.

1 From the Transitions palette, open the *Iris* folder and click-hold-drag the Iris Round transition into the Transition track into the specified position. If the Snap To Edges option is turned on, the clip will automatically align to the right (with the clip in Video 1B), and automatically align to the left (with the clip in Video 1A).

Fig. 10-24. Transition 8 dissolves from Video 1B to Video 1A.

2 Double click on the transition to ensure that the Iris Round setting starts at A and ends with B. Click on OK to close the dialog box.

3 Set the work area bar to preview the transition 2 seconds before and 2 seconds after the transition, and press Enter to preview the transition and its effects on the clips.

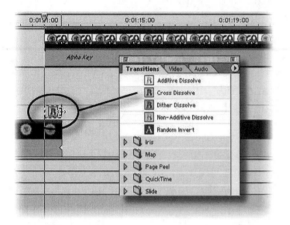

Fig. 10-25. Transition 9 dissolves from Video 1B to Video 1A.

Transition 9

Using figure 10-25 as a guide, place the ninth transition by performing the following steps.

1 From the Transitions palette, open the *Dissolve* folder and click-hold-drag the Cross Dissolve transition into the Transition track into the specified position. If the Snap To Edges option is turned on, the clip will automatically align to the left (with the clip in Video 1B). Position this transition to end at the end of the *Logo.psd* clip.

2 Double click on the transition to ensure that the Cross Dissolve setting starts at B and ends with A. Click on OK to close the dialog box.

3 Set the work area bar to preview the transition 2 seconds before and 2 seconds after the transition, and press Enter to preview the transition and its effects on the clips.

All of the transitions for the tutorial are now in place.

Summary

Chapter 10 has added special effects, keying effects, and transitions to the video clips imported in Chapter 9. Chapter 10 also marks the half-way point in the development of this series of tutorials. Hopefully, you are developing a better sense of where is the tutorials are heading. With the addition of fades, sound, motion, and titles in chapters 11 and 12, you will have concluded this series of tutorials.

Chapter 11

Fading, Motion Effects, and Audio

Introduction

This chapter expands on the tutorials of chapters 9 and 10. By establishing the video format, Chapter 9 set the stage for this series of tutorials. Chapter 10 added special effects to the video clips as well as to still images. In this chapter, you will lay down the audio tracks, which include music, sound effects, and narration.

You will also add motion effects to bring life to the production. Emphasis is given the placement of files, in order to synchronize sound clips with assorted visuals. Using motion effects, you will bring still images to life and complement the overall production. By now, you can see the storyboard process unfolding as the tutorials undergo development.

Objectives

The following are the objectives of this chapter.

- Adding the fading effect to video and graphics clips
- Adding the motion effect to still images
- Placing audio tracks
- Adding effects to enhance audio quality

Tutorial 11-1: The Fading Process

As you know from previous tutorials, the fading process is essential in video editing. To have clips abruptly jump from one scene to another is fine, but to be able to softly merge one clip to another is a nice touch. In Premiere, once a video clip is placed in a superimpose track, an opacity

257

rubber band appears. By adjusting the points on this rubber band, you can modify the opacity for specific regions of the clip.

To begin adjusting the clip fading, make sure the Fade button in the superimpose tracks is selected. In addition, expand the superimpose tracks to reveal the fade controls, or the rubber-bands, and make sure the tracks are visible (i.e., that the Eye icon is displayed). See figure 11-1.

 TIP: *To delete a fade handle, click-hold-drag the handle outside the track. Releasing the mouse will show that the handle has been removed.*

Fig. 11-1. Expanded tracks and the Fade control button in the superimpose tracks.

Modifying the First Instance of the Bottlesmall.psd Clip

To modify the fade-in and fade-out properties of the first instance of the *Bottlesmall.psd* clip, perform the following steps.

1 Move the timeline so that its left edge begins at 0;00;06;00.

2 In the Video 2 superimpose track, insert the edit line at the 0;00;10;00 position.

3 Click once on the fade line, which is at the top of the track, to insert a fade handle.

4 Click-hold-drag the handle at the beginning of the clip to the bottom of the track and release the mouse.

To have the clip fade out, continue with the following steps.

5 Insert the edit line at the 0;00;15;15 position.

6 Click once on the fade line, which is at the top of the track, to insert a fade handle.

7 Click-hold-drag the handle at the end of the clip to the bottom of the track and release the mouse.

The result of the changes to the start and end of this clip should appear as shown in figure 11-2.

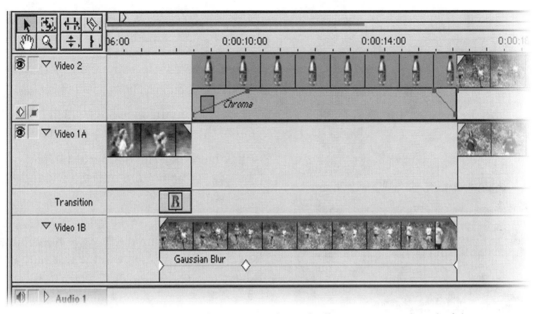

Fig. 11-2. Fade changes made to the beginning and end of the Bottlesmall.psd clip.

The longer fade at the beginning of the clip indicates that the bottle image will fade in gradually. The short fade at the end of the clip indicates that the bottle will fade out quickly.

Modifying the Second Instance of the Bottlesmall.psd Clip

To modify the fade-in and fade-out properties of the second instance of the *Bottlesmall.psd* clip, perform the following steps.

1 Move the timeline so that its left edge begins at 0;00;25;00.

2 In the Video 2 superimpose track, insert the edit line at the 0;00;26;13 position (aligned with the end of the transition). Remember to use the time-code information displayed in the Monitor window for accurate placement.

3 Click once on the fade line, which is at the top of the track and intersects with the edit line, to insert a fade handle.

4 Click-hold-drag the handle at the beginning of the clip to the bottom of the track and release the mouse.

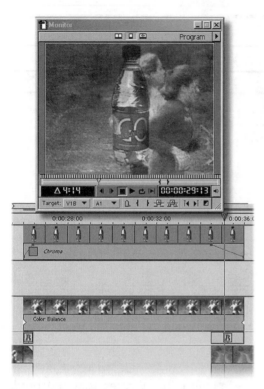

Fig. 11-3. Fade changes made to the beginning and the end of the second Bottlesmall.psd clip.

To have the clip fade out, continue with the following steps.

5 Insert the edit line at the 0;00;34;15 position.

6 Click once on the fade line, which is at the top of the track, to insert a fade handle.

7 Click-hold-drag the handle at the end of the clip to the bottom of the track and release the mouse.

Now the bottle image will fade out in concert with the clip in Video 1A as it transitions. The result of the changes to the start and end of this clip should appear as shown in figure 11-3.

Modifying the Trail.mov Clip

To modify the fade properties of the *Trail.mov* clip, perform the following steps.

1 Move the timeline so that its left edge begins at 0;00;36;00.

2 In the Video 2 track, make sure the track displays the entire fade line area.

This track will slowly fade in to achieve a special effect.

3 Place the edit line at the 0;00;39;00 position. Remember that you can use the right and left arrow keys to move the edit line or handles to achieve precision alignment.

4 At the top of the fade line, where the edit line intersects, click to insert a new handle. Once inserted, select the handle and then press and hold the Shift key down as you click-hold-drag the handle to the bottom of the track, releasing it at the 10% mark.

Pressing the Shift key will display the percentage of change to the handle. Continue with the following steps.

5 At the beginning of the clip, click on the handle at the top and drag it to the bottom of the track.

6 Move the edit line to the 0;00;42;00 position. Where the fade line and edit line intersect, click on the fade line to create a new handle and click-hold-drag the handle to the top of the track.

7 Move the edit line to the 0;00;47;15 location. Click to insert a new handle where the edit line and the fade line intersect.

8 Click-hold-drag the handle at the end of the clip to the bottom of the track.

The effect that should occur here is for the *TrailStill* clip in Video 1B to play for a couple of seconds. This is a photograph of the same trail in the *Trail.mov* clip. By superimposing the *Trail.mov* clip over the *TrailStill* clip, the *Trail.mov* clip will begin playing and slowly dissolve into the *TrailStill* clip, causing the runners of the *TrailStill.mov* clip to slowly dissolve into the image.

9 Review figure 11-4 for precise placement. Position the work area bar as shown in the illustration and preview the effect.

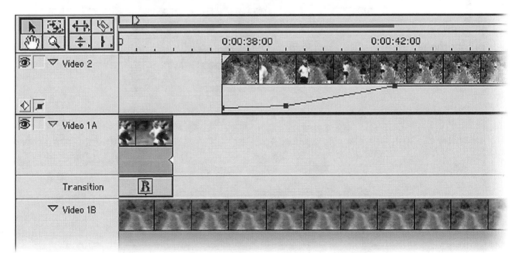

Fig. 11-4. A gradual fade over a similar image creates a ghosting effect.

Modifying the Outline2.psd Clip

To modify the fade properties of the *Outline2.psd* clip, perform the following steps.

1 Move the timeline so that its left edge begins at 0;01;00;00.

2 Position the edit line at 0;01;02;23. This will align with the end of the transition in the transition track.

3 Click where the fade line intersects the edit line, to create a handle.

4 Select the handle at the beginning of the clip and click-hold-drag the handle to the bottom of the screen.

5 Insert the edit line at the 0;01;06;04 position. This will align with the center of the transition in the transition channel. Click on the fade line where it intersects the edit line, to create a new handle.

6 Click-hold-drag the handle at the end of the clip to the bottom of the screen.

7 See figure 11-5 for precise placement of the handles. Position the work area bar as shown in the illustration, and preview the clip and the effect it creates.

Fig. 11-5.
Fade handles
placed for the
Outline2.psd
clip.

8 Save your project.

Modifying the Logo.eps Clip

To modify the fade properties of the *Logo.eps* clip, perform the following steps.

1 Move the timeline so that its left edge begins at 0;10;00;00.

2 Position the edit line at 0;01;11;22. This will align with the end of the transition in the transition track.

3 Click where the fade line intersects the edit line, to create a handle.

4 Select the handle at the beginning of the clip and click-hold-drag the handle to the bottom of the screen.

5 Insert the edit line at the 0;01;19;00 position. This will align with the beginning of the black video clip in Video 1B.

6 Click on the fade line where it intersects the edit line, to create a new handle.

7 Click-hold-drag the handle at the end of the clip to the bottom of the screen.

See figure 11-6 for precise placement of the handles. Previewing the entire clip is not very informative at this point. However, previewing the transition between the clip in Video 1B and the *Logo.eps* clip will reveal the transition.

Fig. 11-6. Logo.eps *clip with fade-in and fade-out handles in place.*

All of the fade controls for the video and graphics clips have been placed at this point. You will add other fades to the sound clips when you place them later in this chapter.

Tutorial 11-2: Working with Motion Effects

As you have seen in previous tutorials, motion effects are a powerful part of Premiere 6.5. To further enhance this project, in the following you will add several motion effects to increase the impact of the individual clips and the movie as a whole.

Adding Motion to the Bottlesmall.psd Clip

To add motion to the *Bottlesmall.psd* clip, perform the following steps.

1 Set the timeline to begin at the 0;00;06;00 position.

2 Select the *Bottlesmall.psd* clip, and then select Clip > Video Options > Motion (or select Motion > Setup from the Effect Controls palette).

3 When the Motion Settings dialog box opens, the upper right-hand screen shows a Visible Area rectangle that represents the computer screen. To the left is the Start image, indicating the starting point of the image, and to the right is a line with a handle. The handle, if selected, will indicate that it is the Finish image. Click on the handle in the Start image to select it. See figure 11-7.

Fig. 11-7. The Start image is selected and then put in motion.

4 With the Start image handle selected, adjust the image settings as follows, shown in figure 11-8.

- Rotation: - 45°

- Zoom: 50%

5 Once these setting have been made, click on the handle and drag the image into the position shown in figure 11-8. Once in position, release the mouse.

*Fig. 11-8.
Start image
rotated,
zoomed, and
repositioned.*

You will notice in the motion preview area on the left of the screen that the image is constantly cycling between the Start and Finish images. This will continue to occur as modifications are made to the motion. To add a new keyframe to the motion path, continue with the following steps.

6 In the Motion Path window, click in the middle of the motion path to add a new keyframe.

7 With this keyframe selected, notice that the keyframe has also been added to the Motion timeline. This keyframe should be highlighted, showing an inverted triangle over the insertion point. This triangle should be at the 25% location. Position the mouse over the triangle and click-hold-drag the triangle to the right or left until the percentage indicator at the right of the Motion timeline reads 25%.

8 With the keyframe still selected in the Motion Path area, click on the Center button on the right of the screen. The image will be centered in the visible area of the screen, as well as in the Monitor window.

9 Make the following changes to the controls at the bottom of the screen.

 • Rotation: - 34°

 • Zoom: 63%

Once again, you will notice the effects of your changes in the Motion Preview area at the upper left of the screen. Use figure 11-9 as a guide to placement and position.

Fig. 11-9. A keyframe is added to change the direction of the motion.

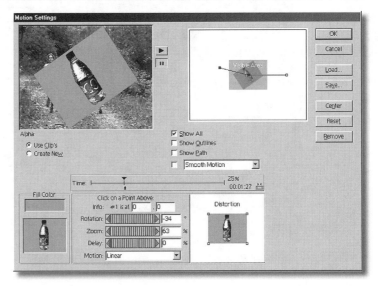

To modify the Finish image, continue with the following steps.

10 In the Motion Path area, click on the keyframe in the center of the Finish image.

11 With this keyframe selected, click on the Center button at the right of the screen. See figure 11-10.

12 With the Finish image centered, make the following changes, shown in figure 11-11.

 • Rotation: 29°

 • Zoom: 120%

13 In the Fill Color area, move the mouse over the green background. The pointer will change to the Eyedropper tool, shown in figure 11-12. Click once in the background to make the background image disappear. This change will be visible in the Motion Preview area.

Fig. 11-10.
Finish image
selected and
centered.

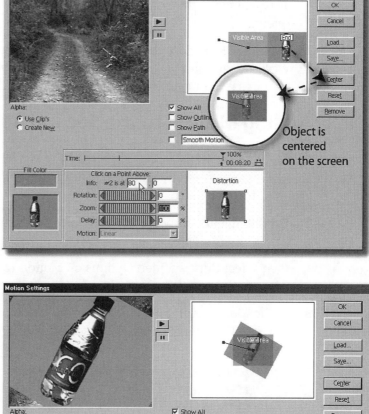

Fig. 11-11.
Modifications
made to the
Finish image.

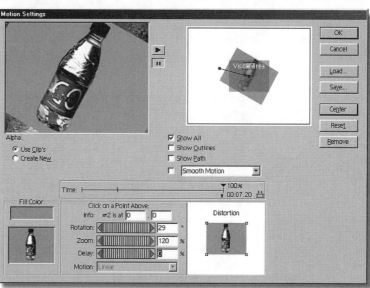

Fig. 11-12.
Using the
Eyedropper tool
to remove the
background
image.

14 Select Averaging - High from the Smooth Motion pull-down menu. This will make the bottle image flow fluidly as it moves across the screen.

15 Click on OK to close the Motion Settings dialog box, and then preview the motion effect you just created. Remember that is a good idea to save your project prior to previewing it.

Adding Motion to the Second Bottlesmall.psd Clip

To add motion to the second instance of the *Bottlesmall.psd* clip, perform the following steps.

1 Set the timeline to begin at the 0;00;25;00 position.

2 Select the *Bottlesmall.psd* clip in the Video 2 Superimpose track, and then select Clip > Video Options > Motion (or select Motion > Setup from the Effect Controls palette).

3 In the Motion Path area, verify that the Start image is positioned at the left of the visible area of the screen. See figure 11-13.

Fig. 11-13. Start image positioned at the left of the visible area of the screen.

4 Verify that the Start keyframe is selected. In the keyframe property controls, type *-35* in the *Info: #0 is at* field, as shown in figure 11-14.

The bottle image will remain at 100% size, with approximately 65% of it visible at the left-hand side of the screen. See figure 11-14.

5 Select the Finish keyframe. Type *-35* in the *Info: #0 is sat* field, as previously. This time, in the Zoom property control, type *115*.

The bottle will stay in the same position as the Start image while gradually growing, or zooming out. See figure 11-15.

Fig. 11-14. Bottle image at the left-hand side of the screen.

Fig. 11-15. Bottle image in the same position as the Start image.

6 In the Fill Color area, drag the pointer over the background color. When the pointer changes to the Eyedropper tool, click on the green background to remove it. See figure 11-16.

Fig. 11-16. Removing the background color using the Eyedropper tool.

7 To create the smoothest possible motion, select Averaging - High from the Smooth Motion pull-down menu, and then click on OK.

Adding Motion to the Logo.psd Clip

To add motion to the *Logo.psd* clip, perform the following steps.

1 Move the timeline to begin at the 0;01;02;00 position.

2 Select the *Logo.psd* clip, and then select Motion > Setup in the Effect Controls palette.

3 When the Motion Settings dialog box opens, select the Start key-frame and then click on the Center button on the right.

4 Select the Finish keyframe and then click on the Center button once more.

5 With the Finish keyframe still selected, type *150* as the value in the Zoom field in the keyframe property controls. See figure 11-17.

6 Select Averaging - High from the Smooth Motion pull-down menu, and then click on OK.

7 Move the work area bar over the clip and press Enter to preview the transition.

Fig. 11-17. The
Logo.psd clip
begins at 150%
and zooms to
100%.

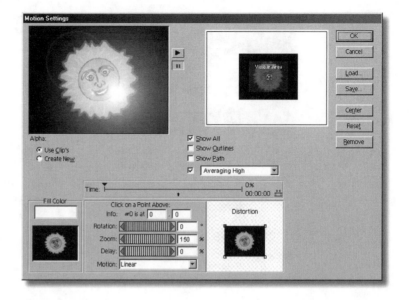

Adding Motion to the Logo.eps Clip

This clip is designed to fade into the *Logo.psd* clip. Proper positioning of
the logo is important to achieve the proper effect. To add motion to the
Logo.eps clip, perform the following steps.

1 Move the timeline to begin at the 0;01;10;00 position.

2 Select the *Logo.psd* clip, and then select Motion > Setup in the
 Effect Controls palette.

3 Select the Start keyframe. In the keyframe property controls, make
 the following changes, shown in figure 11-18.

 • Info: #0 is at: 19, 0

 • Rotation: 0˚

 • Zoom: 140%

 • Delay: 0%

4 Select Averaging - High from the Smooth Motion menu.

Fig. 11-18.
Selection
options for the
Logo.psd *clip*
Start keyframe.

5 Select the Finish keyframe either by selecting it in the Motion Path area or in the Motion timeline.

6 In the keyframe property controls, make the following changes, shown in figure 11-19.

- Info: #0 is at: -1, 2

- Rotation: 0˚

- Zoom: 90%

- Delay: 0%

7 Select Averaging - High from the Smooth Motion menu.

8 Click on OK to exit.

It is important to preview this transition. The desired effect is to have the *Logo.psd* clip in the Video1B track fade into the *Logo.eps* clip in Video 2. Because these clips are at different positions on the screen, changes are made in the Motion Settings dialog to compensate for this.

Should you wish to preview this clip, see the finished presentation found on the companion CD-ROM. Access *CD-ROM/Tutorials/Energy Drink/Go Energy Drink.ppj.*

*Fig. 11-19.
Selection options
for the* Logo.psd
*clip Finish
keyframe.*

Changing Clip Speed to Slow Motion

In this section, you will change the speed of a video clip, creating a slow motion effect. This is a departure from most other effects previously applied, because in this process a clip will actually be altered by changing the length of the original. Perform the following steps.

1 In Video 1B, select the *Drinking2.mov* clip at the 0;00;58;00 position.

2 Select Clip > Speed. The Clip Speed dialog box will open.

3 In the New Rate field, type *70* and click on OK.

4 Select Clip > Video Options > Frame Hold. When the Frame Hold dialog box opens, activate the Frame Blending option. This will make the slow motion effect appear smoother.

5 In the timeline, view the changes to the clip.

The clip now extends beyond the transition, where the movie previously ended. Modify the clip by continuing with the following steps.

6 Move the edit line to the 0;01;02;23 position.

7 From the Timeline toolbox, select the Razor tool. Using the Razor tool, trim the *Drinking2.mov* clip where the edit line intersects the clip. The clip should be divided.

8 Select the Pointer tool, click on the trimmed clip (the portion to the right of the edit line), and delete the clip. See figure 11-20 for details.

Fig. 11-20. Creating a slow motion effect and trimming the expanded clip.

This concludes the motion settings to be incorporated. In tutorial 11-3, you will add the audio aspect of these tutorials.

Tutorial 11-3: Incorporating Audio

No production is complete without laying down an audio track. This project is no exception. The audio portion of this project consists of three audio types: a soundtrack, a narration track, and sound effects. As you may have noticed, the only audio that exists in this project thus far is the tone audio inserted when the *Bars and Tone* file was added at the beginning.

By default, the Premiere workspace contains three audio tracks. In this tutorial, all three will be used to support the sound track, narration, and sound effects.

Importing the Audio Folder

To begin placing the audio files, perform the following steps.

1 Select the Project window to make it active, and select Bin 1.

2 Select File > Import > Folder, and select the *Tutorials/Energy Drink/Audio* folder. Click on OK. The *Audio* folder will be placed under Bin 1.

3 Double click on the *Audio* folder to reveal its content in the Project window, and arrange the files by selecting the List View icon at the bottom of the Project window.

Naming the Audio Tracks

Before placing audio files, in the following you will name the three existing audio tracks. This provides easy visual identification of the tracks.

1 Select the Track Options dialog icon at the bottom of the Timeline window.

2 When the Track Options dialog box opens, click on Audio 1. The Name button becomes active. Click on the Name button.

3 When the Name Track dialog box opens, type *Sound Effects* in the Name A1 field and click on OK.

4 In the Track Options dialog box, click on *A2: Audio 2*. Click on the Name button.

5 When the Name Track dialog box opens, type *Narration* in the Name A2 field and click on OK.

6 In the Track Options dialog box, click on *A3: Audio 3*. Click on the Name button.

Fig. 11-21. Naming the audio tracks.

7 When the Name Track dialog box opens, type *Soundtrack* in the Name A3 field and click on OK.

As all tracks are named, they should appear as shown in figure 11-21.

8 Once the tracks have been named, expand each audio track in order to view changes that will be made to the volume rubber bands and to display other options that will be used as this tutorial develops.

You may find that you must also enlarge the Timeline window. With the audio tracks named and expanded, you can now place narration files.

Placing the Narration Files

There are a total of seven narration tracks. These have been saved as individual tracks in order to place them strategically at the beginning of key video segments, which you will do in the material that follows. Working with shorter narration clips makes it easier to identify the content of the clip, as well as to quickly determine where the clip fits in the timeline.

The Narration1.wav Clip

The *Narration1.wav* clip is the introductory clip, which you will place at the beginning of the movie. Before beginning file placement, make sure the Snap To Edges option, shown in figure 11-22, is activated. To place the *Narration1.wav* clip, perform the following steps.

Fig. 11-22. Narration1.wav *file placed in the timeline.*

1 Position the timeline to begin at the 0;00;03;00 location.

2 Insert the edit line at the 0;00;06;15 location.

3 From the Audio bin, click-hold-drag the *Narration1.wav* file into the Narration track, releasing the clip when its left edge snaps to the edit line.

When properly placed, the file will be in the position shown in figure 11-22.

The Narration2.wav Clip

To place the *Narration2.wav* clip, perform the following steps.

1 Position the timeline to begin at the 0;00;12;00 location.

2 Insert the edit line at the 0;00;16;25 location.

3 From the Audio bin, click-hold-drag the *Narration2.wav* file into the Narration track, releasing the clip when its left edge snaps to the edit line.

When properly placed, the file will be in the position shown in figure 11-23.

Fig. 11-23.
Narration2.wav file
placed in the timeline.

The Narration3.wav Clip

To place the *Narration3.wav* clip, perform the following steps.

1 Position the timeline to begin at the 0;00;24;00 location.

2 Insert the edit line at the 0;00;27;00 location.

3 From the Audio bin, click-hold-drag the *Narration3.wav* file into the
Narration track, releasing the clip when its left edge snaps to the
edit line.

When properly placed, the file will be in the position shown in figure
11-24.

Fig. 11-24.
Narration3.wav
file placed in the
timeline.

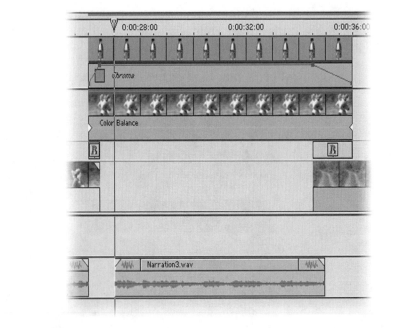

The Narration4.wav Clip

To place the *Narration4.wav* clip, perform the following steps.

1 Position the timeline to begin at the 0;00;34;00 location.

2 Insert the edit line at the 0;00;39;00 location.

3 From the Audio bin, click-hold-drag the *Narration4.wav* file into the
Narration track, releasing the clip when its left edge snaps to the
edit line.

When properly placed, the file will be in the position shown in figure
11-25.

The Narration5.wav Clip

To place the *Narraction5.wav* clip, perform the following steps.

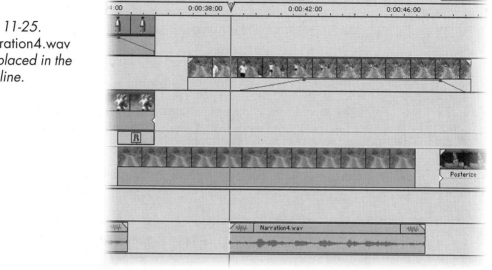

*Fig. 11-25.
Narration4.wav
file placed in the
timeline.*

1 Position the timeline to begin at the 0;00;45;00 location.

2 Insert the edit line at the 0;00;49;00 location.

3 From the Audio bin, click-hold-drag the *Narration5.wav* file into the
Narration track, releasing the clip when its left edge snaps to the
edit line.

When properly placed, the file will be in the position shown in figure
11-26.

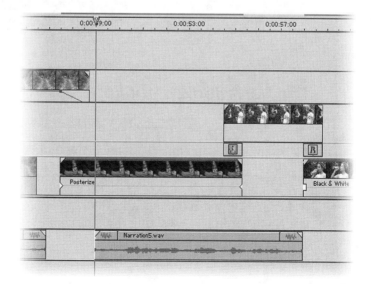

*Fig. 11-26.
Narration5.wav
file placed in the
timeline.*

The Narration6.wav Clip

To place the *Narration6.wav* clip, perform the following steps.

1 Position the timeline to begin at the 0;00;55;00 location.

2 Insert the edit line at the 0;00;58;15 location.

3 From the Audio bin, click-hold-drag the *Narration6.wav* file into the Narration track, releasing the clip when its left edge snaps to the edit line.

When properly placed, the file will be in the position shown in figure 11-27.

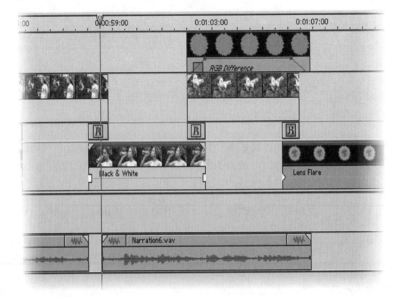

Fig. 11-27. Narration6.wav *file placed in the timeline.*

The Narration7.wav Clip

To place the *Narration7.wav* clip, perform the following steps.

1 Position the timeline to begin at the 0;01;03;00 location.

2 Insert the edit line at the 0;01;10;00 location.

3 From the Audio bin, click-hold-drag the *Narration7.wav* file into the Narration track, releasing the clip when its left edge snaps to the edit line.

When properly placed, the file will be in the position shown in figure 11-28.

*Fig. 11-28.
Narration7.wav
file placed in the
timeline.*

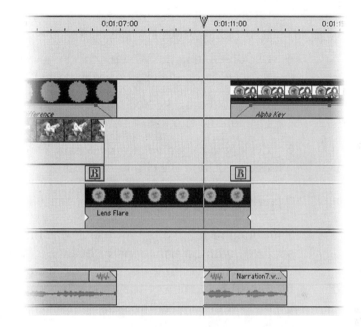

Adding Special Effects Audio Clips

Incorporating special effects audio differs from adding special effects *to* audio. Special effects audio clips are sound effects themselves, and are designed to add an emotional tone or a sense of emphasis to a visual event happening on screen. In this section, you will place the following special effects files.

- *Powerdown.wav*
- *Running1.wav*
- *Running2.wav*
- *Starting up.wav*
- *Woosh.wav*
- *Zoom.wav*

Note that special effects from Premiere's Audio Effects palette can also be added to these files. This is covered in detail in material to follow.

1 To begin, set the Timeline window to the beginning.

2 Click-hold-drag the *Running1.wav* clip into the Sound Effect audio track. Position the clip to begin at 0;00;04;00.

3 Click-hold-drag the *Running2.wav* clip into the Sound Effect audio track. Position the clip to begin at 0;00;16;05.

4 Click-hold-drag the *Woosh.wav* clip into the Sound Effect audio track. Position the clip to begin at 0;00;12;00.

5 Click-hold-drag the *Zoom.wav* clip into the Sound Effect audio track. Position the clip to begin at 0;00;50;00.

6 Click-hold-drag the *Powerdown.wav* clip into the Sound Effect audio track. Position the clip to begin at 0;01;11;22.

The Soundtrack

The soundtrack imported for use in this tutorial has been recorded at a set level, with no variations to quality or volume level. By using Premiere's fading control, via the rubberband, you will adjust the sound level for the duration of the movie. To import the soundtrack and modify the sound level of the *Starting up.wav* clip, perform the following steps.

1 Set the Timeline window to the beginning.

2 Insert the edit line at the 0;00;04;00 position.

3 Click-hold-drag the *Starting up.wav* file into the Soundtrack audio track and align the left edge (the beginning) of the clip with the edit line.

 NOTE: *The clip is designed to run the full duration of the movie. Therefore, no modifications will be made to the length of the clip.*

4 Because the *Starting up.wav* clip consumes almost the entire length of the timeline, use the Navigator palette to go to the following positions and insert handles in the fade line. Use the edit line for precise positioning, and insert the handles where the edit line and fade line intersect.

- 0;00;06;00
- 0;00;07;00
- 0;01;14;00

- 0;01;16;00

- 0;01;19;00

With these handles in place, further modify the fade line by continuing with the following steps.

5 Position the timeline at 0;01;00;00.

6 Select the Fade Adjustment tool from the Timeline toolbox. Press Shift, and while holding down the Shift key click-hold-drag the volume rubber band toward the bottom of the screen. When the percentage value reaches 20%, release the mouse button.

Figure 11-29 shows how in one step the fade line was set to the new volume level from the beginning to the end of the movie.

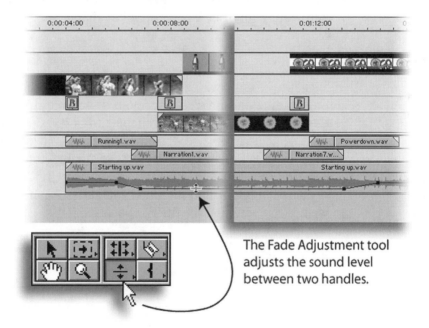

The Fade Adjustment tool adjusts the sound level between two handles.

Fig. 11-29. Using the Fade Adjustment tool, the volume for the soundtrack is adjusted uniformly.

7 In the timeline, move to the end of the movie, and then select the Pointer tool from the toolbox and click-hold-drag the handle at the very end of the clip to the bottom of the screen, or to the 0% position. This will allow the soundtrack to fade out at the end of the movie.

This constitutes all of the changes to the soundtrack. By using Premiere's toolbox and interface, adjusting this clip was easy.

Preview Checklist

A lot of work has been put into the development of these tutorials. You should save your file and preview the project. Keep the following in mind regarding the preview process.

- Set the work area bar to cover the entire project before pressing Enter to initiate the preview.

- Previewing will take a while to render. This time will vary based on your computer's processor speed.

- Previewing also creates preview files on your hard disk drive. Make sure your computer has plenty of available space.

Summary

This chapter has provided some insight into blending audio and video through fading and precise placement of audio tracks. You used motion settings in the tutorials of this chapter to add a dynamic aspect to the project. You have learned essential new skills while using previously learned features in new environments to create a totally different type of project. As this series of tutorials culminates in Chapter 12, you will have gained much insight into the capabilities Adobe Premiere provides, as well as the potential for their application.

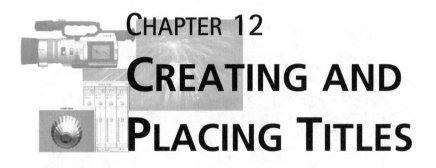

CHAPTER 12
CREATING AND
PLACING TITLES

Introduction

In this chapter you will create titles for use in the Energy Drink tutorial. You will also conclude the tutorial that began in Chapter 9. The nature of these tutorials demands that titles be added to complement the audio, video, and special effects portions of this movie.

Titles are an essential part of the video production process. As you have witnessed in previous tutorials, titles can be created and imported from a variety of formats, including bitmapped images or line art from illustration programs. In this chapter you will use the Adobe Title Designer to create a variety of title designs.

Objectives

A total of four titles will be developed in this chapter. The titles include scrolling text, titles with gradient backgrounds, crawling text, and titles integrating graphic objects. Each effect provides a different experience, and you will learn a variety of techniques that will benefit future project development. You will use the superimpose tracks, specifically the Video 2 and Video 3 tracks, to achieve transparent support for title overlay onto other video clips. Before beginning, take a moment to review the Title window and its tools, as shown in figure 12-1.

*Fig. 12-1. Adobe
Title Designer
screen interface.*

Before You Begin

Before starting the tutorials, there are several topics that should be
reviewed to understand some fundamentals of how titles work in Pre-
miere. The sections that follow explain these fundamentals.

Adobe Title Designer

The Adobe Title Designer is new with the release of Adobe Premiere 6.5.
This feature-rich title generator allows you to generate sophisticated
titles within Premiere. New capabilities include text on a bezier curve;
style templates; enhanced tools for the creation of shadows, strokes,
and fills; and much more.

How Titles Are Saved

When a new title is created and saved, it becomes a file, which is stored
in a bin in the Project window. Titles are independent files and can be
imported into the timeline again and again. As an independent file, a
title can also be used in other Premiere productions. Once you create a
title style, the file can be opened and saved under another name, and
new text can be added to take advantage of a favorite layout.

Logo Incorporation

Another strong feature available in the title designer is the ability to incorporate a logo file along with title text. Incorporating a piece of art with text adds creative design options previously unavailable.

Video Safe Zones

If you are new to video editing or have not had experience with creating and playing video to other equipment, there are certain rules you need to know about video playback on other devices. Video on a computer monitor may be previewed and played back with no display problems. However, take that same video and export it to videotape for playback on a traditional television set and you may encounter alignment inconsistencies.

Televisions typically do not display as much information as a computer monitor. To compensate for this, Premiere has built in graphical display options that allow you to properly plan your video and title elements for proper playback on NTSC-compatible television sets.

In the pop-out menu in Premiere's Monitor window, the Safe Margins for Program Side option will display an image of the area on a screen that has been defined as safe for either video viewing or for title display. These margins are also available in the Adobe Title Designer and are helpful for proper alignment of titles and graphics.

The inner 90% of the window is considered *action safe*, and the inner 80% of the window is considered *title safe*. The action safe area (the inner 90%) is the area in which an image will appear on most television sets. The title safe area (the inner 80%) is the area in which titles must be situated to ensure that an entire title will be visible when played back on a television set. Figure 12-1 shows these zones. The following tutorials take you through the use of a variety of options in Adobe's Title Designer.

Tutorial 12-1: Creating Scrolling Text

In this tutorial you will learn how to add scrolling text that will overlay a video clip. Scrolling text is used at the end of a movie or television program to expose the viewer to a variety of information. In this tutorial, you will add scrolling text as a bulleted list highlighting the features

of a fictitious energy beverage. Knowing how to add scrolling text is a tool that will benefit your development of Premiere projects.

Creating a New Title

To create a scrolling title, perform the following steps.

1 Before beginning, establish the following settings.

- Position the timeline to begin at 0;00;23;00.
- Set the Time Zoom Level option to 1 Second.
- Make sure the Video 2 track is expanded and fully viewable.

2 In the Project window, click once on the Create Item icon. When the Create dialog box opens, it defaults to Object Type/Title. Click on OK to accept this setting. A new, blank Title Designer window opens. This window can also be accessed by selecting File > New > Title.

3 When the Title Designer window opens, select Roll from the Title Type pop-up menu.

4 Using the Text tool, click once on the left-hand side of the Title Designer window and type the following, including the dashes.

```
GO provides:
- 8 essential daily diet supplements
- No sugars
- Low carbohydrates
- 100% Natural
```

5 With the text selected, establish the following text attribute settings in the Title menu.

- Font: Arial/Bold
- Size: 24 pt

6 With the title text selected, select Title > Roll/Crawl Options. From the Roll/Crawl Options dialog box, activate the Start Off Screen and the End Off Screen check boxes. Selecting these options will initiate the text roll procedure. Click on OK to exit.

 TIP: *When the Roll/Crawl option is activated, once the clip is placed in the timeline, the title clip will change, indicating that this option is activated.*

The text in the Title Designer window should appear as shown in figure 12-2.

Fig. 12-2. Text in position in the Title Designer window.

> **TIP:** *Font attributes can also be changed in the Object Style/Properties tab. For a 24-pt font size, select the field and type 24.0.*

> **NOTE:** *Title safe and action safe margins can be turned on or off by selecting Edit > Preferences > Titler and then activating these two options.*

Setting Tabs

As shown in figure 12-2, note that the first bulleted item has an undesirable word wrap. To correct this, in the following you will set a tab to properly align all bulleted items. Perform the following steps.

1 In the Title Designer window, select the Pointer tool and click on the title area, which will select the text.

2 Select Title > Tab Stops. From the Tab Stops dialog box, click on the existing tab arrow and click-hold-drag it to the left. The existing tab arrow is the "left justify" tab. This tab format will align text to the left. As you drag the arrow, a yellow vertical line will move in the Title Designer window, allowing the tab to be aligned with the existing text. For design purposes, move the tab until the yellow line is aligned as shown in figure 12-3.

3 When the tab is properly positioned, click on OK in the Tab Stops dialog box.

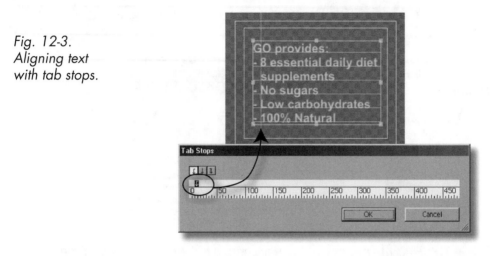

Fig. 12-3.
Aligning text
with tab stops.

4 Select the Text tool, and then insert the cursor in front of the word *Supplements* and press the Tab key once. This will align *Supplements* with the other bulleted text.

TIP: *The Title Designer can be opened by double clicking on the title in the Project window or by clicking on the clip in the timeline.*

Text Color

In the following, you will add text and text shadows for visual impact. Perform the following steps.

1 Select the text in the Title Designer window.

2 Under Object Style, select the Fill tab to reveal its options. The Fill check box should be checked.

3 In the Fill Type pop-up menu, select Solid.

4 In the color selector, click on the color chip to reveal the Color Picker. In the Color Picker, enter the following values.

- Red: 246

- Green: 243

- Blue: 56

As these colors are entered, you may notice the "gamut" warning appear. This is represented by a yellow triangle with an exclamation mark. This warning is to let you know that the selected color is not

suitable for proper display from a television screen. To correct this, click on the color chip under the warning icon. This will select a compatible color. When the chip is selected, the values in the Color Picker will change to reflect the currently selected color. Click on OK to accept the changes.

Creating a Shadow

In the following you will create a shadow for the text. Perform the following steps.

1 Click on the Shadow tab to reveal its options. Click in the Shadow check box to activate the shadow options.

2 With the text selected in the Title Designer window, click on the color chip in the Color option. When the Color Picker opens, establish the following values.

 • Red: 0

 • Green: 0

 • Blue: 0

These settings will yield a solid black color.

3 Click on the angle triangle to reveal the shadow angle settings. Adjust this setting to 315.0. This setting can be set in the following ways.

 • Select the current value and type in a new value.

 • Position the pointer over the numeric value and drag to the right or left.

 • In the angle graphic, move the line until the proper value is displayed.

4 In the Distance field, set a value of 2.0. This setting determines the distance the shadow is from the text.

5 In the Size field, set a value of 30.0. This setting will enlarge the size of the shadow and will surround the text with the shadow. This setting will allow the text to stand out while being displayed over a multicolored background image. See figure 12-4, which shows all of the settings that should be established for the shadow.

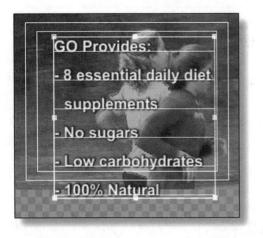

In the title's present state, the line spacing is close together. The scrolling effect would not have much impact with the text arranged in this manner. Adjust the line spacing for the text by continuing with the following steps.

6 Select the text, and then select the Properties tab from the Object Style menu.

7 Set the Leading option to 15.0.

The text will automatically adjust the space between lines.

Fig. 12-4. Shadow settings for the scrolling text.

Viewing Text and the Background Clip

The text design is complete. However, you need to review final alignment against the background clip. To view the title positioned over the actual background clip, perform the following steps.

1 Minimize the Title Designer window to display the timeline.

2 Position the edit line at 0;00;30;00.

3 Maximize the Title Designer window and click in the Show Video check box. To the right of this check box is an icon of the edit line. Click once on this icon to display the video clip from the current location of the edit line. Position the text in the window as shown in figure 12-5.

4 Reactivate the Toggle Track Output icon for the Video 2 track.

This completes the creation of the scrolling text. Save this file as *Scrolling Text* and close the Title Designer window.

Fig. 12-5. Positioning text over the background video clip.

Importing the Title

Having successfully created a scrolling title, you now need to place the file into the timeline to be superimposed over an existing video clip. When titles are created, they are automatically prepared to be used over video clips. This means that the title has had an alpha channel applied, which will display only the text when placed in a superimpose track in the timeline. Import the *Scrolling Text* file by performing the following steps.

1 In the timeline, click on the Track Options dialog icon. When the track options dialog opens, select Add. When the Add Tracks dialog opens, add 1 video track and 0 audio tracks and then click on OK. Click on OK once more to close the Track Options dialog box.

2 Position the timeline to begin at 0;00;24;00.

3 Insert the edit line at the 0;00;26;00 position.

4 The scrolling text title should be located in bin 1 of the Project window. Locate the scrolling text title and click-hold-drag the title into the timeline in the Video 3 track, releasing it as its left edge snaps to the edit line at 0;00;26;00.

5 With the scrolling text in place, click-hold-drag the right edge of the clip to expand it to the right, releasing the mouse when the clip reaches the 0;00;36;00 position (the end of the *Bottlesmall.psd* and the *SideStill* clips).

 NOTE: *When the scrolling text clip is placed in the timeline, the appearance of the clip visually illustrates that it is a scrolling title. Visual representation depends on having the icon view turned on in the Timeline Window Options dialog box.*

Tutorial 12-2: Creating Text with a Gradient Background

Both text and object-oriented graphics can be created in the Title Designer. Graphic objects can be in the form of lines, unfilled shapes, or solid objects with gradient fills. In this tutorial, you will develop text with a rectangular graphic containing color blending and transparency.

Adding Text

To create the text for this tutorial, perform the following steps.

1 Set the timeline to begin at 0;00;40;00.

2 In the Project window, click on the Create Item icon. When the Create dialog box open, select Title and click on OK.

3 When the Title Designer window opens, select the Type tool, click once in the upper left of the screen, and type the following.

- *Focus*
- *Stamina*
- *Alertness*
- *Concentration*

4 With the text selected, set the following attributes in the Title menu.

- Font: Arial/Bold
- Size: 24 pt

5 In the Object Style palette, expand the Properties tab and set the Leading option to 5.0.

6 Position the text so that it is within the title safe zone.

Creating a Filled Object

In the following you will add a gradient to a background graphic rather than to the text. Perform the following steps.

1 Select the Rectangle tool from the Tool palette, and then click-hold-drag from the upper left corner of the title safe border to the lower right corner of the title safe border and release the mouse.

 TIP: *When drawing rectangles, use the handles in the middle of the horizontal and vertical lines to easily adjust the size.*

2 With the rectangle selected, expand the Fill tab from the Object Style palette. Click in the Fill check box to activate the fill options.

3 From the Fill Type pop-up menu, select Linear Gradient.

4 From the Color menu, two boxes appear below the Linear Gradient color fill. Click-hold-drag the leftmost box to the extreme left side of the color bar. Click-hold-drag the rightmost box to the extreme right side of the color bar. Spreading the boxes will create a smoother blend.

5 Double click on the leftmost box. When the Color Picker opens, enter the following attributes.

- Red: 75
- Green: 135
- Blue: 0

Click on OK.

6 Double click on the rightmost box. When the Color Picker opens, enter the following attributes.

- Red: 178
- Green: 147
- Blue: 0

Click on OK.

7 With the rectangle selected, set the Opacity option to 70.0.

8 With the rectangle selected, select Title > Arrange > Send to Back. The title text is now the foremost object.

Adding Shadows

In the following you will add a shadow to the rectangle to provide visual depth to the image. Perform the following steps.

NOTE: *Before a setting can be assigned to any object, the object must be selected.*

1 Click on the rectangle to select it.

2 Click on the tab next to the Shadow option and click once in the Shadow check box to activate the setting options.

3 In the Shadow options, establish the following settings.

- Color: Black
- Opacity: 50.0

- Angle: 310.0
- Distance: 8.0
- Size: 8.0
- Spread: 30.0

This completes the modifications to the rectangle.

Viewing the Background Image

To gain a sense of how the text and gradient will appear in the timeline, in the following you will set a frame to view in the background of the Title window. Perform the following steps.

1 Minimize the Title Designer window to reveal the timeline.

2 Position the edit line at 0;00;43;00.

3 Maximize the Title Designer window. At the top of the window, click in the Show Video check box. To the right of this box, click on the Edit Line icon. This will place a frame from the clip into the Title Designer window from the current location of the edit line in the timeline.

Stretching Text

In the following you will enhance the appearance of the title text. Perform the following steps.

1 Click on the rectangle to select it. Select Title > Arrange > Send to Back. Using the pointer, click on the title text to select it.

2 From the Object Style palette, expand the Properties tab and make the following modifications.

- Aspect: 120.0
- Leading: 12.0

The title will adjust as these changes are made.

At this point in title development, the Title Designer window should appear as shown in figure 12-6.

3 Save the title and name the file *Gradient Title*.

4 Close the Adobe Title Designer. The *Gradient Title* file will be automatically displayed in the Project window.

Fig. 12-6. The final design and position for the gradient background title.

Importing and Positioning the Gradient Title

To import and position the gradient title in the timeline, perform the following steps.

1 Insert the edit line in the timeline at the 0;00;39;00 position.

2 Click-hold-drag the Gradient Title clip from the Project window into the Video 3 track and position the clip so that its left edge snaps to the edit line.

3 Click on the right-hand edge of the title clip and drag it to the right until its right-hand edge snaps to the right-hand edge of the *Trail.mov* clip.

4 Move the edit line to the 0;00;41;00 position. Create a handle in the fade line where it intersects the edit line.

5 Insert the edit line at the 0;00;45;00 position and create a new handle where the fade line intersects the edit line.

6 Move the handles at the beginning and end of the clip to the bottom to make the clip fade in and fade out. See figure 12-7 for placement.

Fig. 12-7. The gradient title in position in the timeline.

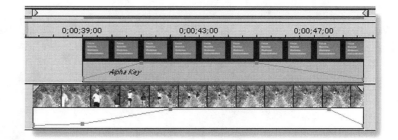

7 Position the preview bar over the title beginning at 0;00;37;00 and ending at 0;00;49;00, and press Enter to preview.

This completes the Gradient Title tutorial. Additional title tutorials follow in this chapter.

Tutorial 12-3: Creating Crawling Titles

The first tutorial in this chapter demonstrated how text can roll vertically on the screen. Text crawls are typically used to display information at the bottom of the screen while other action or information is displayed in other areas. You have probably viewed crawls on your television screen in the form of news updates, stock updates, or emergency weather information. To create crawling text, perform the following steps.

1 Set the timeline to begin at position 0;00;53;00.

2 Click on the Create Item icon at the bottom of the Project window. When the Create dialog box appears, select Title and then click on OK.

3 When the Title Designer window opens, select Crawl from the Title Type pop-up menu. Select the Text tool, click on the screen, and type the following.

Taste Great!

4 The *Taste Great!* text should be selected. From the Object Style options shown on the right of the screen, expand the Properties tab and select Font/Arial Bold from the pop-up window. In the Font Size field, type *48.0*.

5 Position the text as shown in figure 12-8.

6 Select File > Save and name the title *Taste Great!*

Fig. 12-8. Position for crawling text.

Adding a Logo

In the following you will add a logo to the type to create additional interest to the crawling type. Perform the following steps.

1 Select Title > Logo > Insert Logo. Navigate to the CD-ROM and select *Tutorials/Energy Drink/Graphics/Logo.eps.* The logo will be placed on the screen.

2 Select the Selection tool from the Tool palette, click once on the logo, and select Title > Transform > Scale. When the Scale dialog box opens, select Uniform and type *50* in the Scale field. Click on OK.

3 Position the logo and text as shown in figure 12-9.

Fig. 12-9. Text and logo properly positioned.

Adding Color and Gradient Fills

In the following you will add color to the text you created previously. To add color the text, the text must be selected. Perform the following steps.

1 Select the text by clicking on it once with the Selection tool, or by inserting the Text tool in the text.

2 In the Object Style palette on the right of the screen, expand the Fill tab to reveal the fill options.

3 In the Fill Type pop-up menu, select Linear Gradient. In the Color field, a color bar will appear with two color boxes located underneath. Double click on the left-hand box. The Color Picker will appear. Establish the following settings in the Color Picker.

- Red: 250

- Green: 36

- Blue: 0

4 Once these selections have been made, click on OK.

5 Double click on the right-hand box under the gradient color bar. When the Color Picker appears, set the following values.

- Red: 255

- Green: 240

- Blue: 6

6 Once these selections have been made, click on OK. See figure 12-10.

The position of the color boxes indicates the length of the color gradient. The closer together, the harder the gradient blend. If the boxes are positioned to the extreme right and left, the more gradual (or softer) the blend. Continue with the following steps.

7 Click-hold-drag the box on the left to the extreme left of the color bar, and then click-hold-drag the right-hand box to the extreme right side of the color bar.

8 The selected colors reflect colors in the *Go Energy Drink* logo. Once these changes have been made, select File > Save.

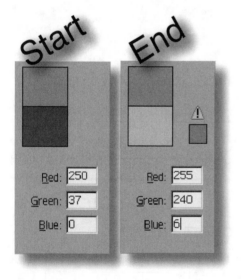

Fig. 12-10. Settings for beginning and ending gradient fills.

The completed logo and shaded text will appear as shown in figure 12-11.

Fig. 12-11.
Logo and
gradient-filled
text.

Adding Text Shadows

To add shadows to the text only, perform the following steps.

1 Select the text using the Selection tool or the Text tool.

2 In the Object Style palette on the right of the screen, expand the Shadow tab by clicking on the triangle.

3 Click the check box next to the word *Shadow*. This reveals the shadow modification options.

4 In the Color field, click once on the color chip to open the Color Picker. Set the following values for this field.

 • Red: 0

 • Green: 0

 • Blue: 0

5 Click on OK. This combination will create a solid black color for the shadow.

6 Click on the triangle next to Angle to reveal its options. Click in the Angle Settings field and type *300.0*. Press the Esc key to accept this angle. This will establish a new angle for the shadow, which will be reflected in the angle graphic shown below the entry field.

TIP: *The shadow angle can also be adjusted by click-hold-dragging the angle line within the circle.*

7 In the Distance field, click to activate the field and type *10.0* for the new distance. Press the Esc key to accept the new value.

The settings and resulting changes are shown in figure 12-12.

Fig. 12-12. Angle and distance settings for the text shadow.

Softening Shadows

The shadows previously set for this title provide a sharp edge and a hard contrast. In the following, you will soften the shadow. Perform the following steps.

1 With the text selected, in the Object Style/Shadow palette, click in the Spread field to activate it. Type *20.0* as the new value and press the Esc key to accept the new entry. The shadow will visibly blur.

2 Select File > Save to save the changes to the title.

Displaying a Background Clip

To view the logo and text against a video clip in the timeline, perform the following steps.

1 Minimize the Title window to reveal the timeline.

2 Position the edit line at 0;00;55;15, and then maximize the Title window.

3 At the top of the Title window, click the check box next to the text *Show Video*. The video clip will appear in the background at the 0;00;55;15 position. The video clip position can be modified by relocating the edit line position and then clicking on the Edit Line icon at the top of the Title window.

 TIP: *The video clip can also be repositioned by using the click-hold-drag technique while positioning the pointer over the timecode indicator and dragging to the right or the left.*

The logo and text should appear as shown in figure 12-13.

Fig. 12-13. A video clip added to the background.

4 Save the changes to the title and close the Title window.

Inserting the Title into the Timeline

In the following you will insert the *Taste Great!* title into the timeline. Perform the following steps.

1 1n the Project window, click once on the *Taste Great* clip. Select Clip > Duration. When the Clip Duration dialog box appears, enter *00;00;06;00* and then click on OK. The new duration will appear under the file name on the clip.

2 Insert the edit line at the 0;00;56;21 position.

3 In the Video 3 track in the timeline, click-hold-drag the *Taste Great* clip so the left edge snaps to the edit line.

4 With the Video 3 track expanded, insert a fade handle at the beginning and the end at the following locations.

- Beginning: 0;00;57;15

- End: 0;01;02;00

5 Drag the fade handles at the beginning and end of the clip to the bottom of the track. This will allow the title to fade in and fade out upon playback.

6 Position the preview bar over the clip and press the Enter key to preview the title and special effects. Figure 12-14 shows the placement for the title as well as a suggested location for the preview bar, which will provide portions of clips before and after the title.

Fig. 12-14. The Taste Great *title inserted in the timeline.*

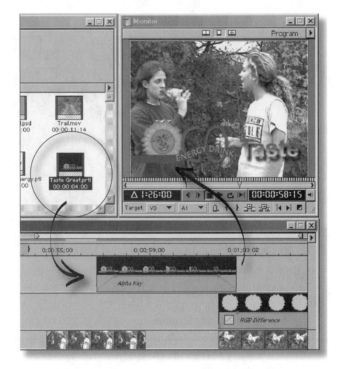

Tutorial 12-4: Creating Text with Line Art

In this tutorial you will incorporate text along with a graphic element created within the Title window. The resulting effect will be superimposed over the *Bottle.mov* clip and will be placed in the Video 2 track.

Creating Text on a Path

To add the text for this tutorial, perform the following steps.

1 Arrange the timeline to begin at the 0;00;48;00 position.

2 Place the edit line at 0;00;50;00.

3 Click on the Create Item icon in the Project window. When the Create Item dialog box opens, select Title and click on OK.

4 When the Adobe Title Designer window opens, select the text on a path tool. Click in the Title window to start a new text entry field. Click to establish a starting point, click-hold-drag as the second point is established, and then click once to establish the end. See figure 12-15 for details.

Fig. 12-15. Establishing a curved text path.

5 Once the path has been established, type the following text.

100% Energy

With the text entered, assign the following attributes in the Title menu.

- Font: Arial/Bold/Italic
- Size: 36 pt
- Align Text: Left

6 To position the text, click in the Show Video check box located at the top of the Title Designer window. This will display a still video frame from the timeline at the current edit line position. Make sure the text box and handles are within the title safe area. See figure 12-16 for proper positioning.

Fig. 12-16. Position for text on a path.

Adding Line Art

In the following you will add a graphic object to enhance the text on a path. Perform the following steps.

1 From the Tool palette, select the Oval tool.

2 Press and hold the Shift key, and then click-hold-drag from the upper left to the lower right, creating a constrained circle as shown in figure 12-17. This circle should completely cover the *100%* text.

 NOTE: *The fill of the circle will vary based on the last fill used. Therefore, the fill in figure 12-17 may not appear exactly as shown.*

Fig. 12-17.
Drawing a circle in
the Title window.

3 From the Object Style palette on the right of the screen, click on Fill to reveal the fill options.

4 In the Fill Type field, click on the pop-up menu. From this menu, select Radial Gradient.

5 In the Color field, double click on the left-hand box under the color bar. When the Color Picker opens, enter the following settings.

- Red: 52
- Green: 58
- Blue: 255

Click on OK.

6 In the Color field, double click on the right-hand box under the color bar. When the Color Picker opens, enter the following settings.

- Red: 255
- Green: 26
- Blue: 2

Click on OK.

7 In the Color field, adjust the left-hand color slider to the mid-point of the color bar. Approximate the location of this box to the 50%

location. Move the rightmost color slider to the far right. Refer to figure 12-18 for positioning and the visual appearance of the circle.

Fig. 12-18. Adjusting a radial fill on a circle.

Additional Text Enhancements

In the following you will make additional text enhancements to make the text more dynamic. Perform the following steps.

1 Select the pointer and click once on the *100% Energy* text, thus selecting it.

2 Select Title > Arrange > Bring to Front.

3 From the Object Style palette, click on the Fill check box to activate the fill options.

4 In the Fill Type pop-up menu, select Solid.

5 In the Color field, click on the Eyedropper tool. Move the Eyedropper tool into the Title window and position it over the yellow sun logo on the bottle label. If the text is selected, the text color will change based on the position of the eyedropper. Select the brightest yellow from this logo.

NOTE: *Using the Eyedropper tool will yield varied results. The goal of selecting text in this manner is to have the yellow match a color that exists in the background video clip.*

6 In the Color field, the color chip changes based on the position of the eyedropper. Click to establish a color selection. For reference, the color selected for final output is as follows.

- Red: 255
- Green: 191
- Blue: 63

If desired, make these changes by clicking on the color chip in the Color field and typing the values in the appropriate fields.

7 Once these steps have been completed, select File > Save. Name the title *100 Percent Energy*, click on OK, and close the Title Designer window.

Placing the Title in the Timeline

To complete the logo, in the following you will add motion to animate the text and graphic. Perform the following steps.

1 Locate the *100 Percent Energy* title in the Project window. Click on the clip icon once to select it. Select Clip > Duration, type *0;00;05;00*, and click on OK.

2 In the Project window, click-hold-drag the *100 Percent Energy* title into the timeline in the Video 2 track, positioning the left edge of the clip at 0;00;48;22, or aligned with the right-hand edge of the *Trail.mov* clip.

3 With the Video 2 track expanded, insert a fade handle at the 0;00;49;10 position and at the 0;00;53;00 position. Drag the handles at the beginning and end of the title, creating a fade-in and fade-out for the title. See figure 12-19 for proper positioning.

Fig. 12-19. Title clip positioning in the timeline.

 NOTE: *If inserting a fade handle at specified locations is awkward, temporarily turn off the Toggle Snap to Edges feature at the bottom of the timeline.*

Adding Motion

In the following you will add motion to this title in order to create interest and animation effects. Perform the following steps.

1 In the Transitions palette, click on the Video tab. This reveals a variety of video effects folders.

2 Click on the Triangle tab next to the *Distort* folder. This will reveal a variety of filters.

3 Locate the Transform filter and click-hold-drag the filter onto the *100 Percent Energy* title in the Video 2 track in the timeline. Once the filter is located over the title, release the mouse button. This action will add a new set of controls for this filter in the Effect Controls palette.

4 Insert the edit line at the 0;00;53;22 position in the timeline. This location is at the end of the *100 Percent Energy* clip. If this location does not match the end of the clip, it is important for the edit line to be at the very end of the title clip, regardless of the indicator specified previously. In the Transform settings in the Effect Controls palette, click on the Enable Keyframing option. A clock icon will appear in the box. Make the following setting changes to this filter. To make the following changes, use the slider or click on the value and enter the exact value.

- Scale Width: 120.0
- Skew: 15.0
- Skew Axis: 15.0
- Rotation: -30.0

See figure 12-20 for settings for the Transform pfilter.

When the Keyframing option is selected, changes are made relative to the position of the edit line in the timeline. In this instance, the edit line is at the end of the movie. Therefore, changes made will affect the end of the clip, whereas the beginning will remain unchanged. This means that the clip will display normally at the beginning, and then gradually change to conform to the settings set for the end of the clip.

5 Preview the effect of the filter by setting the work area bar to begin at 0;00;48;00 and to end at 0;00;54;00. Press Enter to begin the preview.

This completes the text and line art tutorial.

Fig. 12-20. Settings for the Transform filter.

Summary

Congratulations! You have patiently worked through four chapters of tutorials and have completed a fun and energetic movie project. Along the way you have been exposed to a wealth of features and the awesome power of Adobe Premiere 6.5.

CHAPTER 13
WORKING WITH AUDIO

Introduction

Premiere 6 incorporates two major advances in functionality. First is the ability to import and export using DV devices. Second is the introduction of sophisticated audio mixing capabilities via Premiere's timeline and Audio Mixer window. The controls in this window resemble an audio mixing console.

Premiere's audio mixer displays sliders and knobs that let you adjust audio levels and left/right stereo panning. The mixer lets you adjust a clip's volume and pan control while you are viewing the clip. You can also mix multiple audio tracks in real time. With the new automation features, you can record volume and pan adjustments as you make them.

This chapter differs from previous tutorials in that some processes are simply explained. Other processes require step-by-step instructions.

Objectives

In this chapter you will explore the following.

- Audio editing in the timeline
- Audio rates
- Using audio editing tools
- Fading and panning audio clips
- Editing in the Audio Mixer
- Adding audio effects

Facts About Premiere's Audio Capability

Premiere's audio features include the following. There are many additional features discussed in this chapter.

- Premiere can have up to 99 audio tracks.

- Premiere contains a professional-level audio mixer.

- Audio can be adjusted in the audio mixer or in the timeline.

- Special-effect plug-ins are included for sound effects.

- Audio files can be output in many formats, from CD-ROM to the Web.

- Mixed audio tracks can be previewed immediately.

- Audio can be extracted from video clips for other uses.

The Timeline Window

The sections that follow discuss various features of Premiere's audio editing capability. Figure 13-1 shows the Premiere workspace organized for audio editing.

Audio Sample Rate

The audio sample rate is the number of audio samples captured per second. Capturing stereo sound requires twice as much storage as mono. If your equipment and storage space can support it, audio should be captured in the highest possible quality. As a project evolves, the file can be reduced in size as needed to save space.

Audio Rates

The Project Settings dialog box (Project > Project Settings > Audio) provides an example of how the audio data rate is set for an audio CD. As shown in figure 13-2, the Rate field is set at 44.1 kHz (CD quality). Lowering this rate will result in reduced quality in sound but a smaller file size. When capturing audio, it is best to capture the clip at the rate you plan to use for your project. Reducing the size of a clip and resampling a clip require additional processing time.

Fig. 13-1. The Premiere workspace organized for audio editing.

Fig. 13-2. Audio Settings dialog box with CD-quality audio settings.

Audio Bit Depth

Audio bit depth is the number of bits per sample of digitized audio. Higher sample rates and bit depth yield better-quality sound. This quality is in direct proportion to file size. The higher the quality, the larger the file size.

Audio Interleave

An audio interleave is the process of specifying how often audio information is placed among video frames in an exported file. When using a third-party video capture card, refer to its documentation for information about the required audio interleave setting.

If a value of 1 frame is selected, when the frame is played back, the audio for that frame is loaded into RAM in order to continually play until the next frame appears. Occasionally, audio will not play back fluidly; that is, the clip will be broken, containing audible gaps. In this case, the interleave setting may need to be changed.

These settings have a lot to do with the power of the computer and the available RAM. Increasing interleave values allows Premiere to store longer audio segments, which need to be processed less often. Higher interleave values require more RAM. Contemporary computers' hard disk drives perform best when set to 1/2- to 1-second interleaves. Figure 13-3 shows the Interleave pop-up menu as shown in the Project Settings/Audio dialog box.

Fig. 13-3. Audio project settings and interleave settings.

Tutorial 13-1: Audio Editing in the Timeline

This tutorial covers various aspects of audio editing in the timeline, including adjusting gain, using various timeline audio editing tools, monitoring channels, creating cross-fades, cross-fading audio with video, and panning audio.

Adjusting Gain

Gain is a term used to describe the adjustment of an audio signal when it is either too high or too low. During the preview and editing process, individual audio tracks can have their gain set higher or lower based on the need to properly balance all audio tracks. One pitfall that may be encountered is adjusting the gain of a clip recorded at a low level. As the gain is increased, most often background noise or sound distortion occurs. High-quality original sound recordings become an important aspect of the project as a whole.

To adjust gain in the timeline, perform the following steps.

Fig. 13-4. Setting the audio gain of a clip.

1 From the companion CD-ROM, open *Tutorials/Audio/Gain.ppj*.

2 To adjust the gain of a clip, select the clip and then select Clip > Audio Options > Audio Gain.

3 Enter a value of *200* (%) in the Gain Value field. Values can be entered up to 200%. A value between 100% and 200% will increase the sound level, whereas a value less than 100% will decrease the sound level.

4 Preview the file with these changes.

Selecting the Smart Gain feature will automatically select a level for your clip. Figure 13-4 shows the Audio Gain dialog box.

TIP: *Garbage in...garbage out! If the original sound clip was poorly digitized or originally captured at a low volume level, adjusting the gain of the clip will emphasize any hiss or background noise.*

Using the Audio Editing Tools

The sections that follow discuss the use of various audio editing tools.

Scissors Tool

The Scissors tool is selected as shown in figure 13-5. With the scissors, selected, clicking on the volume rubber bands will create two adjacent

fade handles. Initially, the two handles appear as one. The handles, as shown in figure 13-5, have been separated for better viewing. One application for using the Scissors tool is when the sound level of a clip needs to be raised or lowered to support a visual element in the movie.

NOTE: *After the Scissors tool has been selected and used, the pointer needs to be selected for further modifications.*

Fig. 13-5. Using the Scissors tool to add two adjacent handles.

TIP: *By pressing the C key, the tools in the Scissors toolbox will automatically cycle, revealing all available tools. The Timeline window must be selected for this feature to function.*

Fade Adjustment Tool

The Fade Adjustment tool, shown in figure 13-6, allows you to adjust two handles simultaneously. The audio track must be expanded, revealing the red rubber band(s). With the tool selected, clicking on a line between two points and moving vertically will adjust the level accordingly. By pressing and holding the Shift key, a numeric display box will appear in the timeline, providing precise percentage of change as well as the current decibel level as the line is adjusted.

Fig. 13-6. The Fade Adjustment tool moves two handles simultaneously.

TIP: *By pressing the U key, the tools in the Fade Adjustment toolbox will automatically cycle, revealing all available tools. The Timeline window must be selected for this feature to function.*

Monitoring Channels in the Timeline

As audio tracks are placed in the timeline, often they are directly on top of each other or overlapping. As the number of these files increases, it may become desirable to isolate a track in order to review the content individually.

As you know from Chapter 5, synching a sound effect with a visual effect is important in regard to achieving the desired result. The capability of isolating a sound effect or track is a built-in feature of the timeline.

To turn the audio on or off in an audio track, click on the toggle speaker icon in the track header. Figure 13-7 shows this feature turned on and off in specific tracks.

Fig. 13-7. Turning sound monitoring on and off in the timeline.

TIP: *All audio tracks can be turned on or off at the same time. To do so, select any speaker icon in the audio track header while pressing Alt (Windows) or Option (Mac).*

Creating a Cross-fade

Fig. 13-8. Cross-fade tool.

The process of cross-fading is really a process of audio blending. This process is much like using a video transition between, for example, Video 1A and Video 1B. The transition serves as a tool to gradually blend the two clips, resulting in a progressive visual from one image to another. The cross-fade process works the same way for audio. The Cross-fade tool, shown in figure 13-8, will blend two audio clips by fading one out while fading the other in as they overlap.

To use the Cross-fade tool, perform the following steps.

1 Open a new Premiere file by selecting File > New Project.

2 When the Project Settings window appears, select DV-NTSC/Standard 48kHz and then click on OK.

3 Select the Project window by clicking once anywhere on the screen.

4 Select File > Import File and navigate to the companion CD-ROM. Locate the *Tutorials/Audio* folder and import the following files.

- *Crystallize.wav*

- *Cascading.wav*

5 In the timeline, expand the Audio 1 and Audio 2 track to expose the rubber band by clicking once on the triangle next to the track name.

6 Select the *Crystallize.wav* clip and drag it into Audio 1 so that its left edge is at the 0;00;00;00 position.

7 Select the *Cascading.wav* clip and drag it into the Audio 2 track so that its left edge is at the 0;00;11;00 position. The placed files should appear as shown in figure 13-9.

Fig. 13-9. Overlapping audio files.

8 From the Timeline toolbox, select the Cross-fade tool.

9 With the Cross-fade tool selected, click once anywhere on the *Crystallize.wav* audio clip to select it.

10 Move the pointer to the beginning of the clip in Audio 2. You will notice that the pointer changes to the Cross-fade tool. Click once on the *Cascading.wav* file. The *Crystallize.wav* file will fade out, whereas the *Cascading.wav* file will fade in. This is evident by the visible adjustments in the rubber band feature. See figure 13-10 for how the file should appear.

Fig. 13-10. The blended audio clips after the Cross-fade tool has been applied.

Cross-fading Audio with Video

In the cross-fading tutorial, the cross-fade was applied to audio clips only. This is a very straightforward process. Creating a cross-fade with audio linked to video requires additional steps. When a video is imported into the timeline, its audio track is automatically imported into the audio track. As the video is moved or edited, the audio track moves or is edited with it. In the following, you will detach the audio track from the video track, edit the audio, and then reattach the file to the video.

1 In Premiere, select File > New Project.

2 In the Load Project Settings dialog box, select the Multimedia (Mac) or Multimedia QuickTime (Windows) preset and then click on OK.

3 Set the Premiere workspace as follows: Window > Workspace > A/B Editing. As a shortcut, you can press Shift + F10.

4 Click on the Project window to make it active and select File > Import > File. Navigate to the companion CD-ROM and select *Tutorials/Audio/Burner*. Import the file *Ascend*.

5 With the Project window active, click-hold-drag the *Burner* clip into Video 1A, beginning at the 0;00;00;00 position.

6 Click-hold-drag the *Ascend* clip into Video 1A, placing it as shown in figure 13-11 (directly after the *Burner* clip). If necessary, scroll the Timeline window to the beginning.

Fig. 13-11. Burner and Ascend clips in the timeline.

7 In the Audio 1 track and the Audio 2 track, click on the triangle to reveal the rubber bands.

At the bottom of the timeline is the Sync Mode icon. Clicking on this icon will toggle between the on and off state, as shown in figure 13-12.

Sync Mode On

Sync Mode Off

Fig. 13-12. Sync Mode icon.

8 Click on the Sync Mode icon to set it to the off position. If already in the off position, do nothing. This will deactivate the link between the video and audio tracks. The clip need not be selected for this feature to affect all clips in the timeline.

9 With these clips in place, preview the movie by pressing the space bar.

During the preview, you will have noticed that there is no transition between the audio or video tracks between these two clips. For this tutorial, the sudden jump between the video tracks is fine. However, a cross-fade will be applied to the audio track in order to create a smoother transition between the two sound sources. To apply the cross-fade to the audio tracks, continue with the following steps.

10 Make sure the Sync Mode option is in the off position.

11 Click-hold-drag the *Burner* audio clip into the Audio 2 track.

12 Move the edit line to the 6-second mark and release.

13 Move the pointer over the title in the *Ascend* audio clip in the Audio 1 track, and then click-hold-drag the clip to the left until the clip snaps to the edit line. The clip will snap to the edit line if the Snap

To Edges icon is selected. If not, the clip can still be aligned with the edit line. Release the mouse.

14 In the Timeline toolbox, select the Cross-fade tool.

15 Click once on the *Ascend* clip. Nothing appears to happen. Drag the pointer over the *Burner* clip. You will notice that the pointer will change to the Cross-fade tool icon. Click on the *Burner* clip.

16 The clips will flash and the rubber bands will change to reveal that the *Ascend* audio will fade in and the *Burner* audio fade out. The duration for each is equally balanced, creating a perfect blend. See figure 13-13 for placement and settings.

17 Move the edit line to the 0;00;00;00 position and press the space bar once more to preview the project.

18 Select the Sync Mode icon once more to reactivate the linking between the audio and video clips.

19 With the Pointer tool, click once on the *Ascend* audio clip. You will notice that both the audio and video clips are highlighted, meaning that the clips are joined. When these clips are rejoined, they still do not align. If you plan to use a clip that has been modified in this manner, keep this alignment in mind. If repetitive use of the clip is required, simply import the original clip, which contains the format intact.

Fig. 13-13. The video tracks remain unchanged, but the audio tracks have been cross-faded.

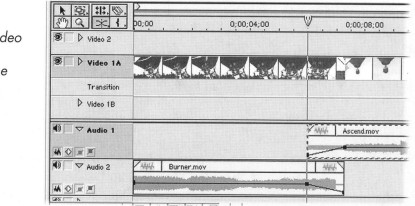

You have created a cross-fade by detaching the audio clips from the video clips. This process will provide many flexible options as you pursue video-editing projects with Premiere.

Panning Audio in the Timeline

You may have experienced this at the movie theater: on the big screen, one actor on the left is speaking to another actor on the right of the screen. The sound of the actor's voice seems to come from the location of the actor. This effect is created via *panning*. In Premiere, you can pan a monophonic audio clip to set the sound position between the left and right stereo channels.

Stereo audio clips cannot be panned because each channel already contains audio information. When working with stereo sound clips, the pan control serves the function of adjusting the balance of the stereo channels within each clip.

Both panning and balancing can be done in the Audio Mixer window or Timeline window. In the timeline, the rubber bands serve the same function as the pan/balance controls in the Audio Mixer window.

You can vary the pan or balance freely along the duration of a clip by adding and dragging handles on the blue Pan/balance rubber band on the audio clip, using techniques similar to those you use for adjusting volume.

As panning and balancing modifications are performed, make sure the audio on your computer is properly configured. Sound cards must be functioning properly and speakers must be properly arranged. This means that the left and right channels are performing properly. If the left and right are not properly configured, the changes you make to audio files will not provide accurate results.

Panning/Balancing Audio Clips

To pan or balance an audio clip, perform the following steps.

1 Open the *Gain.ppj* file. In the timeline, expand the track by clicking once on the triangle to the left of the track name.

2 In the track header, click on the blue pan/balance rubber band to select it. You will notice the L and R designation, indicating the direction to move the rubber band to affect the left or right channel.

3 Move the pointer over the blue pan/balance rubber band. You must have the pointer selected from the toolbox. The pointer will change to a pointing finger with blue arrows displayed beneath it. To pan/balance left, click and drag the pointer up. To pan/balance right,

click and drag the pointer down. As you release the mouse button, a blue panning handle will appear. This handle can be selected again to make additional modifications.

Panning/Balancing in 1% Increments

To pan/balance a clip in 1% increments, perform the following steps.

1 Position the pointer over the pan/balance handle you want to adjust, so that the pointer changes into a pointing finger with blue arrows.

2 Move the pointer over a pan/balance handle in the audio clip. The pointer will change to the pointing finger with blue arrows.

3 Drag the pan/balance handle up (for left) or down (for right). While doing this, press and hold the Shift key. A numeric display will appear over the audio track, indicating the current pan/balance level. By keeping the Shift key depressed, you can drag the pointer off the track and still display changes to the track. This function allows adjustments to be made in 1% increments either to the left or to the right.

Use of the pan rubber bands is shown in figure 13-14.

Fig. 13-14. Adjusting balance and panning in an audio track using the pan rubber bands.

Tutorial 13-2: Editing in the Audio Mixer

The sections that follow discuss various aspects of using the Audio Mixer feature, shown in figure 13-15, for editing.

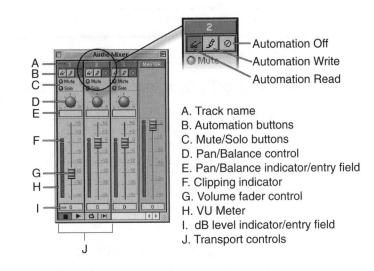

Fig. 13-15. Audio Mixer control panel and its functions.

A. Track name
B. Automation buttons
C. Mute/Solo buttons
D. Pan/Balance control
E. Pan/Balance indicator/entry field
F. Clipping indicator
G. Volume fader control
H. VU Meter
I. dB level indicator/entry field
J. Transport controls

Audio Mixer Workspace

Premiere's audio processing also includes shortcuts for working in the audio environment. A window arrangement preset is available for automatically establishing an optimized arrangement for audio editing. You arrange the Premiere workspace for audio mixing by selecting Window > Workspace > Audio. Premiere will auto-arrange the monitor windows as shown in figure 13-16.

Fig. 13-16. Audio Mixer workspace.

Adjusting Audio Levels in the Audio Mixer

As previously stated, most audio adjustments made in the timeline can be duplicated in the Audio Mixer. In the following, you will balance a stereo clip using the Pan/Balance control in the Audio Mixer window.

Fig. 13-17. Automation Write button selected in the Audio Mixer window.

1 Select File > Import > File and import the *Cascading.wav* file from *CD-ROM/Tutorials/Audio*.

2 With the file in the project bin, click-hold-drag the *Cascading.wav* file into the Audio 1 track of the timeline.

3 Expand the Audio 1 track to reveal the soundtrack.

4 In the timeline, click on the *Cascading.wav* file to activate it.

5 Click on the Audio Mixer to activate it.

6 Click on the Automation Write button in the Audio 1 track in the Audio Mixer window. See figure 13-17.

7 With the Automation Write button selected, select Window > Window Options > Audio Window Mixer Options.

 TIP: *To quickly access the Audio Mixer Window Options dialog box, click on the title bar of the Audio Mixer window while pressing Control (Mac) or right-clicking (Windows).*

8 When the Audio Window Mixer Options dialog box opens, the default setting should be as shown in figure 13-18. If it is not, select the settings as shown. Click on OK.

9 Click on the Play control located at the bottom of the Audio Mixer window. Let the soundtrack play through once.

Fig. 13-18. Audio Mixer Window Options dialog box.

10 Click on the Play control once more.

11 In the Audio 1 channel in the Audio Mixer window, click on and hold the volume slider.

12 When the playback head reaches the 0;00;04;00 mark, drag the slider to the -12 position.

13 Hold the control at this position for approximately 2 seconds.

14 Slowly move the slider back to the 0 position.

15 Release the mouse button.

As you release the mouse button, the playback head should be at approximately the 0;00;09;00 position. With the Automation Write option in the On position, the changes were recorded to the audio track in the timeline in a manner similar to the example shown in figure 13-19.

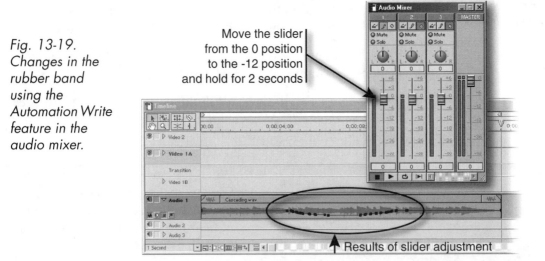

Fig. 13-19. Changes in the rubber band using the Automation Write feature in the audio mixer.

Move the slider from the 0 position to the -12 position and hold for 2 seconds

Results of slider adjustment

This is a trial-and-error process and your results may not be exactly as show in figure 13-19. Repeat this process until you reach a comfort level in using this feature.

Monitoring Channels in the Audio Mixer

In the Audio Mixer, channels can be turned off or on in order to preview clips individually. The Solo and Mute buttons are used to establish the

particular functionality. When the Solo button is selected on a track, only that track will play during preview. To monitor one or more tracks, click on the Solo button for the corresponding tracks. See figure 13-20. The Mute button will affect the track muted. Therefore, all other tracks are audible on playback. See figure 13-21.

Fig. 13-20. Individual tracks can be previewed using the Solo feature.

Fig. 13-21. Muting audio tracks in the Audio Mixer.

Monitoring Peak Sound Levels

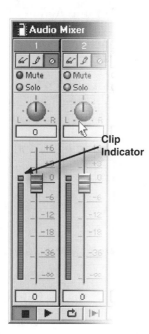

Modifying sound in Premiere allows full customization and level control. Through experimentation, you will find that levels are often too soft or too loud. Based on the content of the clip, sound levels set too loud become distorted and undesirable, especially if the duration is lengthy. The Audio Mixer window offers a management tool for controlling this.

Located at the top of the VU meter is an area called the Clipping Indicator, shown in figure 13-22. As you have noticed, the volume fader control sits at the 0 level. This is the default sound level of the imported clip, which is also the default setting of the clip as imported. Any adjustments to the clip will either be louder (above the 0 level) or softer (below the 0 level). If a sound clip, or any part of the clip, reaches a point at which the

Fig. 13-22. Clipping Indicator light atop the VU meter.

clipping indicator light illuminates (turning red), the sound level needs to be reduced accordingly. Previewing the clip is recommended for proper sound leveling.

Pan/Balance Using the Audio Mixer Window

Just as audio levels can be controlled, so too can panning and balancing. To use the Audio Mixer window to adjust panning and balance, perform the following steps.

1 Open a new Premiere document. Select the NTSC 640 x 480 Quick-Time setting and then click on OK.

2 Select Window > Workspace > Audio.

3 From the companion CD-ROM, select *Tutorials/Audio/Crystal-lize.wav.*

Fig. 13-23. Auto Write button.

4 Click-hold-drag the *Crystalllize.wav* file into the timeline into the Audio 1 track.

5 Expand the Audio 1 track to reveal the rubber bands.

6 Click on the blue pan icon in the audio track header. The L and R designations will appear along with the blue line.

7 Select the Auto Write button in channel 1 of the Audio Mixer. See figure 13-23.

8 Click on the Play button in the Audio Mixer.

9 In the Audio Mixer, click on the pan control handle, hold down the mouse button, and then drag to the position (above the handle) shown in figure 13-24.

10 With the pointer above the handle, drag to the right, and then to the left, as shown in figure 13-25.

Click the Pan/Balance knob then hold and drag upward

Fig. 13-24. By clicking on the handle and then dragging above the handle, precise control can be achieved.

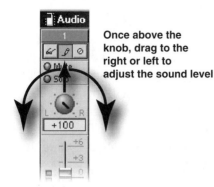

Once above the knob, drag to the right or left to adjust the sound level

Fig. 13-25. To pan the sound, move slowly right, and then to the left.

11 Begin dragging to the right at approximately the 0;00;04;00 position, and then rotate to the left at approximately the 0;00;06;00 position. This is only a 2-second interval, so this process must happen quickly.

12 When the edit line reaches the 0;00;08;00 position, rotate the dial back to the center (0 position). This will evenly distribute the sound to the left and right channels.

Be patient. Perform this method as many times as you need to get a feel for this function. To start over, delete the sound clip from Audio 1A and import it again. Keep trying this until the handles appear similar to those shown in figure 13-26.

Fig. 13-26. Changes to the pan rubber bands after modifying the Left and Right balance controls in the Audio Mixer.

Assigning Audio Effects

Audio effects are easily applied to audio clips by simply dragging an effect onto the audio clip in the timeline. Multiple audio effects can be added to a clip at the same time. Achieving desired results requires experimentation with single effects or the application of multiple effects. Audio effects files are filters that reside in the *Plug-ins* folder. There are additional third-party filters that offer enhanced functionality when placed into the *Plug-ins* folder. To apply an effect to a clip, perform the following steps.

1 Open the *Audio Effects* file from the companion CD-ROM by accessing *Tutorials/Audio/Audio Effects*.

2 From the Project window, select File > Import > File. From the companion CD-ROM, select *Tutorials/Audio/Ganging Audio/Crystallize.wav*. Drag the *Crystallize.wav* clip into the timeline in the Audio 1 track. Select Window > Show Audio Effects.

Fig. 13-27. Audio Effects palette as included with Premiere 6.5.

3 In the Audio Effects palette, shown in figure 13-27, select the triangle next to the *Reverb and Delay* folder. When the folder opens, click-hold-drag the Multitap Delay effect onto the *Crystallize.wav* clip in the Timeline window and release. As the effect is dragged onto the clip, you will notice a color change on the clip. This indicates that the effect is in the correct location and automatically applied.

4 If the effect has controls, the Settings dialog box will appear in the upper right of the screen, as shown in figure 13-28. The settings you choose here apply to the first keyframe (if you change settings for other keyframes) or to the entire clip (if you make no changes to any keyframe). Click on OK to apply the settings.

Fig. 13-28. The Effect Controls palette allows you to modify currently applied effects.

5 In the Audio Mixer, click on the Play button to preview the sound effect.

6 Press the space bar to preview the clip with the effects.

NOTE: *Sound effects take a moment to render. The rendering time is different based on the power of your computer. Rendering is also affected by the number of effects applied to a clip or group of clips.*

The settings in the Effect Controls palette vary from effect to effect. Notice on the Multitap Delay effect that the scroll bar on the right indicates that there are additional settings below the one currently dis-

played. Scrolling down will reveal all available options. The content of these palettes will vary based on the effect selection.

Changing Order in the Effects Palette

By default, effects in the Effects palette are listed in alphabetical order. To change this order, click-hold-drag the *Effects* folder to the desired location and release the mouse button.

Removing Effects

Effects can also be removed. To practice using this functionality, perform the following steps.

1 In the timeline, click once on the *Crystallize.wav* clip to select it.

2 In the Effect Controls palette, select the effect you want to remove. In the Effect Controls pop-out menu, select Remove All Effects From Clip. See figure 13-30.

Fig. 13-29. Effects can be rearranged by dragging them into the Effects window.

Fig. 13-30. Removing an effect from a clip.

NOTE: *Individual effects can also be removed via the Effect Controls menu.*

Ganging Fade Controls

Through various uses of the Audio Mixer in this chapter, you have become familiar with the manner in which each audio track contains its own fade control. These controls allow fading for a single audio track.

But what if you want to fade more than one track at a time, at the same rate? Premiere handles this via the Ganging option built into the Audio Mixer. To gang fade controls, perform the following steps.

1 Select File > New Project.

2 When the Load Project Settings dialog appears, select NTSC 640 x 480 QuickTime from the available presets. In figure 13-31, notice the audio settings description for this setting: Rate (44100), Format (16-Stereo), Compressor (Uncompressed). This setting provides CD-ROM-quality audio. Click on OK.

Fig. 13-31. The Load Project Settings dialog box showing CD-quality audio settings.

3 When the new project opens, select Window > Workspace > Audio. The Audio Mixer will appear in the Premiere workspace.

4 Select the Project window by clicking on it.

5 Select File > Import > Folder. The Choose a Folder (Mac) or Browse for Folder (Windows) dialog box opens, as shown in figure 13-32. Navigate to the following folder from the companion CD-ROM: *Tutorials/Audio/Ganging Audio*. Select the folder by clicking on it once, and then click on the OK/Choose button.

NOTE: *Remember that you are choosing a folder here, not opening a folder or a specific file. When the folder is located, click on it once to*

select it, and then click on the OK/Choose button. This will import the entire folder into the Project window as a bin.

Fig. 13-32. Importing a folder into the Project window.

6 With the Ganging Audio bin in the Project window, double click on the bin to reveal its content.

Six audio tracks are required for this tutorial. To add an additional track, continue with the following steps.

7 Click on the Timeline window to make it active.

8 At the bottom of the Timeline screen is the Track Options Dialog icon. Click on this icon to open the Track Options dialog box.

9 Click on the Add button in the Track Options dialog box. The Add Tracks dialog box will open, containing options for adding video or audio tracks. See figure 13-33.

Fig. 13-33. Adding one audio track.

10 By default, the Video field is selected and contains a 1. Type *0* in this box.

11 By default, the Audio field contains a 1. Because one additional track is required, accept this setting by clicking on OK. This will add the Audio 4 track to the Track Options dialog box. Click on OK to close the Track Options dialog box.

 TIP: *Use the Tab key to toggle between the Video and Audio fields.*

A total of four audio tracks now exist.

12 In the header of the audio tracks, click on the triangle of all four tracks to expose the entire track. You may need to expand the size of the Timeline window to view all four tracks. If needed, expand the window so that all four tracks are visible.

 NOTE: *No activity will occur in the video portion of the timeline for this tutorial.*

 TIP: *As a shortcut, press Option (Mac) or Alt (Windows) and click on any triangle. This will make all four tracks expand or contract.*

You now need to add audio clips to the timeline. To do this, continue with the following steps. The clips should be arranged as shown in figure 13-34.

13 From the Ganging Audio bin, click-hold-drag the *Crystallize.wav* clip into Audio Track 4. The start position should be 0;00;00;00.

14 Drag the *Rain.wav* clip into Audio Track 3.

15 Drag the *Jungle.wav* clip into Audio Track 2.

16 Place the *Bird1.wav* file in Audio Track 1 at the 0;00;04;00 position.

 TIP: *By placing the edit line at specific locations in the timeline, clips will snap to the edit line, allowing precision alignment.*

17 Place the *Bird2.wav* file in Audio Track 1 at the 0;00;07;00 position.

18 Place the *Bird3.wav* file in Audio Track 1 at the 0;00;10;00 position.

19 Select File > Save. Name the project *Ganging Exercise* and preview the project.

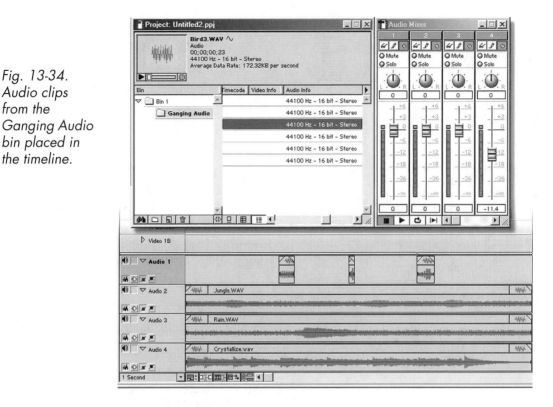

*Fig. 13-34.
Audio clips
from the
Ganging Audio
bin placed in
the timeline.*

Now that the audio tracks have been assembled, you can use the Audio Mixer window to adjust the sound levels of specific tracks. The goal of this tutorial is to not only fade audio tracks using the ganging feature but to isolate specific tracks to fade while leaving others to achieve a desired effect. Continue with the following steps.

20 In the Premiere workspace, close the Monitor window. It is not needed for this tutorial.

21 Expand the Audio Mixer window to show all four audio tracks.

NOTE: *When an audio track is added in the Timeline, the Audio Mixer automatically inserts a fader control for the track.*

22 Verify that the setting for all four audio tracks is at the 0 position.

23 In the Audio Mixer, select the Automation Write icon in Track 2 and Track 4. See figure 13-35.

Fig. 13-35. Audio Mixer window showing all four audio tracks.

Group two audio tracks in the Audio Track window by continuing with the following steps.

24 In channel 2 of the Audio Mixer, press Control (Mac) (or right click, Windows) and click on the fade control handle. When the Gang menu appears, select Gang 1.

25 Repeat this process for channel 4. This will make these fade controls perform in unison. Doing this will also make the handles colorized. By choosing the same gang number (Gang 1), the handles are the same color.

26 Click on the fader, hold the mouse button down, and move the handle up or down. Notice that tracks 2 and 4 move in unison.

27 When finished, move the fader to the 0 position. This can be done by typing a *0* in either box at the bottom of the screen.

In the following, you will use the fader controls ganged previously to fade specific audio tracks from the timeline. The desired effect is to have the *Jungle.wav* and *Crystallize.wav* files fade out, leaving only the *Rain.wav* file playing for the last 2 or 3 seconds.

28 Save your project.

29 Press the space bar to preview the audio clip. You may want to do this a few times to develop a feel for the soundtrack.

30 Press the space bar again to initiate the playback process. When the edit line reaches the 0;00;09;00 position (9-second mark), select the fader handle from track 4 in the Audio Mixer. With the handle selected, click-hold-drag the fader to the bottom. Continue to hold the fader until the clip reaches the end. If the controls are released, they will automatically return to the 0 position. The objective is to drag the control downward so that it reaches the bottom within approximately 2 seconds. See figure 13-36. Start the fade at the *Bird3.wav* file and fade out within 2 seconds.

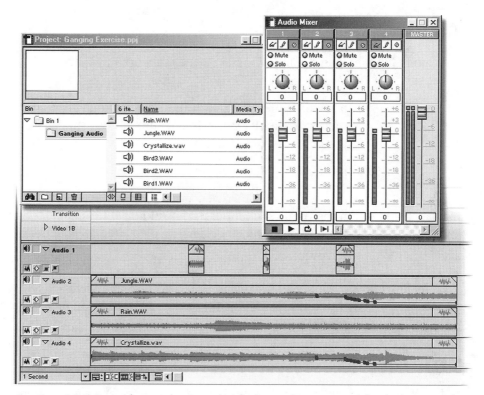

Fig. 13-36. Audio tracks 2 and 4 fade out by ganging the fade controls.

The rubber bands in the timeline reflect the changes made in the Audio Mixer window. The rubber bands should appear similar to those shown in figure 13-36. Due to the individual nature of this process, the rubber bands will vary in position and appearance. Use figure 13-36 as a guide for how the finished project will appear.

If the results for this process are not satisfactory, immediately select Edit > Undo Audio Mixer. If additional changes have been made and you wish to start over, select File > Revert. This will open the project from the last save performed in step 1 of this segment. When using the Revert feature, the Gang controls must be reassigned when the file reopens.

Using Automation Read

Previously you ganged audio clips in the audio mixer using the Automation Write feature. The result of this effect is uniform fading of ganged tracks. Previewing these tracks can happen all at once, or by isolating the track through the controls in the track header. Another way to pre-

view track changes is by using the Automation Read function, as follows.

1 Open the following from the companion CD-ROM: *Tutorials/Audio/ Ganging Exercise.*

2 In the timeline, the four audio tracks should contain the audio files from an earlier exercise. Make sure all four tracks are expanded, revealing the rubber bands.

3 In the Audio Mixer window, turn off all automation settings by selecting the Automation Off icon.

4 In the Audio 4 channel in the Audio Mixer, click once on the Automation Read icon.

5 Press the space bar to preview the project. The changes made in Audio 4 will be previewed.

This tutorial has demonstrated the power of ganging fade controls and isolating sound files.

Summary

This chapter has provided a broad look at Premiere's powerful audio editing tools. Through informative illustrations and hands-on tutorials, you are developing a mastery of the video editing process. By understanding how to use Premiere as a tool for both video and audio, your skill set will grow richly. As your training continues, the result of your knowledge with this product and the experience of content development and assembly will provide a valuable tool for your video editing future.

Chapter 14
Output Strategies

Introduction

Two features of Adobe Premiere make quantum leaps over previous releases: (1) the ability to capture digital video via the FireWire interface and (2) the ability to export to a multitude of formats, allowing your production to be delivered to any device.

This chapter explores the wide variety of output scenarios offered in Premiere 6.5. Knowledge of where and how your production can be viewed will give you an advantage as preparation of dynamic digital media productions are developed. This chapter will follow the menu items found in the File > Export Timeline menu item. From this menu, a total of nine export options appear. Each of these options is reviewed in detail.

 NOTE: *Due to the processing power required for some of the scenarios in this chapter, and the equipment requirements, some processes may not work for your hardware.*

Objectives

The following are the objectives of this chapter.

- To understand the best options when saving and exporting projects for use in video, for the Web, for presentations, and other uses.

- To use files created in various exercises in this book and to export them to a variety of formats.

Readying Your Project for Output

As you have worked through exercises in this book, you perhaps have become familiar with the functionality Premiere provides for linking to external files. Basically, when files are first imported for use in the time-

line, a link is established to the current file location. If files are moved, this link is broken. If a file, including preview files, has been moved to a new location, Premiere will prompt the user for file location when a project is opened.

Support File Organization

As shown in figure 14-1, as a file is launched, prompts are given to locate missing files. This process also includes missing preview files. As you will notice on the buttons on the right of the screen, individual files can be skipped, or all files can be skipped. If the preview files are moved or perhaps discarded, you can choose to skip previews. Another option is to use the Off-line option. This option replaces missing files with an off-line file, or a blank placeholder that will maintain all references to the missing file until it is replaced with the original file. The All Off-line option replaces all missing files with off-line files.

Fig. 14-1. The Locate File dialog allows missing or relocated files to be linked to the current project.

When preparing a project for output, make sure all external files are properly linked. If files are located on an external device, such as CD or DVD-ROM, make sure your computer system is fast enough to handle playback of audio and video clips without dropping frames or other interruption.

Previewing Options

The following sections describe methods that can be used to preview all or part of a project.

To Disk

Previewing to disk is the norm for Premiere. In fact, it is the default preview setting. The location of where files are saved can be changed in the Preferences menu under the Scratch Disk and Device Control menu. If the Premiere project or the associated support files have been moved, when the project is opened, Premiere will look for the files in their last locations. See figure 14-2. Preview files can be very large files, based on the size of the file to be previewed. Keep this in consideration as the project grows and as additional preview files are created.

Fig. 14-2. Preview files saved in specific folders.

To RAM

Previewing to RAM is a fast process due to the fact that files are not written to disk. This is the positive side of this process. On the negative side, this process requires an abundance of RAM to render a scene. In addition, files are not saved, resulting in the need to regenerate the preview once more.

To Screen

This option is another way to see the preview quickly. However, the playback speed does not remain true during this process. This method is good for previewing effects, edits, and transitions. Using this process relies heavily on the power of your computer system. In addition, more complex transitions affect the speed and delivery of information to the screen.

Scrubbing

Scrubbing is perhaps the most often used method of previewing in Premiere. This is true because as editing is performed in the timeline scrubbing is a quick method by which to see how one clip interacts with another. If an area has been rendered, transitions and effects can also be viewed this way. One disadvantage of scrubbing is that the playback speed depends on manually dragging the edit line. Effects and transitions can be viewed using this method by pressing Alt (Windows) or Option (MacOS).

Fig. 14-3. Matrox RT2500 and RT Mac render effects instantly.

Previewing with the Matrox RT2500 or RT Mac

The Matrox RT2500 (for Windows) and the RT Mac (for Macintosh OS) provides a combination video card and breakout box solution for Premiere. (See figure 14-3.) These products offer real-time rendering of many transitions, motion settings, and other effects. With these products, previewing can be done on part or all of the project in the timeline without delay. Specialized effects are included with these products to add variety to the editing process. These products make the entire editing process more productive, with faster turnaround.

Export Timeline Menu Options

In Premiere's File menu, the Export Timeline menu offers many options. This menu is used to export the project contained in the timeline to a variety of formats. These formats include exporting the timeline as a movie, to videotape, as an audio file, as an MPEG file, or assorted formats for streaming video for the Web. Other formats are also available.

The sections that follow explore menu options associated with the Export Timeline option in the File menu. Some of these topics are informative. Tutorials are also provided that explain the process of exporting projects as movies, saving for the Web, saving audio files, printing to video, and exporting for use on a CD.

Exporting Movies

The sections that follow discuss issues regarding the export of movie files.

Exporting a Movie

In a previous tutorial, a movie was exported in a QuickTime format. This is a simple, straightforward process in Premiere. However, with the introduction of Premiere 6.5, numerous options exist for exporting the timeline to various movie formats, including AVI, QuickTime, Animated GIF, filmstrip, and more. In the following materials, you will learn about various export formats and, by following the tutorials, will export files created in various tutorials produced earlier in this book.

Choosing a Playback Format

When choosing an output method, there are two questions to be answered: (1) What will be the final use for your production? and (2) How does this affect how the file is exported? Premiere provides output solutions to support a variety of output options, including tape, web, presentation, CD, DVD, and others.

Exporting Frames

Video footage in Premiere can be cued, allowing a single frame image to be captured as a still image. This functionality offers some unique capabilities and provides the ability to export images that can be repurposed in numerous ways.

Chapter 15 provides much detail for exporting frames from Premiere for use in other applications. For more information about capturing still frames, see Chapter 15.

Exporting Audio

Just as you can export movie files, Premiere also allows the export of audio-only files in a variety of formats. In Chapter 13, an audio exercise was assembled into a file named *Ganging Exercise.ppj*. This audio-only file was previewed in Premiere but never output. In this section, you will output the *Ganging Exercise.ppj* file to various file formats.

When you select Export Timeline > Audio from the File menu, the Export Audio dialog box appears. This dialog box offers the option to name the file and to specify where the file will be saved. In addition, current settings for the file are listed under the File Name box. To change the current settings, you click on the Settings button, which accesses the Export Audio Settings dialog box. Here, you can set custom output formats.

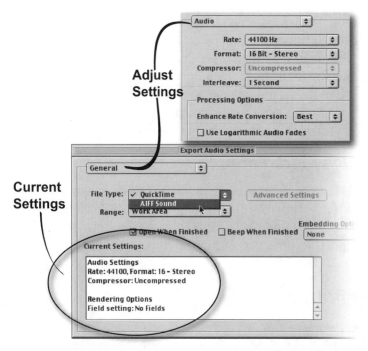

To obtain a feel for the audio output process, review figures 14-4 and 14-5. Figure 14-4 shows the MacOS window for exporting audio. Figure 14-5 shows the Windows dialog box. The audio options shown at the top of these two figures illustrate options available once the Audio option is selected from the general pull-down menu. Options such as data rate, format, and compressor can be modified from this dialog box.

Fig. 14-4. Exporting an AIFF file in Macintosh OS.

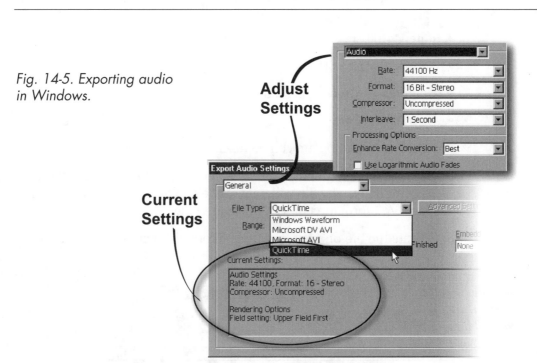

Fig. 14-5. Exporting audio
in Windows.

Tutorial 14-1: General Format Output Options

This tutorial explores various general format output options.

Exporting to AVI/TIFF

To create an AVI (Windows) or TIFF (MacOS) audio file from the time-line under Windows, perform the following steps.

1 In Premiere, open the *Ganging Exercise.ppj* file. Make sure all exter-
 nal files are linked and play back properly.

2 Position the work area bar over the entire project and preview the
 project.

3 Select File > Export Timeline > Audio. When the Export Audio
 window opens, click on the Settings button. When the Export Audio
 Settings dialog box opens, set the file type to Microsoft AVI (Win-
 dows) or AIFF Sound (Mac). Select the General pull-down menu,
 and select Audio. When the audio settings appear, select the follow-
 ing settings.

- Rate: 44100 Hz

- Format: 16 Bit - Stereo

- Compressor: Uncompressed

- Interleave: None

4 Once these setting are complete, click on OK.

5 In the Export Audio dialog box, name the file *Ganging*, saving it to your desktop. The file will now reside on your desktop ready to play as an AVI-formatted or TIFF-formatted file.

6 Locate the file on your desktop and double click on the file to preview it. (See figure 14-6.)

Fig. 14-6. Ganging file exported as a Windows AVI file, shown in Premiere.

Importing an Audio CD Track Under MacOS

The Macintosh version of Premiere offers the capability to directly import CD audio tracks, saving them in either an AIFF or WAV file format. This process performs a direct conversion of data, meaning that no loss of quality will occur during this digital transfer process. This process is possible due to converters incorporated into QuickTime.

NOTE: *The following import scenario requires a user-supplied audio CD.*

To import an audio CD track, perform the following steps.

1 In Premiere, select File > Open. Locate and select the audio CD, select a track, and click on Open.

2 When the Save Translated File As dialog box opens, click on Options and specify the following.

- Rate: 44.1 kHz (for CD audio quality)

- Size: 16 bit (compact disc quality)

- Use: Mono or Stereo

3 Click on Play to verify that you have selected the correct track.

Save Translated File As...

Desktop

Name	Date Modified
Premiere	4/4/02
Premiere Data	4/4/02
Appendix A	4/13/02
Appendix B	4/1/02

Name: untitled New

Options

Audio CD Import Options

Settings

Rate: 44.100 kHz

Size: ○ 8 bit ● 16 bit

Use: ○ Mono ● Stereo

Audio Selection

Track: "Track 1"

Start: 00:00 End: 05:58

00:00

Play Cancel OK

Cancel Convert

Fig. 14-7. Importing a CD audio track from an external CD.

4 The Audio Selection section allows you to manually adjust the beginning and ending of the audio clip to be captured. Likewise, the time can be adjusted by typing in a value into the numeric fields. Make these adjustments if desired.

5 Name and save the file.

6 Click on the Convert button. A status window will appear as the file is being imported.

The converted track is ready to be played from your computer. This process also works by selecting File > Import > File menu. (See figure 14-7.)

NOTE: *When converting CD audio tracks at CD quality, the file size for each track can be rather large. A clip of two minutes and nineteen seconds converted at CD audio quality consumes approximately 25 Mb of disk space.*

Tutorial 14-2: Save for Web Audio Output Options

With the widespread availability of broadband Internet services, the ability to provide audio and video clips on the Web is both practical and effective. Premiere supports numerous output options for delivery of content to the Web. In the following two tutorials, you will prepare files for delivery to the Web.

QuickTime Progressive Download/Audio Only 56K (MacOS and Windows)

A progressive download movie refers to a movie that will open and begin to play, even though it has not completely loaded. You may have experienced this by viewing a movie that has a loading status bar constantly moving just ahead of the movie. This process happens at various speeds, depending on a combination of the power of your computer system and the type of web connection. To create a progressive audio download file for the Web, perform the following steps.

1 In Premiere, open the file *Ganging Exercise.*

2 Select File > Export Timeline > Save for Web. The Cleaner 5EZ dialog box will open, allowing you to establish settings and to specify what is to be exported. (See figure 14-8.)

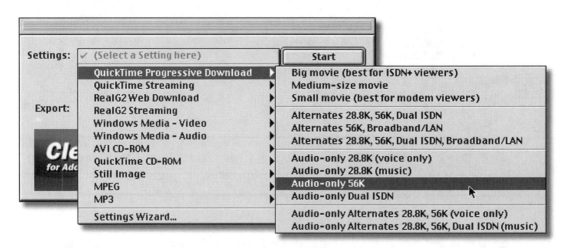

Fig. 14-8. Progressive Download option.

3 From the Settings pull-down menu, select QuickTime Progressive Download/Audio - Only 56k. Click on the Start button. (See figure 14-8.)

4 The Cleaner 5EZ program will launch and you will be prompted to name the file. Name the file *Progressive.mov.* As shown in figure 14-9, the downloading/encoding process will begin.

Fig. 14-9. The encoding process.

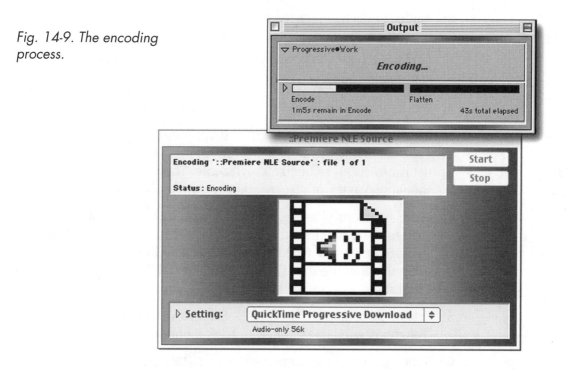

Progressive.html **Progressive.mov**

Fig. 14-10. The Progressive Download option for audio creates an html file as well as the data file, a QuickTime movie.

When the download/encoding process is complete, two files (figure 14-10) have been created with the Progressive name: an *html* file and a QuickTime movie. The *html* file depends on the movie for playback. Like files placed in Premiere, these files must stay in the same location in order to perform as one.

Tutorial 14-3: Printing to Video

Printing to video, simply stated, is outputting the content in the timeline to videotape. The following steps take you through the process of printing to video under Premiere.

Printing to Video Using Premiere

In the following, you will output a portion of the timeline created in a previous tutorial, using the Print to Video option in Premiere. Have a

camcorder or deck connected to your computer and activate the Device Control option. To do this, perform the following steps.

1 In Premiere, select File > Open. Navigate to the CD and select *Saved Files/GoEnergy.ppi.*

2 Set the timeline to begin at the 0;00;00;00 position.

3 Set the work area bar to begin at 0;00;03;00 and end at 0;00;17;00. This will define the area to be viewed. Press Enter (Windows) or Return (MacOS) to build a preview file. The video program preview should play back or display on your deck or camera.

4 Make sure your video-recording device is turned on, with the tape cued to the desired starting point. The videotape will need time to stabilize before the video begins. Make sure that additional time is given to allow the speed of the device to stabilize before the actual video starts.

5 Select File > Export Timeline > Print to Video. The Print to Video dialog box will appear, offering several options.

6 Zoom Screen will enlarge the movie. In this example, the movie is 320 x 240. With Zoom Screen selected, the screen will display at double the size, or 640 x 480. There is also an option for displaying color bars for a set time, as well as an option for the screen to play black prior to the beginning of the movie. Selecting Loop Playback will allow the preview to run continuously. Also in this dialog box is a screen mode option. This will be available if an external monitor is attached. If a monitor is attached, select Current Screen from the pop-up menu for the computer monitor and NTSC to preview on a television monitor.

NOTE: *The Print to Video dialog box displays minor differences between the Macintosh and Windows versions.*

7 Make sure your video-recording device is on and that the tape is cued to the point where you want to start recording.

8 Click on OK to start the video recording device.

9 Select the options shown in figure 14-11.

NOTE: *This print-to-video scenario also works with video clips in the Project window.*

Fig. 14-11. Configuring the Print to Video option.

Print to Video

Color bars for `0` seconds
Play black for `1` seconds
☑ Zoom Screen: `Software` ⬍
Screen Mode: `Current` ⬍
☑ Loop Playback

OK
Cancel

Exporting to Tape

Exporting the content from your timeline onto videotape in Premiere can happen in a number of ways. It can be performed manually at a basic level, consisting of simply building a preview of your movie and then playing it back while connected to a DV or analog camcorder or to a VCR. You can also export to videotape by using the Device Control option. This option will control external devices, such as a DV camcorder or a video deck that supports device control.

DV to DV Device Using Device Control

With the FireWire or IEEE 1394 connection, moving video from Premiere to DV tape is easy. As shown in figure 14-12, both devices must contain a FireWire port and be connected via the FireWire cable. This allows Premiere to take control of the device, and through software settings the device will start and stop per user input.

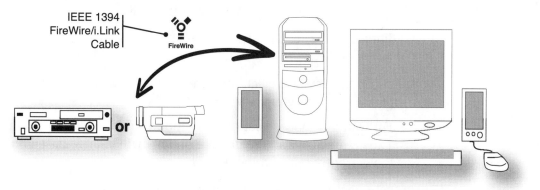

Fig. 14-12. The computer controlling a DV camcorder via FireWire connection.

Preparing a DV Program for Videotape Recording

The following tutorial assumes you have a DV device, such as a DV camcorder or DV recording deck, attached to your computer. The devices should be connected via FireWire/IEEE 1394.

1 In Premiere, select File > Open. Navigate to the D-ROM and select *Saved Files/Fireworks.ppj*. In the timeline, position the work area bar over the entire presentation and press Enter (Windows) or Return (MacOS) to build a preview file.

2 Connect the DV camcorder or DV deck to your computer via FireWire.

3 Turn the DV camcorder on and set it to VTR (or VCR) mode.

4 In Premiere, select Project > Project Settings > General. Click on the Playback Settings button.

NOTE: *When you select a DV preset, Editing Mode is automatically set to DV Playback (Windows) or QuickTime (MacOS). Each of these options provides additional DV playback settings.*

5 From the Output section of this dialog box, activate the following options.

- Playback on DV Camcorder/VCR

- Playback on Desktop

- Render Scrub Output to DV Camcorder/VCR

6 If Editing Mode is set to QuickTime, select the following settings and then click on OK.

- For Output Device, select FireWire to play back all DV-compressed clips to your video monitor.

- For Output Mode, select the appropriate NTSC or PAL mode. The Frame Size and Frame Rate options will change based on the currently selected mode.

7 In the Audio portion of the DV Playback Options dialog box, select *Play Audio on Desktop while Scrubbing*. This option will allow audio to play back through your computer speakers for monitoring. When using FireWire, audio plays through the FireWire device.

NOTE: *To ensure audio and video synchronization, make sure both sources play through the same device.*

For Sample Rate, refer to your DV camera's documentation regarding audio settings and select the sample rate used by your camera. This setting may have been set when the project was started. If so, that setting will not have changed. Most DV cameras use a sample rate of 32 or 48 kHz.

NOTE: *Audio sample rates should reflect the sample rates supported by your DV camera.*

To view DV-compressed clips on the selected output device and your computer monitor, select *Play Also on Desktop when Playing to the Output Device.* Doing this may be a drain on your computer. If so, turn this option off.

NOTE: *Even with this option turned off, scrubbing previews will still appear on the desktop and the external video monitor.*

8 Click on OK to close the Project Settings dialog box.

9 Select Edit > Preferences > Scratch Disks and Device Control and specify the scratch disk to be used for captured movies.

10 Select DV Device Control 2.0 (or later) for Device and click on Options. If necessary, select your camera brand and model.

11 Select the appropriate timecode format for your device and click on OK.

12 Click on OK to close the Preferences dialog box.

Recording the Timeline to DV Videotape Without Device Control

To record the timeline to DV videotape without device control, perform the following steps.

1 In Premiere, select File > Open. Navigate to the CD and select *Saved Files/Fireworks.ppj.* In the timeline, position the work area bar over the entire presentation and press Enter (Windows) or Return (MacOS) to build a preview file.

2 When the preview of *Fireworks.ppj* is complete, the playback should preview through the camera or deck. If the preview does not play through the connected device, check all connections and settings. If needed, consult the documentation for the device. The recording device must be turned on and cued to a desired starting point.

3 In the timeline, position the edit line to the beginning of the project.

4 Manually select the Record button on your recording device.

5 In the Monitor window, click on the Play button to initiate the movie playback.

Recording the Timeline to Videotape Using Analog Video Device Control

Premiere offers a number of ways to output video to external devices. Not only are DV devices controlled, but analog components can also be controlled through hardware and software interfacing. The following is an overview of the process.

• Your recording device should be on and should contain the proper tape.

• Configure your external device by selecting Edit > Preferences > Scratch Disks/Device Control. From there, select the device control plug-in for your specific device. If options are available, set them as necessary and then click on OK.

• To begin, select File > Export Timeline > Export to Tape. Specify options as required.

 NOTE: *Each external device contains its own set of controls, thus making the interface unique. As questions arise regarding settings for these devices and their plug-ins, consult the documentation for the device.*

Timeline to Videotape without Device Control

Sometimes, the need to quickly record the content of your timeline is required. The easiest way to do this is to simply preview the timeline, play back the preview, and press Record on your camera or deck. The workflow for this process is as follows.

- In the timeline, position the work area bar over the portion of the video program to be recorded. Next, build a preview of the timeline by pressing Enter (Windows) or Return (MacOS).

- As the preview plays, it should display at your recording source, your camera, or deck. If not, check all connections and software settings and refer to other documentation for your recording device. Your recording device should be on and the tape cued and ready for recording.

- In the timeline, position the edit line at the beginning.

- To begin the recording process, press the Record button on your recording device.

- Finally, click on the Play button in the Monitor window to begin playback.

File List

By exporting the timeline to a file list, a text file is created containing a list of all files used in your project. On the MacOS, the export dialog box also includes an option to list the exact location of each file. The file list for Windows is automatically exported as a *.txt* file, whereas the file list for the MacOS is given a *.files* extension. (See figure 14-13.)

Fig. 14-13. File List menu.

EDL

Fig. 14-14. EDL information.

An EDL, or an edit decision list, is a data file generated in Premiere for off-line editing. EDLs are needed when a decision is made to edit the source videotape in a postproduction studio. As shown in figure 14-14, an EDL contains information about clips, information such as in and out points, and other information.

Premiere can export an EDL in a generic format as well as preformatted for various controllers. A list of controllers is available as a menu of selections, as shown in figure 14-14. These predesigned formats are plug-in and reside in Premiere's *Plug-ins* folder. Through the plug-in architecture, additional plug-ins can be added for new systems as they become available.

Exporting Video Using the Settings Wizard (MacOS 9 Only)

To export a file using the Settings wizard, perform the following steps.

1 Open a new project in Premiere using the Multimedia QuickTime setting.

2 With the project window selected, select File > Import > File and open *CD-ROM/Saved Files/Popularity.mov.*

3 Drag the *Popularity.mov* file from the bin into the timeline, beginning at 0;00;00;00.

4 Select File > Export Timeline > Save for Web > Settings > Settings Wizard > Start. Cleaner 5EZ will open.

5 In the Settings wizard, make the following selections.

 • Delivery Medium screen: CD, DVD-ROM

- Target Machines: High-end & Midrange

- CD or DVD-ROM Speed: 4x ('Quad Speed') or faster

- File Format: QuickTime

- Preferences: 1st: Video Most Important, 2nd: Balanced Motion and Quality, 3rd: Higher Quality

- Options: Remove Audio Noise

Once these settings have been made, a final screen will appear, as shown in figure 14-15. This screen indicates audio and video output specifications based on the selections made in the Settings wizard.

Fig. 14-15. Using the Settings wizard in Premiere.

6 To accept these settings, select Finish.

7 The Save As dialog box opens, prompting you for a file name. Select a name for the movie and save the file to your desktop. Once the Save button is selected, the movie will begin the encoding process. This will take anywhere from a few seconds to a few minutes, based on the speed of your computer.

8 Once the encoding process is complete, locate the file on your desktop and double click on it to open it. When the QuickTime file opens, click on the Play button.

The Settings wizard offers multiple options for video output. Experiment with these options and view saved files to understand how various settings affect the appearance of the finished movie.

Exporting Video for Use with Adobe GoLive

GoLive is Adobe's web development software for the creation of HTML, design, layout, and overall web site management. GoLive offers plug-in support for QuickTime, Real, and other media types. Because Premiere can export to these media formats, it is important to understand the workflow. (See figure 14-16.)

Fig. 14-16. QuickTime movies from Premiere can be directly imported into Adobe's GoLive.

Like Premiere, GoLive has its own timeline window for controlling events that happen in a chronological order. As shown in figure 14-17, QuickTime video clips are placed into GoLive's timeline for enhancement and to add interactivity. GoLive allows QuickTime movies to be edited and enhanced and to even add interactivity to the movie. Buttons and controllers can be added to the movie, allowing the end user to control the movie.

Premiere and RealMedia

Premiere offers several options for creating streaming video. These include QuickTime Streaming, RealVideo, RealG2 Streaming, and Win-

Fig. 14-17.
Interactivity
can be
assigned to
QuickTime
movies in
GoLive.

dows Media. With the integration of RealNetworks' Advanced RealMedia Export plug-in for Premiere, audio and video files can be highly compressed for playback in any web environment. RealSystems has been around for quite a while and has revolutionized streaming media processes and workflows, providing high-quality media over low-bandwidth connections.

The ability to export to the RealMedia format is an option via Premiere's plug-in architecture. This plug-in architecture also allows inclusion of RealMedia files into Adobe's GoLive product.

In Premiere, selecting File > Export Timeline > Advanced RealMedia Export will open the Advanced RealMedia Export dialog box, shown in figure 14-18. When this dialog box appears, options can be specified to generate the specific format needed for your application. It is really just that easy to output a file for the RealMedia format. To develop an understanding of the options available and to learn how files look, sound, and perform, export a clip from Premiere and test the results.

Exporting for Use in Adobe AfterEffects

Adobe AfterEffects software provides a comprehensive set of tools for the production of motion graphics and visual effects for multimedia, video, film, and the Web. AfterEffects supports both 2D and 3D image compositing in an easy-to-use software environment.

*Fig. 14-18.
Advanced
RealMedia
Export dialog
box.*

Titling is one area in which AfterEffects excels. Many Hollywood movie productions have used this powerful program to incorporate titles, and other powerful visuals. AfterEffects is capable of producing high-end professional results from a desktop computer platform. In many respects, AfterEffects is a direct extension of Premiere, primarily due to the migration between the two programs.

Any Premiere project can be directly opened by AfterEffects, allowing files prepared in Premiere to be opened and taken to new levels by adding new animated and visual effects and features. This interchange of file types is yet another advantage of the tight integration between Adobe products. As a Premiere file is imported, each video, audio, and still-image clip assumes its own layer, arranged in a sequence in the Time Layout window. AfterEffects also maintains bins and web markers from imported Premiere projects.

One aspect of the integration between Premiere and AfterEffects is the ability share common plug-ins. As shown in the video palette in figure 14-19, the AfterEffects plug-in yields the same effect in Premiere. Using these plug-ins will assist in the development of content in Premiere prior to importing the file into AfterEffects. Another workflow advantage is that Premiere projects need not be rendered prior to export into AfterEffects. The imported file can be rendered after import, with the addition of any effects added in AfterEffects (figure 14-20).

Fig. 14-19. AfterEffects plug-in are a part of Premieres video effects.

Fig. 14-20. The Adobe AfterEffects timeline.

Exporting Video for CD/DVD-ROM

The sections that follow discuss various aspects of video export for CD-ROM and DVD-ROM.

Video and Audio on CD

Just as video and audio for delivery on the Web must be saved in specific formats for various connection speeds, video and audio must also be properly formatted for CD playback. The audience for your production should always be the first consideration when deciding the proper format for saving a clip. If producing a CD for mass distribution, a video must be able to play on the slowest CD device, such as a single- or dou-

ble-speed CD drive. Premiere contains flexible options for project output, ensuring compatibility with any playback environment.

For audio files, the higher the data rate the better the sound quality. However, higher data rates consume more disc space and take longer to process. Likewise, a lower rate takes up less space and processes faster. CD-quality sound is 44.1 kHz. Once audio is captured at 44.1 kHz, it can be downsized, or resampled, at a different rates to suit any application. Modifications to audio files should be based on the requirements established for the end product, or the target audience.

CD Export Checklist

The following are considerations that should be reviewed prior to choosing an export format for video.

- Decide on a data rate that is acceptable. How much video and audio quality must be sacrificed to achieve proper playback?

- Consideration must be given to the minimum device that will play the CD. If producing a product that will play back on a 2x CD drive, specifying even a lower rate will be beneficial due to the fact that other system functions are going on simultaneously during CD playback. When exporting a video clip, specify a lower rate than this to achieve the best possible performance during playback.

- The higher the frame rate, the larger the movie. When space and speed are considerations, test clips at a lower frame rate to see if the video playback is desirable.

- Review color depth settings. A 256-color setting will allow the movie to play back on lower-end computers and broaden the range of compatible systems.

- The size of the video is also a factor. The larger the file, the more sophisticated the compression setting should be. The following are compression options for saving a clip for CD.

 - *Sorenson:* Use Sorenson for high-quality video and low data rates. This is a good selection for cross-platform CDs. Compressing in this format takes longer, but the exported video quality is very good.

 - *MPEG:* Motion Picture Experts Group (MPEG) is an effective file compression format. Although MPEG has been around a long

time, it is not as popular as AVI or QuickTime. MPEG takes several forms: MPEG, MPEG-1, MPEG-2, and MPEG-4. Typically, MPEG-1 is the format most often used for the Web and for CD. MPEG-1 offers video quality comparable to VHS, whereas MPEG-2 offers S-VHS quality.

– *Cinepak:* Cinepak is a good selection for older computers with slow CD drives. Cinepak works well with web downloads also. When producing a CD, Cinepak provides a good cross-platform option.

Exporting a Clip

To export a clip to a filmstrip file from the timeline, you must first position the work area bar over the section of the clip you wish to export. (See figure 14-21.) You then select File > Export Timeline > Movie. When the Export Movie dialog box opens, you select the Settings option. As shown in figure 14-21, the Filmstrip option is then selected from the File Type pull-down menu. The file is exported as a filmstrip file. Note that on Windows systems an *.flm* extension is added to the file name. This file should be opened within Photoshop.

Fig. 14-21. Selecting a clip for export, and the file type for creating a filmstrip file.

Figure 14-22 shows the file once opened in Photoshop, which appears as a series of still images as in an actual filmstrip. These Photoshop files can become quite large, based on the original size of the frame output and the length of the exported clip. This will be a consideration as it

relates to the power of your computer and the capacity of your hard drive unit. For example, the work area bar for this clip was set to 2 seconds. The frame size for this clip was 320 x 240 pixels, at 72 dpi.

The resulting filmstrip file was 320 pixels wide and 7,680 pixels high. This created a Photoshop file that was approximately 9 Mb. This is important because the maximum height for a filmstrip file is 30,000 pixels. Once a single filmstrip file reaches 30,000 pixels, a second file is automatically generated. This process continues to capture the specified clips.

Figure 14-23 shows the sequence of still images generated from the filmstrip output command. Note that each frame is individually numbered. (The timecode is shown for reference.)

Fig. 14-22. A filmstrip file from Premiere opened in Photoshop.

Fig. 14-23. Using the Clone Stamp tool in Photoshop to edit a filmstrip frame.

Once a filmstrip file has been edited, it can be reimported into Premiere. Modification made to individual frames will appear during video playback. It is important to note that upon playback changes made to a single frame will pass by almost unnoticed due to the number of frames that play back per second. When modifying frames in a filmstrip, remember the number of frames it takes to create the effect you desire.

Exporting a Single Frame

The export filmstrip process can be a powerful editing tool. However, you may find it useful to simply export specific frames rather than the many frames in the filmstrip process. For more information on exporting still frames, see the "Exporting Frames" section earlier in this chapter or refer to Chapter 15.

Exporting a Still-image Sequence

Exporting a still-image sequence is somewhat similar to the export filmstrip and the export frame process. However, the end result of this process is a numbered series of individual frames from the original video clip. The number of frames actually generated is based on the output setting selected in the timeline, or the position of the work area bar.

Many animation and 3D programs require a series of still-image sequences in order to generate proper output in these software environments. The still-image export process is beneficial to provide the proper format for such applications.

A still-image sequence is generated by first assigning the location of the work area bar in the timeline. This determines the area to be output. By selecting File > Export Timeline > Movie, the file export type can be assigned. As shown in figure 14-24, there are several file options for output. To export a sequence, the file type must contain the word *sequence.*

Fig. 14-24. Exporting a still-image sequence.

Exporting an Animated GIF

By selecting the animated GIF file type for export, a series of still images is arranged sequentially for output as a GIF file. As shown in figure 14-25, advanced settings are available that pertain exclusively to the proper formatting of a GIF file. Selecting the Dithering option will blend the colors of the images for better performance on the Web.

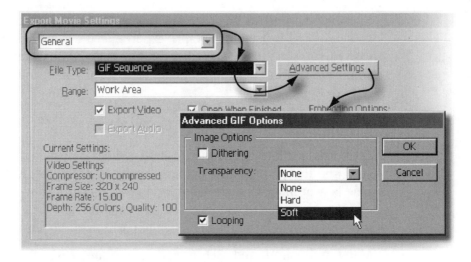

Fig. 14-25. Exporting a GIF animation and advanced option settings.

Each transparency option offers a different result. None will export your file as opaque. Hard allows one color to be transparent. Soft adds soft edges to only one color in the image sequence. The animated GIF will play continuously if the Looping option is selected. To preview a file exported as an animated GIF, open the file in your browser.

Summary

Premiere excels as a technical platform for producing high-quality audio and video productions. The creative part lies with the user. Combining the technical and the creative produces compelling and moving media. Once constructed in Premiere, media files can be routed through many distribution methods. This chapter introduced you to some of the many directions your projects can take. As your involvement with Premiere grows, you will continually discover the power of this dynamic application and the many uses for the files it is capable of creating.

CHAPTER 15

EXTENSIBILITY

Introduction

Developing any type of video project is an undertaking that requires interfacing with a variety of external processes. These processes can include hardware-based solutions as well as software solutions. They can include art creation, technical writing, video and audio capture, and web-based alternatives. But what about taking a part of one file type and using it in a totally different environment?

One of Premiere's strengths is its ability to take content developed from a variety of application programs and to import it for use without further modification. On the other hand, Premiere also contains output options that are not as obvious.

Adobe offers many complimentary applications that make the process of sending one file type to another program a seamless, uncomplicated process. In this chapter, many scenarios are reviewed that demonstrate how files created in one application can be shared, thus simplifying the manner in which files are transported from one application to another.

Objectives

This chapter is designed to enumerate the development of support files used in tutorial development throughout this book. Details of the Premiere, InDesign, Photoshop, and Acrobat applications are explored, as well as how these products were used to create a wide variety of content supporting the video editing process.

This chapter also provides an in-depth review of graphics development in association with the tutorials in this book, demonstrating how these elements were created and prepared for importation into various Premiere projects used in this text. In this chapter, the following Adobe software applications are reviewed.

- Photoshop
- Illustrator
- InDesign
- Acrobat

Premiere and Photoshop

Adobe Photoshop is your foremost ally in the preparation of Premiere graphics. This applies to graphics prepared in Photoshop as well as still images captured in Premiere and exported to Photoshop for visual enhancement. As you learned during tutorial development, Premiere will directly import native Photoshop files. This functionality makes it easy to enhance any video production with scanned photographs, logos, titles, or unique artistic creations. Figure 15-1 provides details about file types Premiere accepts by default.

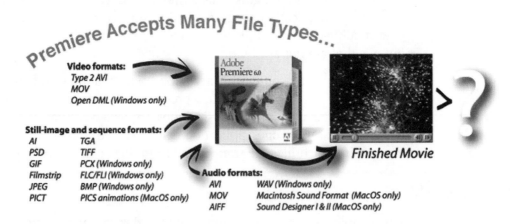

Fig. 15-1. File formats that can be imported into Premiere.

Another unique feature in Premiere, as well as in other Adobe products, is the ability to launch external software in order to edit an imported file. This feature is called Edit Original, and is a command found in the Edit menu. By using this command on an existing file in Premiere's Project window or timeline, the original application will open and launch the selected file for editing. In the following pages you will learn how Photoshop was used to create many visuals incorporated into the finished movies for all tutorials.

Using Photoshop for Project Development

The tutorials assembled in chapters 6, 7, and 8 utilized more content than just video clips. These tutorials relied heavily on graphic images to support the overall project design. All of these graphic images were assembled and edited in Adobe Photoshop. The inner workings between various software products plays a big part in conceptual development. In the following section, how these images were designed is explained in detail.

Fig. 15-2. Various elements make up a scene in the Chapter 3 tutorial.

Figure 15-2 shows a scene from the beginning of the movie that involves an animated balloon image, a photo of the moon as a background, and a title. The title was the only element created in Premiere.

Capturing the Balloon Image

This image was exported from a video clip in Premiere as a still image using the Export Timeline > Frame command (see figure 15-3). By default, the image is saved as a *.pct* file and named *untitled*. Even though the file is a graphic, it is still associated with Premiere. This means that if you double click on the icon, Premiere will launch, allowing you to view the file or use it in its current format.

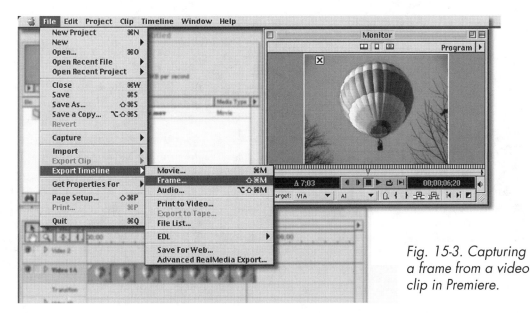

Fig. 15-3. Capturing a frame from a video clip in Premiere.

For use in the tutorials in chapters 6, 7, and 8, this file was saved as a Photoshop document and named *BalloonStill.psd*. The *.psd* extension is the extension used for native Photoshop document. From within Photoshop, the file must be opened and saved, overwriting the original *.pct* format.

Editing the File in Photoshop

Fig. 15-4. A still image captured in Premiere and then opened in Photoshop.

In the previous section, a still image was exported from Premiere, and then saved as a Photoshop file. With the file in this format, the image was opened in Photoshop with the intent to be edited, and then to be replaced in Premiere. The desired effect for this image is to have the balloon become the only object in the frame, thus removing all background elements. Once the image was placed back into Premiere, it was positioned in a superimpose video track and the green screen transparency setting was applied to remove the background (see figure 15-4).

The actual balloon position in the still image exported from Premiere is located away from tree branches, providing a clear shot of the balloon. This angle was selected by scrubbing through Premiere's Monitor window. Prior to removing the background, a green screen color was selected in Photoshop. The settings for the green background are shown in figure 15-5. Even though this color is not the official "green screen" matte color, it is sufficient

Fig. 15-5. Settings for a green screen background in the Color Picker.

for the green screen setting in Premiere's transparency settings. The green color is the Foreground Color selection in the toolbox.

Fig. 15-6. The background is selected for removal.

Removing the background image can be done a number of ways. For this instance, a combination of the Magic Wand and Rectangular Marquee tools was used. Careful detail was employed to make sure the balloon edges were smooth and that removal of unnecessary background elements around the balloon image accomplished. Figure 15-6 depicts the background selection process. Once the background was selected, it was replaced with the green color by selecting Edit > Fill > Foreground Color.

With the background removed and replaced with the solid green fill, the image was checked for size and resolution. By selecting Image > Image Size, details about the image were revealed (see figure 15-7). Due to the settings in the Premiere file, the pixel resolution of the movie defaulted to 320 x 240. Therefore, the exported frame was the same. In the Image Settings dialog box, these sizes are the same. Note that the resolution is at 72 ppi. This setting matches the resolution of the computer monitor.

Fig. 15-7. Confirming an image size of 320 x 240 pixels.

Fig. 15-8. Balloon image with the green screen background in place.

The final step was to save the image with a new name and in a new format (see figure 15-8). In the Photoshop setting, Save As was used to save the file as *BalloonStill.psd*. The image was prepared for reimportation into Premiere, where transparency settings were applied that removed the background image.

Chart Images

An animated chart was developed in tutorial 8-2 to demonstrate simple animation techniques using a series of similar graphics. The six chart graphics used in this tutorial were developed using Photoshop, and incorporated the *BalloonStill.psd* image. These images used a common background, as well as other graphic elements. To create the background image, video footage was reviewed in Premiere to capture a new angle of the balloon. With the desired frame selected, the frame was captured, and then output using Export Timeline > Frame. In Photoshop, the image was opened for further modification. The balloon image (figure 15-9) was moved to the right side of the screen, as shown in figure 15-10.

Fig. 15-9. Clip selected to be exported to a still frame image.

Fig. 15-10. In Photoshop, the balloon image is moved to a new position.

To finalize the design of the background, a filter was applied to the entire graphic. In Photoshop, the following filter was applied: Filter > Artistic > Neon Glow. The filter settings are shown in figure 15-11. A blue color was selected in the Glow Color field. This effect created a soothing blue background and a soft embossing effect to the balloon.

The end result is a subdued background image that will support the design of the chart images.

Fig. 15-11. Filter applied to the image to create a background.

TIP: *To experiment with this process on your own, open the following video clip: CD-ROM/Tutorials/Balloon/Video/Journey1.mov. From this clip, you can locate a frame for capture and export.*

Next, horizontal color bars were created to illustrate the popularity of ballooning over a 20-year period. The bars were created in Photoshop on a series of layers over the background image. Using layers ensures accurate design and relationships among all graphic elements. Yellow was chosen for the bar color because of the strong contrast to the blue background.

To give each bar a unique texture, the lens flare filter was applied and positioned on the left side of each bar (Filter > Render > Lens Flare). On separate layers, dates were added over the bars and placed in proper position using the Move tool. Figure 15-12 shows the development of these images and layers.

NOTE: *Each bar and each date was placed on a separate layer. The file being built will become a layered master file for the chart graphics. Six graphics were developed from this master file to create all background images for this portion of the tutorial.*

The next graphic file used in this sequence was *BalloonStill.psd*. This file was imported into Premiere and animated using motion settings. The resulting motion effects displayed a total of three balloon images that

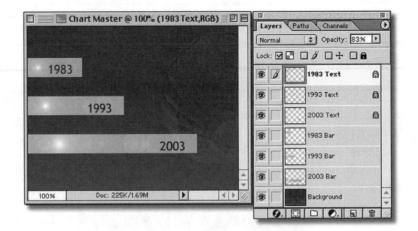

Fig. 15-12. Bar graphics and dates are added to layers in Photoshop.

would fly at a specified time and then come to rest at the end of each bar. The *BalloonStill.psd* graphic then dissolved at the same time the next chart graphic appeared, allowing the image to transition seamlessly. Figure 15-13 shows the placement of these images on their own layer.

Once the elements were created, and in layers in a single Photoshop document, a total of six backgrounds were exported, each configured uniquely. Three of the graphics contained the bars and date information and three more contained the balloon graphics in place. These six backgrounds are shown in figure 15-14. The background images were named *Chart A* through *Chart F*. These images were developed for import into Premiere, where they would be in a sequence allowing them to be built using a wipe-right transition. This effect makes the bars appear to be animated as the chart builds.

Fig. 15-13. BalloonStill.psd graphic added to the end of each bar.

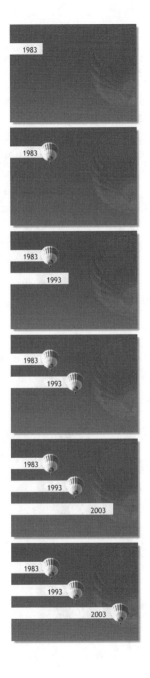

Fig. 15-14. Six charts exported as individual files from the single layered chart graphic.

Backgrounds for Video in a Window

Tutorials 7-1 through 7-3 contain three background graphics to support the "video in a window" process. To develop these backgrounds, the primary background image was taken from the image prepared for the background, as shown in figure 15-11. During project development, this image was opened and saved as *BalloonBuild.psd*. This file was used to develop three new background images to be used in Premiere.

 TIP: *As graphics are developed in Photoshop, copies of the file are saved in various stages for use in other areas during project development. This applies specifically to files with layers that may need to be modified during the development process.*

In the process of developing the background graphic for this tutorial, the placement for the "video in a window clip" was a primary consideration. With the layout containing the balloon graphic on the right of the screen, the natural location for the clip was the upper left-hand corner. Modifications were made to the background image to support this layout.

For this part of the tutorial, a total of three backgrounds were created. All backgrounds are identical, with the exception of text placement and text opacity. The approach to building these graphics was to use layers in Photoshop for design, graphic, text alignment, and consistency. A total of six layers comprise all components needed to create the three background images. The development process is outlined in the following.

Fig. 15-15. BalloonBuild.psd *document as the primary background layer.*

Layer 1: Background Graphic

With the background graphic opened and saved as *BalloonBuild.psd*, development of the chart graphics began. The balloon image remained at the right side of the screen and no additional filters or effects were applied, leaving the image as a natural, photographic image (see figure 15-15).

Layer 2: Setup Type

A new text layer was created for adding the first text object. The word *Setup* was added using 48-pt Garamond Italic type with a white fill at 100% opacity. The text was positioned as shown in figure 15-16.

Fig. 15-16. The Setup text layer is added.

Layer 3: Inflation Type

Another text layer was added to create the Inflation type. Using the 48-pt Garamond type, the word *Inflation* was added to the screen and positioned as shown in figure 15-17. The *Setup* text was faded to make the *Journey* text stand out.

Fig. 15-17. Adding and positioning the text Inflation *on a new layer.*

Layer 4: Journey Type

A third text layer was added to create the *Journey* type. Using the 48-pt Garamond type, the word *Journey* was added to the screen and positioned as shown in figure 15-18. Notice the relationship to the other two text elements. The *Setup* and *Inflation* text have been faded so that the *Journey* text is more visible.

Fig. 15-18. Adding the final text object onto the third text layer.

Layer 5: Gradient

A gradient was added to the background graphic to enhance the background in several ways. From a design standpoint, the gradient is beneficial because it made the bottom of the screen become darker, making the text and the "video in a window" clips appear more dominant. To create the gradient, in Photoshop's toolbox, black was selected as the

foreground color. Next, the Gradient tool was selected. At the top of the screen, in the Options palette, the Gradient picker was selected, and then the Foreground To Transparent Gradient option.

While depressing the Shift key, the pointer was then inserted at the bottom of the graphic, dragged to the top of the image, and released at approximately two-thirds the distance from bottom to top (establishing the direction for the gradient). Pressing and holding the Shift key kept the gradient direction in a constrained vertical path. This ensured that the gradient (see figure 15-19) was flowing in a consistent direction. Next, in the Layers palette, the opacity for the gradient was set to 90% so that the black area would appear somewhat translucent.

Fig. 15-19. Adding a gradient onto a new layer.

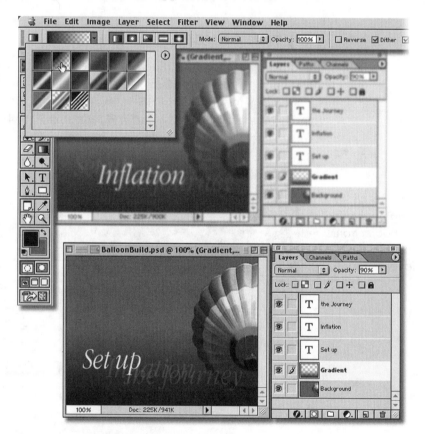

Layer 6: Drop Shadow

A drop shadow was added to the master graphic file to serve as a placeholder for all "video in a window" clips. The overall size of the graphic is 320 x 240 pixels. This is also the size of the video clips used in the

"video in a window" tutorial in Premiere. However, these clips were reduced by 50%, or to a size of 160 x 120 pixels. This means that the drop shadow area should be designed at 160 x 120 pixels.

To create the drop shadow, the Rectangular Marquee tool was selected from Photoshop's toolbox. This displayed the Options palette at the top of the screen. From the Style menu at the top of the screen, the Fixed Size option was selected and 160 x 120 (pixels) height attributes were entered. Next, in the toolbox, black was selected as the foreground color. Using this color, the rectangle was filled using Edit > Fill. To create the shadow, Layer > Layer Style > Drop Shadow was selected and settings were adjusted to have the shadow drop to the bottom right. The drop shadow will now serve as a placeholder for the video clip. See figure 15-20.

Fig. 15-20. Setting a drop shadow to appear behind the video clips.

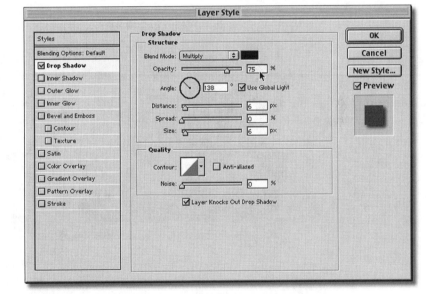

Outputting Three Background Graphics

As previously mentioned, a total of three graphics were created from this layered graphic to serve as backgrounds for the "video in a window" portion of tutorials 7-1 through 7-3. Each graphic was made unique by opacity adjustments and placement of the title graphics. The three files were created from the *BalloonBuild.psd* graphic by using the Save As command and modifying each saved file. The *BalloonBuild.psd*

file remained unchanged and was archived on hard disk drive, serving as the master file.

Setup Graphic. The *Setup* graphic was created using the following creation sequence.

- With the *BalloonBuild.psd* graphic open, Save As was chosen from the File menu and the file was named *Setup.psd*.

- In the Layers palette, the *Setup* layer was set to 100% opacity and the *Inflation* and *Journey* layers were each set to 20% opacity.

- The Flatten Image option was used to combine all layers into a single graphic.

- The file was saved and ready for use as a single-layer background in Premiere, as shown in figure 15-21.

This same sequence was used to create the other two backgrounds.

Fig. 15-21. The completed Setup background graphic.

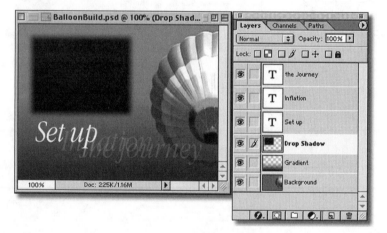

Inflation Graphic. The Inflation graphic was designed as follows.

- The *BalloonBuild.psd* file was opened and the file was saved as *Inflation.psd*.

- The opacity for the *Setup* and *Journey* layers was set to 20%, and the *Inflation* layer to 100%.

- The file was flattened and resaved, becoming a single-layer graphic, as shown in figure 15-22.

Fig. 15-22. Completed Inflation *background graphic.*

Fig. 15-23. Completed Journey *background graphic.*

Journey Graphic. The Journey graphic was designed as follows.

• The *BalloonBuild.psd* file was opened and the file was saved as *Journey.psd*.

• The opacity for the *Setup* and *Inflation* layers was set to 20%, and the *Journey* layer to 100%.

• The file was flattened and resaved, becoming a single-layer graphic, as shown in figure 15-23.

Using Photoshop in Tutorial 9-14

Photoshop was used extensively in the creation of graphics for tutorial 9-14, to edit still frames captured in Premiere and files created and exported from Adobe Illustrator. The versatility Photoshop offers made it the logical choice to embellish graphic images to be used in Premiere.

Preparing and Creating the Bottle Image

The bottle image was captured on mini DV tape using a digital camcorder. Using Premiere's Device Control option, the tape was previewed until the desired image was queued. The image was exported as a still frame using File > Export Timeline > Frame. The file was opened within Photoshop for editing. Next, using the Lasso tool, the bottle was traced, selecting only the bottle. The selection was inverted using Select > Inverse, and the background image was then deleted.

Next, on a new layer, a green background was added. With the bottle in the foreground, the file was flattened. The image size was reduced to 320 x 240 pixels. The image was left at the 320 x 240 size so that it need not be constrained or modified once placed in Premiere, in that 320 x 240 is the finished movie size. (See figure 15-24.)

The image, once placed in a superimpose track, had the background removed, revealing the bottle only. Once in Premiere, the bottle was scaled, rotated, and put in motion to create a dynamic motion sequence. (See figure 15-25.)

Fig. 15-24. Bottle image with background removed.

Fig. 15-25. Bottle image with the green-screen background removed.

TrailStill Image

Fig. 15-26. A still image serves as a background to create a special effect.

In tutorial 11-1, the blending of a still image and a video clip provided a unique effect. This sequence appears to consist of video clips only. However, it does not. A still image was used to create an effect that makes the runners appear to fade in. This effect was created by capturing a still frame of the trail without the runners, shown in figure 15-26. From this footage, a still frame of just the trail was exported, captured, and named *TrailStill.pct*.

As previously discussed, still frames output in Premiere remain associated with Premiere and are initially saved as a *.pct* file. In Premiere, the file was imported into the timeline and played as a still image as the video clip of the runners was faded over the still image. The resulting illusion is that the runners fade in as they are running, going from a ghosted image to actual video. In this scenario, there was no need to export the graphic into Photoshop.

SideStill Image

Fig. 15-27. A captured frame serves as a background for scrolling text.

As with the *TrailStill* image, the *SideStill* image was taken from a single frame of videotape. The frame was captured specifically to be added to the end of a video sequence in order to give the appearance that the video has been paused. This image was carefully placed at the end of the clip, where the actual captured frame ends. This created the illusion that the video clip was paused, whereas actually the video clip simply faded into the still image. The still image became an important design element in Premiere. By using a color balance effect to fade the image to a blue tone, the image becomes a subdued background as text scrolls over the screen (see figure 15-27).

Premiere and Adobe Illustrator

Like Photoshop, Adobe Illustrator is one of those versatile programs that allows graphic development for export to almost any destination. With the tight integration among all of Adobe's products, it is easy to create a design in Illustrator that can be opened in Premiere, or in a format that can be opened in Photoshop for further embellishment. In this section, examples of Illustrator files are reviewed to help you understand how files were created for use in tutorials created for this text.

Custom Border Design

Tutorials 11-1 and 11-2 both include Illustrator art files. Figure 15-28 provided a variety of elements used in this tutorials.

Fig. 15-28. Logo.eps file designed for tutorials 11-1 and 11-2.

A custom border was designed (for use in Premiere), which began as part of the *Logo.eps* illustration. This border was used as a mask in Premiere to create a unique visual effect. Development of this border design, as shown in figure 15-29, is reviewed in the material that follows.

Fig. 15-29. Custom border used to frame a video clip.

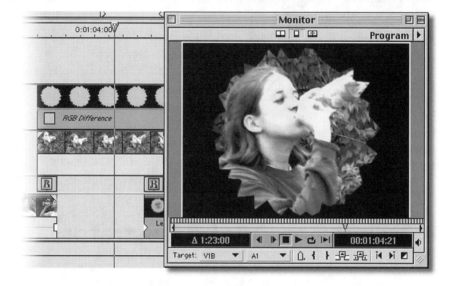

To begin, a copy of the *Logo.eps* file was created, and saved under a new name. Next, all elements were deleted, with the exception of the sunburst line (see figure 15-30). The line was then saved as an Illustrator *.eps* file.

Fig. 15-30. Outline of the sun used as a guide for creating a background matte.

Fig. 15-31. Custom frame design created in Illustrator and edited in Photoshop.

The sunburst line image was opened in Photoshop. Using the Paintbucket tool from the toolbox, the center was filled with green in order to be knocked out via the green-screen setting in Premiere. Once again, the Paintbucket tool was used to fill the outer portions of the sunburst with solid black. Figure 15-31 shows the filled outline shape and the filled black background. This graphic will function as a mask for the video clip. With the center of this graphic removed, the video clip of the runner drinking the beverage appears inside the sunburst design.

In the Chapter 4 tutorial, the "runner drinking" clip is replaced by a part of the sunburst logo (*Logo.psd*). The *Logo.psd* graphic faded into the frame, replacing the runner video. As you know, the sunburst logo originated as an Illustrator graphic and was converted to a Photoshop document for use in Premiere. When inserting the *Logo.psd* graphic, careful detail is given to placement and alignment to ensure design and transition consistency. Figure 15-32 shows the logo as it replaces the runner clip. Note the lens flare effect applied in Premiere.

Fig. 15-32. The Logo.psd *graphic replaces the runner video clip.*

Bottle Label Design

The *GO Energy Drink* logo and label were created in Illustrator for several reasons. One reason is that the logo served as a fake bottle label for the photography used in the tutorial. Next, most of this logo was

imported directly into Premiere and used in a variety of formats in the development of tutorials 11-1 and 11-2.

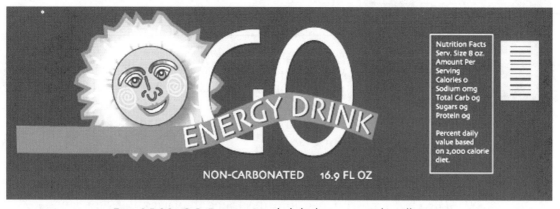

Fig. 15-33. GO Energy Drink *label as created in Illustrator.*

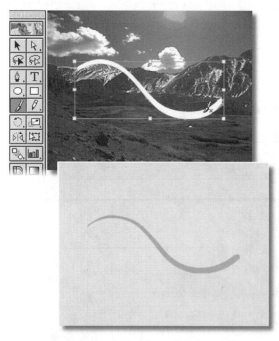

Fig. 15-34. A freehand line drawn in Illustrator using the Paintbrush tool, and then edited in Photoshop.

Creating the Line.psd

Tutorial 8-3 demonstrated how to move a graphic object along a visual path. In this scenario, a mountain photograph was used as a backdrop and a visible path was established for a balloon image to follow. The line art was created as a separate image and used as an overlay to the photograph of the mountains. The line path was created in Illustrator as a freehand stroke using the Paintbrush tool, as shown in figure 15-34.

The photo of the mountains was imported into Illustrator and the path was drawn overlaying the imported photo image. By creating the path as an overlay, the proper visual relationship between the line and the composition of the mountains in the photograph was achieved. Once the line was designed to satisfaction, the mountain photograph was removed and the line art was saved as an *.eps* file.

The next process was to open the line file in Photoshop. Here, the line was changed to a yellow tone and a green screen was added to the background. The yellow tone of the line complemented the colors in the mountain photograph. A green color was applied to the background, which was removed via the green-screen technique in Premiere. To complete the image, the canvas was cropped to 320 x 240 pixels. When this file was placed in a superimpose track in Premiere, the background image was removed and the line was positioned in the center of the screen, in proper alignment with the visual terrain of the mountain photograph. In the final tutorial, the balloon image appeared to float along the path.

Sojourn Logo in Tutorial 7-4

The Sojourn Balloons logo was designed in Illustrator very loosely over the photograph of the balloon. With the balloon photograph imported, the Paintbrush tool was used to trace over the image to provide a free-hand effect. Line width settings were adjusted, which provided a variable line width.

Using the Paintbrush tool, the balloon image was created by outlining the balloon photograph. A yellow fill was selected in order for the image to contrast with the blue tones in the background video clip of the clouds. In Premiere, the balloon photograph appeared briefly and then faded out as the illustration faded in (see figure 15-35).

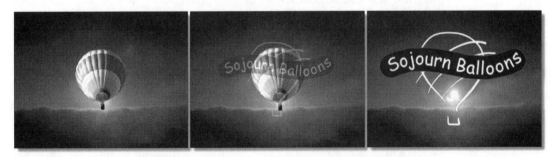

Fig. 15-35. The Illustrator logo gradually dissolves over the balloon image.

Adding Text in Tutorial 7-4

Text was added to the *BalloonLogo.eps* logo using Illustrator's Bezier line tool. A curved path was created for the text, as shown in figure 15-36. Once the line was created, the Text on a Path tool was selected and

the words *Sojourn Balloons* were typed. Next, the text was changed to 100% white. A background image was then created to enhance the appearance of the white text. This image was drawn using the Bezier line tool and was designed to provide a solid black background for the text, completing the logo.

Fig. 15-36. Using Illustrator's Path Type tool to create text.

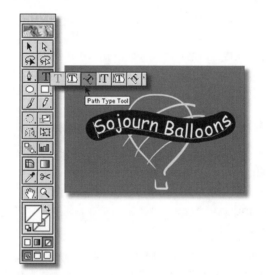

Premiere and Adobe InDesign

A big question in general computing is how to take a file created in one program and use it in other applications. Another way to put this is how can I repurpose files to be used in other environments. Premiere offers some obvious options to this question. Video clips can be output to film, can be used for presentations on the Web and can be placed on CD-ROM or DVD-ROM. Having worked through the tutorials in this book, you have seen the ease with which Photoshop and Illustrator files are imported directly into Premiere. These are essential programs for still image development for use in Premiere.

When you think of Premiere, you think of making movies, so how can Premiere movies serve other purposes? What about using movies for the creation of documents for the Web or for print? What about extracting frames, or still images, for use in other programs? In the following section, a workflow is presented to inspire creative alternatives for the use of digital video clips. By utilizing Premiere's frame capture feature, Adobe's InDesign 2.0 will be used to create a document that can be distributed in a variety of formats.

About InDesign

Adobe InDesign can accept a variety of external files to create virtually any type of document. Traditionally, InDesign is associated with printed documents. However, InDesign files can be exported as XML, EPS, or Adobe PDF documents. InDesign maintains a tight integration with other programs, particularly with other applications by Adobe Systems. These programs include Photoshop, Illustrator, and Acrobat. Much of the smoothness of this integration is due to the fact that they all share a similar interface and commands, and all have the ability to import/export common file types.

Using Premiere Images in InDesign

The ability to capture a video frame from Premiere is as simple as selecting the frame and then File > Export Timeline > Frame. When frames are exported from Premiere, they can be placed directly into InDesign without modification. Once placed, images can be cropped, reduced, enlarged, scaled, or have a multitude of other effects added. InDesign can also import many types of graphics file formats.

Should an image require touch-up, it can be opened in Photoshop and modified as needed. Figure 15-37 demonstrates a frame captured and exported from Premiere. Next, the image is opened in Photoshop, reduced in size, and enhanced with a drop shadow effect. The image is now ready for use in other applications.

Fig. 15-37. A still image is exported from Premiere and modified in Photoshop.

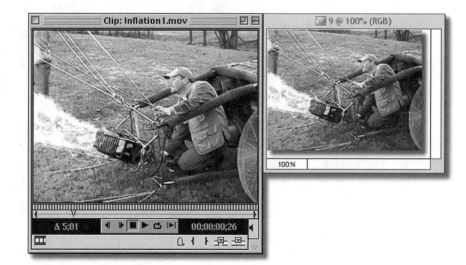

Figure 15-38 provides a glimpse of how a page can be assembled in InDesign from frame grabs in Premiere. This page is a mock-up of a step-by-step installation guide. The images were taken from clips used in tutorials 7-1 through 7-3, which follow the setup and launch of a hot air balloon. By using preexisting elements, this page is easily assembled. The logo at the top is an existing Illustrator file from tutorial 7-4 that imports into InDesign without modification. The frame grabs were captured from existing video clips used in the tutorials. The only elements added were the text and the cloud art at the top of the page.

When considering printing a hard copy of the document, as shown in figure 13-38, resolution should be considered. Keep in mind that frames exported from Premiere are originally in a *.pct* format at 72 dpi resolution. This resolution is fine for on-screen display. However, it will not reproduce a high-quality image for printing. When using this process, keep in mind the end product and the level of quality required.

Fig. 15-38. A variety of images repurposed to develop a document in InDesign.

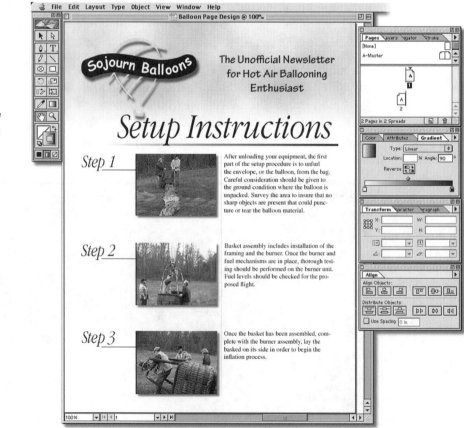

This is an excellent example of repurposing content. From this page design, the document can be easily distributed via print, PDF, and the Web.

Output Options

Fig. 15-39. InDesign's file export options.

In the old days, before the popularity of the Web, about the only way to distribute a computer document would be to copy it to a floppy disk or to print it. Today, however, there are numerous means of distributing an electronic document. Sophisticated software such as InDesign allows you to design and repurpose content for use in various media, including print, the Web, e-books, PDAs, and wireless devices. This process promotes an easy-to-manage workflow for the distribution of any document.

InDesign's output formats are varied. See figure 15-39 for a list of output options.

Premiere and Adobe Acrobat

Adobe Acrobat and the .pdf format have become the standard vehicle for electronic document delivery. This is true primarily because the technology is proven, easy to use, portable, and very reliable.

The Acrobat Reader is the engine that allows anyone, on any computer platform, to open documents saved in .pdf format. This technology allows the user access to content-rich documents that display and print exactly as the sender designed it.

The Acrobat Reader, however, is only one branch of the Acrobat family tree. Acrobat, the application, allows any type of document to be saved

as a *.pdf* file. The Acrobat application allows the creation of rich documents capable of containing graphic images, links, bookmarks, forms, comments, handwritten notes, and sound and movie clips.

Acrobat *.pdf* files are an excellent means of document distribution via the Web. Individual pages display with clarity, file sizes are small, and pages load quickly. The icons shown in figure 15-40 are of Acrobat's primary components: the Acrobat Reader and the Acrobat application program. The reader is easily acquired by selecting the Get Acrobat Reader icon, which links to Adobe's web site, allowing a free download.

Fig. 15-40. Adobe Acrobat icons.

Acrobat Media Flexibility

As Acrobat evolves with each release, new features constantly redefine its unique capabilities. One giant leap in functionality includes the ability to save *.pdf* files in various non-native formats. Beginning in Acrobat 5.0, files can be saved to a variety of formats, including *.rtf*, *.eps*, and *.ps*. You can also extract images included in *.pdf* files and save them in *.tif*, *.jpeg*, or *.png* formats.

Acrobat uses the same Adobe Color Engine as Illustrator and Photoshop, complementing the reliable workflow between the products. This will ease the process of swapping and recapturing art from one application to another and ensure color fidelity as images are passed from one application to another. Web pages can also be converted to Adobe *.pdf* by selecting the Open Web Page button on the Acrobat toolbar, entering a URL for the web site you want to open, and entering a number of levels you want to include from the web site.

Premiere/Acrobat Interface Example

Acrobat's strength lies is its power to take any document and package it in a format that can be distributed to any computer for viewing and/or printing. Acrobat ensures that the document will always look the same and will print text and graphics as originally designed. As reviewed earlier in this chapter, still frames were captured and output in Premiere and used as still images for the creation of an InDesign document.

This document was exported as a *.pdf* file within InDesign and saved as *Balloon Page.pdf*. Next, the file was opened in Acrobat 5.0, where video clips were inserted directly over the existing photographic images, thus replacing these graphics. The following workflow demonstrates how files created in Premiere and related source material from various tutorials were integrated into an Acrobat document, creating a new delivery medium for this content.

- The *Balloon Page.pdf* document was opened in Acrobat 5.0.

- A copy of the file was created and saved as *Balloon Video.pdf*.

- Using the Movie tool from the Editing toolbar, the current photograph was traced, establishing a location for the movie file. Upon release of the mouse button, the Movie Properties dialog box opened, providing options for locating a movie, setting a poster frame, showing the controller, and incorporating border options. See figure 15-41.

Fig. 15-41. Using the Movie tool, a video clip is placed in an Acrobat document.

- Once these options were selected, the movie was linked to this location in the Acrobat document.

NOTE: *QuickTime movies placed in a .pdf document are only pointers to the original movie file. If a .pdf file is distributed that contains linked movies, the actual movie file must be included. File names and associated paths must keep the original path in order for the file to be located for playback.*

- By adding additional movies to the document, the file was saved and ready for distribution, or to be viewed using the Acrobat Reader. Figure 15-42 shows that as a movie clip is selected, playback automatically begins and the movie controller appears on the video clip, allowing the user control.

Fig. 15-42. Video clips with playback controls in an Acrobat 5.0 document.

Document Workflow and Distribution

Figure 15-43 shows the illustrated workflow as reviewed in figures 15-41 and 15-42. This page can be used for the Web or as an instructional piece on CD-ROM or in other workflows.

Fig. 15-43. Illustrated workflow as reviewed in figures 15-41 and 15-42.

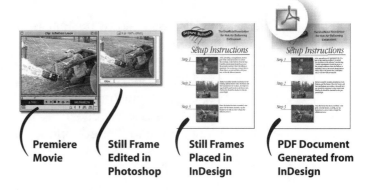

Premiere Movie | Still Frame Edited in Photoshop | Still Frames Placed in InDesign | PDF Document Generated from InDesign

As the preceding example illustrates, the workflow between the selected products is a natural, seamless process. The workflow, however, does not stop once the document has been created. The distribution process picks up immediately after the creation process is complete. How and where these documents are used is based on the need of the end user. As shown in Figure 15-44, Acrobat can export files to many varied formats to meet a variety of end user needs.

Fig. 15-44. Distribution capabilities for a .pdf file.

Acrobat's capabilities are almost endless because of the types of media it can incorporate and the varied formats in which it can be distributed. Creative design and distribution of *.pdf* documents is a process that will benefit any communication initiative.

NOTE: To review InDesign and Acrobat files used in this chapter, see the files *Saved Files/InDesign Examples* and *Saved Files/PDF Example* on the companion CD-ROM.

Summary

This chapter discussed software that is complimentary to Adobe Premiere. Photoshop, Illustrator, InDesign, and Acrobat offer tremendous flexibility to the potential of Premiere. All of these products support one another by adding visual impact to any image, either motion or still. This chapter has also illustrated the workflow between these programs and the creative process involved in the development of the various media types used in tutorial development for this text.

GLOSSARY

aliasing: Produces jagged edges on an on-screen image. If severe, produces an undesirable image.

analog: Pertaining to video editing, analog video is any type of nondigital video source.

animatic: Basic animation used to build a story sequence in order to pre-visualize how a screen will appear upon completion. Animatics can be images on film or videotape. They can also be computer generated, which allows quick previews and easy editing. This also spares the expense of using real actors and shooting on location.

antialiasing: An effect that softens (blurs) the edges of on-screen images to make them appear smoother. Important for higher-quality images.

architecture: In nonlinear video editing, refers to the software environment used to edit and produce video. This software affects the manner in which video is created, compressed, and stored, and influences other aspects of the overall workflow of producing a finished video. Video architecture includes video presentation formats such as MPEG, QuickTime, and RealVideo, all of which can be generated in Adobe Premiere.

artifact: Undesirable visual elements that appear in a movie. Typically expressed as undesirable color blocks or rough details in certain portions of the screen during movie playback, dramatically around images of high contrast.

aspect ratio: In video, the ratio of screen image width to height. The aspect ratio for standard video is 4:3. 16:9 is the HDTV standard.

AVI: A Microsoft term that stands for Audio Video Interleave. This is the file format used for video under Microsoft Windows.

batch capturing: In Adobe Premiere, batch capturing allows a specified series of video clips to be captured from analog videotape. Once captured, these clips become digital files.

BNC connector: Used to connect professional video equipment cables.

camcorder: Handheld video recording device with built-in record-to-tape mechanism. Recording formats include VHS, S-VHS, VHS-C, 8-mm, Hi8, and mini DV. Mini DV camcorders record images digitally and allow digital file transfer from camcorder to computer via FireWire or the IEEE 1394 interface.

capturing: Typically refers to the acquisition and conversion of analog video to digital video. This is done by connecting an analog video source to a digitizing card in the computer. Selected video clips are captured once they are converted to a digital file that can reside on computer.

CGI: Computer Graphic Imagery file format.

channel: In video, refers to each of the red, green, and blue (RGB) colors that make up the total video image. Each of these colors (channels) can be manipulated individually for customization of the image.

character generator: External hardware device that allows text to be created that can be inserted over video.

chrominance: Color portion of a video signal.

clip: Digitized video segment.

codec: Stands for compressor/decompressor. An algorithm that compresses and stores video signals and playback with predetermined results. Many codecs are available and are designed for specific output scenarios. An example is using the Cinepak codec for saving a file for playback on a CD-ROM.

component video: Video signal consisting of three individual signals: Y (luminance), Cr (chroma and red), and Cb (chroma and blue). Component signals offer the maximum luminance and chrominance bandwidth. Some component video (such as Betacam and BetacamSP) is analog; other component video (such as D1) is digital.

composite video: Video signal combining both chrominance and luminance.

compositing: Combining of two or more images. In Premiere, this would include overlaying one image with another, typically using a transparency, motion, or special-effect filter. When the file is complete, the images become one.

compression: Applicable to single images as well as video and audio clips, an algorithm used to reduce the amount of data in such images or clips. The result is a smaller file size.

compression ratio: Ratio of the compressed size of an image or clip to its noncompressed size.

data rate: The rate at which data travels. Typically thought of as the rate at which information (data) can be delivered and/or received.

digital: The opposite of analog. All computer data is encoded digitally as zeroes and ones, meaning that information is either on or off. Digital information is easy to store as well as to manipulate. Working with digital video or audio means that captured files will reproduce faithfully upon duplication.

digitizing (digitization): The conversion of an analog medium, such as a video or audio clip, into a digital signal.

dissolve: In video editing, to fade one clip into another gradually.

DV: Stands for digital video. For camcorders, DV refers to units that use mini DV videotape that compresses captured video using the DV25 standard. These cameras also possess an IEEE 1394 or FireWire port for connecting to a computer and transferring files. DV also refers to a type of videotape used in DV camcorders and decks.

DVD: Stands for digital versatile disc. DVDs may look like a standard CD but have a much higher storage capacity. DVDs can hold all types of digital information, but the most popular application is for storing movies saved via MPEG-2 compression. DVDs can be played back on computer DVD drives and consumer DVD players.

DV25: The most commonly used form of digital video compression.

EDL: Stands for edit decision list, a master list of all edit-in and edit-out points (as well as any transitions, titles, and effects) used in a film or video production. The EDL can be input to an edit controller, which interprets the list of edits and controls the decks or other gear in the system to recreate the program from master sources.

effect: Filter that when placed on a video or audio clip changes the behavior and/or appearance of the clip.

fields: Component of television screen image, where the image consists of alternating lines of information. These lines alternating at the proper rate display an image on the screen. These lines are also considered field 1 and field 2 lines, or odd (upper) and even (lower) lines. The NTSC standard calls for a total of 525 lines of resolution on a screen. These lines are divided between odd and even fields; therefore, 262.5 lines per field.

filter: Programming element that produces an effect in a video.

FireWire: Developed by Apple Computer, a technology for transferring audio, video, and other data from digital devices to the computer at a high transfer rate. The industry-standard designation for FireWire is IEEE 1394.

fps: Frames per second; the rate at which video plays.

frame: In video editing terminology, a frame is a single still image. In a video clip, the entire motion sequence consists of many still images, or frames. When these images are played in sequence at a particular speed, the illusion of live motion is achieved.

frame rate: Number of video frames, or images, shown in a specific time period. See also *fps*.

generation loss: With analog media, such as VHS tapes, generation loss occurs each time a tape is copied, due to video "noise" copied during the duplication process. With digital tape and digital files, the quality of each copy is the same as the original.

IEEE 1394: Standards designation for FireWire, a technology made possible by a cable that facilitates digital transfer between DV devices, including computers, digital cameras, DV camcorders, hard disk drives, and other external devices.

i.LINK: Sony trade name for the equivalent of IEEE 1394, or FireWire.

insert edit: The insertion of frames into an existing clip (or clips), lengthening the original clip.

interframe compression: Process that reduces the amount of video information by storing only the differences between a frame and those that precede it.

intraframe compression: Process that reduces the information in a single video frame.

JPEG: Stands for Joint Photographic Experts Group, of the International Organization for Standardization (ISO), which sets standards (among many others) for compression of still computer images. This file format standard is applicable to video due to the fact that video consists of a series of still images.

keyframing: Establishing a minimum of two points on a video clip that determine the starting and an ending points for the duration of an animated effect.

log: List that describes video clips, or shots, and detailed information related to such shots.

lossless: Describes the process of pure transfer of a video signal from one source to another. The IEEE 1394, or FireWire, transfer process is an example of lossless data transfer.

lossy: Compression scheme characteristic that causes degradation of signal fidelity.

luminance: Level of brightness of a video signal.

MJPEG: As JPEG is to still images, Motion JPEG (MJPEG) is to motion images. See also *JPEG*.

motion effect: Effect that changes the motion of a video clip, including reversing motion, slowing motion, increasing motion, and similar effects.

MPEG: Stands for Motion Picture Experts Group, a working group of the International Organization for Standardization (ISO). MPEG is a video format and a compression technology. The initial goal of the MPEG-1 standard was to provide near-broadcast video quality for clips stored digitally. MPEG achieves high compression rates by storing only the changes from frame to frame and not the entire frame. The compression technology allows clips to play back accurately on slower delivery media, such as CD-ROM. MPEG-2 is the format used on DVD-ROMs. This is a higher-quality format that requires decoding devices for proper playback.

NLE: Stands for nonlinear editing. Typically used to refer to a computer system that edits nonlinearly.

noise: Any external noise that interferes with the purity of an original video or audio signal. Typically caused by some form of signal interference.

nonlinear editing (NLE): Typically video and audio editing performed on a computer using a software interface that allows changes to occur at any point during production. Once changes are made, the edited sequence can be output instantly, with changes expressed in the output. See also *NLE*.

NTSC: Stands for National Television Standards Committee. NTSC is the standard for color television used in the United States, Japan, and other countries. Specifications for NTSC include an interlaced display with 60 fields per second and 29.97 fps (frames per second).

PAL: Video format standard for most European and South American countries. It is a broadcast-only format that operates at 50 fields per second and 25 fps (frames per second).

pixel: Stands for picture element. The minimum computer display element. Each pixel on a screen can have a unique color and brightness, or intensity level. In video editing, a pixel is used as a unit of measure of the width and height of a video clip (e.g., 320 x 240 pixels).

post-production: Phase of production that begins once video is shot. Involves the assembly of video footage, as well as the addition of graphics, titles, sound, and other effects.

pre-production: First stage of a project, in which the scope of the project and a step-by-step plan for execution are established.

previsualization: Process utilizing sketches, storyboards, animatics, edits, and the like to establish the look and feel of how a project will eventually unfold.

Print to Tape: In Adobe Premiere, an option found in the File menu that plays the assembled clip and allows the project to be recorded to an external recording device.

production: The process of capturing raw source material.

program monitor: In Adobe Premiere, the program monitor is a window that displays a currently selected image or video clip.

project: In Adobe Premiere, a project is the software interface that displays the current project. Files visible in the project are stored on a hard drive or external storage device.

QuickTime: Developed by Apple Computer, a multimedia software architecture that allows the playback of video, sound, text, music, 3D imagery, and virtual reality content. This platform also facilitates web streaming (downloads).

RCA connector: Standard audio and video connector for components such as VCRs and audio receivers.

RealMedia: Software architecture that provides low data rates and compression, allowing audio and video to play back on the Web.

real-time: In video editing, describes the manner in which video information is received or played back, providing natural movement of all images. Descriptive also of the manner in which effects and transitions are added and reviewed. Real-time previewing of these effects and transitions means that previews can be viewed instantaneously (i.e., in real time).

rendering: Process that calculates how effects, motion, or other changes made to a clip will work, and processes such changes for viewing.

resolution: Size (width and height, measured in pixels) of a frame of video in relation to the number of its constituent pixels. Images higher in resolution (i.e., better ratio of size to number of pixels) provide superior image quality.

RGB: Stands for red, green, blue. These are the three primary colors that constitute a computer display.

ripple: The movement forward or backward of clips in the Adobe Premiere (or similar package) timeline to accommodate inserted clips.

scrubbing: Process in which a mouse or other device is used to preview a video clip manually forward and backward.

SECAM: Video format standard for France, Africa, and the Middle East. A broadcast-only format that operates at 25 fps (frames per second). This standard affects equipment such as cameras and recording decks. See also PAL and NTSC (other standards).

slide edit: Edit in which a clip's out point is adjusted, affecting the next clip's in point. Does not affect the balance of the program or the entire movie duration.

slip: Editing term referring to an adjustment of the in and out points of a clip without affecting adjacent clips. Does not affect the balance of the program or the duration of the program.

source monitor: In Premiere, the source monitor is a window displaying video clips being edited.

streaming: Playback of video as it is being streamed direct from the Web or via a network server. That is, the video begins to play back before the video has been entirely downloaded.

S-Video: Stands for Super-Video. A technology that uses a video signal consisting of two separate signals, one for luminance and one for chrominance. The S-Video cable is unique, connections for which can be found on recording decks, TV monitors, camcorders, and other devices. See also *Y/C video*.

time code: Numbered reference code added to videotape that establishes locations on the tape that can be accessed based on a time sequence. In and out points can be accessed via these time marker locations.

timeline: In Premiere, the timeline is a window in which video clips, transitions, audio files, and graphics are added and then arranged into a timed sequence, creating a finished movie.

transition: The blend of the end of one video clip into the beginning of another video clip. A transition is typically effected by using one of many pre-designed transition effects placed between the two video clips to be affected.

transparency: Level of opacity of a video clip, photo, or graphic element. Typically can be adjusted up or down in 1-percent increments or at larger percentages.

trimming: The process of editing an individual clip at specific frame locations.

24-bit color: Color consisting of red (8 bits), green (8 bits), and blue (8 bits).

uncompressed: Descriptive of video that has not had a compression scheme applied to it prior to its digitization and storage.

video capture card (or video capture board): Device (typically produced by a third-party company), installed in one of a computer's expansion slots, which facilitates connectivity to a camcorder, or other device, in order to capture (or digitize) video clips. Hardware or software codecs are used to compress video clips upon capture and uncompress the video for playback on an NTSC television monitor.

XLR connector: Connector that incorporates three conductors. Typically used in professional audio and video applications.

Y/C video: Y (luminance) and C (chrominance) video. The Y/C designation indicates that the luminance and chominance signals are separated, which provides superior image quality. Used as a component of S-Video.

YCC: Y (luminance) and two C (chrominance) components.

APPENDIX:
ADOBE PREMIERE 6.5 INTERFACE
COMPONENT VISUAL REFERENCE

This appendix illustrates and serves as a quick reference to the functional features of the major components of the Premiere 6.5 interface.

Timeline Window

Timeline window menu button

Adobe Premiere® Help
Track Options...
Snap to Edges
✓ Edge View
✓ Shift All Tracks
Sync Selection
Add Video Track
Add Audio Track
Hide Shy Tracks
Single-Track Editing
✓ A/B Editing
Timeline Window Options...

A. Tools (see below)
B. Toggle Track Output/Shy State
C. Superimpose track
D. Display Keyframes
E. Display Opacity Rubberbands
F. Video track
G. Transition track
H. Toggle Expand track
I. Video Track
J. Shy Audio track icon
K. Waveform, Keyframe, Volume, and Pan icons

L. Time Zoom Level menu (see below)
M. Track Options Dialog button
N. Toggle Snap to Edges button
O. Toggle Edge Viewing button
P. Toggle Shift Tracks Options button
Q. Toggle Sync Mode button

L
1 Frame
2 Frames
4 Frames
8 Frames
1/2 Second
✓ 1 Second
2 Seconds
4 Seconds
10 Seconds
20 Seconds
1 Minute
2 Minutes
4 Minutes
8 Minutes

Tools
Range Select
Block Select
Track Select
Multitrack Select
Rolling Edit tool
Ripple Edit tool
Rate Stretch tool
Slide tool
Slip tool
Fade Scissors tool
Multiple Razor tool
Razor tool
In Point tool
Out Point tool
Link/Unlink tool
Fade Adjustment tool
Cross Fade tool

405

Project Window

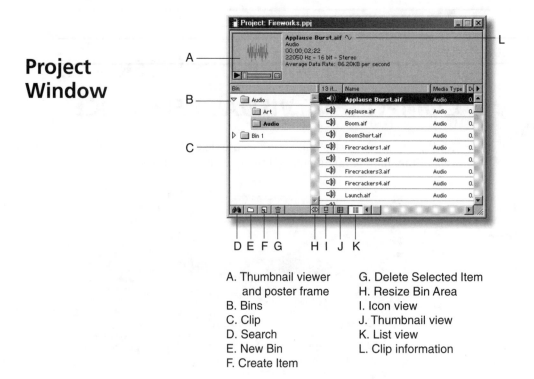

A. Thumbnail viewer and poster frame
B. Bins
C. Clip
D. Search
E. New Bin
F. Create Item

G. Delete Selected Item
H. Resize Bin Area
I. Icon view
J. Thumbnail view
K. List view
L. Clip information

Audio Mixer

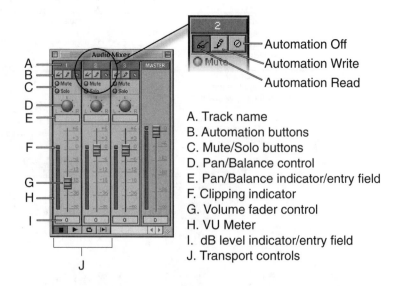

Automation Off
Automation Write
Automation Read

A. Track name
B. Automation buttons
C. Mute/Solo buttons
D. Pan/Balance control
E. Pan/Balance indicator/entry field
F. Clipping indicator
G. Volume fader control
H. VU Meter
I. dB level indicator/entry field
J. Transport controls

Monitor Window

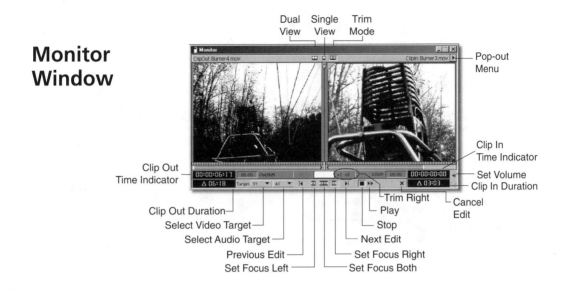

Dual View · Single View · Trim Mode

Pop-out Menu

Clip In Time Indicator

Clip Out Time Indicator

Set Volume
Clip In Duration

Clip Out Duration

Cancel Edit

Select Video Target

Trim Right
Play

Select Audio Target

Stop
Next Edit

Previous Edit

Set Focus Right

Set Focus Left

Set Focus Both

Title Window

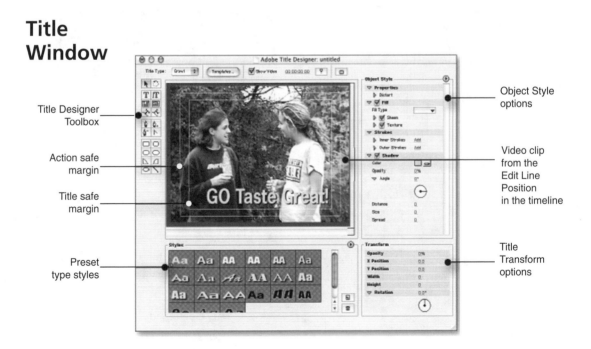

Title Designer Toolbox

Action safe margin

Title safe margin

Preset type styles

Object Style options

Video clip from the Edit Line Position in the timeline

Title Transform options

Palettes

Effect Controls Palette

Delete

Info Palette

Navigator Palette

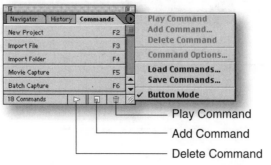

Enlarge View

Manual Adjustment

Reduce View

History Palette

Delete State

Commands Palette

Play Command

Add Command

Delete Command

Palettes

Transitions Palette

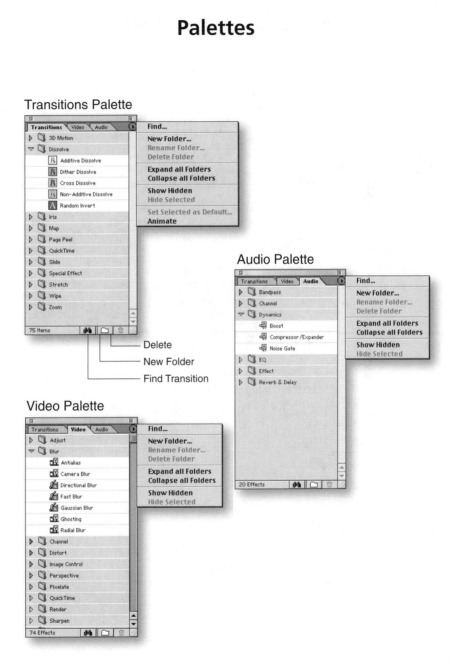

Audio Palette

Video Palette

Effect Controls and Their Effects an a Clip

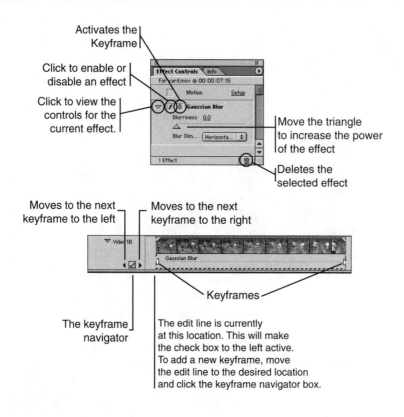

Activates the Keyframe

Click to enable or disable an effect

Click to view the controls for the current effect.

Move the triangle to increase the power of the effect

Deletes the selected effect

Moves to the next keyframe to the left

Moves to the next keyframe to the right

Keyframes

The keyframe navigator

The edit line is currently at this location. This will make the check box to the left active. To add a new keyframe, move the edit line to the desired location and click the keyframe navigator box.

Index